Early Christian & Byzantine Art John Lowden

ART&IDEAS

Φ

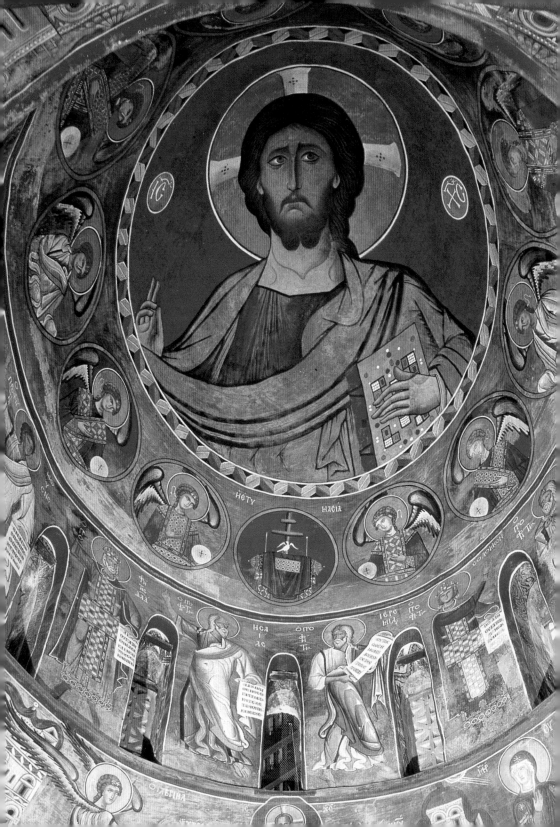

Early Christian & Byzantine Art

Opposite
The Pantokrator, Christ the Omnipotent (detail of 219). Wall-painting in the dome of the church of the Theotokos, Lagoudera, Cyprus

How do you picture God? Should images of Christ show him as young and beardless, or with long dark hair and a curling beard, or as a lamb? How would you recognize St Peter if he appeared to you in a dream? What shape ought a church to be? Inside, what forms of decoration are appropriate? It was questions like these that confronted the people who made and paid for and used the art and architecture of the Early Christian and Byzantine world. The answers they came up with are visible today in surviving buildings and in works of art now often in museums and scattered around the world. But they are also familiar – much more familiar – from later periods, because Early Christian and Byzantine artists invented and defined the Christian tradition in visual representation that dominated European art until recent times. The images and structures they created to embody the visible and invisible worlds of religious experience and belief were visually and intellectually so satisfying that their tradition was maintained, even through periods that sought self-consciously to throw off the burden of the past. This book is about that art – why it was made, how it was viewed, and what we need to do in order to understand it.

From the outset, it is important to bear several factors in mind. First, the timescale that is involved, which spans roughly one and a half millennia, the first three-quarters of the Christian era. Second, the geographical range that is covered, from the beginnings of Christian art in the Mediterranean world of the Roman Empire into its hinterland throughout the Balkans and the Near East, and in due course into areas that had never been Romanized, such as the Christian principalities of Russia. Third, the fact that though much has been destroyed or lost, many important – and vast numbers of lesser – works of art and architecture from this period survive, making any survey necessarily selective as to the examples described, the places visited and the narratives of individuals and ideas that are recounted.

The picture that emerges is one of powerful and intriguing paradox, prompting us to ask how it was possible, through centuries of change and often cataclysmic political upheaval, that the clearly defined artistic traditions of the Byzantine world continued to prevail even up to and beyond the final demise of the Christian empire in the East with the fall of Constantinople in 1453. Byzantine art often communicates a profound – if deceptive – sense of continuity in a changeless world-order, with an element of transcendent isolationism; but it must be remembered, too, that in terms of developments in western Europe, the period in question extends from the heyday of the Roman Empire right through the Middle Ages and into the early Renaissance. At certain times and places – as in Sicily under Norman rule in the twelfth century – Byzantine art can clearly be seen in direct relation to foreign ideas and radically different styles, both architectural and artistic.

In approaching this art, we must be aware that certain modern assumptions can stand in the way of an appreciation of what it actually is or represents. As will become clear, even the basic art-historical categories used in this subject can be misleading. For example, what is termed Early Christian art – art making direct reference to New (or Old) Testament themes and/or Christian symbols – does not date back to the time of Christ, but first appeared some two centuries later. Similarly, the term Byzantine, which derives from the name of the ancient Greek colony of Byzantion (latinized as Byzantium) that was refounded by the emperor Constantine as his capital and renamed Constantinople (modern Istanbul), is applied to art and architecture created at widely different times and places, often outside the borders of the 'Byzantine Empire' controlled or laid claim to by the emperors in Constantinople itself.

Most of the people we now describe as 'Byzantines' would have found this term incomprehensible. Constantine and his successors did not think of themselves as 'Byzantine' emperors: to the very end they styled themselves 'Emperor (or King) of the Romans', as heirs to the Roman Empire in the East. They viewed their territories – which over time fluctuated greatly in extent – in terms of this inheritance. The

populace of this world were thus definable as inhabitants of the Roman Empire or one of its successor states, invaders or neighbours. Latin and, from the seventh century, Greek remained the principal languages, as they had been throughout the ancient Mediterranean during the centuries of Roman rule, although many other languages were spoken too.

Because the culture in which the people of those times lived is very remote from our own, a considerable effort is needed if we are not to misjudge what we see. In particular, since Christianity has been such a shaping influence on the Western world-view, we need to be careful not to read the more distant Christian past in terms of modern notions. For these reasons, this book often stresses aspects of the unfamiliar that might easily be glossed over – for example the chosen forms for terminology and names. To anglicize a name from this period, such as 'John' or 'Gregory' (rather than calling the person Ioannes or Gregorios) may serve to link us to the world of Early Christian or Byzantine saints, but there is a real danger that it makes the past seem reassuringly familiar – which would be a serious mistake. On occasions, therefore, it may be more helpful to give people (and sometimes places) their 'real' names, although complete consistency is more than can be expected. Technical terms too are an important source of possible misapprehension. We could, for example, refer to parts of a Byzantine church as 'the nave' or 'the choir', which would cause the reader no problem. But in many important ways the *naos* or *bema* were not like the nave or choir of an English parish church or French Gothic cathedral – the terms used can be helpful, therefore, in highlighting unfamiliar concepts. Such terms will generally be explained when they first occur (and again in the Glossary).

Although some have looked for and found secular art produced during the centuries covered here, the very concept of 'secular' as 'not concerned with religion' is suspect, except perhaps at the start of this period. The great achievements of Early Christian and Byzantine culture – from church buildings and their mosaic decoration to painted manuscripts, carved ivory panels and cloisonnée enamels –

are overwhelmingly religious in context. But despite the familiarity that Bible stories and Christian imagery retain for some people today, there are many aspects of the theological and intellectual background to Byzantine art that are decidedly foreign to all of us. For example, while we like to think in terms of progress, of things developing and improving over time, the people we shall consider thought in a totally different way: they believed that, as time passed and the world became more distant from the Creation (usually reckoned as a historical event occurring at a date we would cite as 5508 BC) and the Incarnation and Resurrection of Christ, things were getting steadily worse. Similarly, while we find it comforting to follow the sort of narrative that moves forwards in time and appears to give meaning to a linear sequence of events, the people we seek to understand lived in a mental world of continuous flashbacks: they dreaded the future and the prospect of the Last Judgement, but looked back with admiration to the past, especially the more-or-less distant past.

These attitudes were implicit in their art. Artists did not seek after novelty for its own sake, and to make the innovative acceptable they often had to disguise it as if it were the product of some ancient tradition. Thus they were always involved in a highly complex relationship with the works of their predecessors, and to appreciate their art we too have to be constantly looking back. Moreover, their concept of tradition was far more than a simple respect for established norms. Holy images (icons), for example, were not seen as mere 'artists' impressions' of what Christ or the saints might have looked like: they were held to be versions of 'true' images of these figures and thus to contain or transmit – not just represent – the presence of divinity or supernatural power. Artists were commissioned to produce work that would impress God and the saints by its religious truth, and the cost and beauty of its materials and craftsmanship. These were works made to last and be effective far beyond a lifetime – literally until the end of the world.

Once again, familiar words can disguise unfamiliar concepts. We are used, for example, to referring to – or reading or hearing about – Jesus as 'Christ' (from the Greek translation of 'Messiah', the

Anointed) and Mary as 'the Virgin'. But 'the Virgin' is an epithet scarcely ever used for Mary in the art we shall look at. To the Byzantines, an image of Mary was an image of 'the Mother of God' or of 'the Theotokos'. To refer constantly to the Theotokos as 'the Virgin' may seem unproblematic, but it imposes the prevailing modern idea of the tender Virgin, meek and mild – a perception over-laid with Victorian sentiment – on the complex and powerful figure of the Mother of God whom we shall frequently encounter.

Images like words shape ideas as well as expressing them, and Early Christian and Byzantine art was profoundly ideological. But it was also an art that was made to be gazed at long and passionately. The illustrations that accompany the text that follows were chosen to convey an impression of what this art looks like. But no photograph, however stunning, is a substitute for the original it reproduces. It is my hope, then, that this book will not only help those who read it to think about the art it discusses, but that it will also encourage them to go and look at it. In the meantime, before setting off on that literal or metaphorical journey, there is a final point that it will be helpful to bear in mind. Every image reproduced in this book is visi-ble to exactly the same public or audience as every other. For the people for whom the works reproduced here were originally made, however, the situation could not have been more different: grand public buildings and their decoration were intended to be seen by tens of thousands of viewers every year, whereas some objects were made for the private contemplation of a single individual. 'Public' art would have subtly moulded the ideas of large sections of the popula-tion. 'Private' art would have been all but invisible in comparison. We need constantly to bear in mind the differences between present and past viewing conditions, although not, I think, so as to regret them. It is our great good fortune as modern viewers to be able within the compass of this book effortlessly to climb over barriers and look behind locked doors, to open museum cases and peer inside precious reliquaries, to turn the pages of priceless books and approach close up to jealously guarded images, to ascend scaffolding with restorers and photographers, to jump vast distances in time and space, and to see all this art together.

I

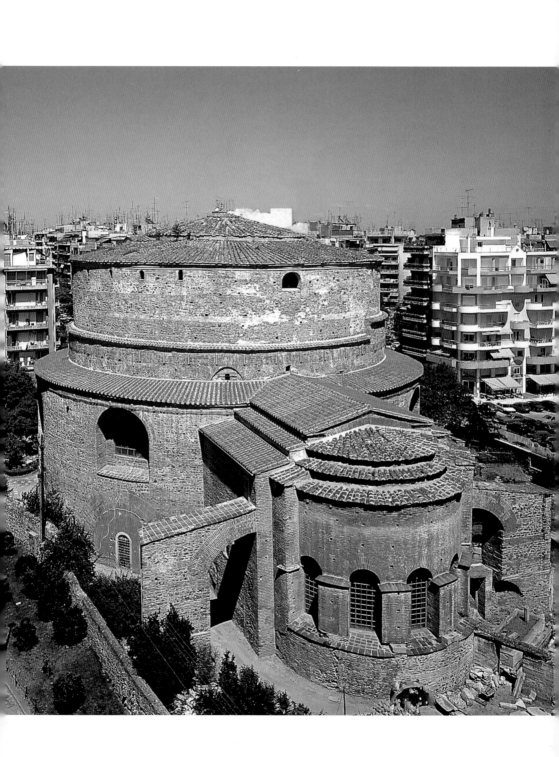

'The people who have been turning the whole world upside down have come here now' (Acts 17:6). With these words the Jews of Thessalonica began their denunciation of the apostle Paul to the council of the city in 50 AD. St Paul had been preaching Christianity in the city's synagogue for three sabbaths. He had been successful in convincing many Jews and Greeks, as well as a number of Thessalonica's leading women, according to the account in the New Testament. The city authorities were concerned to hear from St Paul's denouncers that Jesus was being proclaimed as another king (*basileus*) alongside the Caesar (the Roman emperor Claudius), and, although the charge was false, the apostle was obliged to leave under cover of darkness.

1
Hagios
Georgios,
Thessaloniki,
Greece,
c.300 and
later. Eastern
exterior

What sort of world was it that St Paul and other followers of Christ were accused of turning upside down? In 50 AD Thessalonica (now Thessaloniki; see map on pp. 436–7) was a prosperous cosmopolitan city which for two centuries had been part of the Roman Empire and capital of the province of Macedonia. Its citizens were interested in many religions and cults, and lived surrounded by an amazing wealth of grand public buildings, sculpted monuments, statues of all sorts, wall-paintings, floor mosaics, fancy gold and silver plates and table-ware, ornate jewellery, and all the variety of material we class as works of art. They were heirs to a cultural tradition that stretched back before Alexander the Great to the fifth and sixth centuries BC, but which was still continuing confidently to develop new ideas.

St Paul's Christian proselytizing is reported to have had an immediate and powerful impact in Thessalonica, but where and when did the impetus generated by this new faith lead to the emergence of a specifically Christian art? What is the evidence from the site itself? It is still a bustling and cosmopolitan Greek city, which until relatively recent times was dominated architecturally by the surviving great

churches within its walls, now masked by concrete tower blocks. But these were definitely not built by the immediate followers of St Paul. So far as we can tell, St Paul would have had to wait more than three hundred years had he wished to see such buildings. Why should this be so? Let us consider the question while looking at one of the biggest and earliest of the churches (1).

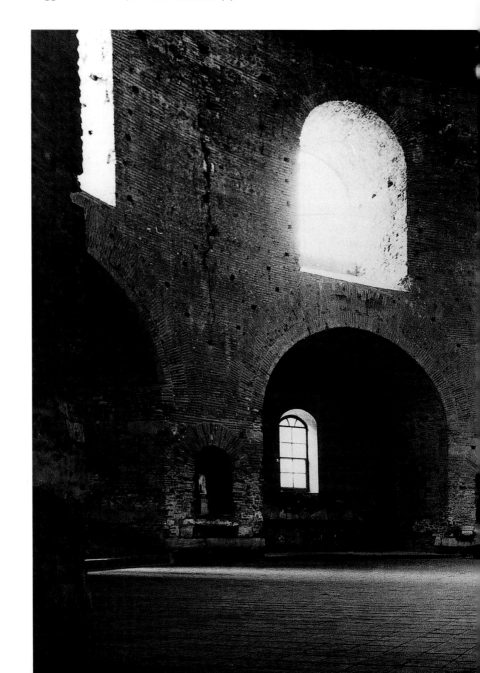

The massive round church of Hagios Georgios (pronounced Ayios Yoryios), now preserved as a museum, stands close to the site of the palace of the Roman emperor Galerius (d. 311), and just northeast of the triumphal arch celebrating Galerius' victory over the Persians in 297. The visitor enters down a flight of steps, and is confronted by conflicting impressions (2). The interior does not look like a church at

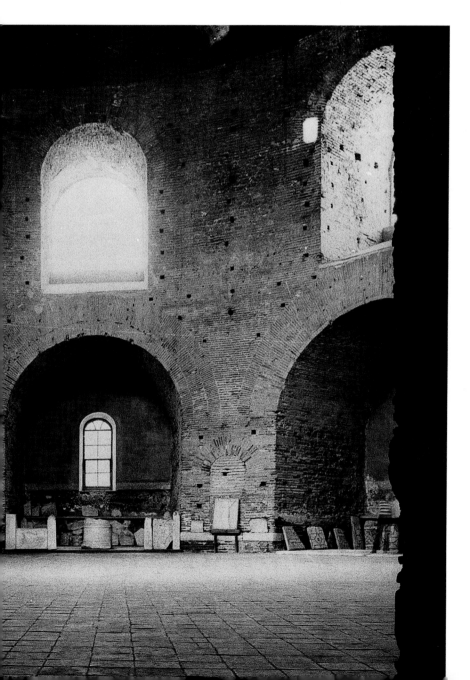

all, although an eastern extension, clearly an alteration to the original fabric, is identifiable as an <u>apse</u>. The massive walls more than 6 m (20 ft) thick, relieved by arched spaces at floor level and above by windows, rise vertically before blending into the brickwork of the huge dome (some 24·5 m, 80 ft in diameter). The bare wall surfaces have been stripped of their <u>revetment</u> (facing) of precious marble slabs, which would have been arranged in various geometric patterns and decorative designs to conceal the structural brickwork from view. The marble was doubtless reused in some other building. Far up in the dome (3–4) the eye can make out a broad band of gold mosaic (some 8 m, 26 ft deep), but all except the circular border of the central element in the upper parts of the dome has been lost. The plaster into which the small coloured glass and stone cubes (tesserae) of the mosaic were set has fallen in many places, helped by water leaking through the roof and an occasional good shaking from the earthquakes to which the city is prone.

The surviving sections of the dome mosaic consist of an upper band of parts of the heads and wings of four angels who support a richly decorated garland within which must once have stood a figure of Christ (lines scored in the brickwork sketch the forms, but they are not visible from the floor). In the better-preserved lower zone we see a band of complex architectural fantasies in front of which stand male figures, their hands raised in prayer. Although the figures appear small at this distance, they are larger than life-size. Alongside each figure the mosaicist placed an inscription giving his name, his occupation – whether bishop, presbyter (priest), soldier, physician, or, in one case, flute-player – and a month, presumably that of his death or commemoration. St Ananias presbyter (January) is a lightly bearded figure (5) dressed in the priestly phelonion (chasuble). But his companion, a more fully bearded figure in similar dress, cannot now be identified due to the loss of the inscription. In technical and artistic terms these mosaics are works of the very highest quality that

3–5
Mosaics,
c.5th century.
Hagios
Georgios,
Thessaloniki
Far left
St Kosmas and
St Damianos
Left
St Onesiphoros
and
St Porphyrios
Right
St Ananias
(detail)

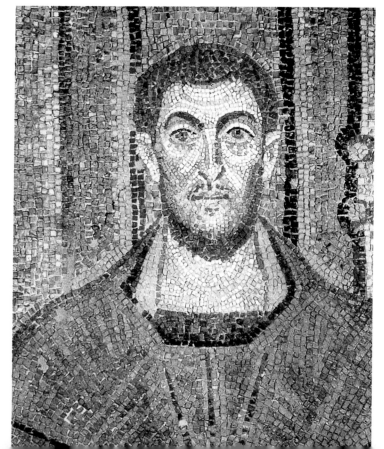

can stand comparison with products of any period or region. But what did these images mean to those who executed and viewed them? Why, for example, were these particular saints chosen? Why is the church itself round, and why does it seem that its images, so skilfully executed, were placed so high as to be difficult to see from the floor?

To consider the structure's form first, we can deduce that Hagios Georgios was not built to serve as a church. In all likelihood its construction was ordered by the emperor Galerius at the beginning of the fourth century. The approximate alignment of the circular structure with his triumphal arch and palace suggests that it was originally intended to serve as his imperial mausoleum. But when Galerius died in Serdica (modern Sofia in Bulgaria) in April 311 he was buried there, and the building now known as Hagios Georgios seems to have been left unfinished. We have no precise information on when or why the rotunda came to be converted into a church. There are expert advocates for a wide range of possible (but mutually exclusive) dates between the end of the fourth century and the early sixth century. The other major ecclesiastical buildings of this period in Thessaloniki are also all undated. And even though there is agreement that the impressive church of the Theotokos Acheiropoietos (named after a much later miraculous image 'not made by [human] hand') was constructed in the mid-fifth century, it cannot provide a basis for comparison as it has no surviving figural mosaics. We do not even know what the rotunda church was originally called, for its Christian dedication was lost during the long period of Ottoman rule in the city (1430–1912), and it functioned as a mosque after 1591.

In view of the profound effect its mosaics can still have on us, it would be satisfying to be able to answer all the questions raised by an enigmatic structure like Hagios Georgios – but this may be asking too much. To understand how the preaching of the Gospel by St Paul in 50 AD could have led to the conversion and decoration of emperor Galerius' mausoleum as a church around 400 AD or later, we will have to consider a number of possible explanations for a highly complex process that involved innumerable people, a multitude of works, a

vast geographical range, and a period of centuries. We will also have to bear in mind that much of the evidence has been irretrievably lost – burned, melted down, or otherwise destroyed, or simply decayed through the passage of time. Many images still seem to be able to communicate with us directly, but even to begin to understand them requires that we do more than gaze in admiration.

It is clear that Christian art did not begin in the time of Christ (d. *c.* 33 AD); from a perspective of almost two millennia we can assert this with confidence. Yet when people in the eighth or ninth century looked back to the origins of Christian art (as we shall see in Chapter 4) they were equally certain of the opposite view, and stated authoritatively: 'Painting is coeval with the preaching of the Gospel.' We shall need to consider this retrospective understanding in due course, but for the present an archaeological approach will be more appropriate. The evidence for Christian art forms just one strand in the rich and varied fabric of the Roman world in the first four or five centuries AD, and its history must be considered in relation to the broader history of the Christian religion.

After Christ's death Christianity grew slowly from a small base in Palestine by means of vigorous proselytizing. Through periods of official indifference and of tolerance alternating with more or less severe persecution, it eventually became the 'official' religion of the Roman Empire. The decisive turning point came early in the fourth century. Emperor Galerius, who had pursued a vigorously anti-Christian policy, issued an Edict of Toleration shortly before his death in 311, allowing Christians to practise their religion. A fuller and more generous version of this text was produced in 313 (the so-called 'Edict of Milan') by the co-emperors Constantine (r. 312–37) and Licinius (r. 308–24). This embodied not only freedom of worship but the restoration of confiscated church property. The following discussion, therefore, approaches the subject in terms of 'pre-Constantinian' and 'post-Constantinian' art, while also paying some attention to the figure of Constantine himself.

No large-scale Christian buildings from before 313 have survived intact, although such buildings must have existed in major centres of

population, despite the periodic persecution, destruction and confiscation of property to which Christians were subject, for there were large numbers of Christians throughout the empire by the fourth century. In the pre-Constantinian period, nonetheless, we can assume that Christians were not in a position to make bold public statements about their religion through monumental art or architecture, except perhaps in a funerary context (for reasons explained below). Throughout the Roman Empire, however, they must have met from the earliest times to celebrate the eucharist (in remembrance of Christ's 'Last Supper', eg Matthew 26:26–8), to sing hymns, hear readings, and listen to sermons following Jesus' assurance that 'Where two or three are gathered together in my name, there am I in the midst of them' (Matthew 18:20). Although by c. 300 there is evidence that purpose-built halls were being used for worship, these are known primarily from accounts of their destruction or orders for their reconstruction. In the third century and before, most of these meetings seem to have taken place in private rooms, some of which could doubtless have held sizable congregations.

Some of these rooms were probably painted with appropriate images, as they would have been in any Late Roman house, but of such decorated 'house-churches' only a single example has been discovered to date, at the site in Syria of a prosperous Roman trading post and garrison town called Dura-Europos, strategically located at the top of a steep slope above the River Euphrates on the eastern borders of the empire. Here, in around the year 256 AD, the inhabitants were hastily preparing their defences to meet an expected attack from Sasanian Persians. The walls were strengthened by infilling adjacent streets and buildings with a mixture of sand and rubble so as to increase their width – a defence against undermining. The expected attack came, the walls were indeed mined, and the city was taken. In one area a counter-mine dug by the defenders met a Sasanian excavation, a fight ensued, the mine collapsed, and the soldiers were buried. One was carrying his pay with him, and a coin of 256 provides the approximate date for the battle. Dura-Europos was deserted after its capture, and already a desolate site when visited and described by the emperor Julian ('the Apostate') some hundred years later.

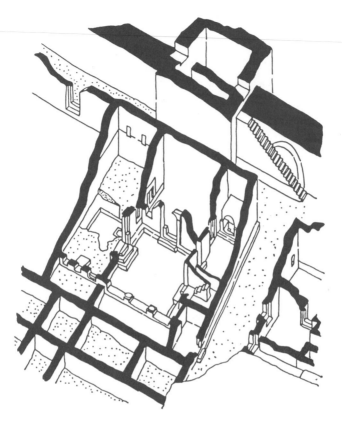

6
Christian
building with
the Baptistery
at the right
(isometric
view),
Dura, Syria,
before 256

Excavation in the 1920s and 1930s revealed that a number of reli-
gious cult buildings had been among those adjacent to the city walls
which had been hastily filled with earth and rubble. Christians were
but one of the religious groups for which Dura provided evidence. A
courtyard house of typical Roman design, no bigger or more impos-
ing than any of the other houses in the neighbourhood, had been
converted to serve as a church (6). Part of the decoration survived in
a small room (6·8×3·1 m, 22×10 ft) which was identifiable, on the
basis of its font, as a baptistery. The workmanship of the wall-paint-
ings is crude and their content schematic, but we can make out
enough to identify several scenes. Beneath the canopy over the font
was an image of a shepherd carrying a sheep on his shoulders, and

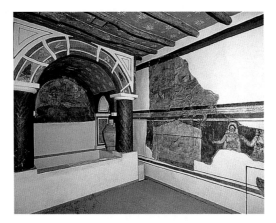

following his flock (7–8). This is a visual formula with a very long tradition in the Greco-Roman world, and carries the general implication of salvation (the sheep that was lost or had strayed is saved or rescued). The image of the Good Shepherd (as we term it) is then emphatically not a Christian invention, and yet it would have been understood by Christians in a specifically Christian way, for Jesus described himself as the Good Shepherd (John 10:11; compare the Old Testament verse 'The Lord is my shepherd', Psalm 23:1). The image thus communicates a precise and optimistic message to the Christian viewer: salvation comes through Christ.

On the fragmentary south wall of the Dura Baptistery were representations of two of Christ's miracles (7): the healing of a paralytic (eg Matthew 9:1–8), who is shown first lying on a bed, and then carrying it on his back; and Christ and Peter walking on the water (Matthew 14:22–33), with other apostles visible in a boat in the background. Below, on a much larger scale and more carefully executed, are figures of two women approaching a large sarcophagus. This presumably represents the Maries' visit to Christ's tomb (Matthew 28:1ff). Unlike the Good Shepherd image, these others focus on the miraculous, and on the narrative of the life of Christ. To the converts to Christianity who were brought to this room for initiation by baptism (compare Acts 8:37–8) the message of the images, to judge by what survives, was entirely positive so long as the viewers had adequate knowledge with which to interpret what they saw. But to the non-Christian these images would have failed to convey any special meaning: they would have been just paintings of some men, women, a boat, a bed, a tomb, and so on. The message of these spare and economical images is not self-evident: the viewer must work to interpret them.

More surprising even than the discovery of the paintings in the baptistery of the 'house-church' at Dura was the decoration found on the walls of that city's synagogue (9–10). Here were representations of individual figures, presumed to be the authors of biblical books, and images of narratives such as the Israelites crossing the Red Sea and the drowning of Pharaoh and his host, along with paintings of cult

7–8
Baptistery (reconstruction), Dura
Above
Wall-painting, c.250
Below
Detail of the Good Shepherd, 108×140 cm, 42¹⁄₂×55¹⁄₈ in

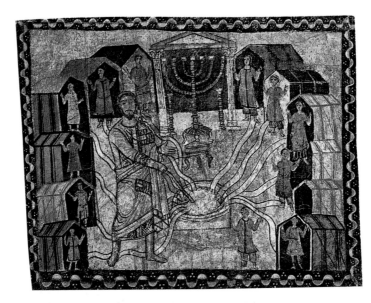

9–10
Wall-painting
from the
Synagogue at
Dura, *c.*250.
Reconstructed
in the National
Museum,
Damascus,
Syria
Left
Detail of
Moses at the
Well of Be'er,
140 × 190 cm,
55⅛ × 74⅛ in
Below
General view,
west wall

objects, such as the menorah – the seven-branched candlestick formerly kept in the Holy of Holies of the Temple at Jerusalem. These images were combined in a sophisticated way on the walls (almost 7m, 23 ft tall) of an imposing room (13·65×7·68 m, 45×25 ft), and the painting was skilfully executed. Like the Christian building, however, the synagogue occupied a site within the normal city blocks of domestic housing. It was approached through a forecourt, but this could only be reached by passing through another building, 'House H'.

Before the discovery of the Dura synagogue it was assumed that the commandment given to Moses on Mt Sinai prohibiting the making of any image or likeness of anything in heaven above, or in the earth beneath, or in the waters under the earth (Exodus 20:4) made the decoration of a synagogue with paintings of this sort inconceivable. This is a point to which we shall need to return, but for the present we can make three assertions. First, Christians in the third century decorated their religious buildings like the followers of other religions. Second, at Dura the Jewish community was larger than the Christian and had the means to employ a more skilful artist. And third (and more speculatively), had Dura not fallen to the Persians in 256, but flourished into later centuries, its modest 'house-church' would have been replaced with a much grander structure, and the evidence of its pre-Constantinian form and decoration would have been destroyed. In other cities the earliest phases of 'church' art and architecture have been lost because they fell victim to Christianity's later success. Only archaeological excavation is likely to bring further examples to light.

The paradox of success leading to destruction is perfectly exemplified in the city of Rome. No 'house-churches' decorated with Christian images or halls have been found, although we can confidently assume that they existed beneath such sites as the present church of S. Clemente, and it is only in the context of cemeteries that a major body of pre-Constantinian Christian art has survived in Rome. The crucial factor here seems to have been a legislative one: burials were regarded in Roman law as sacrosanct, so that even during periods of persecution Christian tombs were left largely unscathed.

Because of their beliefs about bodily resurrection, Christians generally buried their dead intact rather than cremating them. By law, corpses had to be buried outside city limits. Cemeteries, then as now, generally took the form of open areas in which monuments, markers, mausolea or other indications were placed above ground. Initially, it seems, Christians had no objection to being buried next to adherents of any other religion. Over time, it is true, Christians came to regard all non-Christians dismissively as 'pagans', but the burials of Rome's earliest Christians, including the apostle St Peter himself, were in 'pagan' cemeteries. The burials of figures regarded as especially important by the Christian community, the 'saints', often came to be marked by the type of funerary architecture characteristic of Greco-Roman attitudes to death: monuments or memorials generally symmetrical about their centre-point and relatively small. Only emperors built for themselves huge mausolea like that of Galerius in Thessaloniki. The small Christian memorials, however, like the painted house-churches, almost all fell victim to Christianity's success, later becoming the sites for major churches. The principal survivals from this early period are other types of burial or commemoration.

Around Rome, the excavation of intricate networks of galleries and chambers for burial in the soft volcanic tufa beneath fields or cemeteries (sometimes taking advantage of a worked-out quarry) was a relatively inexpensive activity. Such grave-sites, now generically termed catacombs, had the further advantage that they could easily be extended outwards or downwards in several storeys according to need. Burial in catacombs, as in cemeteries, appealed to adherents of various religions, although in due course 'pagan', Christian and Jewish tombs became separate. Catacomb burials also occurred elsewhere, although the Roman examples are the most numerous. And because catacomb burials were largely abandoned in the fifth century, and the very existence of most such burials was gradually forgotten until rediscovered by chance in the sixteenth century, their state of preservation is much better than that of the above-ground cemeteries.

Most catacomb burials were in niches (*loculi*) in the wall areas of the long excavated galleries. These were closed by slabs or tiles, and sometimes plastered over. There were standard sizes for one, two, three, four or more bodies, and small *loculi* for children. More costly was a larger excavation surmounted by a semicircular recess (an *arcosolium*), and a sarcophagus (or stone coffin – a major expense) might be used in these cases. Wall-paintings are mainly found in *cubicula*, separate 'rooms' off the galleries which were probably mainly intended for families or other groups. These were excavated so as to resemble built structures above ground and could contain *loculi* and *arcosolia* around the walls. The paintings in such *cubicula* probably resemble the kind of decoration that would have been found in contemporary buildings. Nevertheless, even these *cubicula* were emphatically burial places, not underground churches in which persecuted Christians met secretly to hold services (as was once generally believed). Only the funerary meal (*refrigerium*) that immediately followed burial, in imitation of pagan and Jewish practice, might occasionally be taken underground.

Few of the catacomb paintings are precisely datable, but there is general agreement as to which are pre-313. A certain deacon Callixtus was in charge of the cemetery on the Via Appia, southeast of Rome (now called the catacomb of S. Callisto) before he was made Bishop of Rome (*ie* Pope) in 217. This particular catacomb has more than 20 km (12 miles) of galleries on four levels, and includes a large chamber in which the third-century popes, at least from Pontianus (d. 235), were buried. The Christian content of the wall-paintings generally takes the form of relatively small figures within an overall decorative scheme (11), as in the damaged figure of Daniel between two lions surrounded by figures including orants (men or women raising their hands in prayer) and a Good Shepherd. Elsewhere we see, for example, Jonah thrown from a ship, being cast up by a sea monster, and reclining beneath the gourd plant (this narrative reads from right to left, and not in the usual direction). Other third-century catacombs, such as those of Domitilla, not far from S. Callisto, or of Priscilla (12), on the Via Salaria to the north of Rome, add further biblical images, such as the story of Susannah and the elders, to the

11
Daniel and the Lions, figures with hands raised in prayer, late 3rd century. Wall-painting. Catacomb of S. Callisto, Rome

familiar Jonahs, Daniels, Good Shepherds, orants, and so on. The message of the images in the catacombs is optimistic and focused on salvation: the scenes are predominantly of events in which God shows his power by saving his adherent(s) by some miraculous intervention. It is no surprise to discover that this is what third-century Christians wished to represent in their burial places.

As a place in which to be buried, an ornately carved marble sarcophagus was vastly more expensive than an excavated *loculus* or *arcosolium*, with or without paintings. Most such sarcophagi are now displayed in museums, but to appreciate their original context we

need to imagine them in catacombs, with their carved faces visible, or in the above-ground cemeteries, either free-standing or within a memorial. Not surprisingly, the same concerns about life, death and the afterlife predominate in their imagery. In a frieze sarcophagus of the late third century the central action again involves the story of the Old Testament prophet Jonah, who is cast from his ship into the mouth of a sea monster (13). He prays from the monster's mouth for salvation, and then is shown sleeping naked – like the figure of Endymion from Greek mythology – beneath a flourishing gourd plant. In the upper part of the sarcophagus the optimistic message is

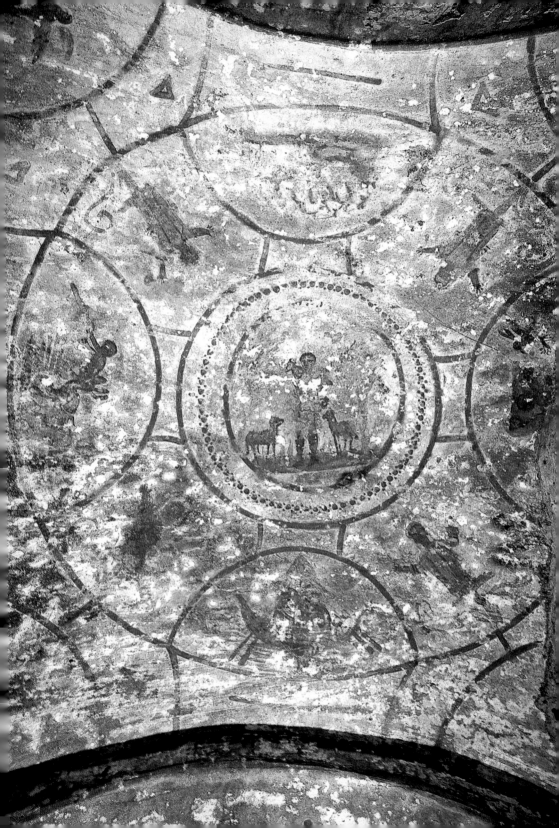

reinforced by the figure of **Christ bringing back to life the dead Lazarus,** whose swathed body is seen standing in its tomb. Further to the right Moses, with God's help, miraculously provides water for the Israelites in the desert, after the Exodus from Egypt, by striking a rock with his staff. Taken together, the imagery of this sarcophagus amounts to a compendium of Christian ideas: God saved Jonah after three days; Christ revived Lazarus after three days; Christ himself rose from the dead after three days; God saved the Israelites through Moses; and, by implication, St Peter (a latter-day Moses) and his successors (the bishops of Rome) will help to save Christians. This last point – the connection between Moses and St Peter – becomes more obvious in later images, but is probably already present here.

Of approximately the same late third-century date is another frieze sarcophagus now in the Vatican Museums, found on the Via Salaria (14; there has been extensive restoration, including the rams and the head of the Good Shepherd). It is a much simpler composition, with the Good Shepherd as the central focus. To the left is a seated man in the traditional guise of a philosopher – an image familiar by *c.* 300 after centuries of repetition – flanked by two others. To the right the composition is balanced by a seated woman, her head covered as a sign of piety. She also has two 'assistants', one of whom (in the short *peplos* or tunic) spreads her arms in a gesture of prayer. It is thought that the seated figures are idealized representations of the dead couple. The Via Salaria Sarcophagus thus provides a frieze of images that can be, but do not *have* to be, read as Christian. At this date, we can be sure, most artists or craftsmen did not work exclusively for clients of one religion. Their job was to supply what the client wished from a general repertoire of ideas and images that could be adapted to suit particular settings and religious messages. With an object like the Via Salaria Sarcophagus we can see that it was the original location for which it was made, and the beliefs of the viewers, which gave its figures their precise meaning. It is not necessarily an earlier work than the Jonah Sarcophagus simply because it has a less obvious Christian message. Nor does it seem to be inconceivable that it was made for a husband and wife only one of whom (in such cases usually the wife) was Christian.

12
The Good Shepherd, praying figures, the story of Jonah, late 3rd century. Wall-painting. Catacomb of Priscilla, Rome

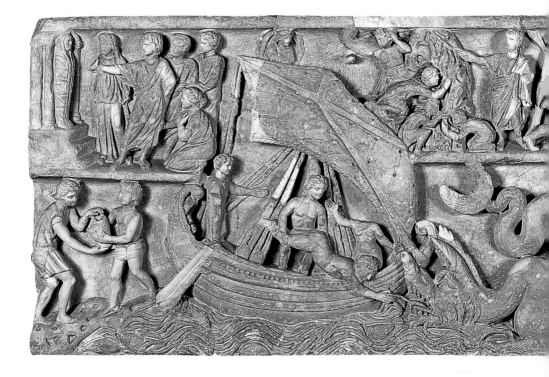

13
Jonah
Sarcophagus
(much restored),
late 3rd century.
66×223 cm,
26×87¾ in.
Vatican
Museums,
Rome

14
Via Salaria
Sarcophagus
(much restored),
third quarter of
the 3rd century.
75×240 cm,
29½×94½ in.
Vatican
Museums,
Rome

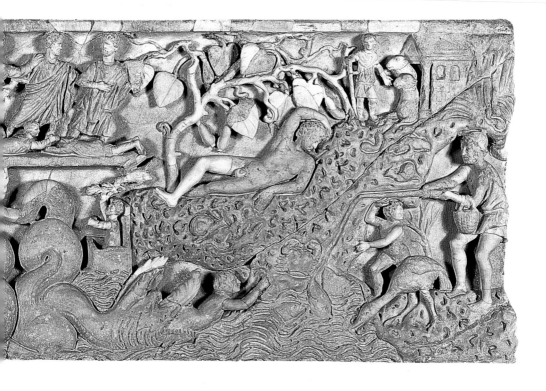

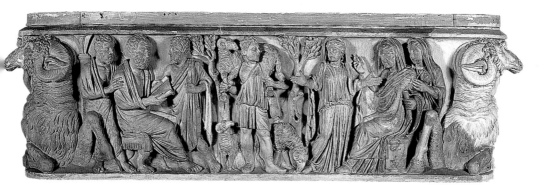

For the individual, religion in the Late Roman world had become focused increasingly on the question of personal salvation. For the state, as embodied in the emperor, religious belief was a very different matter: Roman official religion involved the preservation of the status quo primarily in the form of festivals, sacrifices at altars to the Roman gods, and the cult of the emperor as divine. Christianity began to be perceived as a threat to the stability of the empire as the number of its adherents, who refused to participate in the traditional cults, grew rapidly. Because all religions claimed miraculous powers, the efficacy of a deity was considered quantifiable in a variety of ways. A military success, for example, could indicate divine approval, but by the same token a disaster, be it military or natural, could be interpreted as a sign of divine disapproval, or even of the weakness of a particular god. Constantine was the first emperor to be fully persuaded of the potential benefit to the empire (and to himself as ruler) of enlisting the help of the Christian God. Although Christian apologists were happy to regard this as a miraculous conversion, it is important for us to see the position in a broader way.

The vast size of the Roman Empire with its immensely long land borders made it difficult to administer and to defend. Communication between the centre and outlying provinces extending across Europe, North Africa and the Near East could take months. In 292 the emperor Diocletian had sought to solve the problem by dividing the empire between four rulers, the tetrarchs: an Augustus and a Caesar (the titles of the senior and junior emperors) in both the Eastern and Western halves of the empire. These four were in theory maintaining the empire's unity. Not surprisingly, the system led to rivalry and in due course open warfare. The full story is complex, although its eventual outcome was straightforward. When Galerius, who had been Augustus in the East, died in 311, Constantine, Augustus in the West, formed an alliance with Licinius, Galerius' successor as Augustus in the East, and marched with his army against Maxentius, a rival claimant to Constantine's title. Constantine defeated Maxentius outside the walls of Rome near the Milvian Bridge. Although the first decade of the fourth century had been a period of particularly intense persecution of Christians, Constantine

attributed his victory to the protection of the Christian God, for after a religious experience before the battle he had instructed that the symbol XP (termed *chi-rho* from the Greek names of the first two letters in Christ's name) be displayed on his soldiers' shields and standards (this at any rate is the version of events that later gained currency). From this moment in October 312 the status of Christianity seems to have been assured by Constantine. Later Constantine was to defeat Licinius (in 324), and emerge as sole and undisputed ruler of the Roman Empire.

Questions about Constantine's personal religious faith and the 'sincerity' of his conversion have long been debated. While it is true, for example, that he instituted a law making Sunday a day of rest, it has to be acknowledged that he linked this explicitly with veneration of the Sun not of the Christian God. When in 324 he instituted the building works that were to transform the ancient settlement of Byzantium into the city of Constantinople (Constantinoupolis: 'City of Constantine'), and from 330 make it a worthy setting for the imperial residence and administration, he did not build a conspicuously Christian city. In his time the city's religious focus was the circular mausoleum he constructed for himself. Next to this his son, the emperor Constantius II (r. 337–61) built the cross-shaped church of the Holy Apostles in the 350s. Even Constantinople's first cathedral church of St Sophia, built adjacent to the imperial palace, was consecrated only in 360, by Constantius II; thus it too must have been constructed by him in the 350s, not by Constantine in the 320s or 330s.

The emphasis in Constantinople was on creating a city of familiar Greco-Roman type, albeit exceptional in its magnificence. Constantine, we are told, virtually denuded every city in the empire of its statuary (pagan of course) to adorn his own, and he and his successors laid out a capital with all the expected features of an ancient metropolis – public buildings, fora, colonnades, honorific columns, arches, aqueducts, cisterns, baths, theatres, a hippodrome, and so on. In the forum to which he gave his name Constantine even erected a column of porphyry stone on which stood a statue of the emperor with a radiate crown. Although we cannot be certain, it

would seem that Constantine was here seeking to identify himself in traditional Roman imperial fashion with *Sol invictus*, the Invincible Sun.

Nevertheless, the significance of Constantine's political and financial support for Christianity is beyond question. He immediately undertook a programme for the building of vast churches, most notably in Rome (which was his capital in the years after 312) and later at the holy places associated with Christ's life in the Roman province of Palestine, particularly Jerusalem and Bethlehem. These churches were richly furnished and lavishly endowed, for like any imperial endeavour they were expected to impress the viewer with an indelible sense of splendour. Beneath the mask of later remodellings or total reconstructions, we can still discern the layout of many of these buildings.

Since there was no tradition of grand church architecture before the official acceptance of Christianity in 313, it is hardly surprising to discover that Constantine's architects erected Christian buildings that followed various well-established Roman types. Of these types the one that proved most successful, and from which the basic plan of most Western churches derives, was the basilica. The Roman basilica was a long rectangular hall with an interior lit by a clerestory, often divided by colonnaded aisles, and sometimes with an apse facing the entrance. It was a secular building type used for various public functions, decidedly not for worship. In architectural terms, Roman public and official religion was focused primarily on temples and altars. Like the temples of Classical Greece, whose forms they inherited, Roman temples were intended to house the gods themselves, rather than their worshippers. As a general rule priests, or sometimes priestesses, performed rituals focusing on a cult statue of the deity in the temple's windowless interior, while worshippers remained outside in the open air. The typical temple's exterior was as imposing as possible, with columns supporting a pediment framing the entrance and often lavish use of architectural sculpture, both decorative and figurative. An altar for sacrifices – the most public part of religious ritual – often stood directly in front of the temple, or might be an impressive free-standing structure.

Christian worship, in sharp contrast, was from the start congrega-
tional and even the most sacred ritual, the eucharist, was intended
to be visible and to involve priests and worshippers together at an
interior altar. Architecturally, therefore, the principal requirement in
a Christian church was for an interior with space and good light, and
the most impressive decoration was reserved for this interior. The
hall-like basilica offered several advantages in terms of form and
function: it was not associated with pagan cults, it was relatively
easy and quick to construct (unlike a domed or vaulted building),
and it could very readily be adapted to the materials and resources
available as well as to the anticipated size of the congregation by
selecting an appropriate width and length for the structure at the
planning stage.

At Rome itself, Constantine's first construction was a cathedral for
the city's bishop, generally called the Constantinian Basilica (later
S. Giovanni in Laterano, or 'the Lateran', and many times rebuilt). It
is widely believed that work on it was begun more or less immedi-
ately after the defeat of Maxentius in 312. The church comprised a
vast hall, 75×55 m (246×180 ft) overall. Its broad central body had
twenty-two columns on the two longer sides, supporting upper walls
pierced by windows and surmounted by a wooden roof. To either side
were two further colonnaded aisles (the type is known as a five-aisled
basilica). At the east end the central body was terminated by an apse,
semicircular in plan, and topped by a curving vault (a semi-dome). In
front of this was the altar, or table (in memory of the Last Supper),
around which the services were focused. The bishop and clergy were
separated from the congregation by a low screen (*cancellum*). The
congregation was divided (in theory at least) between men and
women, and between those who through baptism had become
members of the church, and those who were candidates for admis-
sion (catechumens).

The Lateran was built adjacent to the site of what had been an imper-
ial palace within the walls of Rome. The complex included a free-
standing baptistery, essential for the work of conversion, and a
residence and administrative offices for the bishop (in the palace).

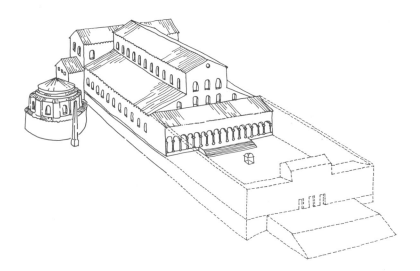

Constantine's church of St Peter at Rome (15), which was completed
by 329, was different in many important ways (the original building
no longer stands – it was demolished in stages between 1505 and
1613 and replaced by the present St Peter's). It was built to incorpo-
rate the burial place of St Peter in what had originally been a pagan
necropolis outside the city walls on the Vatican Hill. The site had to
be partially cleared and the ground levelled so that the structure over
the saint's tomb could be located at the centre point of the apse,
where it was visible above floor level (later the floor was raised). To
either side extended a broad transept, and this terminated in a huge
five-aisled basilica (90×64m, 295×209ft) with twenty-two columns
per row. The major architectural members of St Peter's – columns,
capitals, the architrave they supported – were all reused spoils from
various earlier buildings.

In Constantine's time St Peter's was intended to function in two
ways. It was not a cathedral or parish church with regular services.
The five-aisled hall was a place of burial, and the 'transept' was a
place of pilgrimage: the faithful could approach and pay reverence to
the memorial over the tomb of Peter. The place bore witness to the
saint's life and death, and such sites came to be called martyria (from
martyr, literally 'a witness').

The most important martyria were those that bore witness to the life of Christ himself in the Holy Land, and in due course Constantine turned his attention to these sites. In Bethlehem, a church was built on his orders at some time before 333 to incorporate the supposed site of Christ's Nativity. In this case an octagon was constructed around the holy place – a cave – which was the focal point. It was visible to pilgrims through an aperture in the floor. Once again a five-aisled basilica was also attached (destroyed in a revolt in 529, it was reconstructed shortly after by the emperor Justinian). In Jerusalem a basilica was built at Golgotha, over what was believed to be the site of the Crucifixion, with an adjacent rotunda over the Holy Sepulchre (the buildings have been many times remodelled). Like the longitudinal basilicas, these centrally-planned structures – rotundas, octagons and more complex shapes – were a traditional aspect of Roman architecture and had previously been employed for such structures as mausolea, rooms in palaces and public baths.

15
Reconstruction
of Constantine's
church of St
Peter, Rome,
c.400

We know in broad terms what the interiors of some of Constantine's great churches were like: their size and shape, their construction and materials. But what did their interiors look like in detail, and how were images used if at all? Occasionally we can gain an insight, as when, for example, the *Liber Pontificalis* (or *Book of Pontiffs*) lists the fixtures and fittings in precious metals given by Constantine to the Lateran. In addition to numerous lighting devices (for example, more than 170 silver chandeliers) and items for celebrating the eucharist, Constantine supplied for the basilica 'The Saviour seated on a chair, 5ft [1·5m] in size, weighing 120lb [54·4kg], and twelve apostles, each 5ft [1·5m] and weighing 90lb [40·8kg; all of silver]'. For the adjacent baptistery his donations included:

A golden lamb, pouring water, weighing 30lb [13·6kg]; on the right of the lamb the Saviour in finest silver, 5ft [1·5m] in size, weighing 170lb [77·1kg]; on the left of the lamb a silver St John the Baptist, 5ft [1·5m] in size, bearing the inscription 'Behold the Lamb of God, Behold him who takes away the sin of the world' [John 1:29] weighing 125lb [56·7kg].

The baptismal font was itself reportedly covered with silver weighing a total of 3008 lb (1365 kg). All this gold and silver must have created a sense of overwhelming opulence. But in the huge basilica, figures 1·5 m (5 ft) tall would not have been especially conspicuous (the effect in the much smaller space of the baptistery would have been different). The really large areas available on the walls and around the apse seem to have been covered with marble revetment, or with plaster, and painted and gilded stucco reliefs in decorative patterns, or simply with beaten gold. There is no evidence that churches at this time had large images in mosaic with Christian themes of the sort that occur frequently in the fifth century and later. And the silver and gold figures, because they were so valuable and could easily be recycled, disappeared long ago together with all Constantine's other gifts in precious metals to the Lateran, as well as to other churches, so that we cannot be sure what they looked like.

A familiar monument of exactly this period provides a further insight, or perhaps caution, as to how images might have been used. This is the Arch of Constantine (16), a highly conspicuous public monument of traditional Roman type set up in 313–15 at the expense 'of the senate and people' specifically to commemorate Constantine's victory over Maxentius.

16
Arch of
Constantine,
Rome,
313–15

We search it in vain for the slightest visual reference to the intervention of a Christian God on Constantine's side. The huge inscription refers merely to the help of *divinitas* (divinity), but nothing more precise. When looked at closely the arch is a somewhat bizarre pastiche constructed from sculpture of earlier periods (*ie* spolia) with some Constantinian additions and remodellings. Although not a work of 'Christian' art, therefore, the arch is the product of the masons and sculptors who probably also worked on Constantinian churches in Rome, and produced sarcophagi for the city's wealthiest patrons. Whether the large-scale work of contemporary Roman silver- and goldsmiths was at all similar in style is hard to say. But the combination of new material with reused spolia, often of the highest quality, seems to be characteristic of building activity at the time.

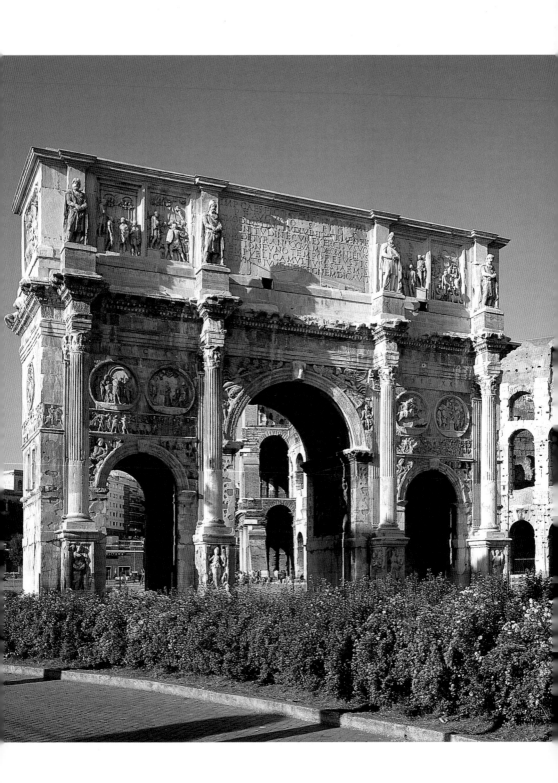

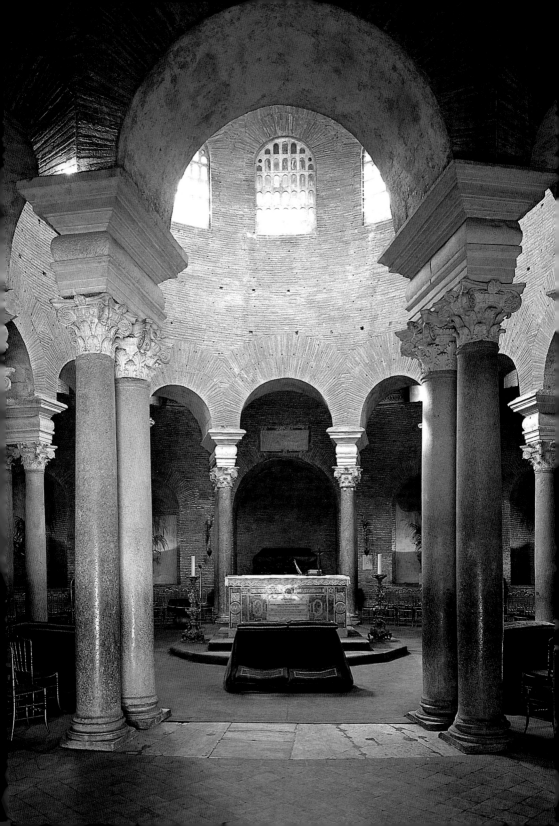

There is also a single surviving structure, of a slightly later period, which may provide some guidance. It is now known as the church of Sta Costanza (17), and stands on the Via Nomentana to the north-east of Rome. It was built around 350, however, not as a church, but as the mausoleum of Constantine's daughter, Constantia (or Constantina), who was a devout Christian and died in 354. It stands next to the surviving substructures of a basilica that was erected over the catacomb in which the relics of the martyr St Agnes (S. Agnese) were venerated. The mausoleum is a domed circular structure,

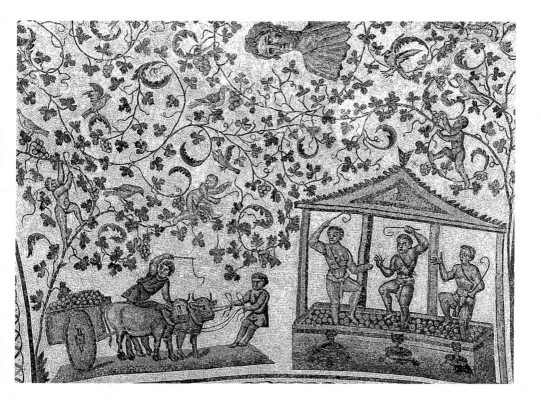

17–18
Sta Costanza,
Rome, c.350
Left
Interior
Above
Ambulatory
vault mosaics
(detail)

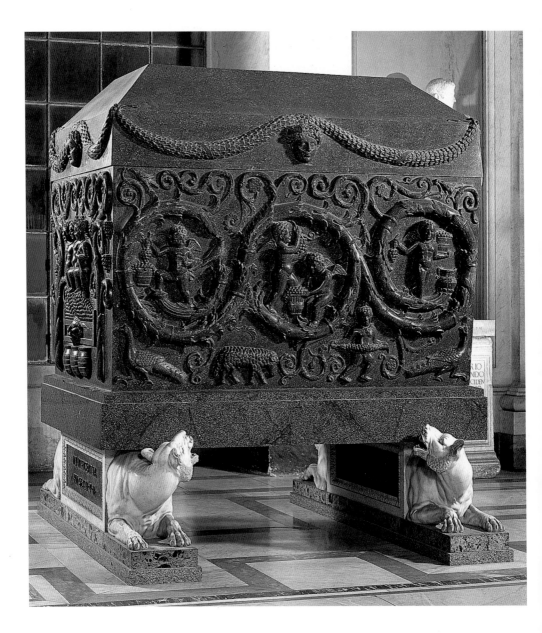

surrounded by a barrel-vaulted ambulatory (22·5 m, 74 ft in diameter) in which the mosaic decoration has survived. This consists of various figures, birds, animals, vine scrolls and decorative patterns (18) in a scheme without conspicuous Christian content. The scattering of pictorial elements over the white ground indeed bears a stronger comparison with contemporary floor mosaics than with what we shall find on the walls and vaults of later churches. It is true that the decoration of the central dome is missing, but sixteenth-century drawings record the scheme. It consisted of a rich overall pattern of acanthus stems and caryatids enclosing small panels in which were biblical scenes. The overall design elements, however, swamped these small scenes, which resembled the third-century catacomb paintings. But we have to be cautious in making any judgement on the basis of much later drawings, for we cannot be certain that the scenes they recorded dated from the time of Constantia, and were not inserted subsequently.

19
Sarcophagus
of Constantia,
c.350 (base
and supports
later).
Vatican
Museums,
Rome

As a mausoleum, Constantia's rotunda was built to house a sarcophagus, and this survives (now in the Vatican Museums; 19). It is of massive size, and in porphyry, an exceptionally hard and difficult stone to work, but one which because of its purple colour had strong imperial connotations. Even without the original lid and later base and supports, the chest alone measures 128 cm (4 ft $2^3{}_8$ in) high, 233 cm (7 ft $7^1{}_2$ in) long, 157 cm (5 ft $1^3{}_4$ in) wide. The sculpted images on the sarcophagus, like those in the ambulatory mosaics, show no conspicuous Christian message. The design consists largely of winged putti, within acanthus and vine scrolls, occupied in the grape harvest and winemaking. Such scenes could certainly be read in a Christian way in part because of the use of wine in the Eucharist (compare Matthew 26:26 ff.). Christ had also termed himself 'the true vine' (John 15:1), his followers its fruitful branches, and likened the kingdom of heaven to a vineyard. But connections would have been made, in the minds of some viewers at least, with traditional Greco-Roman scenes of Bacchus, the god of wine.

Pre-Constantinian burial practices did not cease in 313; on the contrary, the enthusiasm for cemeteries, catacombs and sarcophagi

gathered momentum. A characteristic building type of the period, for example, was the funerary basilica. This was a hall built over or adjacent to a Christian cemetery, often one that had sprung up in proximity to the tomb of an esteemed saint or martyr (as with S. Agnese or the 'nave' of St Peter's). Such funerary basilicas were themselves filled with graves and came to be surrounded by monuments and mausolea. These complexes were conspicuous demonstrations of the wealth and power of Christian communities as well as individuals.

The fact that the emperor had chosen to promote Christianity did not mean, however, that the empire's inhabitants suddenly all became Christian. Christian and 'pagan' art continued to coexist throughout the fourth century. An interesting example is provided by the relatively well-preserved wall-paintings in a catacomb on the Via Latina, discovered only in 1956. The catacomb is assumed to have been private, in that it seems to have catered for a small number of families who could afford burials in *cubicula* and interconnecting rooms, rather than for 'the public' in numerous *loculi* in galleries. Unlike the third-century paintings, here the emphasis is on much larger figures. These figures unquestionably dominate the spaces they occupy. Moving around the catacomb, we can deduce that this figure in Room N (20), because of its context among images

20–21
Wall-paintings,
c.350–400.
Via Latina
Catacomb,
Rome
Left
Hercules in
the Garden of
the Hesperides,
84×74 cm,
33×29⅛ in
Right
Samson and
the Lion,
113×107 cm,
44½×42⅛ in

from pagan mythology, must represent Hercules (the latinized version of the Greek Herakles) in the Garden of the Hesperides. The image provided a suitably optimistic message for the non-Christians buried in this chamber. But the work in Room L, quite possibly by the same artist, is not Hercules and the Nemean Lion, but Samson, 'the Christian Hercules', and the lion he met and slew near Gath (21). The story of Samson is in the Old Testament Book of Judges, and there is nothing conspicuously Christian about the way it was painted here. We see Samson finding honey and bees in the mouth of the dead lion. But to a Christian the image is symbolic or allegorical as well as narrative or historical, for it implies how through God's intervention sweetness, that is the sweetness of heaven, can come after death.

Moving through Room N into Cubiculum O we find among other scenes (such as the Raising of Lazarus, Daniel and the Lions, etc.) a painting of Moses and the Israelites, with the Egyptians drowning in the Red Sea (22). (It was damaged when a secondary burial was ransacked, perhaps in the fifth or sixth century.) This is different in most details from the painting of the same scene in the synagogue at Dura-Europos, but it is not conspicuously more Christian. And yet the way it will have been viewed and interpreted has been trans-

22
Overleaf
The Crossing
of the Red Sea,
c.350–400.
Wall-painting.
95 × 175 cm,
37⅜ × 69 in.
Via Latina
Catacomb,
Rome

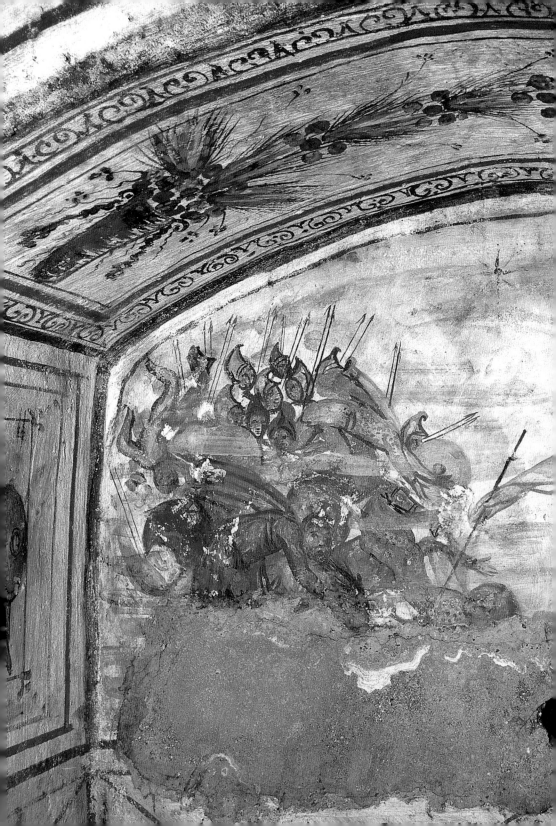

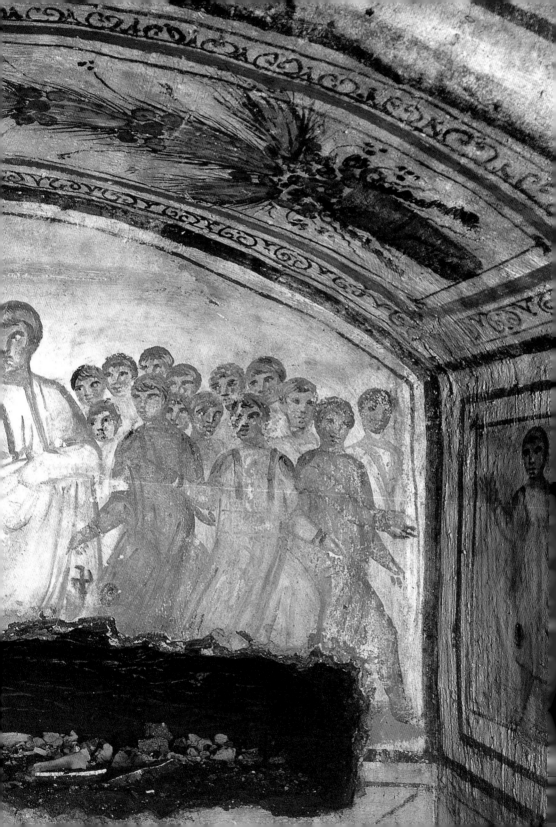

formed because of its context in a place of Christian burial. In the
synagogue image the Jewish viewer saw the mighty Moses lead God's
chosen people, the Israelites, out of slavery in Egypt towards the
Promised Land, overwhelming adversaries. In the catacomb chamber,
the Christian viewer saw Moses as a forerunner of Christ, who will
save his people, the Christians. And because the catacomb is in Rome,
there are probably two further links to be made: between Moses and
St Peter, and between St Peter and later bishops of Rome, who lead
the Christians as Moses led the Israelites. For non-believers, here
represented by the Egyptians, there is death, but for Christians there
is a passage through death to the other side, to the Promised Land of

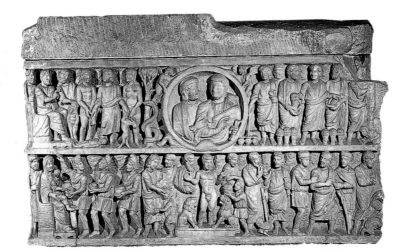

an afterlife in heaven. Nowhere was this Christian reading of the
image made explicit; it had to be supplied by the viewer. By the mid-
fourth century, therefore, Christians must have been very adept at
the type of speculative viewing and ruminative thinking we have
been considering, for much of the art made for them requires inter-
pretation in just this sort of way.

Both before and after 313 the market for sarcophagi was evidently
large enough for the development of certain standard types, for both
local consumption and export. And whereas most artworks must
have been produced to a specific commission, there is evidence that
large workshops had the resources to prepare sarcophagi 'on spec'

(since even with heavy use of the drill, production must have been a quite lengthy process if a lot of detailed carving was required). Purchasers could then have a sarcophagus customized according to their requirements, and extra carving could be done (or left undone) in the short period between death and burial. Most sarcophagi seem to have been bought 'off the shelf', presumably by relatives of the dead person. But members of the imperial family, and doubtless of other wealthy families, probably ordered and approved the production of their own sarcophagi during their lifetimes, at least in part so as to ensure that they were adequately splendid.

One standard type of sarcophagus includes a central medallion, with busts of the deceased. The crowded figures of this unfinished Christian sarcophagus (the so-called 'Dogmatic' Sarcophagus now in the Vatican Museums; 23–6) make it difficult at first to discern what events are being called to our attention. Reading from left to right, and from top to bottom, we see a seated figure with two similar bearded companions, one of whom places his hand on the head of a tiny Eve, while Adam lies below. Perhaps these three represent the Trinity. Next a beardless figure (is this God in the form of Jesus?) introduces Adam to Eve, while the serpent twines in the tree at the right. Further to the right Jesus performs three miracles: turning water to wine, multiplying the loaves, and bringing Lazarus back to life. Depicted below are the Magi, Jesus healing a boy, Daniel in the lion's den, and three scenes from Peter's life: Jesus tells him of his denial, he is arrested, he strikes water from a rock in imitation of Moses (here the Moses/Peter link is beyond doubt).

23–26
'Dogmatic' Sarcophagus, c.325–50. 131×267 cm, 51½×105⅛ in (without lid). Vatican Museums, Rome
Left
General view
Top right
Figure of God (detail)
Centre
Figure of Mary (detail)
Below right
Figure of St Peter (detail)

To understand the images of this sacrophagus we must scan its surface in various directions. At the corners there is a strong vertical comparison between the seated God and the seated Mary (at the left), and between the miracle of Jesus and that of Peter (at the right). The Old Testament scenes do not stand as prefigurations of the New here, but are to be understood with the benefit of what we might call Christian hindsight. Now the concern of the images is definitely not limited to miracles, death and resurrection: there is a much wider narrative and dogmatic import.

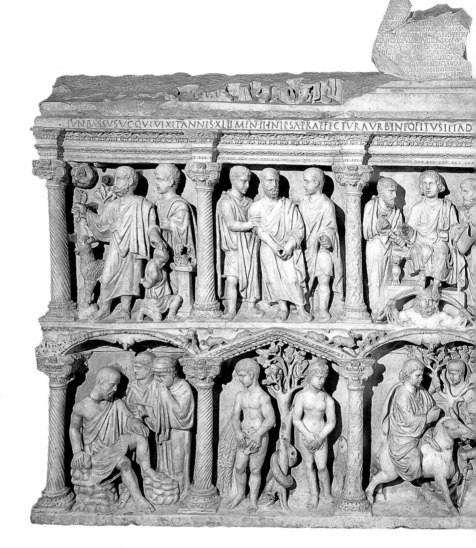

The elements we have been considering could be put together with
others, as they were in the sarcophagus made in 359 for Junius
Bassus, an aristocrat, prefect of the city of Rome and son of a consul
(27). Although baptized only on his deathbed, Junius' wealth or rank
or piety (or some combination of these) meant that his sarcophagus
was placed beneath the floor of St Peter's adjacent to the apostle's
tomb. On its carved front, scenes from Christ's passion were added to
miracles of salvation from the Old and New Testaments. Now each

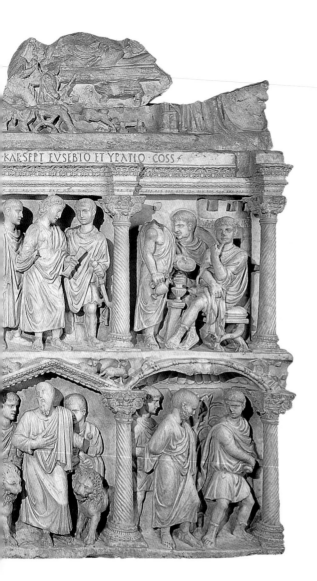

KAESEPT EVSEBIO ET YPATIO COSS

27
Sarcophagus
of Junius
Bassus,
359.
141×243 cm,
55½×95¾ in
(without lid).
Treasury of
St Peter's,
Rome

scene instead of being run together in a frieze was isolated by a
complex architectural frame, a device which could itself be skilfully
exploited to locate the events in an interior setting, as with the
divided composition of Christ before Pilate at the top right. The
sculpture on this sarcophagus has a certain monumental quality,
despite the relatively small scale of the individual figures, that seems
to invite us to imagine (for we cannot do much more) what large-
scale Christian art might have looked like in the mid-fourth century.

The earliest surviving major scheme of figural decoration in a
Roman church is at Sta Maria Maggiore (a three-aisled basilica origi-
nally c.73·5×35 m, 240×115 ft), which we know to have been deco-
rated by Pope Sixtus (Xystus) III, between 432 and 440, a full century
after the death of Constantine (28). During the first half of the fifth
century, it would seem, the great basilicas of St Peter's and St Paul's
also received a large-scale decoration of their nave walls with images
which, though now lost, survived in some form into the sixteenth

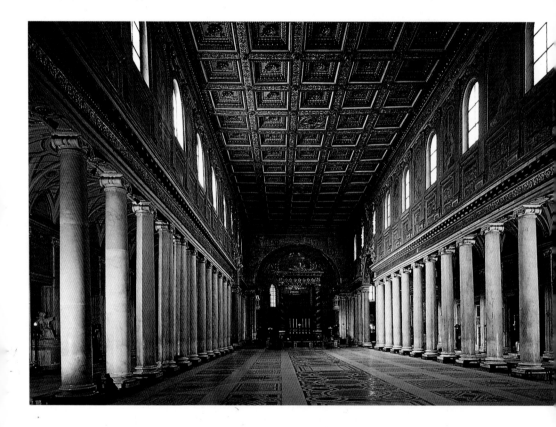

century (St Peter's) and the nineteenth (St Paul's). Unlike St Peter's,
St Paul's had not been built in Constantinian times, but it was
certainly an imitation of the earlier great basilica, begun in 385 by
Emperor Theodosius I and his co-rulers. In both cases the decorative
scheme involved a long series of rectangular images on the nave
walls, below the clerestory windows. At St Paul's there were scenes
from Genesis and Exodus on the right wall, and from the life of St
Paul on the left, both in two registers. At St Peter's the layout was

28–29
Sta Maria
Maggiore,
Rome,
432–40 and
later
Left
Interior
looking east
Right
The Crossing
of the Red
Sea, 432–40.
Mosaic;
192×175 cm,
75⅝×69 in

similar, although the New Testament wall seems to have focused on scenes from the life of Christ (in which Peter – unlike Paul – had played a leading role). At Sta Maria Maggiore, however, there is just one register and only Old Testament scenes, although these went beyond Exodus, as far as the Book of Joshua. They are aligned beneath the windows, twenty-one per side, but only twenty-seven of the original forty-two scenes survive. It can be seen at once that in style and technique they could hardly be more different from those in the rotunda church in Thessaloniki, now known as Hagios Georgios, with which we began (compare 3–5 and 29). We are presented at Sta Maria Maggiore with numerous small figures against a more naturalistic ground, with the mosaic tesserae handled quite differently. In the Crossing of the Red Sea (29) Pharaoh's soldiers and charioteers ride out of the walled city that represents Egypt, only to be drowned in the waters. Moses is at the rear of a great crowd of Israelites, and with his staff releases the pent-up waters. Instead of a setting of gold, the predominant colours are green and blue; the stress is on conveying a sense of action, not on creating an atmosphere of contemplation.

At both St Peter's and St Paul's we lack any certain knowledge of the decoration of the apse, arguably the focal point of the imagery in a basilica. Here too Sta Maria Maggiore is more informative. To judge by Sixtus' dedicatory inscription, the apse must have contained an image of the Virgin (he terms her *Virgo Maria*) flanked by saints, but this was replaced at some point in the years 1292–6. Across the arch at the entrance to the apse (an area often termed 'the triumphal arch'), the awkwardly shaped space was treated in three zones with scenes from the infancy of Christ (30). To the left we see the Annunciation, Adoration of the Magi, and in the lowest zone the Massacre of the Innocents. It is generally agreed that the dedication of this church to Mary, and the decoration of its apse area, both reflect directly a decision of an ecumenical (universal) church council held at Ephesus in 431, which sought to end a long controversy by declaring that Mary was not merely the mother of Jesus, but was the Mother of God (Theotokos). To judge by the mosaics of Sta Maria Maggiore, Christian art of the fifth century was already

30
Apse mosaics, 432–40 and 1292–6. Sta Maria Maggiore, Rome

Art before Iconoclasm

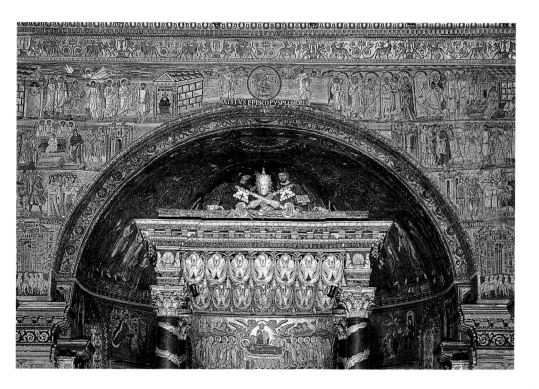

exploring the possibilities of promoting orthodox (correct) belief by competing not with vanquished pagan systems, but against ideas promoted by heretical Christians.

Although so little survives, the presence of images in the service of Christianity must have been ubiquitous by the time that Sta Maria Maggiore or the rotunda church in Thessaloniki were being decorated with mosaics. Sometimes we can glimpse this from written sources. The ascetic Saint Neilos (Nilus) of Sinai (d. *c.* 430), for example, is reported to have given the following advice:

Represent a single cross in the sanctuary … Fill the Holy Church on both sides with pictures from the Old and New Testaments, executed by an excellent painter, so that the illiterate who are unable to read the Holy Scriptures may, by gazing at the pictures, become mindful of the manly deeds of those who have genuinely served the true God, and may be roused to emulate their feats.

Neilos provides not only a skeletal programme for church decoration, but a justification for its employment: it is to remind and inspire and

inform those who cannot read or reread the stories for themselves. In the West, the Roman poet Prudentius composed around 400 AD a series of verses on Old and New Testament subjects that read as though they could have been intended to accompany a church decoration of this sort. In addition, Prudentius' choice implies that parallels could be drawn between images with similar subject matter from the two Testaments on the opposite walls.

As we have seen, Christian art did not emerge ready-formed in Palestine in the time of Christ, nor spread from Rome by imperial decree in the time of Constantine. Instead it developed slowly and by degrees through the third, fourth, fifth (and later) centuries in many parts of the Roman world. How then are we to explain what are perceived as the unifying factors in Christian art, in particular a certain consistency over what figures and scenes to represent, and how to represent them? Could it be that Christian art was based on pre-existing images of biblical figures and events that had developed, like Christianity itself, not just out of Judaism, but specifically out of a flourishing Jewish tradition of biblical art (as witnessed at Dura)? An obvious problem here is that this theory leaves New Testament art entirely unexplained, and it seems more likely that synagogue art reflected parallel developments in church art, with the possibility of connections sometimes brought about, for example, by the employment of the same craftsmen in different buildings.

Was knowledge of Christian art spread by portable objects, not just larger-scale works such as sarcophagi (which certainly were on occasions transported long distances) but the smaller items which travellers might have carried, and Christians have had in their homes? This seems highly probable, and we will return to this idea again in Chapter 2. The existence of small-scale Christian art in a private context is attested in a variety of ways. The church historian and biographer of Constantine, Eusebius, Bishop of Caesarea in Palestine (d. 340), commented: 'I have examined images of the apostles Paul and Peter and indeed of Christ himself preserved in painting: presumably men of old were heedlessly wont to honour them thus in their houses.' His reference to 'men of old' implies that he

believed such practices went back well before the time of Constantine. Elsewhere Eusebius comments on an image of Paul and Christ 'in the guise of philosophers' brought to him by a woman. 'I took it away from her and kept it in my house,' he says. Given his strong disapproval, it is perhaps surprising he did not destroy it. But it was obviously easily portable, and he continued the private use for which it was intended. (He does not say whether it was painted, woven, or made in some other technique.) Epiphanios, Bishop of Salamis in Cyprus (d. 403), in the context of an attack on the Christian use of images, made a different point, describing how painters: 'Represent the holy apostle Peter as an old man with hair and beard cut short; some represent St Paul as an old man with receding hair, others as being bald and bearded.'

To be able to write about images in this way presupposes that, public or private, they must have been completely familiar to Epiphanios and his audience. But whereas a single image of a saint, perhaps on a panel or textile, or even a single scene, could be readily portable, how would a large number of images – such as might have been needed in the decoration of an entire church – have been conveyed? Could an illustrated book or books have provided the sort of portable repositories of images that could have spread a knowledge of Christian art around the empire? Christians who travelled with their holy books could also have disseminated the art they contained – namely the pictures that accompanied or illustrated the Bible stories – if such images existed. At first sight this is an attractive theory, but it runs up against a serious obstacle for only a very few early illustrated biblical books survive, and their evidence points to a quite different conclusion.

The oldest surviving illustrated biblical manuscript is a now pitiful fragment of the Old Testament books of Samuel and Kings, known as the 'Quedlinburg Itala' (it was found at Quedlinburg and contains the 'Old Latin' version of the Bible). The four surviving illustrated leaves are in a poor state of repair (31), with much of the paint surface lost, but this has the inestimable advantage that it reveals underlying writing. This is what we can read beneath the first two scenes on folio 1r

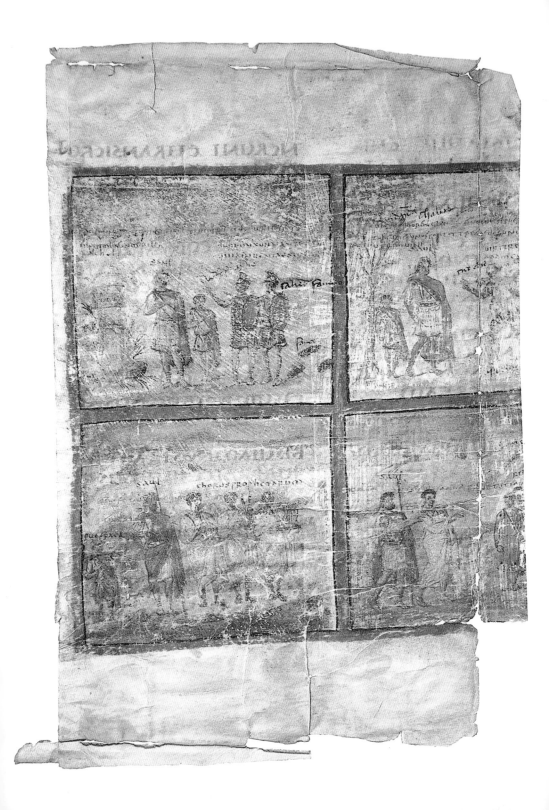

(note that the text is no longer entirely legible):

You make the tomb [by which] Saul and his servant stand and two men, jumping over pits, speak to him and [announce that the asses have been found].
You make Saul by a tree and [his] servant [and three men who talk] to him, one carrying three goats, one [three loaves of bread, one] a wine-skin.

The corresponding biblical text reads:

When you will depart from me this day you will find *two men by Rachel's sepulchre* in the borders of Benjamin to the south. *And they will say to you: The asses which you went to seek are found*, and your father thinking no more of the asses, is concerned for you, saying: What shall I do for my son?
And when you will depart from thence and go further on, and shall come *to the Oak of Tabor, there shall meet you three men going up to God at Bethel, one carrying three kids, and another carrying three loaves of bread, and another carrying a bottle of wine.* [Vulgate: 1 Kings 10:2–3; Authorized Version: 1 Samuel 10:2–3]

From their language there can be no doubt that the texts in the Quedlinburg Itala were not only written by someone who knew the Bible well, but that they are instructions to the artist as to what he should paint in the relevant compartment of each miniature. When this book was made, probably in Rome in the first half of the fifth century, it seems that there was no established tradition of biblical illustration in book form on which to draw. Someone could, of course, have carried this particular manuscript once completed to a church and said to an artist 'Copy this!', and on occasions this may have happened, but there is no reason to suppose that that was ever the usual procedure.

What the Quedlinburg Itala implies is that artists were able to create complex images by combining simple visual formulae: a seated figure, a group of standing figures, a landscape, a tree, a tomb, a ruler (in appropriate costume), a servant (smaller in scale), and so on. It was the context in which these formulae were used that could give

31
Scenes from the Book of Kings, folio 1r, Quedlinburg Itala, *c.*425–50. 30·5×20·5 cm, 12×8 in. Staatliche Bibliothek, Berlin

them a specifically Christian flavour, or make them appropriate illustrations to a narrative. Inscriptions could also be supplied to accompany the image, as they were in this book (the instructions were under the paint layer, the inscriptions on top), so as to provide the reader/viewer with any further guidance thought necessary as to what was happening or who was who. Because artists of the third, fourth and fifth centuries worked within the ubiquitous and long-established Greco-Roman tradition, it is only to be expected that the visual formulae they used are similar.

This general observation, however, cannot explain every major artwork of this period. We began this chapter in Thessaloniki and with the church of Hagios Georgios there, yet, despite our investigations, the superb mosaics in this building still remain puzzling. They have few parallels, and the fact that they are fragmentary presents a further obstacle, because we cannot reconstruct what is missing by reference to some comparable example. In the end, it is the variety of the material that survives, not its consistency, which is most striking, and the mistake we need to avoid is in thinking in terms of norms and variations. Each work needs to be considered individually, since artists generally responded to the requirements of particular commissions rather than reproducing preordained schemes. The art of this period thus remains intriguing because it encourages speculation but resists definition.

2

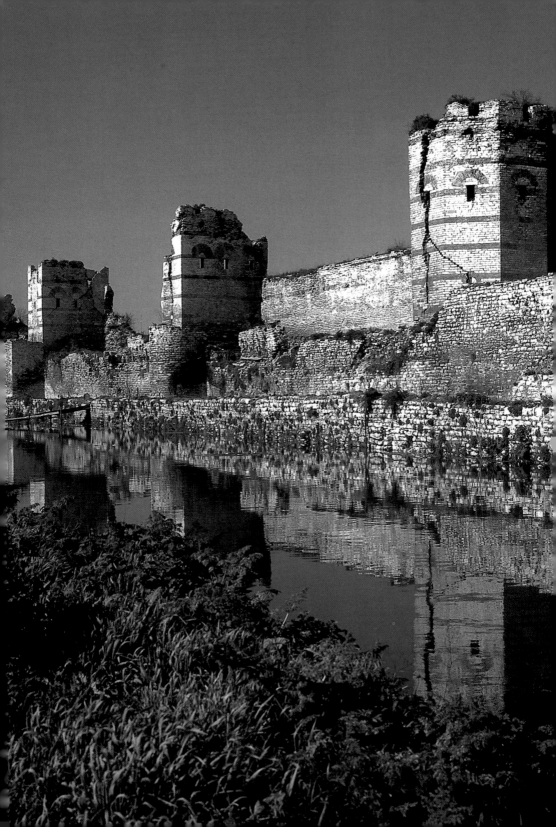

In 325 the emperor Constantine called an ecumenical council (a meeting of the bishops 'of all the world') with the purpose of standardizing Church doctrine and policy. It was held at the city of Nicaea (modern Iznik in Turkey), near the Eastern imperial residence at Nicomedia (modern Izmit). Among the decisions of the Council of Nicaea was that the bishops of Antioch, Alexandria and Rome – the great urban centres of the time – were to be given jurisdiction over provinces, and the special status of the bishopric of Jerusalem was also recognized. In 381, however, when an ecumenical council was convened by Emperor Theodosius I, it took place at Constantinople and its Third Canon declared boldly: 'The Bishop of Constantinople shall have the precedence of honour after the Bishop of Rome, because Constantinople is New Rome.' Slowly through the fourth and fifth centuries Constantinople grew in importance as it gradually became the epicentre of imperial activity, and associated trade, commerce, patronage and prestige, while its rivals (and especially 'Old' Rome) declined. By the beginning of the sixth century it was indisputably the most important urban centre in the Western world, a position it maintained for some seven centuries, until sacked by the Crusaders in 1204 (see Chapter 9). Throughout this period the centre of gravity of the Roman Empire became ever more firmly established in Constantinople, and the divisions between the empire's Eastern and Western provinces became increasingly marked.

Constantine's scheme to create a city to rival and surpass in magnificence the ancient cities of the Mediterranean world was continued enthusiastically by his successors. The emperors Theodosius I (r. 379–95) and Arcadius (r. 395–408) even erected enormous public columns carved with narrative scenes of their achievements like those of the emperors Trajan or Marcus Aurelius in Rome itself. And statues were still being brought from Classical (ie pagan) temples in the reign of the emperor Justinian (r. 527–65), who removed the

32
Land walls of
Theodosius II,
Istanbul,
412/13

horses from the Temple of Artemis (Diana) at Ephesus – one of the Seven Wonders of the World. At the same time as removing pagan statuary to beautify Constantinople, however, the emperors became increasingly intolerant of pagan practices. Theodosius I, for example, prohibited all pagan cult activities in 392, and Justinian closed the Academy of Athens, the last pagan philosophical school, in 529.

The most conspicuous surviving signs of Constantinople's rapid growth from the later fourth century onwards are its land walls (32), which were laid out by the emperor Theodosius II in 412/13. They enclosed a vastly greater area than Constantine or his planners had envisaged. Even the sprawling development of modern Istanbul (as the city is now called) cannot disguise the massive scale of these works. But (as in Rome) the very success of Constantinople/Istanbul has meant that the layers of its early history have been frequently disturbed. For example, the monolithic columns which are now found in the mosque of Mehmed the Conqueror (Fatih Camii) support an eighteenth-century reconstruction of a fifteenth-century building on the site of a sixth-century rebuilding of Constantine's fourth-century church of the Holy Apostles, and they were probably originally shipped to Constantinople after removal from some pagan temple. As a result of reconstructions such as these, the early history of Constantinople and its buildings can only be partially recovered.

After Constantine himself, it is the name of the emperor Justinian that is most permanently linked with the history of Constantinople. Justinian was the nephew of the emperor Justin I (r. 518–27), and both were from Balkan peasant stock. He was a person of vision and extraordinary energy, both intensely pious and utterly ruthless. Justinian's active and partially successful – but enormously costly – policy was to reconquer and restore the Roman Empire's former borders. Not only was there the traditional enemy in the form of the Persian Empire in the east, but the devastating invasions of the fifth century by the Goths, Huns, Vandals and other peoples had removed most of western Europe and North Africa from imperial control (see also Chapter 3). Justinian's military ambitions were matched by his grandiose building programme, and both are recorded in the writ-

ings of Procopius, from whom Justinian commissioned not only an official history of his various wars but an entire volume lavishly praising his building works. (Procopius also wrote a lengthy private memoir, the *Anekdota* or *Secret History*, in which he attacked the personality and actions of Justinian and his wife Theodora in the most outspoken terms: the resulting combination of invective, prurience and hypocrisy has proved popular with modern readers.) The volume is called the *Buildings* (sometimes given the Latin title *De Aedificiis*, although it was written in Greek) and is an extraordinary record of the imperially-directed construction of churches, monasteries, hostels, roads, bridges, aqueducts, monuments, fortifications, towns and even entire cities (two were named Justiniana and three Justinianopolis). Book I of the *Buildings* is devoted to Justinian's works in Constantinople and its suburbs, and Procopius begins with the one building that was clearly intended to surpass all others – the church of St Sophia.

The cathedral church of Constantinople, the church containing the *cathedra* (seat or throne) of the city's bishop, was not dedicated to a saint or in commemoration of an event in Christ's life, but to an idea or attribute of God, namely Wisdom (and hence to Christ as the embodiment of God's Wisdom). The name Hagia Sophia literally means 'Holy Wisdom', although the church is generally referred to as St Sophia, and in the Byzantine period was often called simply 'the Great Church'. Near it is a church dedicated to Holy Peace, Hagia Eirene (or St Irene), which must always have formed a sort of pair with St Sophia. Of the first church of St Sophia, dedicated in 360 by Emperor Constantius (son of Constantine), only the site survives, for it was burned down in rioting in 404. The church was rebuilt by Emperor Theodosius II and rededicated in 415. This second St Sophia (along with St Irene) was itself destroyed in a fire started during rioting that began in the city's Hippodrome in January 532. The building that survives today (now no longer a church but a museum and previously a mosque) is in large part the St Sophia erected on Justinian's orders in 532–7, and shares with its predecessors the name, the site, and presumably parts of the substructures.

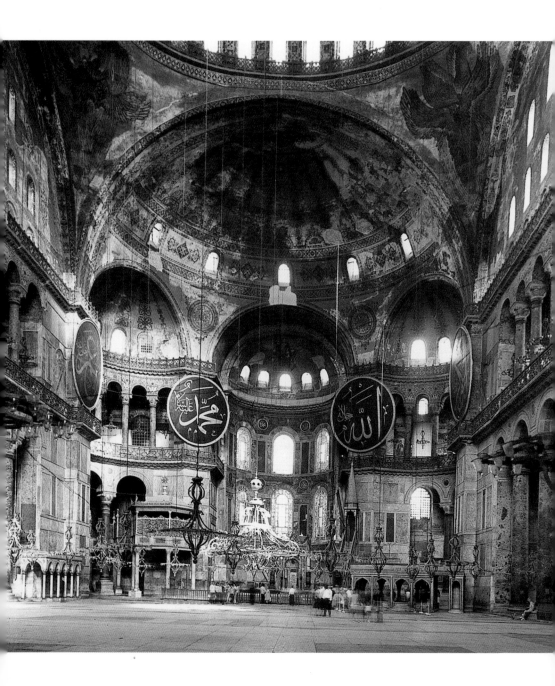

St Sophia is an unrivalled architectural achievement for the sheer daring of its design (33). It is no accident, therefore, that, unusually for Byzantine architecture, the names of its designers were recorded: Isidoros of Miletos and Anthemios of Tralles. Both were mathematicians in the Greco-Roman tradition. Isidoros edited the works of Archimedes, as well as writing a commentary on the technical treatise on vaults by an earlier mathematician, Heron (or Hero) of Alexandria (first century AD). Both made studies of parabolas and curved surfaces. Their plan involved placing a vast dome on a square base of 30·95 m (assumed to be 100 Byzantine feet), supported at a height of some 41·5 m (c. 136 Byzantine feet) above the centre of the church. The thrust of this dome is carried on four great arches. Beneath the arches to north and south are semicircular tympana originally pierced by enormous windows (the present windows are much smaller). The tympana are themselves supported by two-storey arcades. To east and west, the area below the arches is extended by 'semidomes'. The lower parts of these semidomes are then opened out further to east and west by arches and smaller semidomes. The result is a vast space in which the curving surfaces of arcades, arches, window-heads and vaults create an effect of extraordinary lightness and movement above a floor which, although basically rectangular, is so modified by curving exedras (niches) and views into the flanking aisles that its precise shape is impossible to comprehend at ground level. Although the dome collapsed in 558, and was rebuilt by 562 with a greater curvature so as to rise higher by some 7 m (23 ft) or more, and further partial collapses have taken place over the centuries (according to legend the church has withstood more than a thousand earthquakes), the essential plan and a large part of the structure that survive are those of 532–7.

St Sophia is a supreme example of the creation of that spacious and light-filled interior which since the fourth century had been the principal requirement of church architecture. The building's exterior, now plastered, painted, buttressed and dominated by minarets (and in appearance a source of bewilderment to modern visitors), was scarcely more than the husk within which the precious interior could be created and by which it would be protected. The dome, semi-

33
St Sophia, Istanbul, 532–7 and later. Interior looking east. The church has been converted for use as a mosque

67 Constantinople and the East

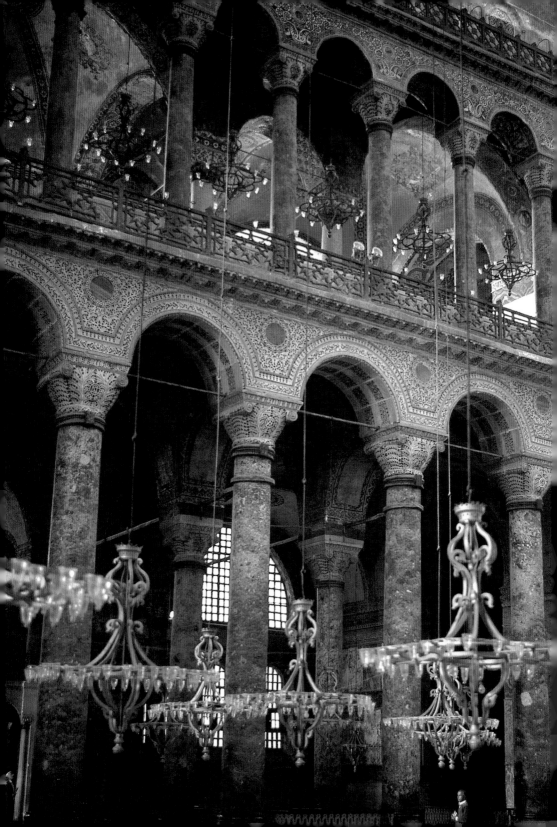

domes and vaults, despite the enormous forces they created and the exceptional technical problems of their construction, enabled a far wider and more open basilical layout than would have been possible had even the longest roof timbers been employed. (The gigantic dome of Hadrian's temple of the Pantheon, completed by 128 AD, or the vaults of the civil Basilica Nova of Maxentius, completed by Constantine – both in Rome – are sometimes cited as precedents for St Sophia, but there are no historical links.) The combination in St Sophia of horizontal and vertical axes within the building was interpreted by contemporaries in a variety of allegorical ways. In particular, the central dome, suspended from heaven as it seemed to the viewer beneath (we are told), was likened to the dome of heaven itself. So powerful was this image, found also in descriptions of other domed sixth-century churches, that it came to dominate the entire architectural tradition of the Byzantine world. In later centuries even the simplest rural chapel was usually planned and constructed around a central dome. The church interior came to be regarded as not merely a microcosm, but as a view of heaven and of divine order.

Much of the sixth-century decoration of St Sophia survives. Up to the level where the arches that support the central dome begin, the wall surfaces were revetted with panels of gleaming coloured marble, and the arcades with coloured inlays. While the columns that support the arcades were spolia from ancient buildings, carefully selected for the decorative quality of their marble (34), their capitals were new, and were treated as surfaces for decoration, with the stonework heavily drilled so as to leave a delicate pattern of acanthus leaves surrounding monograms of the names Justinian (35) and Theodora. The Ionic volutes are the only forms that are reminiscent of the Classical capital, and here, in a context very different from that of Greco-Roman architecture, they look somewhat incongruous. The decoration of the upper parts of the building was in mosaic; in the sixth century this is thought to have consisted largely of plain gold grounds ornamented with a cross in the dome, and crosses or other types of non-figurative decoration elsewhere.

Contemporary descriptions reveal that there were religious images in Justinian's St Sophia, but that they were much closer to the viewer than placing them on the vaults would have allowed. We are told, in a highly rhetorical description of the church after its rededication in 562, that the area around the apse and gold altar was not only revetted in silver but also contained large-scale silver figures (replacing the silver decoration of the same area destroyed by the collapse of the dome in 558). The text's author, Paul the Silentiary, says:

Elsewhere the sharp steel has fashioned those former heralds of God by whose words, before God had taken on flesh, the divine tidings of Christ's coming spread abroad [*ie* the prophets]. Nor has the artist forgotten the images of those who abandoned the mean labours of their life – the fishing basket and the net – and those evil cares in order to follow the command of the heavenly King [*ie* the disciples], fishing even for men and, instead of casting for fish, spread out the nets of eternal life. And elsewhere art has depicted the Mother of Christ, the vessel of eternal life, whose holy womb did nourish its own Maker.

As is often the case, this written description gives no idea of what such figures actually looked like. But it appears that this type of silver decoration followed a tradition dating back to the time of Constantine, as exemplified in the description of the Lateran from the *Liber Pontificalis*.

For a long time no other major contemporary buildings with which to compare the architecture and decoration of Justinian's St Sophia were known in Constantinople. Then, in the 1960s, excavations in the city brought to light the enormously strong foundations and some decorative elements from a church identified as that of St Polyeuktos. This building was erected by Anicia Juliana, a wealthy aristocrat with imperial connections over generations, adjacent to her own palace, probably around 524–7. The church may have had a central dome, some 17 m (56 ft) in diameter, but this remains uncertain. Its sculpture is of a type with parallels in St Sophia and (as we shall see in Chapter 3) at Ravenna, and some of its larger decorated elements were considered sufficiently remarkable to be shipped to

Venice after the sack of Constantinople in 1204 (see Chapter 9) and set up outside or built into the west façade of St Mark's (36). In order to prevent her wealth falling into the hands of Justinian, who had requested a 'contribution' to the imperial treasury, Juliana is said to have used it ('my poverty' she called it) to gild the roof of St Polyeuktos. And Justinian, it has been proposed, was not merely trying to surpass Solomon – the Old Testament king who built the Temple at Jerusalem – in his building works at St Sophia, but also to outdo Juliana's church of St Polyeuktos.

Although the world of a sixth-century inhabitant of the Byzantine Empire was still characterized as in previous centuries by great cities, there had also been impressive building projects in rural areas, associated with the growth of interest in monasticism, and the need to cope with crowds of pilgrims and would-be baptizands who travelled to sites made holy by the presence of saints or their relics. The Greek word *monachos* (monk) originally meant 'single' or 'solitary', and the

36
Sculpted pier from St Polyeuktos, Constantinople, 524–7, reused, Piazzetta, Venice

first monks were hermits in Egypt who retired from the temptations of the world to pursue their religious life in solitude. Their prototype was St Anthony, who retreated into the desert c. 285 and around whom a community had already formed by c. 305. As these monks attracted followers and imitators, monasteries to enable a communal monastic life were established throughout the Christian world in the fourth century and later.

An intriguing case of monasticism and pilgrimage is provided by Qalat Seman in Syria, in the hills some 75 km (46 miles) northeast of Antioch. St Symeon (d. 459) was an ascetic who spent his last thirty-six years living on top of a column, which was periodically increased in height until some 16 m (52 ft) tall. He was the first stylite saint (from the Greek *stylos*, a pillar or column), and the cult of devotion that grew up around him in his lifetime, attracting pilgrims from as far afield as Britain, increased after his death. It brought sufficient prosperity to enable the construction, probably with the support of Emperor Zeno (r. 476–91), of a four-armed basilica, baptistery and other major buildings around his site, even though his body had been removed under the guard of 600 soldiers to Antioch. The adjacent town, Deir Siman, had huge buildings erected to cope (it is thought) with the pilgrim traffic; from here pilgrims proceeded through a triumphal arch to the holy site. The main church was oriented (*ie* faced east), but Symeon's column provided the central focus at the meeting of the four basilical arms (37). Presumably this space was covered with a wooden conical roof, perhaps with a large oculus (eye) above the column, keeping it open to light, the elements and heaven; however, it was left completely open after the roofing collapsed in 528. Symeon achieved a worldwide fame for his holy life and posthumous miracles, and further stylite saints ascended columns in emulation of his ascetic feats – including one hardy individual in the much chillier region near Cologne. And in Rome craftsmen are said to have had images of Symeon on his column in their workshops. These were perhaps locally made imitations of the type of badge-like tokens that were brought back by pilgrims. Such tokens were a means by which art and ideas were transmitted over long distances in these centuries.

37
The cruciform church of St Symeon, Qalat Seman, Syria, c.476–90. Viewed from the northeast

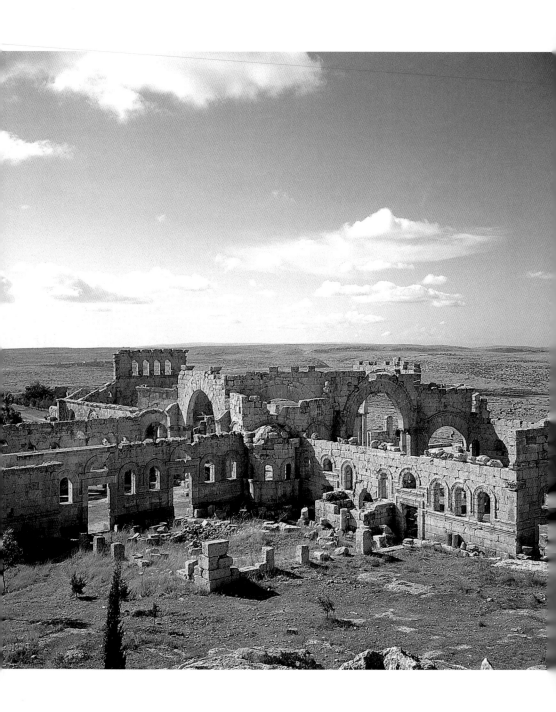

It is clear from other sites in northern Syria that the late fifth and early sixth centuries marked a period of extraordinary prosperity in the region, with a local economy that flourished to the extent that imperial intervention was not necessary to make major building projects possible. The situation must always have been different, however, on the farthest and most desolate borders of the empire, at such sites as that of the monastery now called St Catherine's, in the desert at the foot of Mount Sinai, in Egypt (40). The emperor Justinian was certainly involved in a major project here, and Procopius provides the official record. A church dedicated to the Mother of God and a surrounding 'very strong fortress' were built by Justinian, we are told, to protect both the monks who lived at the site and the more distant inhabitants of the province of Palestine from attack by marauding bands of 'Saracens' (*ie* Arabs). Procopius explains that the holiness of Mt Sinai was due to the belief that this was where Moses received the Law (the Ten Commandments; Exodus 20:1–17) from God, but he does not mention that the siting of the fortress at the foot of the mountain, and of the church within it, was determined by the location of a second holy place: the bush which had burned without being consumed, and from which God had first addressed Moses, instructing him to go to Egypt to rescue the Jews from oppression and begin the Exodus to the Promised Land (Exodus 3–4). Nor does Procopius mention what we know from other sources: that these two holy sites on Mt Sinai had been important destina-

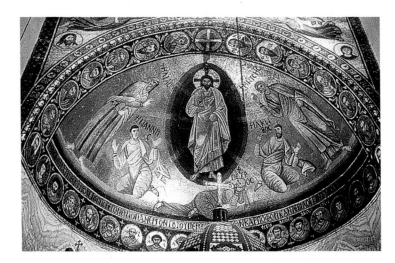

38
The
Transfiguration,
c.565/6.
Apse mosaic.
St Catherine's
Monastery,
Sinai

tions for Christian pilgrims since the fourth century. The garrison installed by the emperor at Sinai would thus have been able to protect the pilgrim trade as well as the monks.

The fortress and church at Sinai are built entirely of local stone, as we might expect, but the interior decoration of the church is a different matter. The east end is revetted with panels of Prokonnesian marble, readily identifiable by its streaky grey and white patterning. These panels must have been shipped from the quarries on the island of Prokonnesos in the Sea of Marmara (literally, Sea of Marble) some 180 km (112 miles) southwest of Constantinople, and then carried overland to the monastery. Above the marble panels is a magnificent mosaic which covers the semidome of the apse, and extends over the vertical wall surface above (38).

A visual connection between the monastery's site and the biblical events it commemorates is made in the mosaic on the upper wall, where Moses is shown in two panels, receiving the Law, and before the burning bush. The apse composition, however, works in a different way. In the centre is a figure of Christ, dressed in white and framed by a mandorla (almond-shaped) aureole. Rays of light extend over the gold ground to the flanking figures, Elijah and Moses, and to the three apostles below, John, Peter and James. The event is the Transfiguration (Matthew 17:1–6) when Christ ascended a high mountain with the three apostles, who were amazed to see him transfigured by light, accompanied by the two Old Testament figures, and acknowledged by God. Around the main panel are two bands containing medallions with heads of the apostles (rising vertically), and the prophets (extending horizontally). Where the bands meet are medallions of figures identified as 'Abbot Longinos' and 'John the Deacon' (39). A mosaic inscription further attributes the work to 'the zeal' of Theodoros the Priest (not an artist, but an organizer of some sort), and provides the date 'Indiction 14' (a calculation based on a fifteen-year cycle). If the mosaic was part of the Justinianic project, which is not certain, we can deduce that it was created in 565/6. Fifteen years earlier in 550/1 the abbot is known to have been called George, not Longinos.

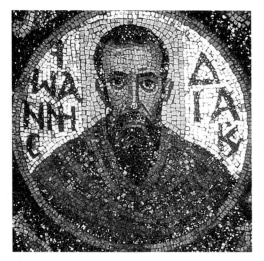

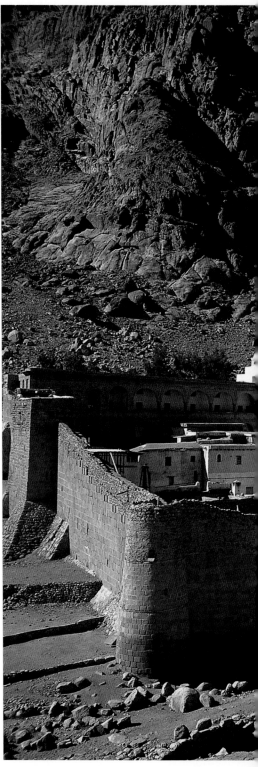

39–40
St Catherine's
Monastery,
Sinai
Above
Apse mosaic,
John the
Deacon
(detail), *c*.565/6
Right
General view
of monastery

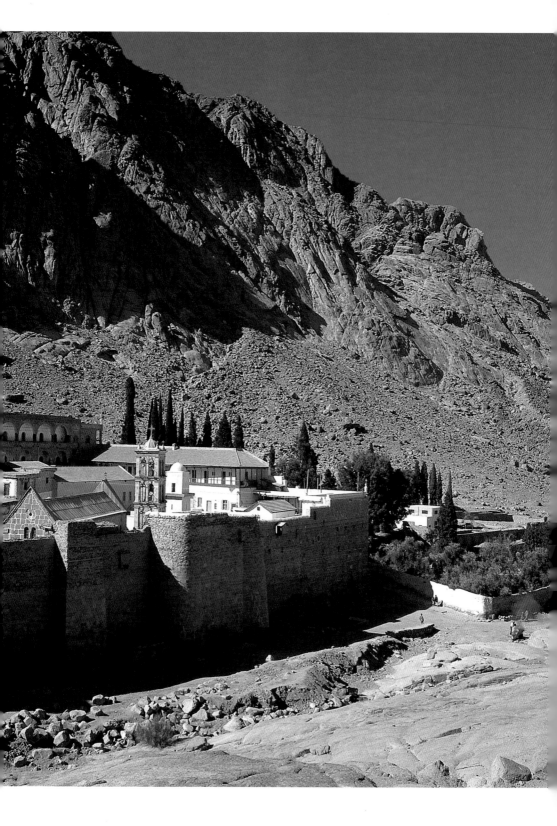

The mosaicists and their materials were certainly dispatched to Sinai from elsewhere, but unlike the marble, they may not have come from the region of Constantinople. As it happens such a long journey would have been unnecessary. Justinian had sponsored major programmes of building and reconstruction in the churches of the Holy Land, and doubtless these included mosaic decorations. The eastern part of the Constantinian Church of the Nativity at Bethlehem, for example, was vastly increased in size, while in Jerusalem Justinian built the enormous Nea (New) Church, dedicated to the Theotokos (he sent an architect named Theodoros). It is most likely, therefore, that the craftsmen employed at Sinai came from a nearby centre such as Jerusalem. The architect was certainly local, for his name was recorded on one of the roof beams: Stephanos of Aila (modern Aqaba in Jordan).

The initial reason for choosing the Transfiguration as the principal image for the church, even though it was dedicated to the Theotokos, was presumably because it provided a biblical link between Moses and Christ, emphasized by the fact that both the events depicted had mountain settings. The existence of a cult of Elijah at Mt Sinai must have reinforced this choice. But the image of the Transfiguration as executed in mosaic uses a gold background to deny any terrestrial connection, in contrast to the landscape background in the Moses scenes on the upper wall. It emphasizes a crucial theological point by affirming the duality of Christ, who was able not only to be man and God at the same time, but was perceived by men (the apostles) as such in the Transfiguration.

The precise nature of Christ as God and man had been a matter of bitter controversy in the Church since the fourth century. Constantine had summoned the Council at Nicaea in 325 to define the orthodox view and to condemn as heretical the followers of the priest Arius, who held that Christ had been created by God, and was therefore not truly divine by nature (Arianism). The Council of Constantinople in 381 was intended to unite the Church after the defeat of Arianism. The Council held at Chalcedon, near Constantinople, called by the emperor Marcian in 451 was intended to remove (but had the effect

of hardening) the monophysite heresy, which in some senses reversed the central tenet of Arianism. Monophysites held that Christ was divine by nature, but did not become also fully human by nature after the Incarnation. Monophysitism was prevalent in large parts of the empire, notably in the region stretching southwards in an arc from Armenia through Syria to Egypt. The Sinai Transfiguration mosaic, therefore, may well have been intended as a statement of orthodox belief in Christ's divine and human natures. Nonetheless, it is possible that a monophysite might have viewed the preponderance of gold mosaic as supporting a monophysite position. That images were viewed in these ways as arguments in complex theological debates cannot be doubted.

The eighteenth-century Russian iconostasis (icon screen) that now obscures the view of the east end of the church at Sinai, or the nine-teenth-century koranic inscriptions that are so conspicuous in the interior of St Sophia, make it hard to reconstruct an idea of the magnificent fixtures, fittings and portable objects that would have been used and displayed in such buildings. While the silver revet-ment of the altar area of St Sophia does not survive, a number of hoards of sixth-century church silver have been discovered in the eastern Mediterranean, and these, like the architecture of such sites as Qalat Seman, testify to extraordinary wealth. Doubtless, too, the wealthiest private households continued to have silver dishes, bowls, etc., as they had in previous centuries.

A treasure of superlative craftsmanship said to have been found at Kumluça, near Antalya on the south coast of Turkey, consists of numerous silver patens and chalices (the plates and cups used for the bread and wine in the Eucharist), with inscriptions recording their donation to a church called Holy Sion by a Bishop Eutychianos and others (41). There are also complicated *polykandela* (candelabra) of different shapes to be hung from silver chains (recalling Constantine's donations to the Lateran), silver crosses, silver book-covers, and even the sheets of silver used to cover an altar. Sets of control marks, stamped into the silver when it was shaped but not worked, indicate that these objects were made in the years around 570.

A silver paten said to have been found near the village of Riha, some
55 km (34 miles) southeast of Antioch, was executed in a repoussé
(hammered) technique to show the image known as the Communion
of the Apostles (42) – an appropriate choice. The biblical description
of Christ's Last Supper (Matthew 26:26–8) is here reinterpreted with
Christ as a priest, ministering to the congregation of apostles from
an altar. At the left is the offering of wine, and at the right of bread.
The surrounding inscription records that the paten was presented

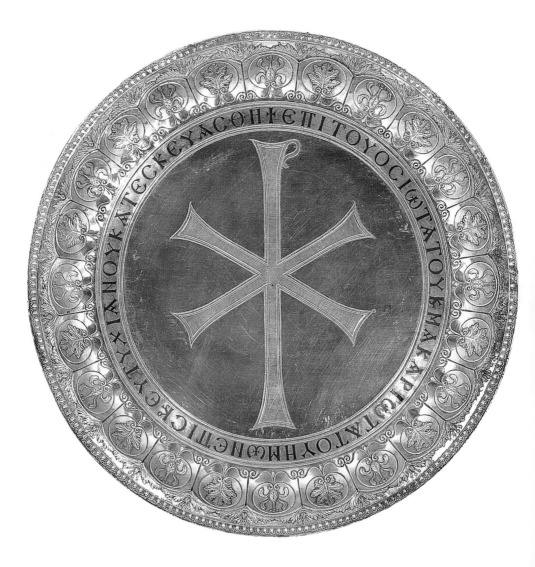

'For the repose [of the souls] of Sergia, [daughter] of Ioannes, and of Theodosios [ie these two were deceased] and the salvation of Megas and Nonnous and of their children'. Megas was a high-ranking imperial official, and control stamps suggest a date of 577 for the paten. It has been proposed that the other liturgical objects shown on the paten represent further donations by Megas, and that even the conspicuous epistyle (behind and above the figures) could represent a silver revetment given by him to the church.

It is striking that such church treasures are almost exclusively of silver, rather than of gold. This reflects not merely the much larger quantity of silver in circulation at the time, but the fact that gold (and not silver) was required by the imperial mints for coinage.

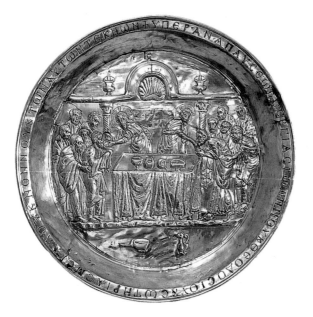

41
Paten from the Sion Treasure, c.570.
Silver; diam. 60·5 cm, 23¾ in.
Dumbarton Oaks, Washington, DC

42
The Riha Paten showing the Communion of the Apostles, 577.
Silver; diam. 35 cm, 13¾ in.
Dumbarton Oaks, Washington, DC

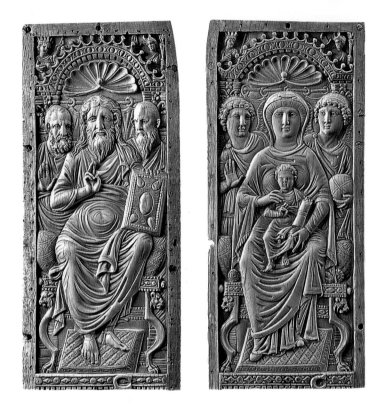

43
Christ and
the Theotokos
and Child
with saints
and angels,
6th century.
Ivory diptych;
panels
29×13 cm,
11½×5⅛ in.
Staatliche
Museen, Berlin

Ivory was another relatively precious commodity which was used in
civil but also in religious contexts. Ivory diptychs consisting of two
tall carved panels joined by hinges were issued by the consuls (civic
officials, though much altered from the consuls of republican Rome)
who continued to play an administrative role until 541. They were
normally carved with a generic image of a consul, beneath an inscrip-
tion with the man's name and titles. These so-called consular
diptychs are paralleled in form by diptychs of, for example, Christ
and the Theotokos (43). The latter were presumably intended to
stand on altars during the liturgy. In this example (now in Berlin)
there is an interesting contrast between the heavily bearded and
strongly modelled heads of the seemingly aged Christ, Peter and Paul
on one wing, and the soft, fleshy, unlined faces of Mary, the angels
and the Christ Child (much worn) on the other. These differences are
best understood as deliberate features testifying to the craftsman's
skill. It makes no sense to suppose that the figures look different
because the diptych wings were carved by different hands.

44
The Theotokos
and Child with
saints and angels,
6th century.
Reused as the
cover of the
10th-century
Etchmiadzin
Gospels.
Ivory; panels
36·5 × 30·5 cm,
14⅜ × 12 in.
Matenadaran,
Erevan, Armenia

A characteristic development of such diptychs seems to have involved
their use as book-covers (44). Because the shape of an elephant's tusk
precludes the cutting of a rectangular panel of more than a certain
width, it was necessary to assemble such covers from a number of
smaller panels, usually five (unless a tall narrow book was made).
This assembly in turn suggested a compositional arrangement, with
Christ or Mary remaining in the centre (for the front and back of the
book), and angels, apostles, saints or smaller-scale figures in scenes
in the flanking panels. Regrettably, even when such covers survive,
they are no longer on the books they were made for.

It is not now possible to estimate the relative cost of a silver or ivory
cover for a book, as against the materials and workmanship of the
pages within, but there is no disputing the fact that the few books
from the sixth century that do survive are among the most carefully
and expensively executed of any period. The number of books we
have, especially when compared to the number of ecclesiastical build-
ings, whether ruined or not, is very small. Of course there must once
have been many more, but it needs to be borne in mind that it was
exactly those books which were thought most important by later
generations that stood the best chance of being preserved – saved
from a fire, ransomed, or even treasured as a relic because of their
association (genuine or assumed) with some saint. The more ordi-
nary, workaday books that were in frequent use would have been
replaced as they wore out.

The sorts of books that were decorated and illustrated with images at this time were almost exclusively biblical – especially the Gospels, but also for some reason the Book of Genesis. Books were written by hand, by highly skilled calligraphers, on the specially treated animal skin known as parchment (Greek *pergamene*, from the supposed origin of the process in the city of Pergamon). Although we often call them manuscripts, to distinguish handwritten from printed books, to contemporaries in this age before printing they were simply books. The most costly and ostentatious treatment a book could receive (excepting a single fragmentary case in which the parchment was entirely covered in gold leaf) was for it to be written in letters of silver or gold on parchment that had been dyed with the *purpura* dyestuff usually employed for textiles, and at this period reserved for imperial use (45). These books are generally referred to as 'purple codices' (Latin *codex* meaning 'book', as distinct from roll or scroll), which is misleading if we imagine that this describes a particular colour of parchment, for the *purpura* dye can produce a wide range of intense tones between a deep blue and a deep red (when not faded by prolonged exposure to light). The pages of these books never equate with our modern notion of the single colour 'purple'.

The Rossano Gospels is a purple manuscript preserved in the treasury of the cathedral of Rossano in southern Italy (it is not known how or when it got there). Its images are gathered together as frontispieces. Most characteristic are the scenes from the life of Christ, which occupy the upper part of the page. These are observed from below by gesticulating figures holding scrolls on which texts are written. The observers are identified by inscriptions as Old Testament authors, and the texts they hold are quotations from their works that can be taken to prophesy the New Testament event seen above. As is appropriate to their context in a book, these images cannot be properly understood unless the viewer reads as well as looks. But what he or she reads is not 'the story' of what is being illustrated, or even an explanation of the event, but a piece of religious argument, emphasizing the true nature of Christ (the Messiah) as the one who had been foretold in the Jewish scriptures.

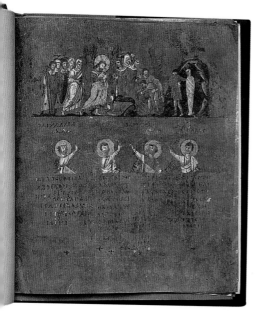

45
The Raising of
Lazarus, with
prophets below,
folio 1r (facsimile),
Rossano Gospels,
6th century.
30·7 × 26 cm,
12 × 10½ in (page).
Rossano Cathedral
Treasury

The only way to understand how this art works, therefore, is to both look and read. For example, the image of the Raising of Lazarus (told in John 11:1–44) shows Mary at Christ's feet (verse 32) and the stinking swathed corpse of Lazarus in his tomb-cave (verse 39). Below, reading from left to right, are David, Hosea, David and Isaiah. The short texts they hold comment on the Raising of Lazarus as follows (note that the Greek Old Testament – the Septuagint – often differs slightly but significantly in wording, and in its verse and chapter divisions, from familiar English versions. There is a greater problem of accessibility even to a text like the Bible than might at first seem to be the case):

[David] The Lord kills and makes alive; he brings down to Hades [or: to the grave] and brings up. [I Kings 2:4]

[Hosea] I will deliver them out of the power of Hades, and will redeem them from death. [Hosea 13:14]

[David] Rejoice in God who alone does wonders. [compare Psalm 71:18]

[Isaiah] The dead shall rise, and they that are in their tombs shall be raised. [Isaiah 26:19]

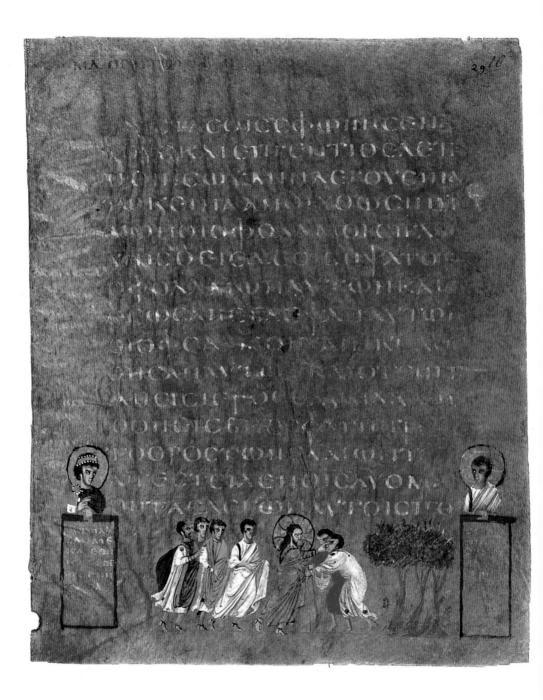

It can now be seen that the prophets holding their scrolls must be imagined as speaking the words written on them. We the viewers have to recreate this act by speaking the prophets' words ourselves.

A fragment (46) of an even more magnificent Gospel Book was found in the late nineteenth century at Sinop (ancient Sinope) on the Black Sea coast of what is now Turkey (the book is in the Bibliothèque Nationale, Paris). We do not know what prefatory images the book might have had, for this part is lost, but it included images in the lower margins of some of the pages of Gospel text. The formula employed resembles the Rossano Gospels by including Old Testament authors displaying prophetical excerpts from their texts to accompany a New Testament scene. The story illustrated is that of Jesus' healing of two blind men near Jericho (Matthew 20:29–34). This text ends on the page we see, six lines up from the image. Jesus in a golden robe stretches out his hand to touch the men's eyes (verse 34). The figure at the left is David (beardless in this image) who holds the text: 'You have fashioned me and have laid your hand upon me' (Psalm 138:5). The youthful beardless figure at the right must be Isaiah, to judge by the text he holds (there is no inscription). It reads: 'Then shall the eyes of the blind be opened' (Isaiah 35:5). In this case, therefore, the image functions more obviously as an illustration, since it is near the text that narrates the event, but it also comments on and interprets that event at the same time. The viewer is actively involved in this process, for he or she must read and speak and think about the words on the page.

The Vienna Genesis (47–8) is another book on purple-dyed parchment, arranged in yet another way. (Its name derives from its present location, in the Österreichische Nationalbibliothek in Vienna.) Each page is divided in two, with a section of the Book of Genesis above, and a large image below. Some of the artists who worked on this book (there were certainly several) painted over the purple-dyed ground entirely so as to provide an illusionistic setting with a foreground receding to misty mountains and a cloudy sky. But the spatial organization of the paintings is less than convincing – the aged Jacob, for example, is seated in what appears to be the middle

46
Christ Heals
Two Blind Men,
folio 29r,
Sinope
Gospels,
6th century.
30×25 cm,
11¾×9⅞ in
(page).
Bibliothèque
Nationale, Paris

47–48
Overleaf
Vienna Genesis,
6th century.
33·5×25 cm,
13¼×9⅞ in (page).
Österreichische
Nationalbibliothek,
Vienna
Left
Rebekah and
Abraham's Servant,
p.13
Right
Jacob Blesses the
Sons of Joseph,
p.45

distance as he crosses his hands to bless Joseph's sons (Genesis 48:14). Some of the images have a simple centralized arrangement, but in others the viewer's eye is led around the image by the figures, following the direction implied by the narrative above from one event to the next. In one example (47) Rebekah sets out from the city with her pitcher upon her shoulder (Genesis 24:15); she then draws water from the well (note the personification pouring water from an urn), and gives it to Abraham's servant and to his ten camels (compare verse 10).

In the Vienna Genesis book there are no captions or inscriptions: each page must be read and viewed entire if its art is to be understood. But in this case the viewer had to do more. There are elements in some of the images that are not found in the biblical text, such as the presence of Joseph's wife in the scene of blessing (48). These suggest that the artist, or possibly some adviser, knew of stories and legends elaborating on the Bible, some of which derive ultimately from Jewish writings. Was the viewer also supposed to know this non-biblical material? Although this question cannot be answered, the issues it raises are intriguing.

Less costly in terms of materials perhaps, but far more ambitious in terms of its sheer number of images, is another illustrated book (49) containing only Genesis, called the Cotton Genesis after the seventeenth-century English collector Sir Robert Cotton (now in the British Library, London). This book was largely destroyed in a terrible fire in 1731, but enough survives to enable it to be reconstructed in the mind's eye as a large volume of more than 440 pages (for Genesis alone!) with some 339 framed images, painted in spaces of varying sizes that had been left in the text when it was written. A reconstruction drawing (50), shows how the pages shrank to about half their original size as a result of the heat of the fire. So far as we can tell, Genesis was never again treated to such a profusion of illustrations as in this book.

By the sixth century there were well-established Christian communities in the Byzantine world, or on its borders, which had developed liturgies in their own languages: notably the Georgian, Armenian,

49–50
Cotton Genesis, late 5th–early 6th century. British Library, London
Above
God Introduces Eve to Adam, folio 3r, 13·6 × 8·8 cm, 5⅜ × 3½ in
Below
Reconstruction to show shrinkage of two of the pages as the result of fire damage

Syriac and Coptic (Egyptian) churches. Their art probably took its lead from Greek Byzantine examples, although in architectural terms the situation is not so readily defined. The most lavishly illustrated book to have survived from these linguistically non-Greek contexts is the Gospels in Syriac made by the priest Rabbula (as he tells us) in and for the monastery of Bet Mar Yohannan (St John) at Zagba, perhaps in the same region southeast of Antioch as the Riha Paten (see 42). This book (51), which was finished in 586, is now in the Biblioteca Medicea-Laurenziana in Florence. To the range of ideas we have already encountered as to how to provide images in a text, the Rabbula Gospels adds further types of frontispiece: full-page framed images of New Testament events, such as the Choosing of Matthias to join the Eleven (Acts 1:15–26), the Ascension and Pentecost; a sepa-rate image of the Mother of God and Child; a donor image showing (unidentified) monks in the presence of an enthroned Christ present-ing him with a book (*ie* this book); and Canon Tables – tables of concordances between parallel passages in the various Gospels, set out in richly decorated arcades, and flanked by small marginal images of biblical figures, events and authors.

51
The Ascension, folio 13v, Rabbula Gospels, 586. 33·6 × 26·6 cm, 13¼ × 10½ in (page). Biblioteca Medicea-Laurenziana, Florence

It is worth noting that, although the manuscript of Rabbula is a Gospel Book, the three full-page images it includes from the story of Christ are all of events recounted in Acts, not in the Gospels them-selves. Furthermore, in the Ascension the composition is focused on the central figure of Mary, who stands in an orant (praying) pose. Yet Mary was not present at the Ascension according to Acts. None of these images, then, is a simple illustration of an accompanying text. They are making wider points about Christian ideas and beliefs. They also serve to remind the viewer of the great festivals of the church year. And they probably recall the images that decorated church inte-riors at the time.

The chances of any book without an obvious connection with the Church surviving from the sixth century are extremely small, because only the Church as an institution has survived from that time, however changed. The book in Vienna (Österreichische National-bibliothek) generally known as the Vienna Dioskurides is thus a

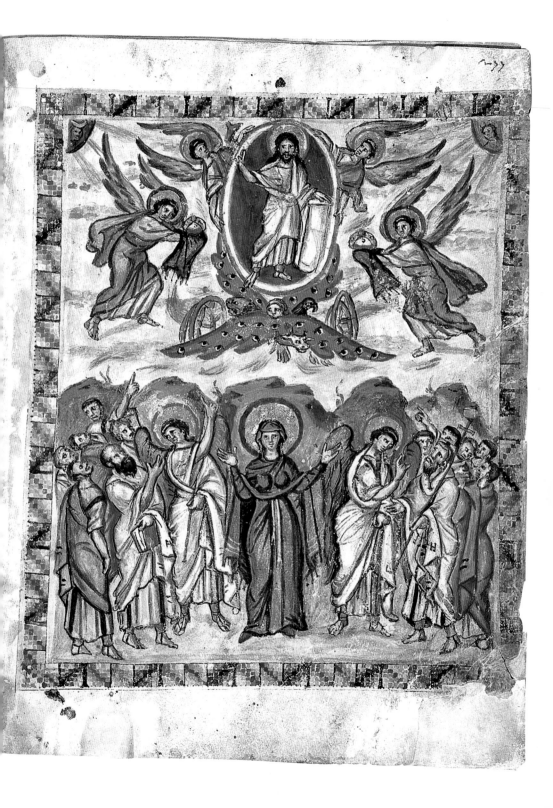

اری یو یؤ نیروں

سفن

remarkable exception. It is a huge volume of herbal, medical and scientific lore, containing almost 1,000 pages and illustrated with 498 images, mostly of plants, but also of birds, snakes and other creatures. The execution of the plant images, in particular, is astonishingly true to nature (52). A series of frontispieces shows the writers of the various texts, notably Dioskurides (the author of the herbal) accompanied first by a personification of Heuresis (Invention or Discovery) who holds a mandrake, and then by an artist who paints the example of the plant held by a personification of Epinoia (Thought), on a sheet pinned to a large board on a tripod easel, while Dioskurides writes about it (53). The book's recipient is also shown on a full-page (54): she is identified by silver letters on purple panels as Iouliana, that is Juliana Anicia, the wealthy Constantinopolitan lady of imperial family who rebuilt the church of St Polyeuktos. The image of the princess enthroned between personifications of Magnanimity and Prudence bears a striking resemblance to the standard image of the Mother of God between two angels (as in 43, for example). The book, we are informed, was a thank-offering by the people of the town of Honoratai, near Constantinople, for whom Juliana had built a church of the Mother of God before 512. An unexplained issue is why this particular book should have been given to Juliana; a gold and purple Gospel Book, for example, might seem a more obvious gift for a church's imperial foundress.

The bishops, priests, monks and lay congregations in fifth- and sixth-century churches must have been familiar with holy images of Christ and the saints, and events from the Old and New Testaments, not only through large-scale painting and mosaic on the walls and vaults, and the smaller-scale silver and ivory objects, books and textiles (of which examples have been discovered, notably in Egypt), but through paintings on wooden panels. We know about these not just from written sources but also from the preservation of a small number of examples, primarily at St Catherine's Monastery on Mt Sinai, believed to date from the sixth or sixth–seventh century. These images (icons: the term is considered further in Chapter 4) are painted with a skill that gives them an extraordinarily direct and powerful contact with the viewer.

53–54
Vienna
Dioskurides,
c.512.
38×33 cm,
15×13 in
(page).
Österreichische
Nationalbiblio-
thek, Vienna
Above
Dioskurides
at work,
folio 5v
Right
Juliana Anicia,
folio 6v

The image (55) known as the Sinai Christ is approximately life-size
(the panel measures 84×45·5 cm, 33×18 in). The strongly asymmetri-
cal face confronts the viewer through an intense gaze. The flesh,
especially around the eyes, is very carefully modelled, whereas the
hair and beard are treated more impressionistically. The paint surface
of the drapery is not in its original condition, but the bulky volume
that Christ holds has a jewel and pearl-encrusted cover of a type that
a viewer might have seen displayed on an altar.

A slightly larger panel (92·8×53·1 cm, 36½×21 in) depicts the image
of the Sinai St Peter, identifiable by the keys of the kingdom of
heaven (Matthew 16:19) that he holds in his right hand (56). It is
treated somewhat differently: the pigments have been thickly applied
to the face to suggest an older man with weatherbeaten features, and
bold highlights decorate large areas of the surface in contrast to the
sombre lighting of the Christ. The image is completed by three small
medallions above: Christ in the centre flanked, it is thought, by St
John (the evangelist) and Mary.

A third Sinai panel, of the Theotokos and Child with saints and angels
(57), is on a smaller scale (68·5×49·7 cm, 27×19½ in), and is complete

μεγάλο
τύχα

σοφίᾱ⟨τ⟩

θεουμσιο⟨σ⟩

πολεστης
σο διᾱ

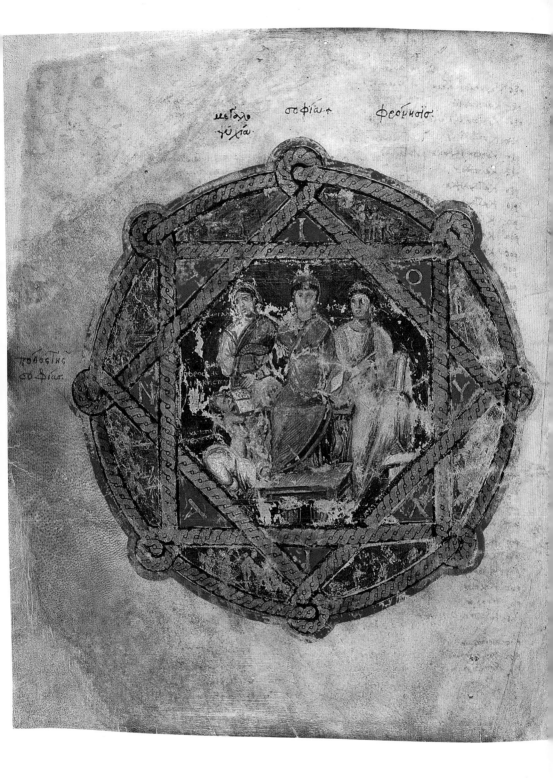

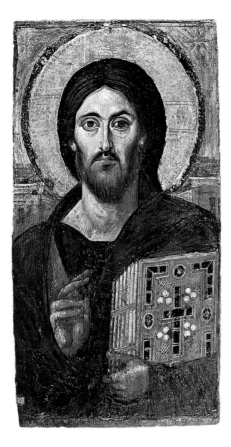

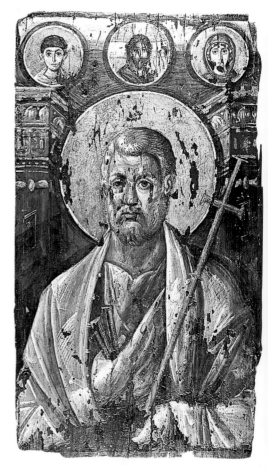

on all sides. It must originally have performed a somewhat different function from the Christ and the St Peter. Here it is the military saints, probably St Theodore (at the left) and St George, who through their frontal gaze make contact with the viewer. In contrast, the Theotokos turns her eyes away, while the condition of the paint surface makes the direction of the Christ Child's gaze uncertain. The two angels behind turn their heads and look up towards heaven, from which a hand of God blesses the central pair. This is presumably an image of prayer: the viewer appeals to the saints to intercede with

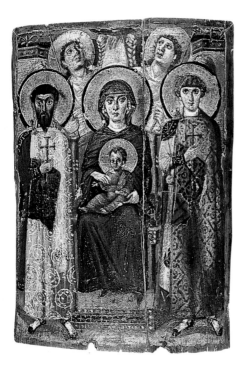

55–57
Painted wooden panels.
St Catherine's Monastery, Sinai
Opposite far left
Christ,
6th century.
84×45·5 cm,
33×18 in
Opposite left
St Peter,
6th century
or early 7th century.
92·8×53·1 cm,
36½×21 in
Left
The Theotokos and Child,
with saints and angels,
6th century.
68·5×49·7 cm,
27×19½ in

Mary who, as the Mother of God, will be able to appeal to Christ. His right hand probably made a gesture of blessing. But it could also be an image of protection: the saints will be vigilant in their protection of the viewer, as they are of the Theotokos and Child.

In the end there is now no way of knowing exactly how images such as these were understood, but this uncertainty is not necessarily what those who paid for and made these objects intended. All three panels were constructed with separate frames, as their unpainted

borders indicate. As on the silver patens (compare 41 and 42) such border areas were frequently used to record in detail the circumstances of an object's donation, and this was probably the case with the icons. Nonetheless, there is a good chance that such inscriptions, even if they had survived, would not have answered the questions a modern viewer might think important about, let us say, the Sinai Christ (55): Who made this work? When? Where? What is its title? While these are the sort of questions created by a mentality that is conditioned by gallery and museum labels, contemporary inscriptions recording who paid for a work, to whom it was presented, and why, reveal what was of importance to the makers and original viewers of this art. Look again at the Sinai Christ – what could be more ridiculous than to think of this work as somehow diminished in significance because we do not happen to know the name of the artist who painted it?

3

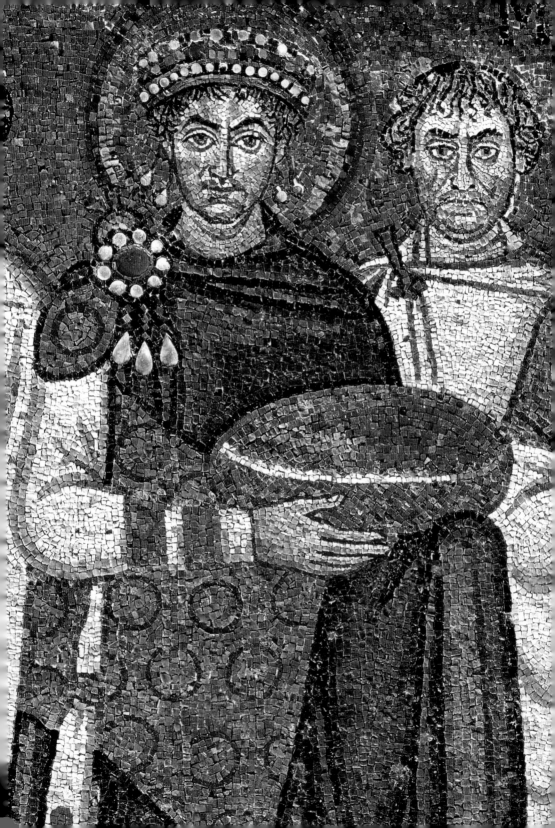

The Italian city of Ravenna is the principal Western site in which to study the art and architecture of the fifth and sixth centuries. To understand why this should be the case – why we should not continue to follow developments in one of the great fourth-century centres like Rome itself – requires an awareness of various factors.

To begin with, the history of this period and area is dramatic, intriguing and complex. The Western part of the Roman Empire was for centuries the setting for conflict and open warfare between imperial forces (often mercenaries) and invaders consisting largely of Germanic warrior tribes (including the Franks, Goths, Huns and Vandals), who moved down with proverbial ferocity and destruction towards the rich Mediterranean littoral from northern, central and eastern Europe, in many cases settling and gradually becoming absorbed into the indigenous 'Roman' culture. Far-flung provinces, such as Britannia (sacked and settled by 'Anglo-Saxons'), were abandoned to their fate, but the centres of power were protected vigorously. Theodosius I (r. 379–95) succeeded in reuniting the administration and hence the defence of the empire (split on Constantine's death in 337), but before his death in Milan in 395 he divided power between his two sons: Arcadius (the elder) was made Augustus in the East, and Honorius (the younger) became Augustus in the West. Initially, Honorius – under the guidance of his all-powerful half-Vandal general Stilicho – made his principal residence at Milan, close to what was then the empire's northern frontier. During 402, however, Honorius was forced to retreat from Milan under threat from the Visigothic chief Alaric, and he moved to the more easily defensible site of Ravenna, a city surrounded by marshes on the northern Adriatic coast, connected by waterway to the nearby deep-water harbour of Classis. Thenceforth, Ravenna was to remain the western 'capital' of the Roman (or Byzantine) Empire until 751.

58
Justinian
with courtier
(detail of 80).
Mosaic.
S. Vitale,
Ravenna

103 Ravenna and the West

In the fifth and sixth centuries Ravenna was the most prosperous city in the West, for it was not only the seat of authority but the principal trading entrepôt between the Eastern and Western Empire. There is evidence, for example, for more than sixty churches in the city in the period c. 400–750. Rome in the fifth and sixth centuries, by contrast, was repeatedly besieged and ruthlessly plundered on six occasions. Its grain supply from North Africa ceased, its aqueducts were cut, and its population plummeted. Constantinople, meanwhile, was burgeoning as the unquestioned centre of power – political, economic, social and religious (the effects of this in terms of art and architecture were seen in Chapter 2).

It is clear from a modern perspective that in this period the Eastern and Western parts of the empire, despite their numerous links, followed historical courses that may often be parallel but nonetheless remain in various ways distinct. It may sometimes be helpful, therefore, to be able from this point onwards to term certain ideas or individuals or products 'Byzantine', so long as it is borne in mind that formulating a distinction in this manner would not have been recognized at the time.

Because of its wealth of architecture from this period, Ravenna is sometimes called 'the early medieval Pompeii', but this comparison is misleading. Like any continuously occupied site, Ravenna has undergone many changes since the sixth century, and although several of the city's most important churches have survived, their condition has often been altered by rebuilding or by overzealous restoration. Floor levels have been drastically raised to keep them above the rising water table (the church of S. Apollinare in Classe is the only exception). In particular, even the churches that do survive lack the context of the buildings that originally surrounded them, such as can be reconstructed when sites are excavated. Nonetheless, the rapid decline in importance of Ravenna from approximately the late sixth century did mean that its citizens generally lacked the finances or will to replace the early churches with grander or more modern structures (in obvious contrast to Rome or Constantinople). It is to the later relative insignificance of Ravenna that we owe the

59
Ravenna in the
5th and 6th
centuries. Plan

preservation (despite shelling in 1944) of so much early material.

There is an invaluable source of information on the city's churches in a text known as the *Liber Pontificalis Ecclesiae Ravennatis*, an account of Ravenna's bishops (in emulation of the Roman *Liber Pontificalis*) composed by a local priest, Agnellus, who died *c.* 846. Agnellus provides some legendary or fanciful material, which reveals what people thought or wanted to believe in the ninth century, but he also copied down many carved, embroidered, painted or mosaic inscriptions, later to disappear, that identified the founders or donors of churches and of their fixtures and fittings. It is the combination of a careful examination of the buildings with the results of Agnellus' antiquarian investigations that allows us to construct a detailed picture of Ravenna in the fifth and sixth centuries (59).

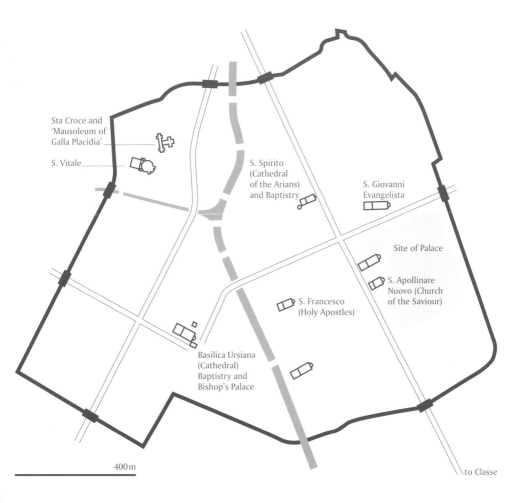

Sta Croce and 'Mausoleum of Galla Placidia'

S. Vitale

S. Spirito (Cathedral of the Arians) and Baptistry

S. Giovanni Evangelista

Site of Palace

S. Apollinare Nuovo (Church of the Saviour)

S. Francesco (Holy Apostles)

Basilica Ursiana (Cathedral) Baptistry and Bishop's Palace

400 m

to Classe

60
Medallion of
Galla Placidia,
425–50
(setting *c*.5th–6th
century).
Gold;
diam. 5 cm, 2 in.
Koninklijk
Penningkabinett,
The Hague

The principal surviving churches of Ravenna are often connected with
three great names of the period *c.*400–*c.*550: the empress Galla
Placidia (60), the Gothic king Theoderic, and Bishop Maximian.
Although we do not know enough about these people to discuss the
buildings and mosaics in terms of their personalities, their back-
grounds and histories are relevant, partly at least because of their
emphatic differences. Galla Placidia's eventful life, for example,
sounds like the synopsis for an improbable historical novel. She links
the great cities of the time and the principal warring groups in a
complex tale of aristocratic romance, intrigue, and bloodshed.

In 410 the imperial forces were unable to prevent the Visigoths under
the leadership of Alaric from sacking Rome after a long siege. Galla
Placidia, the half-sister of the emperor Honorius (the daughter of
Emperor Theodosius I by his second marriage) was taken by the
Goths as a hostage. In 414 she was married at Narbonne to Alaric's
successor, the Goth Athaulf, and had by him a son whom she named
Theodosius (after his grandfather), who died in infancy. On the death
of Athaulf she returned to the empire and joined Honorius, who was
by this time ruling from Ravenna under the title Augustus. She
married the consul Constantius in Ravenna in 416. Constantius ruled
briefly as Augustus in 421 (he was a usurper), but after his death Galla

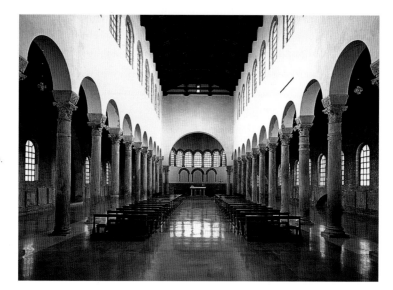

61
S. Giovanni
Evangelista,
Ravenna,
c.425–30
(reconstructed).
Interior
looking east

Placidia was banished by Honorius and sought refuge in
Constantinople. After Honorius' death in 423 she returned to
Ravenna in 425, ruling the Western part of the empire in her own
name as Augusta, and in the name of her young son the Augustus
Valentinian III. She died in Rome in 450, and Valentinian III was
murdered in 455. (The Juliana Anicia we met in Chapter 2 was the
granddaughter of Valentinian III.)

Galla Placidia Augusta, to judge from Agnellus, was the most impor-
tant sponsor of church building in Ravenna in the first half of the
fifth century. She built a large basilica (twelve columns per arcade)
dedicated to St John the Evangelist in fulfilment of a vow – she had
prayed to the saint for deliverance when she and her family were
caught in a storm at sea, presumably in attempting to cross the
Adriatic on her return from Constantinople in 425. From the church's
original structure the marble columns, capitals and bases (which
were reused from a third-century structure) have survived in the
present S. Giovanni Evangelista (61). The antiquarian G Rossi
provided a detailed description of the church's original apse mosaic
before it was destroyed in 1568, prior to a rebuilding. The mosaic
centred on an enthroned figure of Christ holding an open book with
the text 'Blessed are the merciful, for they shall receive mercy'

(Matthew 5:7). Most interesting was the inclusion of two mosaic panels showing the storm at sea, and numerous representations of members of the imperial family. In medallions above, curving over the apse (like the apostles at Sinai, 38) were images of ten of Galla Placidia's relatives, going back to Emperor Constantine, and including (it is assumed) her deceased son Theodosius. Beneath the enthroned Christ was a large-scale image of the current Bishop of Ravenna, Peter Chrysologus ('Golden word', who held office 425–49), with his hands raised in prayer before an altar. It seems remarkable now that a contemporary bishop should have been so conspicuous in the mosaics. Peter was flanked by images of the Eastern emperor and his family: Theodosius II (r. 408–50) and Eudokia, and their children Arcadius and Eudoxia (who was later married to Galla Placidia's son, Valentinian III). As we shall see, later mosaics in a number of churches in Ravenna seem to owe something to the original decoration of this building.

It was also Galla Placidia, according to Agnellus, who built a large cross-shaped church, dedicated to the Holy Cross (Sta Croce). This contained a relic reputedly of the True Cross – the one on which Christ had been crucified. To the southern end of the *narthex* (vestibule) of the church of Sta Croce (later rebuilt) was attached a much smaller cross-shaped structure which still survives, and which was considered in Agnellus' time to be the burial place – now usually termed mausoleum – of Galla Placidia. Its interior is richly decorated, with marble revetment on the walls (restored), and mosaic on the vaults and tympana (62). The mosaic is not especially complex in its content, and as it is complete (albeit partially restored) its programme can be described in full. Facing the entrance is a tympanum with the Spanish martyr saint, Vincent, holding an open book and a large cross. Opposite him is a cupboard with its doors open to reveal four fat books: the Four Gospels. In the space between, beneath a window, is the gridiron over the fire on which the saint was martyred. In the opposite tympanum is a beardless Christ as the Good Shepherd, holding a similar large cross, and seated in a naturalistic landscape among his flock. The other tympana have deer drinking at fountains (the Fountain of Life: Psalm 36:9 etc.). The barrel

62
Mausoleum of Galla Placidia, Ravenna, c.430–50. Interior looking south

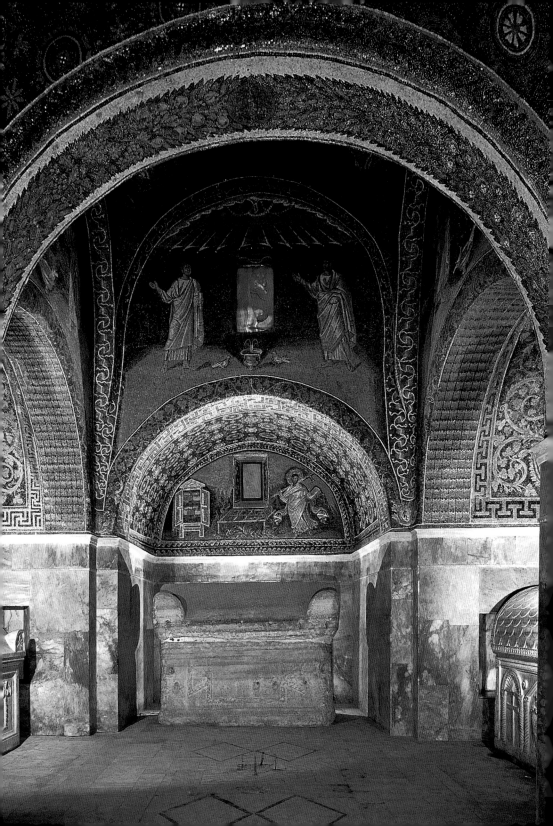

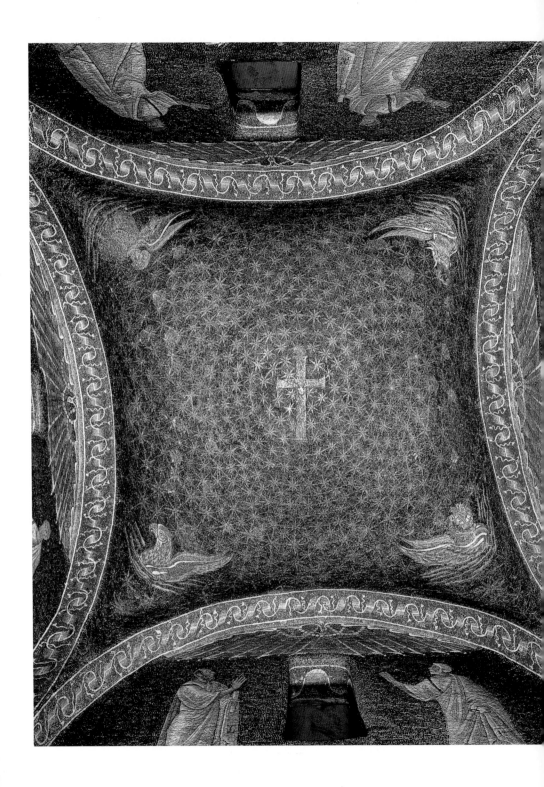

vaults above the four arms of the cross are decorated with circular patterns, or curling vine scrolls around a central chi-rho medallion with small figures holding scrolls. In the vault above the crossing the central motif is a cross in a starry firmament (63), with the four symbols of the evangelists in the pendentives. Below are four pairs of saints, presumably apostles, flanking vases or fountains. The primary focus of the decoration is thus paradise (if the viewer stands in the centre and looks vertically). The secondary focus is salvation and the power of St Vincent (the viewer follows the longitudinal axes). Most likely, therefore, this structure was originally intended as a martyrium chapel, witnessing to the cult of the Spanish martyr Vincent. Until recently the image was believed to represent the Roman martyr St Lawrence, but we know from St Augustine of Hippo (in North Africa) that St Vincent's cult was widespread by *c.*425, although it still remains an open question as to whether the chapel was also intended from the start as a burial place for one or more people who had a special veneration for St Vincent (the raising of the floor level by 1·43m, 4ft 8in, has covered the evidence that could decide this). The three sarcophagi now in the arms of the cross, said to be those of Galla Placidia and her family, are in fact of different dates: one of the fourth century, the other two probably of the fifth.

The buildings founded by Galla Placidia were constructed on a large scale, but it is assumed that they must postdate by some twenty-five years the sudden rise of Ravenna to prominence in 402. What had come before? A city needs a cathedral, and Ravenna's cathedral was known as the Basilica Ursiana in honour of its founder, Bishop Ursus, although, according to Agnellus, it was dedicated to the Anastasis, that is to the Resurrection (the convention of referring to churches by name, rather than by their dedication, is reminiscent of Rome). This five-aisled basilica (with fourteen columns per aisle) could have been built after 402, but there is some evidence that Bishop Ursus may have died in 396, in which case the cathedral would have predated the city's 'promotion'. Ravenna certainly had a bishop already in 342/3, for 'Severus of Ravenna from Italy' attended the Church Council at Serdica in that year. The original Basilica Ursiana was demolished in 1733 and subsequently reconstructed.

63
Mosaic decoration of the central vault, *c.*430–50. Mausoleum of Galla Placidia, Ravenna

A cathedral needs a baptistery, and fortunately this has survived. The original structure (presumably from the time of Ursus) was remodelled in its upper parts and domed by Bishop Neon around 458. It is now variously known as the Neonian, Orthodox or Cathedral Baptistery (there is no evidence to support the legend that it was built over a Roman bath). Its decoration, much restored, is of an exceptional richness (64). The building's octagonal form provides an appropriate frame for the huge octagonal font at its centre, which gives the building its purpose. The decoration, moving up the wall surfaces, starts with marble revetment and decorative inlay (*opus sectile*). This is framed by mosaics of vine scrolls enclosing figures holding books or scrolls. The windows are flanked by stucco figures carrying books or scrolls, set within stuccoed niches. Originally these would have been painted and gilded. The rest of the dome is covered with mosaic in three concentric zones (65). At the lowest level are architectural fantasies: on the axes of the building are four enthroned crosses, alternating with four altars displaying open Gospel Books (the treatment of this zone is distantly related to the mosaics of Hagios Georgios at Thessaloniki: compare 3–4). The middle zone is occupied by twelve apostles, bearing crowns, and at the summit is a medallion showing the Baptism of Christ (crudely restored).

Early remodellings of Bishop Ursus' cathedral did not end with Bishop Neon. Bishop Peter II, who held office from 494 to 519, built and decorated a chapel (now called the Capella Arcivescovile) in the adjacent bishop's palace (66). In the centre of its vault is a cross (originally a chi-rho symbol) in a medallion supported by four angels, accompanied by the four symbols of the evangelists. In the soffits (undersides) of the four arches are medallion busts of Christ (twice), twelve apostles, and six male and six female saints. Victor, who was Bishop of Ravenna 537/8–544/5, is known to have provided a silver ciborium (a canopy supported on four columns) to cover the cathedral's altar. According to Agnellus' description it weighed 2,000 lb, some 900 kg (compare the descriptions of silver altar fittings for the Lateran Basilica in Rome or St Sophia in Constantinople, and remember that this figure represents its weight in pure silver). Bishop Victor also provided liturgical vessels and a precious embroidered altar-

64
Cathedral
(or Orthodox)
Baptistery,
Ravenna,
c.458.
Marble, *opus
sectile*, stucco
and mosaic

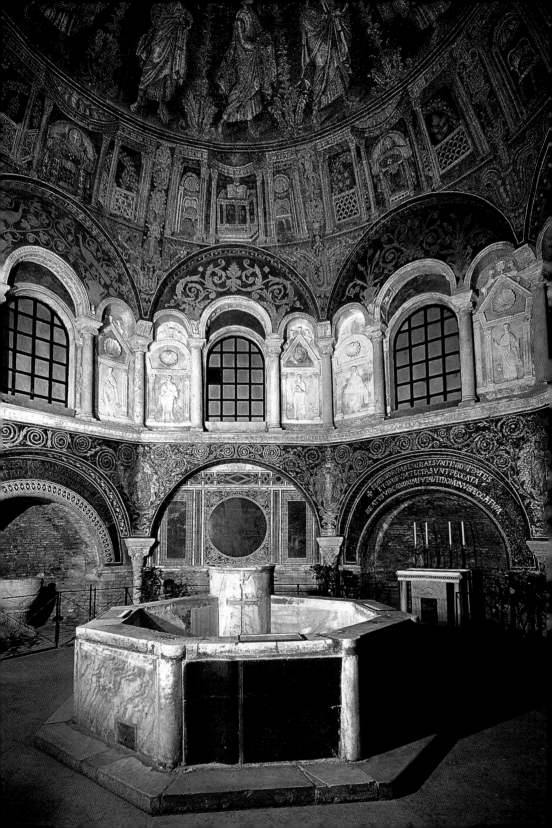

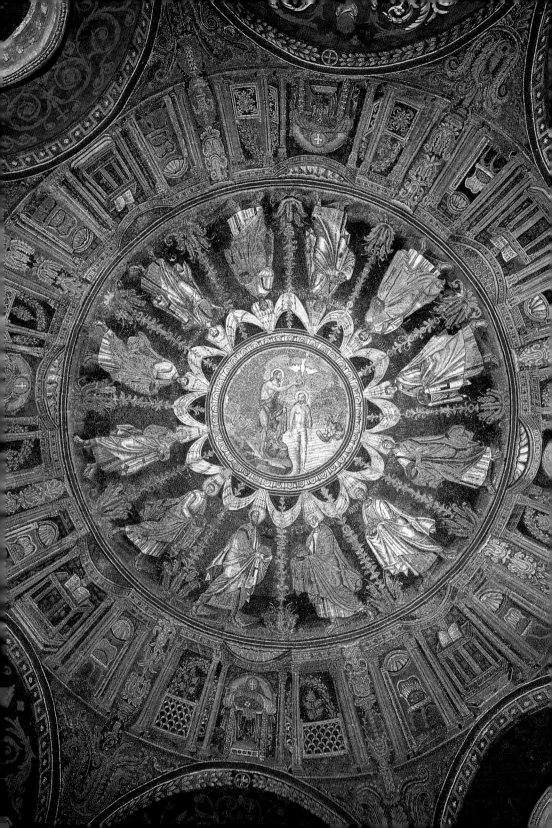

65
Left
The Baptism,
apostles, altars,
c.458.
Dome mosaic.
Orthodox
Baptistery,
Ravenna

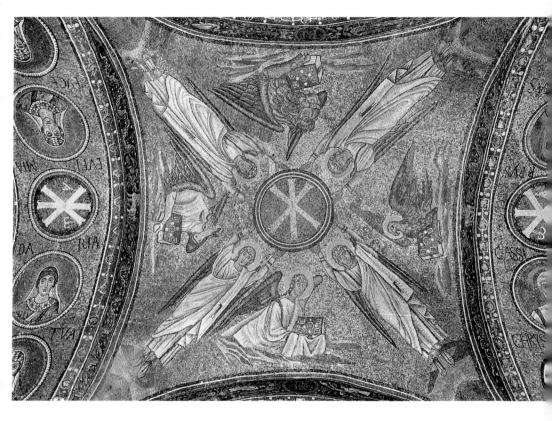

66
Above
Angels
and saints,
494–519.
Vault mosaic.
Cappella
Arcivescovile,
Ravenna
Cathedral

cloth, as did his successor, Maximian (Bishop, 546–c.554), whose work on one altar-cloth was completed by his successor Bishop Agnellus, who held office from 557 to 570. All this the ninth-century Agnellus was able to establish on the basis of conspicuous inscriptions.

Whereas these costly objects are all lost, Maximian's most remarkable episcopal furnishing has survived: a bishop's throne (*cathedra*), constructed entirely from ivory (67–8). It seems likely this was shipped to Maximian from Constantinople, although Agnellus does not mention it (and as a consequence there has been much speculation as to where it might have been made). It consists of panels of scrolling vines, inhabited by birds and beasts, framing various figured panels. The interior and exterior of the throne's back have scenes from the life of Christ, originally consisting of sixteen ivories of which nine are lost. The eight upper panels (above the seat) were carved on both sides, the eight lower ones (visible only at the back) only on one. Of an original twenty-four scenes, therefore, sixteen have survived. The sides of the throne each have five panels with scenes from the story of Joseph, narrated in Genesis. The most conspicuous area is the front, where there are four separate panels showing standing evangelists, each holding a Gospel Book. They flank the central figure of John the Baptist, who holds a medallion with the Lamb, representing Christ (compare his words 'Behold the Lamb of God'; John 1:29). He stands beneath a complex monogram which can be deciphered to read MAXIMIANVS EPISCOPVS (Bishop Maximian).

In stylistic terms the throne is closely related to the ivory diptych of Christ and the Theotokos, now in Berlin (see 43), but it still remains in many respects a puzzling object. What, for example, was the throne's real purpose? It is difficult to imagine that such a fragile object could have been intended for a bishop actually to sit on, since it has no underlying wooden structure that would have absorbed the stresses, only the ivories themselves. Was it intended then not only as a conspicuous symbol of the power of the see of Ravenna, but perhaps envisaged as becoming itself a precious relic?

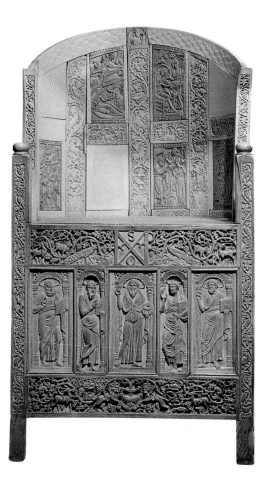
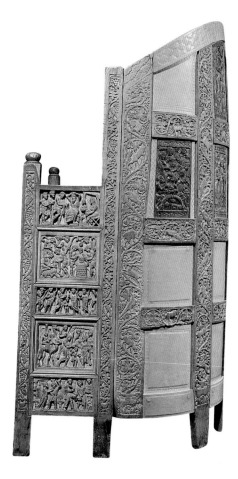

67–68
Throne of
Maximian,
*c.*550. Ivory;
150×60·5 cm,
60×23¾ in.
Museo
Arcivescovile,
Ravenna

Another curious fact is that the ivories are many different shades. This puzzle is easier to solve: several of the panels were removed at some unknown date and only returned from a variety of sources to the *cathedra* in the twentieth century. The very white, almost floury appearance of the majority of the ivories is due to overzealous bleaching in the nineteenth century, intended in part to make them more attractive to contemporary taste. The differing conditions under which the different parts of the throne were preserved is thus reflected in their colouring, although they would originally have matched one another closely.

If we focus on the cathedral of Ravenna, the impression gained is of a more or less uninterrupted pattern of episcopal patronage from the beginning of the fifth to the middle of the sixth century. But if we consider the wider history of the same period it appears both discontinuous and violent. After the murder of Galla Placidia's son Valentinian III in 455, a lengthy period of confusion was brought to an end in 476 by the capture of Ravenna by the Germanic leader Odovacer (Odoacer), who ruled Italy ostensibly in the name of Emperor Zeno (r. 476–91). In 493 Ravenna was captured by the Ostrogothic king Theoderic (69), who had been campaigning against Odovacer with the encouragement of the same Emperor Zeno since 487. Odovacer was reputedly stabbed to death by Theoderic in the palace called Ad Laureta in Ravenna. Theoderic's rights as King of Italy were recognized by Emperor Anastasius (r. 491–518), and he was succeeded on his death in 526 by his daughter Amalaswentha, who reigned in the name of her son or husband until 536, and was succeeded by Vitiges. In 535 the emperor Justinian launched a campaign to recapture all of Italy from the Goths, and his commander, Belisarius, entered Ravenna in 540. From 540 to 751 Ravenna remained the administrative centre for 'Roman' Italy, which meant in effect that it was a Byzantine outpost in the West. Byzantine rule was administered first through a prefect, and then through a governor, or Exarch, who resided in Ravenna. Did recurring political uncertainty or violent change of ruler really make little difference to art and architecture in Ravenna, as the evidence from the cathedral might seem to suggest?

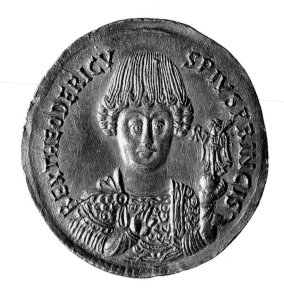

69
Medallion of
Theoderic,
493–526.
Gold;
diam. 3·3 cm,
1¼ in.
Museo
Nazionale
Romano, Rome

Theoderic (r. 493–526) was an Ostrogothic king, but he was emphati-
cally not 'a barbarian'. He had been brought up as a privileged
hostage in the imperial palace at Constantinople. Among his senior
court officials in Ravenna were the philosopher Boethius (who was
executed on a charge of treason c.524), and the learned administrator
Cassiodorus (who left the city in 540, was then in Constantinople,
and founded a famous monastery at Vivarium in the far south of
Italy). Since much of Theoderic's official correspondence was drafted
by Cassiodorus, his letters perfectly exemplify the Latin rhetorical
tradition. At Ravenna Theoderic built himself a palace (some founda-
tions have been excavated), and its principal gate was known as Ad
Calchi in imitation of the Chalke ('bronze') Gate of the imperial palace
in Constantinople. Outside his Calchi Gate was a gilded bronze eques-
trian statue. Whether this was a new work of the decades around
500, or as seems more likely a reused statue appropriated from some
other city (in imitation of the emperors in the East), we cannot be
sure, but it certainly had Theoderic's name carved on it. At this time
the gilt bronze equestrian statue of Marcus Aurelius (now in the
Palazzo Nuovo of the Capitoline Museums, Rome) may already have
stood outside the Lateran Palace in Rome, where it came to be
thought to represent Constantine; and some decades later Justinian
had an equestrian statue of himself set up near the Chalke Gate in

Constantinople. According to Agnellus, Theoderic's statue so impressed Charlemagne that on his way back from Rome, where Pope Leo III had created him Emperor of the Romans in 800, he had it removed to be set up outside his palace at Aachen (it has not survived).

Theoderic was not only a 'Roman' (or a 'Byzantine') in his taste for courtiers, palaces and antiques, he was also a Christian. The Ostrogoths – or 'eastern goths', so called to distinguish them from the Visigoths ('western goths') who settled primarily in the western half of the Mediterranean lands – had been converted to Christianity already in the mid-fourth century by Bishop Ulphilas (or Ulfila), who provided them with a Gothic translation of the Bible and of the liturgy. He followed the position favoured by the then reigning Emperor Constantius (r. 337–61) in the theological debate over the nature of Christ and was an Arian – that is to say he agreed with Arius of Alexandria in holding that, because Christ had been created by God, he could not be fully divine. The Ostrogoths were therefore converted to Arian Christianity, and although Arianism was defeated at the Council of Constantinople in 381, it remained diplomatically prudent for later emperors, who sought the military assistance of Ostrogothic chiefs or kings, to overlook what were from a Byzantine point of view their 'mad and insane' heretical beliefs.

Next to his palace Theoderic built a huge basilica of standard type (with twelve columns per aisle), dedicated to Christ, which still stands (it is now called S. Apollinare Nuovo). Its apse has been destroyed, and the floor level raised by some 1.20m, 4ft, but nonetheless the upper parts of the church walls are substantially as they must have looked in the sixth century (70). They are entirely covered in mosaic, composed in three separate tiers (a fourth tier – the lowest – was destroyed when the arcade was raised). At the top level, and at rather small scale, are twenty-six scenes from the life of Christ (thirteen on each side). These represent the earliest surviving long cycle of Gospel scenes in monumental art (71–2). The focus is on Christ's miracles and passion, but the Crucifixion was not included. The scenes are treated in a simplified fashion, and the repeated figure of Christ is readily identifiable. It is conspicuous, however, that within the overall

70
S. Apollinare Nuovo, Ravenna, c.500 and later. Interior looking east

decorative scheme these scenes do not immediately attract the viewer's attention; if there is a hierarchy of images, the Gospel scenes have a paradoxically lowly if lofty place.

Alternating with each Gospel scene is the representation of a conch-shaped niche, enclosing a crown, and acting as a frame for the large standing figures in the middle tier below. They hold books or scrolls, but are not identified by inscriptions. As there are sixteen figures on each side, these are often said to be the prophets of the Old Testament and the apostles and evangelists of the New (twelve plus four in both cases), but this is uncertain. The most conspicuous part of the mosaic decoration is that which now forms the lowest level. It is treated in a different way, as a single continuous frieze of great length, stretching from the western wall all the way to the apse on both north and south sides. Both sides of the frieze represent processions. On the north wall, twenty-two female saints set off from a city identified by inscription as Classis (Classe), the port of Ravenna

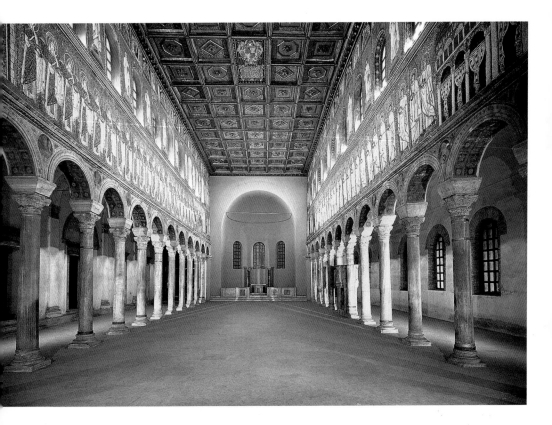

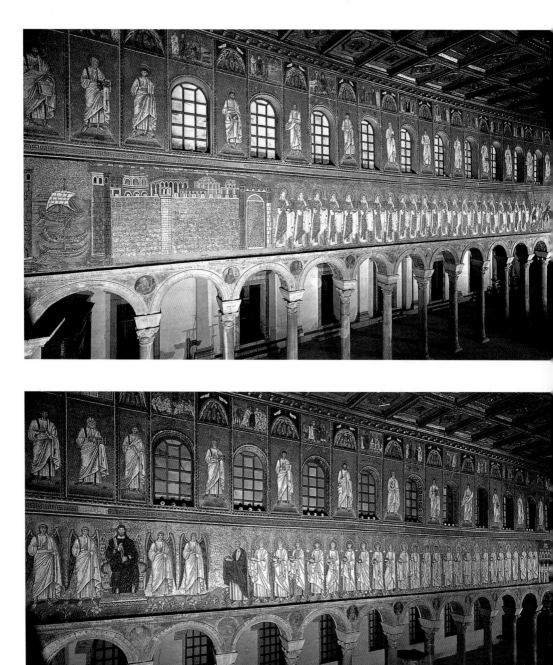

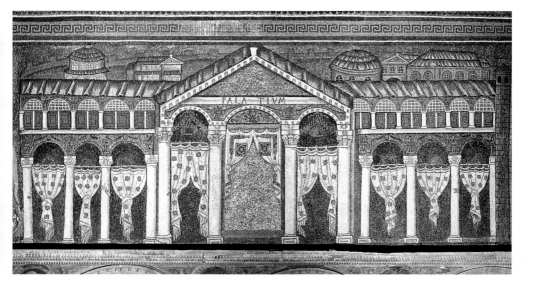

1–73
 Apollinare
uovo,
500 and *c.*561
oove left
osaics on the
orth wall
oking east
·ft
osaics on the
uth wall
oking west
oove right
latium mosaic

(71). They are magnificently dressed with patterned silks and jewels.
They carry crowns and there are palm trees behind: they are martyrs.
They join the three magi who kneel and present their gifts to the
Virgin and Child. On the south wall (72), twenty-six male saints set off
from the city of Ravenna and a magnificent palace (inscribed PALA-
TIVM; the word is derived from the residence of the Roman emperors
of the early centuries AD on the Palatine hill in Rome) heading for the
enthroned Christ, flanked like the Virgin and Child by angels. They
too are martyrs, and carry crowns, but their dress is the simple tunic
and toga of the apostles.

An intriguing detail of the mosaic representation of the *Palatium* is
that it has clearly been altered (73). Against the column between the
second and third arch to the left is a gesticulating hand and part of a
forearm. Where there is now a curtain there must once have stood a
figure. Starting from this clue, investigation of the mosaic surface
and of old photographs has revealed that this entire lower section of

the mosaic decoration on both walls is the work of two distinct phases. Figures once stood in all the intercolumniations of the *Palatium*, and across the golden wall of Classis. The two entire processions of male and female saints and the Adoration of the Magi are also replacements for the original scheme, and only the enthroned figures of Christ and the Virgin and Child, together with the flanking angels, were retained from the earlier scheme. Who would have gone to the trouble to alter these sections of the mosaic, and why? The answer lies in a conflict of religious ideas: the struggle between orthodoxy and heresy.

The capture of Ravenna from the Arian Goths by the army of the orthodox Justinian in 540 could have been viewed as a triumph over heresy. Around 561, Bishop Agnellus (according to his ninth-century namesake) was empowered by Justinian to confiscate Arian church property and convert it to orthodox use. Thus it was that Theoderic's palace church was rededicated to St Martin, a renowned fighter against heretics, whose cult in Ravenna was focused on a miracle-working image in the church of SS John and Paul, described by Venantius Fortunatus writing in Ravenna *c*.560. (It was only in 856, it would seem, after the 'translation' [transfer] of the relics of St Apollinaris by Bishop John VII from Classe to this church, for greater security, that it came to be known as S. Apollinare Nuovo [the new].) It was apparently Bishop Agnellus who set up the mosaics of 'the martyrs and virgins walking in procession', and the male saints are indeed led by St Martin. We can assume that the representations of the *Palatium* and Classis were altered at the same time. The obvious deduction is that this tier of the mosaic was in some conspicuous way unacceptable to non-Arians (whereas the upper wall surfaces were not). Since the church was attached to Theoderic's palace, there is no difficulty in deducing that the mosaic *Palatium* represents that palace, and that within it (and at Classis) were images of Theoderic or his family or members of his court. It also seems likely that the inserted processions of male and female saints were replacements for similar processions, probably also divided between male and female. Were these Arian saints? Or were they processions of courtiers, led by Theoderic and his queen? A procession from earth to heaven, from

the king's palace to the throne of the heavenly king, moving eastward in the church in the way that Theoderic himself presumably processed, all this would be plausible. We can even note that the mosaic image of the enthroned Christ originally held a book with the text *Ego Sum Rex Gloriae* ('I am the King of Glory'): an appropriate model, perhaps, for *Rex Theodericus*. Such processions could be seen as referring to two types of precedent: a tradition in Ravenna, dating back to the time of Galla Placidia, for treating images of the ruling dynasty on a par with images of the saints; and knowledge of the decoration of the churches of the imperial palace at Constantinople.

Unfortunately we do not know what the apse mosaics of Theoderic's church represented, but Agnellus does not mention that there were any changes there. It seems likely, therefore, that the apse was not considered unacceptable or heretical. To judge by what was changed, it seems to have been the visual argument for the church's connection with Theoderic, rather than with Arianism, that was found most objectionable. This theory can be tested by evidence from elsewhere in Ravenna, at the church of S. Spirito. This is a small structure in comparison to many of those in Ravenna, and it was probably built during the rule of Theoderic as a cathedral for the Arian population. Its baptistery also survives (usually termed the 'Baptistery of the Arians'). In its dome (74) it has a mosaic decoration (much restored) obviously based on the model provided by the Orthodox Cathedral Baptistery (compare 65). The most striking difference is the inclusion of the enthroned cross, towards which the apostles advance in procession. But even this is a recurrent, if less conspicuous, element in the earlier baptistery mosaics. In visual terms, therefore, the mosaic decoration of the Arian Baptistery was just as orthodox as the model that was imitated. No later changes were therefore necessary to expunge heretical notions. What differed between the two baptisteries was presumably the range of ideas that the viewers brought with them: such images undoubtedly could mean different things to different people.

The next major phase of building activity at Ravenna after the death of Theoderic in 526 is often associated with the name of Bishop

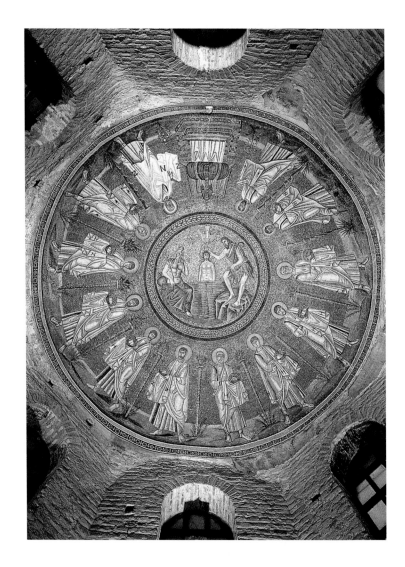

74
Baptism and
apostles,
c.500–25.
Dome mosaic.
Baptistery of
the Arians
(now Sta Maria
in Cosmedin),
Ravenna

Maximian, who arrived in the city in 546. It involves two large churches: S. Vitale in Ravenna itself, dedicated by Maximian in 547; and S. Apollinare in Classe, at Classis some 5 km (3 miles) to the southeast, which was dedicated by Maximian in 549. But work on both churches was begun long before Maximian's arrival, even before the city was recaptured from the Goths in 540. And on the basis of inscriptions we learn that the person who funded both these great projects, begun under Gothic rule, was a certain Julianus called Argentarius – *ie* a banker, not a bishop. These two churches thus represent a continuity of sorts across the political divide implied by the events of 540.

S. Vitale is unlike any other church in Ravenna, and was considered by Agnellus to be unlike any in Italy in its construction and design. It has a centralized plan (75), based on an octagon with a dome raised on a tall drum and a projecting eastern presbytery and apse. But the regularity and angularity suggested by the exterior (or by a ground-plan) is far from obvious in the interior, which is instead dominated by curves (76). The central space opens out on seven of its sides into curving exedras in which the double arcades lead the eye up to vaulted semidomes, arches, and thence to the central dome. Large windows at ground and gallery level, set well back from the central

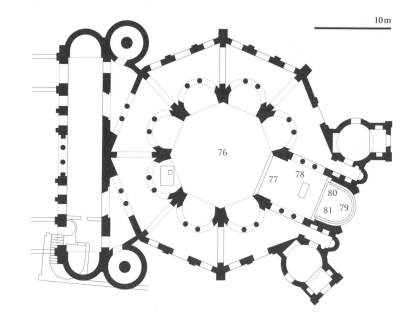

10 m

75
S. Vitale,
Ravenna.
Plan

space by broad ambulatories, provide a light that is modulated by the curving forms (in contrast to the lighting of a basilica). Towards the east the eye is led through the arch to the vaulted presbytery, and thence to the semicircular apse surmounted by its semidome (note that the church is not correctly oriented, so that 'east' here refers to the liturgical direction, *ie* towards the apse). The lower part of the church was originally entirely revetted with coloured marble (now partially restored), and the presbytery with marble and costly *opus sectile* in geometric patterns. Above this level in the presbytery the surface was covered with mosaic, but the original decorative scheme for the upper surfaces of the main body of the church is not known.

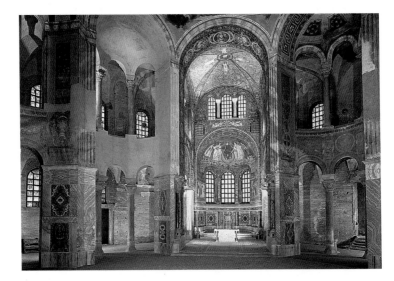

76–77
S. Vitale, Ravenna
Left
Interior looking east
Right
Mosaics of the presbytery area. Marble and *opus sectile*

The mosaic decoration of S. Vitale was executed and doubtless in-tended to be understood as comprising a single programme, albeit divided by the architectural structure of the building's interior into defined fields. In the arch that leads into the presbytery are medal-lions with Christ and the apostles (77). In the presbytery vault is a central medallion of the lamb, supported by four angels, the whole set within a rich vine-scroll motif. The vertical faces of the north (78) and south presbytery walls balance one another: the evangelists and their symbols, set in a rocky landscape; beneath them prophets: Moses (twice), Jeremiah and Isaiah; and in the arched space over the arcade scenes of Old Testament sacrifice that prefigure the Christian

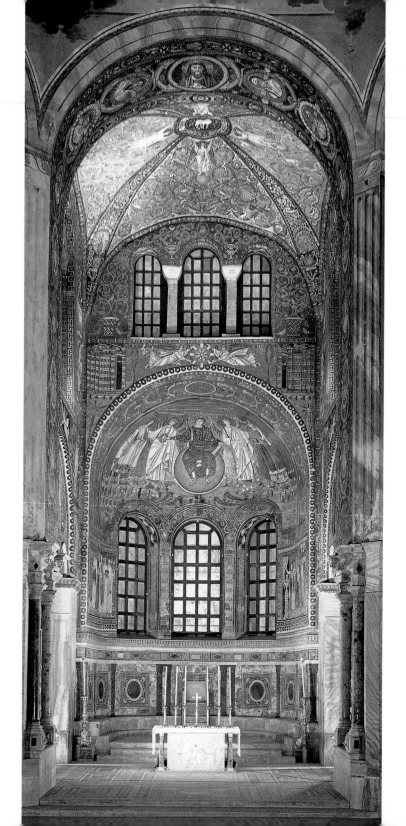

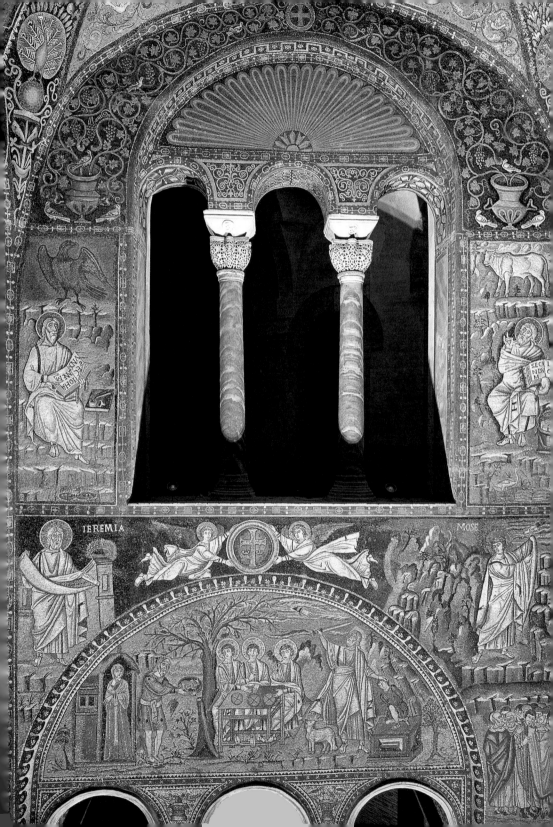

sacrifice of the liturgy which will take place on the adjacent altar table – Abraham and Isaac, Abraham's hospitality to the three angels, Abel's offering of a lamb and Melchisedek's of bread, flanking a large altar.

Moving into the apse the composition is centred on a youthful figure of Christ (79), holding a scroll with seven seals (Revelations 5:1). He is flanked by two angels who usher two further figures into the divine presence. On the left is St Vitalis, to whom Christ extends a crown.

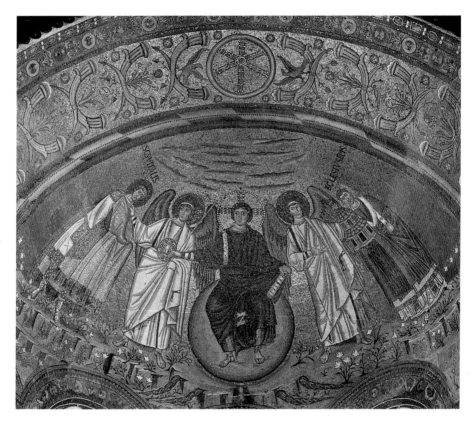

At the right is Bishop Ecclesius, who presents this church as an offering, in the form of a small-scale model. Our impression from the landscape that the scene takes place in paradise is confirmed by the four small rivers that flow from beneath Christ's feet (compare Genesis 2:10–14). Finally, closest to the viewer on the side walls of the apse and level with the windows, are the two most familiar panels, generally referred to as the emperor Justinian and empress Theodora and their court.

Although most of the figures in the two imperial panels face directly forwards, we can tell from the positions of their hands and feet that the mosaicist intended us to see two processions. In the Justinian panel (80), on the north wall, the figures move from left to right, towards the east, whereas in the Theodora panel (81), on the south wall, they move from right to left, but still towards the east. The emperor is preceded by three churchmen: two deacons, one with a censer and the other holding a jewelled (Gospel) book, and a bishop, identified by inscription as Maximianus, holding a cross. The

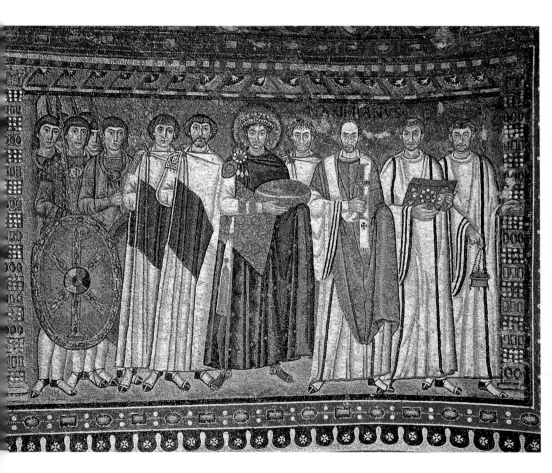

80
Justinian
with Bishop
Maximian,
clergy, courtiers
and soldiers.
Mosaic.
S. Vitale,
Ravenna

emperor holds a large golden bowl (a paten), and is flanked by three courtiers and followed by a detachment of soldiers who put their faith, as did Constantine, in the chi-rho symbol that is conspicuous on the shield. The figures in the procession on the south wall are less differentiated, but their location is more specific. A courtier holds aside a curtain to lead them through a doorway from a courtyard with its fountain. The empress holds a chalice, and to emphasize the meaning of the gesture, the hem of her robe is decorated with the Magi bearing gifts. She is followed by the ladies of her court.

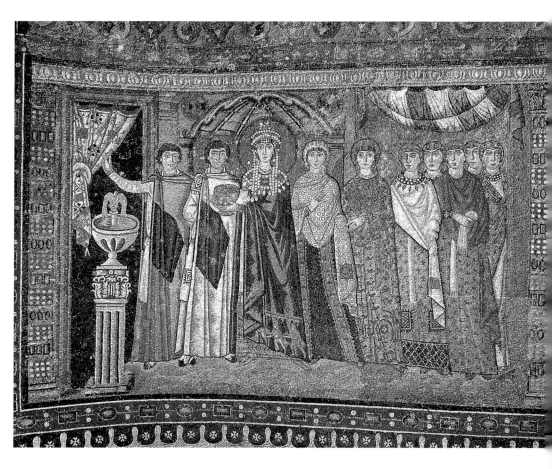

81
Theodora
with courtiers.
Mosaic.
S. Vitale,
Ravenna

Since Maximian reached Ravenna late in 546, and the church was dedicated in 547, we can be certain that the imperial couple are Justinian and Theodora. But since Justinian and Theodora never came to Ravenna, let alone to S. Vitale, and Justinian had no direct involvement in any major building works in the city (to judge from the account by Procopius), these two panels are not quite the historical record they might at first seem to be. In one sense they do represent an event: it is known that in the sixth century as part of the liturgy of St Sophia – the cathedral of Constantinople – the imperial couple did process into the church to make offerings, the emperor preceded by the patriarch (*ie* the Bishop of Constantinople). So at one level the panels suggest that Bishop Maximian of Ravenna enjoys a relationship to the emperor equivalent to that of the patriarch, a bold claim, and that the church of S. Vitale is another St Sophia, a second bold claim. But S. Vitale was never the cathedral church of Ravenna (which remained the Basilica Ursiana), so the connection with St Sophia is somewhat strained. The idea being expressed, therefore, must be on a more general plane. We can note that in moving towards the east, the two processions are in fact moving further away from this church's altar (for they are behind it), but they are approaching the paradise in which Christ welcomes St Vitalis and Bishop Ecclesius. That is to say Maximian and his clergy are leading the imperial couple towards a liturgy that will bring them to Christ in paradise: Vitalis and Bishop Ecclesius have arrived, Bishop Maximian and the others are on their way. Perhaps the processions towards Christ and the Virgin in Theoderic's palace church (S. Apollinare Nuovo), still at this date unaltered, provided an idea that was adapted to the very different spatial setting of S. Vitale.

The *raison d'être* of the church of S. Vitale was the cult of the relics of St Vitalis. Vitalis was not, like St Vincent (whose image we found in the 'Mausoleum of Galla Placidia'), one of the famous early martyrs. His body is said to have been found by Bishop Ambrose of Milan at Bononia (modern Bologna) in 395. At some point in the fifth century a small cross-shaped martyrium chapel was built for Vitalis at Ravenna. It has been located by excavation beneath the western part of the present church. At this date Vitalis' cult must have been

relatively modest, and we have no way of knowing why it grew to the importance of requiring the magnificent new church. Nothing seems to have been known of the history of Vitalis in the mid-fifth century but by the early sixth a legend had been constructed according to which he was the father of Gervasius and Protasius, two important Milanese saints, and all three had been martyred on the site. Thus a strong undercurrent of rivalry between *nouveau-riche* Ravenna and long-established Milan was manifest in a kind of *Realpolitik* of the saints as the cities vied for the prestige, prosperity and protection which they believed particular cults could bring them.

The present church of S. Vitale must have been begun under Ecclesius (Bishop of Ravenna, 522–32/3), to judge from the apse mosaic, and continued under Bishop Victor, for his monogram was carved in many of the impost blocks above the capitals. The work was funded by Julianus Argentarius, and cost a total of 26,000 gold solidi (over 160 kg, 352 lb of gold), according to an inscription recorded by Agnellus. Presumably the total was remarked on because it was unusually large, but we have no comparable figures for the cost of other churches in Ravenna. Julianus was in due course buried in S. Vitale, along with Bishops Ecclesius, Ursicinus, Victor and Maximian.

The second major surviving church funded by Julianus Argentarius was also dedicated to the cult of a local saint, St Apollinaris, the first Bishop of Ravenna (82). The church is at Classis, the sea-port of Ravenna (hence S. Apollinare in Classe). It was begun under Bishop Ursicinus, who held office 532/3–35/6, and dedicated by Bishop Maximian in 549, thus once more bridging the political divide in 540. But unlike S. Vitale, S. Apollinare in Classe is a huge basilica of standard type (with twelve columns per aisle). And excavations at the site have found no evidence for any previous martyrium to the saint: it appears that the church was built adjacent to a cemetery, in which Apollinaris' tomb must have been marked, but not previously venerated in any major way. A legend had grown up (first written down in the seventh century) that Apollinaris was the pupil of St Peter, so the motives for erecting the church probably included a desire to emphasize the quasi-apostolic beginnings of the bishopric of Ravenna. That

the church became (if it was not from the start) the focus of rivalry with Rome is suggested by the fact that the bishops of Ravenna chose to be buried there from 595 to 765 (like the popes at St Peter's).

The mosaic decoration of S. Apollinare in Classe is restricted to the apse and 'triumphal arch' (as it is often termed), and although at first it appears to be a unified composition (83), it is in fact the result of several distinct phases of work. The mosaics of the semidome of the apse, the four bishops between the windows below, and the angels on the arch are from the original scheme dedicated in 549. In the

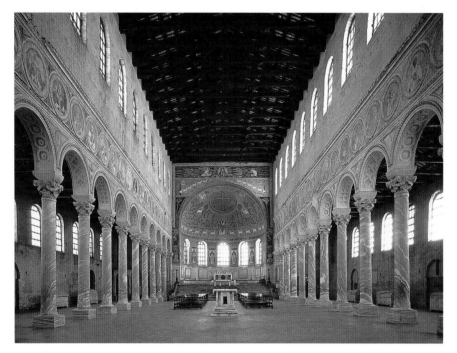

seventh century, Reparatus (Bishop of Ravenna, 673–9) inserted a panel in imitation of the Justinian panel at S. Vitale, showing himself with the emperor Constantine IV (r. 668–85), and to balance it a version of the S. Vitale Melchisedek panel. At about this time the floor of the apse was raised to allow the relics of St Apollinaris to be visited in a crypt, and the upper mosaics of the triumphal arch – a medallion of Christ flanked by the evangelist symbols, with sheep proceeding out of Bethlehem and Jerusalem below – were set. (The evangelists at the entrance to the apse are later still, perhaps of the late twelfth century.)

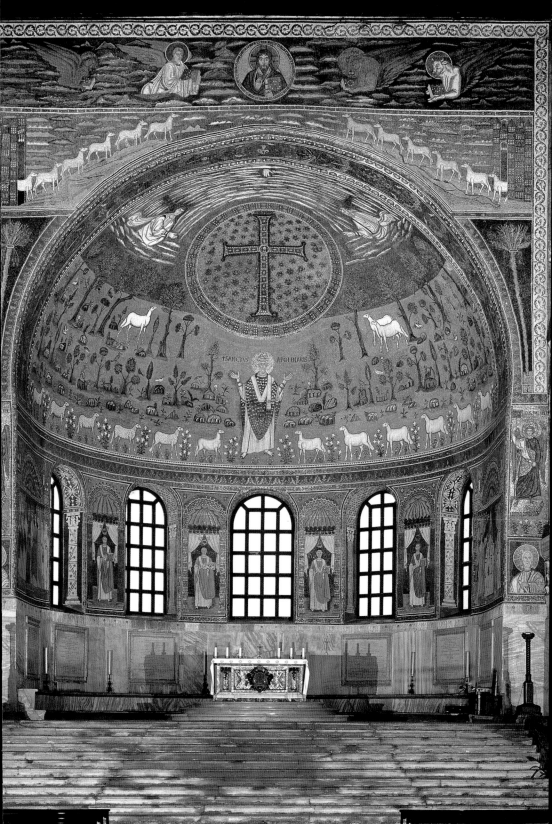

The four bishops depicted in the apse represent a meeting of the recent and distant past of Ravenna: Ecclesius and Ursicinus (from the 520s and 530s) join Ursus and Severus (from the fourth century). Above them is their saintly forerunner Apollinaris. He stands in his bishop's robes, his hands open in a gesture of prayer (compare the description of the image of Bishop Peter Chrysologus at S. Giovanni Evangelista), beneath a large cross within a jewelled aureole. The cross is flanked by Moses and Elijah appearing from the clouds, and observed from below by three sheep. This grouping suggests a kind of Transfiguration scene (compare 38). To either side of Apollinaris are six further sheep in a paradisiacal setting; they must represent the flock of which Apollinaris is the shepherd (*ie* the people of Ravenna), but also the twelve apostles (emphasizing Apollinaris' importance).

There can be no doubt that the apse mosaic at S. Apollinare in Classe was carefully thought out, but what exactly does it mean? The cross, with a small medallion of Christ at its centre, is obviously an image of Christ, but why was Christ not represented in his bodily form here? Could it be that the mosaic was intended specifically to emphasize Christ's divine nature, perhaps as a conspicuously anti-Arian image? In a church in a predominantly monophysite area (contrast the mosaic at Sinai; 38) such an image would definitely have been understood to run the risk of denying the full humanity of Christ by overemphasizing his divine aspect. The image thus expresses a range of sophisticated ideas through the use of familiar symbols and formulae, such as the cross, the sheep and the plants.

From the early fifth century to the mid-sixth, Ravenna was an extremely prosperous city with a flourishing trade in the construction and decoration of churches, about which we know a good deal – and of palaces, mansions and many other types of building, about which we now know little or nothing. The volume of work must have kept teams of builders and decorators busy, drawing both on local skills and on expertise from further afield. Local techniques included the use of terracotta pipes for the construction of light vaults, apsidal semidomes and true domes (as in Bishop Neon's remodelling of the

Cathedral baptistery, or at S. Vitale). And the mosaics from throughout this period have a recognizable stylistic homogeneity (albeit now affected by restoration). But what looks at first like a fairly limited artistic range in terms of content was adapted to make a wide variety of points. For example, bands of medallions usually included representations of the apostles, but male or female saints, or even members of the imperial family, could be substituted. The figures in images could be static, but processions were important too; biblical figures, local saints, even living contemporaries could all be treated in similar ways. Plain gold grounds alternated with the landscape of paradise. Christ could be represented as youthful and beardless, as bearded and mature, or in the form of a lamb or a cross. In general it seems likely that mosaic decorations were set up with knowledge of, and to some extent in reaction to, precedents in other churches in Ravenna although many of these have not survived.

Both ideas and materials also came from outside the city. The unusual plan for S. Vitale is generally thought to have come from Constantinople. All the new marble that was required for over a century came from the quarries on Prokonnesos in the Sea of Marmara near Constantinople: not just columns, capitals and bases, but altars, ambos (lecterns), screens and other fittings. The first certain use of Prokonnesian marble was for the Church of the Holy Apostles (now S. Francesco), founded under Bishop Peter Chrysologus (d. 450). This employed the same capital types as were used by Theoderic for his palace church, now S. Apollinare Nuovo, a half-century later. And S. Apollinare in Classe has capitals of a type already in use in Theoderic's time, for two examples survive with his monogram on them. Whereas unfinished Prokonnesian capitals found at some sites attest to their export in a rough state, the evidence from Ravenna implies a different procedure. Most probably the stone was supplied already finished, the complex capitals with their delicate surfaces very carefully packed with sawdust and straw to avoid damage in transit, and then set up by local teams. There is even a letter of 535 to Justinian from Queen Amalaswentha (drafted by Cassiodorus) requesting the despatch of 'those marbles'.

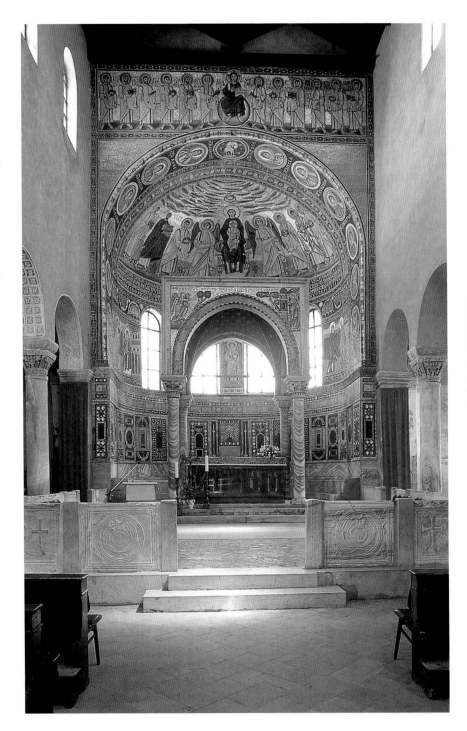

84–85
Basilica
Eufrasiana,
Poreč
Left
Interior
looking east
Right
Theotokos
and Child,
with saints
and angels,
543–53.
Detail of apse
mosaic

Nor was Ravenna isolated from her northern Adriatic neighbours, especially after 540. In Istria, Maximian built the cathedral of St Mary at Pula, where he had served as a deacon. Although little of it survives, his contemporary Bishop Euphrasius, who held office 543–53, built a basilica, known as the Basilica Eufrasiana, at nearby Poreč which is well-preserved (84–5). It is of a familiar Ravennate type, with Prokonnesian marble columns and capitals, and stucco decoration in the soffits of the arches. The revetment of the apse is particularly rich, and above the main composition is a mosaic of the Mother of God and Child, flanked by angels. To the right are three unnamed crowned saints. To the left is St Maurus, the city's first bishop, and with him Euphrasius with a model of the church, accompanied by Archdeacon Claudius, and his son, also called Euphrasius. In the arch over the apse are medallions of eight female saints flanking the Lamb. Lest Euphrasius' contribution be forgotten, he had it recorded in the very long mosaic inscription that runs round the base of the apse.

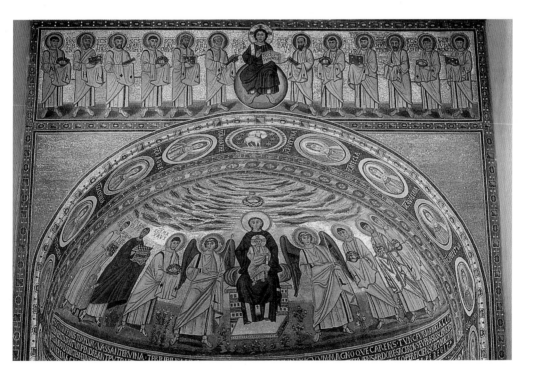

At Grado, at the head of the Adriatic, a new cathedral was built by Bishop Elias in the 570s. The most remarkable surviving feature of its original decoration is the mosaic floor. Inscriptions show that this was paid for by the square (or linear) foot, by more than twenty named donors (Ravenna has no surviving equivalent to this). It is best understood, however, not as a sign of the broad distribution of capital in Grado, but rather of the relative poverty of the see, which made such a subscription arrangement necessary.

From the late sixth century the division between the Western and Eastern parts – or former parts – of the Roman Empire became increasingly marked. It is traditional for modern historians to observe this division and to treat the history of later centuries as being either Western Medieval or Byzantine. But before crossing this divide, which will be bridged at various points in the following chapters, it may be helpful to look back over the ground that has already been covered.

By the late sixth century artists had explored the possibilities of expressing Christian ideas visually in a wide variety of ways. They had worked in different media, at every scale from the colossal to the minute, and for different social, geographical, linguistic and ethnic groups. They had sought to produce an art that could satisfy varying functions, and were able to represent anything from a single figure in isolation to a series of hundreds of narrative scenes. They could work with an artistic vocabulary based on the natural world, but since most of the ideas they were required to express were transcendent ones, they often combined the natural with the symbolic in an attempt to represent a truth based on visions, precepts and beliefs. Architects in the same period had explored the possibilities of churches of virtually every shape and size, from the simplest to the most complex and irregular forms. Construction was generally based on local materials and techniques, but these were often supplemented with new material imported over immense distances or spolia ransacked from some older site.

The world for which this art was made was primarily that of the old Roman Empire, but it is generally now defined by one of three terms:

'Early Christian', 'Early Byzantine' or 'Late Antique'. These differing terms express differing views of what was important or characteristic about the period, views that subtly but emphatically shape what we choose to look at and how it is perceived. To use the term 'Early Christian' is to make three decisions: Christianity (and its art) will be the primary focus; further growth and development will be expected (although as it happens no one ever refers to a 'Middle Christian' or 'Late Christian' period); and from a modern perspective many of the phenomena we observe in this period will appear novel. To use the term 'Early Byzantine' would imply altered priorities, since by definition we would be looking for continuity and development with later periods in what we call the Byzantine Empire. Political structures, in the broadest sense, would be important to the framework of what we studied. And, as before, novelty in what we observed would be at a premium. The use of 'Late Antique' would imply a focus on the forms of life, thought and art considered to be representative of Antiquity. It would be broadly social phenomena, rather than specifically religious or political ones, that would provide the agenda for discussion. And continuity, rather than novelty, would be of particular relevance.

It can be appreciated that the differing terms overlap in places, that all have some merit, but that all are misleading in the way they simplify as they seek to define the past. Was a sculptor working on two sarcophagi, one for a wealthy pagan, and the other for the pagan's Christian brother, more 'Late Antique' or 'Early Christian' according to which one he was carving? And if a third sarcophagus in his yard was intended for shipment to Constantinople, was our hypothetical sculptor more 'Early Byzantine' when he turned his hand to it? Would it be helpful to study a church in Ravenna in terms of a rigorous division between Late Antique building traditions (the basilical form or the *opus sectile* decoration, for example), Early Christian mosaics, and Early Byzantine sculpture? I think not. Artists and their clients in these centuries lived in a world of Late Antique ideas and practices, within which Christianity grew to be a dominating force, and which was changing as the power of the empire, radiating now from Constantinople rather than Rome, waxed and waned.

Artists responded to the requirements of Christianity in a variety of ways in these centuries. The Gospels said nothing about a Christian art or architecture. In the Old Testament God gave Moses highly detailed instructions about the sanctuary, its fixtures and fittings (Exodus 25–31), and the descriptions of Solomon's temple and palace are long and precise (I Kings 6–7), but Jesus made no such pronouncements in the New. The evangelists did not record what Christ or the apostles looked like, except in the occasional metaphor as when John the Baptist decribed him as 'the lamb' (John 1:29, 36), or Jesus called himself 'the shepherd' (John 10:11). Christian art, therefore, was not codified. Christ could be represented as a lamb or a shepherd, as a child, as an idealized beardless youth, or as a mature bearded man. His hair could be long or short, curly or straight.

Because of the workshop traditions within which craftsmen were trained and operated, familiar compositions, figures, types, gestures, and landscapes could all be easily adapted to the requirements of Christians, as they could for any other clients. Flourishing centres were able to reproduce their designs and formulations sufficiently frequently for these to gain currency, and the images set up in the most important churches would have enjoyed a special prestige as well as being seen by huge numbers of people. To these methods of dissemination of images must be added pilgrim souvenirs, such as those representing St Symeon the Stylite or from other holy places; though small in scale, these could spread visual ideas even more widely, and they must have had a standardizing effect. The ease with which Saints Peter and Paul became recognizable, for example, was presumably due to the wide distribution of images of all sorts made in connection with their cult in Rome. By the end of the sixth century images were ubiquitous in the life of the Church and throughout the public and private spheres. But it was not long before the successors of the emperors who had so promoted the use of religious images were to demand their destruction.

4

Between 726 and 843 the Byzantine Empire was embroiled in a theological debate known as the Iconoclast Controversy. Like the later religious conflicts of Reformation and Counter-Reformation Europe, Byzantine Iconoclasm had wide-ranging political and social repercussions, as well as profoundly affecting the conditions for artistic production. The Iconoclast Controversy was specifically concerned with the appropriateness of images in the context of worship, and documentary records from this period show how religious art became the focus for intense, often violent, dispute over its place in Christian society. As we have seen in previous chapters, images came to be ubiquitous in the religious life of the fourth, fifth and sixth centuries, and, since the foundations and entire superstructure of the Byzantine Empire were religious, a radical questioning of the use of images could be considered comparable to challenging – for example – the role of democracy in a modern Western state. The implications of this controversy for the development of Western art have been profound; indeed, no other culture or society is known to have engaged in such a prolonged and serious debate over the role of the visual.

The historical background to Iconoclasm involved widespread changes taking place in the Byzantine Empire during the sixth, seventh and eighth centuries, in particular the threat posed by the rise of the militant new religion of Islam from the early seventh century onwards. In the context of the visual arts, however, it is the arguments themselves and the actions they gave rise to that exert a particular fascination. As we listen to the debates that raged in successive Church councils, to learned evidence, propaganda and anecdote, we are taken to the centre of Byzantine ideas concerning art and religion, and to a world in which authority defined itself in terms of its stance on the question of Iconoclasm.

86
Iconoclasts
(detail of 102),
folio 67r,
Chludov
Psalter,
c.850–75.
Defaced by
iconophiles.
State Historical
Museum,
Moscow

The word iconoclasm comes from the Greek words *eikon* (icon or image) and *klao* (break or destroy), and means literally the deliberate destruction of images. While this still takes place today, and thus seems a familiar enough idea, the phenomenon of Byzantine Iconoclasm, which gave us the word and defined the issues, remains a complex subject. Fortunately there is a clear point of reference, namely the artistic image itself – how it was defined, what arguments were advanced for and against its use, and what the results of those arguments were, both for religious images and for those who made and viewed them.

Christianity had inherited from Judaism a fierce antipathy to the misuse of religious images. This was based on the commands given by God to Moses: 'Thou shalt not make an idol ... Thou shalt not bow down to [idols] nor serve them' (Exodus 20:4–5). The word 'idol' (Greek *eidolon*), like 'icon', also has the root meaning 'image', but its connotations became totally negative. Idols were decried in the Bible as images of false gods. Those who worshipped idols (idolaters) were therefore followers of false gods: pagans had idols, Christians did not. In one view – the fundamental view of the iconoclasts – Christians had become idolaters by worshipping images, and must therefore be displeasing to God. The only possible remedy was to remove the offending cause: the icons (or idols). In addition to those who smashed images, there were people who burned them (icono-causts), and the term most commonly employed at the time for someone who was opposed to their use was *eikonomachos* or 'image-fighter'. On the other hand, there were people who loved images (iconophiles) and who served them (iconodules), and who were able to marshal impressive arguments upholding the Christian tradition of religious imagery.

The argument against images focused on their role in worship, and there can be no question that by the eighth century religious images had come to be used in what could be considered illegitimate ways. This is best judged not by the polemical and prejudiced literature of the Iconoclast controversy itself, but from passing references in earlier sources in which the use (or abuse) of images was not itself an

issue. For example, the monk John Moschos (d.c.634) reports the following story in a collection of edifying accounts:

In our times a pious woman of the region of Apamea dug a well. She spent a great deal of money and went down to a great depth, but did not strike water. So she was despondent on account both of her toil and her expenditure. One day she sees a man [in a vision] who says to her: 'Send for the likeness of the monk Theodosios of Skopelos, and, thanks to him, God will grant you water.' Straightaway the woman sent two men to fetch the saint's image, and she lowered it into the well. And immediately the water came out so that half the hole was filled.

There is nothing at all religious about the context in which the image of St Theodosios of Skopelos was being used in this account. The image, presumably a painting on a wooden panel (did the woman send two men because it was large and heavy?), was employed because it was believed to have miraculous powers, and this indeed proved to be the case.

The collection of miracle stories connected with the healing saints Cosmas and Damian, written down at about the same period, provides further insights into popular beliefs – that one could, for example, eat the plaster, on which the two saints' images were painted, for a cure:

[A certain woman] depicted [the saints Cosmas and Damian] on all the walls of her house, being as she was insatiable in her desire of seeing them. [She then fell ill.] Perceiving herself to be in danger, she crawled out of bed and, upon reaching the place where these most wise saints were depicted on the wall, she stood up leaning on her faith as upon a stick and scraped off with her fingernails some plaster. This she put into water and, after drinking the mixture, she was immediately cured of her pains by the visitation of the saints.

In this case the magical power seems to reside in the material of which the image is made. While artists certainly did not paint holy images in the expectation that they were going to be used in this way, such practices may have been widespread. No doubt anyone

who heard or read this story would have felt encouraged by it to imitate the woman's actions. From a modern perspective it must seem ironic that this extreme level of devotion to images led people at times deliberately to damage or destroy them in a fashion that was in effect iconoclastic, although in motivation iconophilic (or idol-atrous, depending on your point of view).

Another Cosmas and Damian miracle records a different use of icons. The story involves a soldier who always carried about with him 'out of faith and for his own protection' an image of the two saints. The image was, therefore, regarded by its possessor as a phylactery (an amulet or talisman believed to ward off evil, of the sort familiar in many cultures). But because it was an image representing the saints (and not an abstracted symbol such as the cross, or non-representa-tional object such as a precious stone), it had an additional function. The soldier's wife was able to recognize the saints, who had appeared to her in a dream, when her husband later showed her the image he carried 'in the wallet under his arm'. Thus the magical world of the saints was brought into the everyday experience of the Byzantines through the ubiquitous presence of such images.

In none of these stories are we told that the images, although undoubtedly religious, were displayed or used in the context of a church. Nor are we told of people worshipping such images, like pagans before idols, for the accounts were written by authors who knew very well that idolatry was wrong. Nonetheless, the impression such stories convey is of a credulous populace for whom the religious image was widely perceived as a source of magical power. Iconoclasts argued that all religious images were by their nature susceptible to abuse in this way and should therefore be suppressed.

In arguing *for* the use of images, the iconodule or iconophile position was far more complex than the iconoclast view. It was based on three principal arguments involving: first, the use to which images were put; second, the appeal to tradition; and third, the definition of what constituted an image. The argument that Christians worshipped images, and hence had become idolaters, was flatly denied. Theologians proposed that people merely venerated images, not

believing them to be holy in themselves, but as representing something holy which would receive this veneration. This must be considered a weak argument, since it requires every individual Christian to observe the subtle distinction between worship and veneration.

The argument from tradition appears at first much stronger. The use of religious images, it was stated, was as old as the Gospels themselves. As it happens, we know this belief to have been completely erroneous, but it was not merely a convenient invention by the iconophiles of the eighth and ninth centuries. We can best judge this, as before, from pre-iconoclast writings, such as the *Life of St Pankratios*, a text written by a certain Evagrios perhaps in the seventh century. It includes the following story:

The blessed apostle Peter sent for the painter Joseph and said to him: 'Make me the image of Our Lord Jesus Christ so that, on seeing the form of his face, the people may believe all the more and be reminded of what I have preached to them'… And the apostle said: 'Paint also mine and that of my brother Pankratios so that those who use them for remembrance may say, "This was the apostle Peter who preached the word of God among us …".' So the young painter made these also and wrote on each image its own name. This is what the apostles did in all the cities and villages from Jerusalem as far as Antioch. And having taken thought, Peter made the entire picture-story of the incarnation of Our Lord Jesus Christ, beginning with the angel's crying 'Hail' to the Virgin [*ie* the Annunciation], and ending with the Ascension of Our Lord Jesus Christ, and he commanded that churches should be decorated with this story. From this time onward these things were given earnest attention by everyone and they were depicted on panels and parchment, and were given to bishops who, upon completing the construction of a church, depicted them both beautifully and decorously.

The authenticity of such stories was not questioned, even by the iconoclasts. The argument they permit was then reformulated in the carefully chosen words appropriate to the decisions of a Church Council, as at Nicaea in 787:

The making of icons is not an invention of painters, but an institution and tradition of the Catholic Church. Whatever is ancient is worthy of respect, said St Basil, and we have as testimony the antiquity of the institution and the teaching of our inspired Fathers, namely that when they saw icons in holy churches they were gratified, and when they themselves built holy churches they set up images in them … The conception and the tradition [of using holy images] are therefore theirs and not the painter's; for the painter's domain is limited to his art, whereas the disposition manifestly pertains to the Holy Fathers who built [the churches].

The Patriarch Nikephoros (deposed in 815, d. 828) expressed the same point even more succinctly:

We affirm that the delineation or representation of Christ was not instituted by us, that it was not begun in our generation, nor is it a recent invention. Painting is dignified by age, it is distinguished by antiquity, and is coeval with the preaching of the Gospel …
These sacred representations came into existence and flourished …
from the very beginning.

Note how Nikephoros steps adroitly from the statement that images of Christ are not 'a recent invention' (a point which in the ninth century was obvious to everybody), to assert that they go back to the time of Christ himself. Who could disprove this assertion? No iconoclast, certainly, could hope to prove that images of Christ did *not* go back to His lifetime. This, then, was a telling argument.

The final iconodule argument revolved around the definition of what constituted 'an icon'. Like our word 'image', the Greek *eikon* has a wide range of meanings, which was duly exploited. This is what a leading supporter of images, St John of Damascus (d. *c.* 750 – he lived beyond the frontiers of the Byzantine Empire) said in answer to the question 'What is an image?':

An image is a likeness, an exemplar or a figure of something, such as to show in itself the subject represented. Surely, the image is not in all respects similar to its prototype, *ie* its subject; for the image is one

thing and its subject another, and there is necessarily a difference between them.

Thus far we have no difficulty in following him. But this is only the start. He then answers the further question 'How many different kinds of images are there?' in the following way, giving a taste of the complexity of contemporary theological argument on the subject:

The first, natural and identical image of the invisible God is the Son of the Father [ie Christ] …

The second kind of image is God's knowledge of what will be done by Him …

The third kind of image is the one made by God in the way of imitation, ie man [Genesis 1:26] …

The fourth kind of image is when Scripture invents figures, forms and symbols for invisible and incorporeal things and the latter are represented in bodily form [eg angels].

The fifth kind of image is said to be the one which represents and delineates the future in advance … as the [brazen] serpent [set up by Moses at God's command (Numbers 21:8–9) represents] Him who by means of the cross [ie Christ] was to heal the bite of the [other] serpent [ie the Devil] …

The sixth kind of image serves to record events, be it a miracle or a virtuous deed … This is of two kinds: in the form of speech that is written in books … and in the form of visual contemplation [of images] … So, even now, we eagerly delineate images of the virtuous men of the past [ie the saints] for the sake of love and remembrance.

In John of Damascus's scheme images, together with written words, come sixth and last in the list. But this does not mean they are the least important: in an argument it is often the last point that is the most telling. John prepares the ground with the preceding five examples, which, since they are arguments in favour of images derived from the actions of God and the words of the Bible, can scarcely be disputed. For the iconophile, the existence of the sixth kind of image,

the religious text or artwork, was legitimized by the preceding five. To argue against pictorial images was thus, according to John of Damascus, to argue against the actions of God. This formulation proved irrefutable, and has stood the test of time.

St John of Damascus's defence of images was written in response to the attack that had been made on them in the early stages of the Iconoclast Controversy, and we must now turn to the historical context in which this assault on tradition took place.

In the sixth century the emperor Justinian had presided over a period of territorial conquest and vigorous artistic productivity. For the following century and a half, however, the Byzantine Empire experienced a prolonged series of setbacks. There were devastating outbreaks of plague in the 540s (and again in the 740s). There were further invasions by Germanic, Slavic and Turkic peoples (including the Lombards, Huns, Avars and Bulgars) who overran the Balkans and Italy. The Holy Land was conquered by the Persians in 614, Jerusalem sacked and its churches despoiled. (John Moschos was a refugee from this assault.) In 626, Constantinople itself was besieged by the Avars (from the north) and the Persians who had crossed Asia Minor. The city's preservation was credited to the personal intervention of the Mother of God, who was allegedly seen fighting outside the walls. Her image was set up on the city's Golden Gate, to drive away 'the foreign and devilish troops', and carried in procession around the walls. The relic of her *maphorion* (veil), preserved in a gold and silver casket in the church of Blachernae, came to be regarded as the palladium of the city, ensuring its safety.

The greatest threat to the Byzantine Empire, however, was the rise of the new and militant religion of Islam in the Middle East. After Muhammed's death in 632, the Muslim Arabs began their rapid conquests. In 636 they overwhelmed what was left of the Persian Empire. Jerusalem, recaptured in 620 by the Byzantine emperor Heraclius, fell to the Arabs in 638. In due course much of the Mediterranean coastline and many of its islands were lost. The Arabs raided Asia Minor continuously, besieging Constantinople from 674 to 678 and from 717 to 718 (when once again an image of the

Theotokos was carried round the walls). In the late seventh century and early eighth the landscape of the Byzantine world was transformed; many of the Late Antique cities, still flourishing in the mid-sixth century, were completely abandoned. Only the walls of Constantinople and Thessaloniki kept the invaders at bay. It is no exaggeration to say that there were times when the Byzantine Empire was reduced effectively to those two cities.

At one level, the official policy of Iconoclasm was undoubtedly a response to this long catalogue of disasters. It began under Emperor Leo III (r. 717–41), a successful general who came from the Syrian borderlands of the empire and usurped the throne in 717. In 725, according to the chronicler Theophanes, Leo III began to formulate a *logos* (here meaning a 'document' or 'policy') condemning holy images. In 726, after a terrible earthquake, taken to be a divine portent, the image of Christ above the Chalke (Brazen) Gate of the imperial palace in Constantinople was removed (it is said; perhaps it looked like the Sinai Christ; see 55). Some of the emperor's men (we are told) were killed by iconophiles, thus becoming the first (iconoclast) victims of Iconoclasm. In 730 Leo III promulgated an edict requiring the removal of religious images from all churches, and he replaced the iconophile Patriarch Germanos with an iconoclast, Patriarch Anastasios. Whether the edict of 730 was enforced, and if so with what vigour, we cannot now say.

Leo III seems to have believed that God was displeased with the Byzantines on account of some misdemeanour. It was widely held at the time that Muslims were Christian heretics, worshipping the same God but in an incorrect way. Since Muslims had chosen to eschew images in their mosques, and were extraordinarily successful in battle, it was thought that God might be punishing the Byzantines for misusing religious images and falling into idolatry. The solution appeared simple: to ban the use of religious images in Byzantium and hope for divine approval, which would become apparent through political and military success. Leo's reign of twenty-five years – longer than that of his five predecessors combined – could thus be interpreted as an indication of God's satisfaction with Iconoclasm.

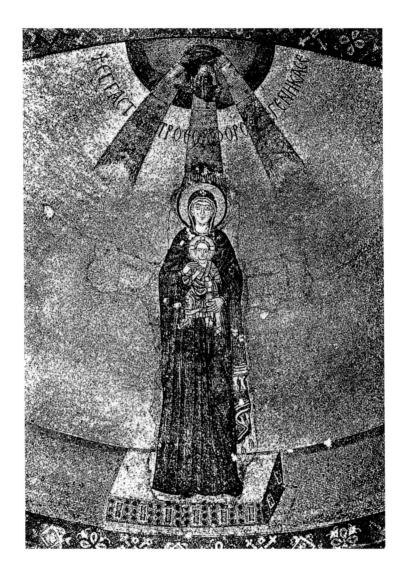

In 754 a Church Council met at the Hiereia palace in a suburb of Constantinople under Leo III's son and successor the emperor Constantine V, and later at the Blachernae Church. It issued a definition of Iconoclasm as orthodox Christian faith, and from this point onwards many images were destroyed or whitewashed over, and the supporters of images were subject to persecution. This policy was, however, reversed by a Church Council at Nicaea in 787, called by the empress Irene (widow of Constantine V's son and successor), and later regarded as ecumenical (*ie* representing the entire Church). Iconoclasm was condemned as a detestable error, and in due course an image of Christ was again placed above the Chalke Gate of the imperial palace.

The defeat of Iconoclasm at Nicaea, however, proved to be shortlived. In 814 the emperor Leo V had the Chalke image removed again, and in 815 a second Iconoclast Council was convened, this time at St Sophia, Constantinople. It condemned the Iconophile Council of 787, and reaffirmed the conclusions of the Iconoclast Council of 754. The pendulum had swung back, and a second period of Iconoclasm began. Finally in 843, an iconophile empress again intervened decisively: in the name of her son, the emperor Michael III, Empress Theodora finally and definitively restored the veneration of images, and replaced the icon of Christ at the Chalke Gate.

To judge by written sources, the image of Christ above the Chalke Gate of the imperial palace at Constantinople played a crucial role in displaying publicly – by its presence or absence – current imperial policy on images. It no longer survives, but the church of the Dormition in Nicaea (originally the monastery of Hyakinthos) had an apse mosaic that seems to have experienced a related history. Unfortunately it was destroyed in 1922, but old photographs reveal an interesting tale (87). The main element of the apse mosaic was a standing Theotokos and Child. Around this can be seen an irregular black line on the gold background, following approximately the outline of Mary, and cutting across the jewelled step on which she stands. Level with her elbows can be traced a further black line, extending to either side in the rough shape of a cross. Above the

87
The Theotokos and Child, 8th and 9th century (3 phases). Apse mosaic. Church of the Dormition (destroyed 1922), Nicaea/Iznik, Turkey

Theotokos, the hand of God (also surrounded by a black line) extended from a segment of heaven, and an inscription read: 'I have begotten thee from the womb before the morning' (Psalm 109:3).

The black lines on the mosaic visible until 1922 marked irregularities of the surface on which dust and dirt had collected. They were the sutures between different phases of activity, where the old plaster had been cut and new mosaic tesserae on fresh plaster inserted. They show that the Theotokos and Child was from the final phase (as was the Hand of God). This composition must have been a replacement for a large cross. But the cross was itself a replacement for the original scheme: this too must have been a Mother and Child, of which the inscription and most of the jewelled step (and the plain gold background) had been preserved through all the other changes. To either side in the presbytery vault were pairs of angels; these too had been removed and then replaced. We can thus deduce that in order to economize on labour and materials, only such areas of the mosaic as had to be altered were cut away, replastered and reset.

From the evidence of inscriptions we know the names of the church's founder, Hyakinthos, and its restorer, Naukratios, but their work cannot be dated precisely. Hyakinthos probably built and decorated his monastery before 726, and the images of the Theotokos, Christ and the archangels were presumably removed and a cross placed in the apse during Iconoclasm, perhaps in the 750s or 760s. The final restoration by Naukratios probably dates from after 843.

To focus on the church at Nicaea, or the written accounts of the Chalke Gate image of Christ, is perhaps to gain the impression that artists were kept busy during the Iconoclast Controversy in taking down and putting up images. These cases, however, were undoubtedly the exceptions. When the iconophile empress Irene and emperor Constantine VI sponsored the mosaic decoration of the apse of the church of St Sophia in Thessaloniki, probably at some time between 787 and 797, after Iconoclasm had been rejected at Nicaea but before the empress blinded her son, a cross rather than a figurative image was set in the semidome of the apse. This was the same scheme as the iconoclast emperor Constantine V had employed in the semi-

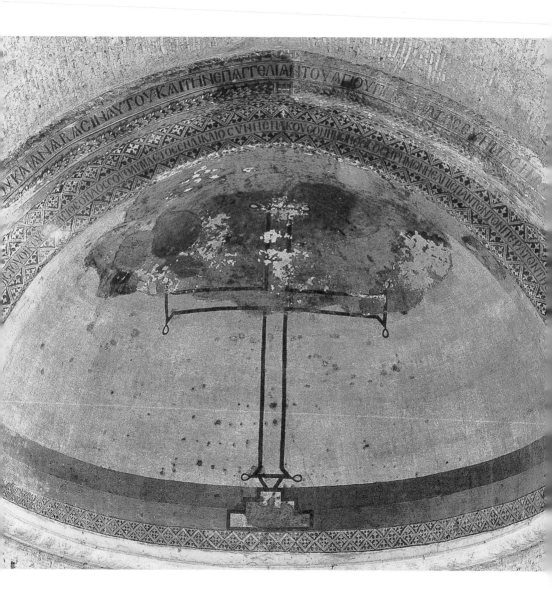

88
The Cross,
after 740.
Apse mosaic.
St Irene,
Istanbul

dome of the apse of the church of St Irene in Constantinople, when it was rebuilt after a severe earthquake in 740 (the cross had been considered a suitable apse decoration since at least the early fifth century). The cross in St Irene is still there today (88), but in St Sophia in Thessaloniki it was changed for a Theotokos and Child (89). Yet this change did not happen shortly after the official end of Iconoclasm in 843, as at Nicaea, but some two centuries later, to judge from the style of the workmanship.

While the monumental mosaics discussed above were carefully altered, Iconoclasm more usually entailed the irrecoverable destruction of images. We can gain a vivid sense of what was lost from the proceedings of the Iconophile Council of Nicaea in 787.

Demetrius the God-loving deacon and sacristan said: 'When I was promoted sacristan at the holy Great Church [St Sophia] at Constantinople, I examined the inventory and found that two books with silver bindings with images were missing. Having searched for them I discovered that the heretics had thrown them in the fire and burnt them. I found another book … which dealt with the holy icons. The leaves containing passages on icons had been cut out by these deceivers. I have this book in my hands and I am showing it to the Holy Synod.' The same Demetrius opened the book and showed to everyone the excision of the leaves.

Leontius the holy secretary said: 'There is, O Fathers, another astonishing thing about this book. As you can see it has silver covers and on either side of them it is adorned with the images of all the saints. Letting these be, I mean the images, they cut out what was written inside about images, which is a sign of utter folly.' …

Leo, the most-holy bishop of Phokia said: 'This book has lost its leaves, whereas in the city in which I live they have burnt more than thirty books.' …

Tarasius, the most-holy Patriarch, said: 'They have scraped not only holy icons, but also [the images in or on] Gospel Books and other sacred objects.'

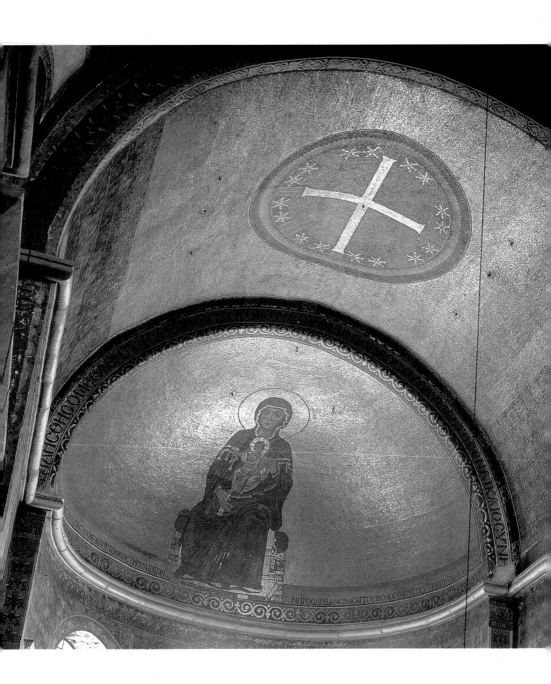

To see what this meant in practice we can take a specific instance from the church of St Sophia in Constantinople (90). On the southern side of the western gallery is a locked door, behind which is a suite of rooms that belonged to the palace of the patriarch, which adjoined the cathedral church on the south side. The rooms were known as the large *sekreton* (council chamber) and the small *sekreton*, and were built on to the church of Justinian by Patriarch John III between 565 and 577. The large *sekreton* functioned at different times as a vesting room for the patriarch and his suite before the liturgy, as a space for welcoming the emperor as part of the ceremonial of St Sophia, and generally as a setting for important meetings or receptions.

90–92
St Sophia,
Istanbul
Left
Plan at
gallery level
Right
Vault mosaic
(detail),
*c.*565–77.
Small *sekreton*
Far right
Inserted
mosaic of a
cross,
*c.*770.
Small *sekreton*

10 m

The adjoining small *sekreton* was built over the ramp that gives access to the south gallery, and contained a major relic of the True Cross. The small *sekreton* is a vaulted room measuring $c.6 \times 4.65$ m (20×15 ft). Originally it was lit by windows on all four sides, its walls were revetted with marble, and their upper surfaces and the vault were entirely covered with mosaics. Much of the sixth-century mosaic on the vault survives in the form of luxuriant curling vine scrolls (91) around a central medallion, of which only a small fragment of the border now remains. On the four semicircular tympana below, flanking the blocked-up windows, are medallions enclosing crosses (92). Of these, only the panels on the south wall have survived.

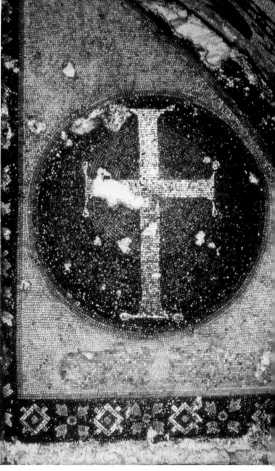

93
Mosaic
replacement of
an inscription,
c.770.
Small *sekreton*,
St Sophia,
Istanbul

Below the medallions it can be seen that the mosaic surface has been disturbed. Tesserae have been cut away around what were obviously inscriptions. We can reconstruct a small cross, followed by a shorter, and then by a longer word. In one case the final letters of the inscription were obliterated by picking out the dark tesserae and replacing them with others that matched the pale background (93). But the curving lines of the pale tesserae that trimmed the letters still retain the letters' distinctive shapes: … IOC (the last a *sigma*, or Greek 'S'). We can even see the final two black tesserae of the foot of the preceding letter (an A, K or X). Given that there were eight medallions it seems likely that originally there were images of saints here, each inscribed ✝O AGIOS and their name. Perhaps there were the four evangelists (including Matthew: MATTHAIOS), together with Peter and Paul, the Theotokos and John the Baptist. The medallion in the centre of the vault would presumably have contained an image of Christ.

It was certainly an act of iconoclasm to cut out these images of saints and to replace them with crosses, and we know precisely when and by whom the destruction of the images was ordered. According to the chronicler Theophanes, in the year 768/9 'the misnamed Patriarch Niketas scraped off the mosaic work images of the small *sekreton*'. According to the chronicle of Nikephoros the images were 'of the Saviour and the saints made of golden mosaic'. Neither source, however, refers to the substitution of crosses.

There is a danger that texts on Iconoclasm, and examples such as the mosaics of Nicaea or St Sophia, may be taken by a modern reader to imply the sort of systematic destruction of art throughout the Byzantine world that a police state might have organized. This certainly did not happen, as can be judged by the survival of images from earlier centuries in the church of St Demetrios (94) and other churches of Thessaloniki. (Some of the places considered in previous chapters would have escaped Iconoclasm in any case, because they were beyond Byzantine control by this date: Ravenna, for example, was captured by the Lombards in 751, and Sinai had been lost since the 630s.) Votive mosaic panels set up in the sixth and seventh

centuries to record the wishes of supplicants, who are shown accompanied by St Demetrios – whose relics the church contained – have survived unscathed. And this is despite the fact that they are close to the viewer and could easily have been destroyed (perhaps they were whitewashed over instead), unlike the mosaics set high in the dome of Hagios Georgios (which not surprisingly were also left undefaced). But a curious sidelight is cast by a story, written perhaps in the twelfth century, about the mosaic in the little church of Latomos, now called Osios David (95). The mosaic, which is in fact probably a work of the sixth century, is reputed to have been made for a daughter of the emperor Maximian (286–310), a notorious persecutor of Christians. She had it hidden to escape suspicion:

She directed her servants to bring a cowhide together with mortar and baked bricks, and she securely covered the image of the God-man [ie Christ] so as to cause it no harm.

In the reign of the iconoclast emperor Leo V (813–20), according to the account, the mosaic was miraculously revealed:

[The aged monk Senouphios] having for some reason been left alone in the church, there occurred a storm and an earthquake and, in addition, a shattering thunder-clap, so that the very foundations of the church seemed to shake. And directly the revetment of mortar and cowhide and brick that overlay, as has been said above, the sacred image of the Lord fell to the ground, and that holy figure of Christ appeared gleaming like the sun … [The old man] cried out loudly, 'Glory be to God, I thank thee!' and he gave up his blessed soul.

There can be little doubt that the story has been woven around the rediscovery of an image carefully hidden during Iconoclasm. Quite possibly it was indeed revealed as the result of an earthquake, although there is no need to believe it happened in 813–20 (this date seems to have been chosen because it is important to the theological argument of the text). Was it merely the mosaic's proximity to the ground that led to its covering? Perhaps the little church was under the jurisdiction of an iconoclast imperial official in Thessaloniki, who felt compelled to carry out imperial policy where he could, even if

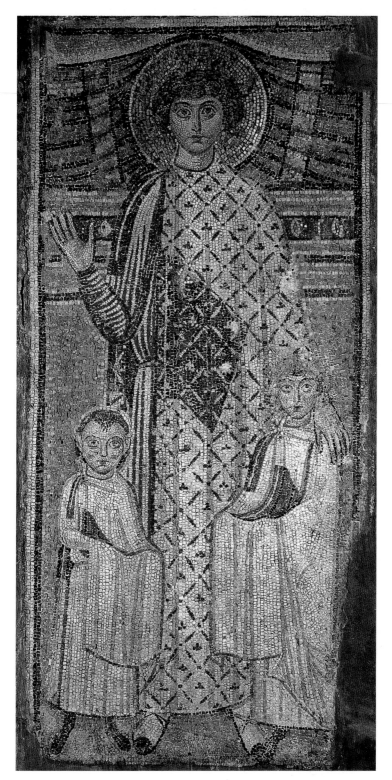

94
St
Demetrios(?)
with two
children(?),
early 7th
century.
Mosaic.
St Demetrios,
Thessaloniki

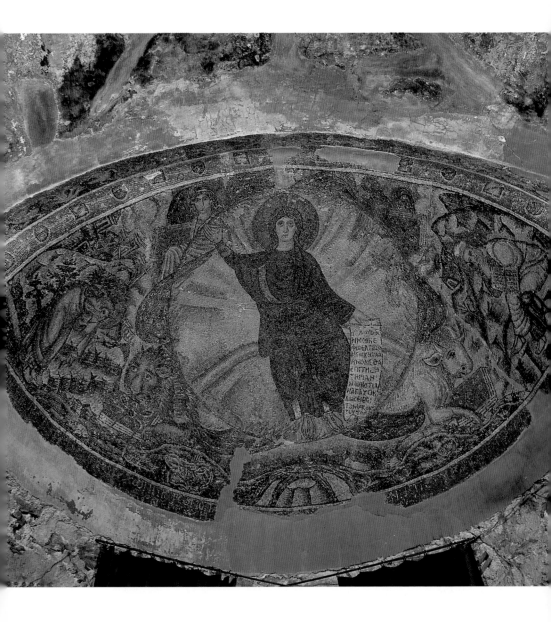

the major churches of the city were left unaltered. Yet it must remain uncertain whether the mosaic was carefully obscured so as to protect its viewers from the temptation of idolatry, or (as the story implies, and as seems more plausible) to protect it from its viewers.

The fate of icons is paralleled by the case of relics and their amuletic use during Iconoclasm. The image of Christ in his human form was at the centre of debate in Iconoclasm. His representation as a lamb, however, had already been proscribed by the pre-iconoclast Church Council of 692. The same council vigorously promoted the veneration of the cross, and banned its representation on floors, where it might be trodden on and desecrated. The image of the cross in any religious context was found to be an acceptable symbol by iconoclasts and iconophiles alike. Crosses of all sizes were set up or displayed in churches. Since at least the sixth century small crosses had also been worn, suspended like an ornament from a chain round the neck. These were called *enkolpia* (singular *enkolpion*), literally meaning 'on the chest'. Examples survive in museums around the world. But the years around 800 saw the development of a particular interest in the wearing of crosses that not only bore images but also contained small relics. The finest were undoubtedly those of gold with images in enamel.

The skill of firing ground glass so as to fuse it to metal was known in antiquity, but seems to have been rediscovered in the West in the late eighth century. In the cloisonnée technique (French *cloison*: 'partition' or 'division') small strips of gold are soldered to a gold tray and then coloured ground glass is placed within the divided compartments. When fired and polished, the gold backing shines through the translucent glass, and the gold *cloisons* trace the outlines of figures, features, letters and so on. A key work is the enamelled reliquary cross presented to the Lateran by Pope Paschal I (r. 817–24) which is still preserved in the Vatican Museums. This cross, almost certainly made in Rome, was not intended to be worn in any way, for it measures 27×18 cm ($10^3{}_4 \times 7^1{}_8$ in). Closely related to it technically, but seemingly made in Constantinople (although research currently in progress may change this view in favour of Rome), are the

95
Vision of
Christ in
Majesty,
late 5th or 6th
century.
Apse mosaic.
Osios David,
Thessaloniki

96–97
Overleaf
Crucifixion and
Theotokos with
saints, front
and back of
the Beresford
Hope Cross,
early 9th
century.
Cloisonné
enamel;
8.5×5.5 cm,
$3^3{}_8 \times 2^1{}_8$ in.
Victoria and
Albert Museum,
London

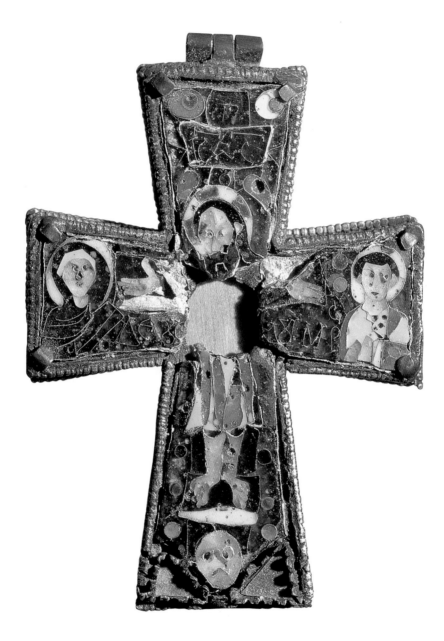

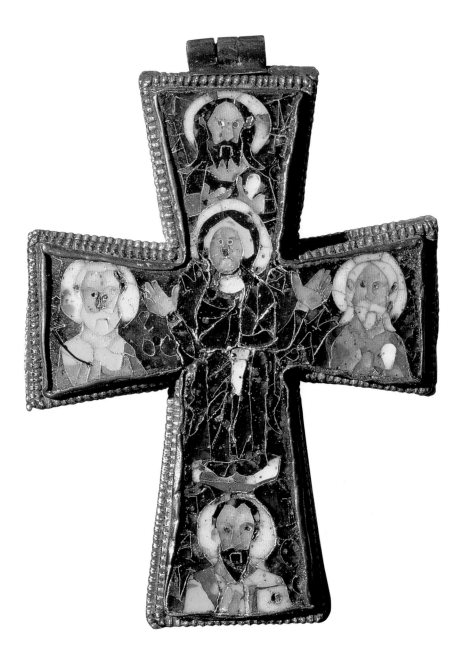

Beresford Hope Cross (96–7), in the Victoria and Albert Museum, London, and the Fieschi-Morgan Reliquary (98) in the Metropolitan Museum of Art, New York (both are named after previous owners). Neither has an inscription revealing its donor or destination. They are traditionally considered to be among the earliest Byzantine examples of cloisonnée enamelling. The technique at this date is somewhat hesitant, and the *cloisons* are irregular. But over decades the craftsmanship was progressively refined and became a Byzantine speciality. Byzantine enamels were highly prized throughout the Middle Ages in East and West (as we shall see in later chapters).

The Beresford Hope Cross (shown here enlarged to twice its actual size) is hinged at the bottom to allow access to its hollow interior, which would have held one or more relics (perhaps of the True Cross). Its imagery is straightforward: a Crucifixion on the front, the Mother of God in prayer with four saints on the back. The Fieschi-Morgan Reliquary (also here enlarged to twice its actual size) is much more complex. It is constructed as a shallow box with a sliding lid. On the four sides are images of thirteen saints. On the cover is a Crucifixion framed by fourteen further saints. The inside of the front cover was also provided with images, this time in niello on silver. These are scenes from the life of Christ: the Annunciation, Nativity, Crucifixion and Anastasis (Christ's Resurrection). When the cover is removed the interior of the box is found to be divided into compartments for relics, although none has survived. The principal relic was undoubtedly a fragment of the True Cross, and it looks as though this would have been flanked by further enamelled plaques (there are flanges to support them), and probably further relics beneath. Despite the complexity of its images and construction, the reliquary is still a small object, and holes at the top corners indicate that it was intended to be suspended on a chain and worn as an *enkolpion*.

In 811 Patriarch Nikephoros sent Pope Leo III a 'gold *enkolpion* [which] has inside another *enkolpion* in which particles of the True Cross are inserted'. Such an object could have resembled the enamelled cross reliquaries that have survived. After his deposition, Nikephoros wrote (in 818–20) of the numerous Byzantine iconophiles

98
Crucifixion and saints, front of the Fieschi-Morgan Reliquary, early 9th century. Cloisonné enamel; 10·2×7·35 cm, 4×2⅞ in. Metropolitan Museum of Art, New York

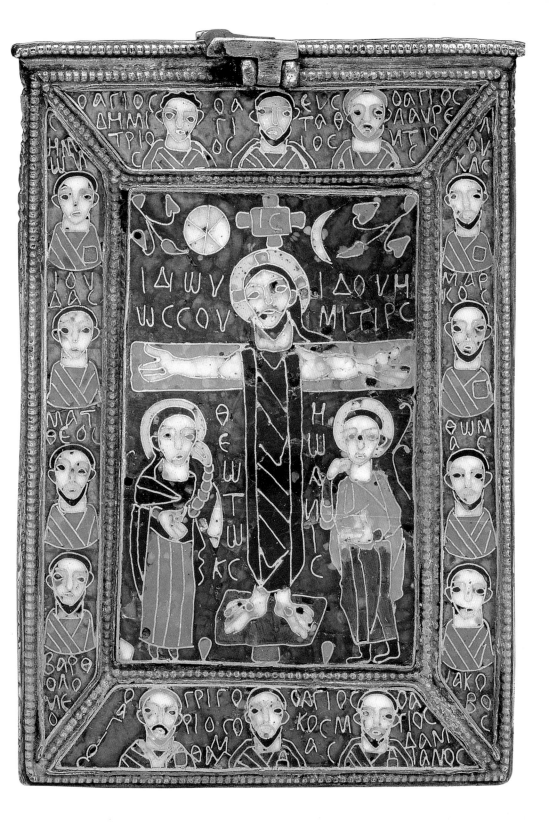

(only those who could afford the expense, of course) who wore gold and silver reliquaries of the True Cross as phylacteries 'to guard and insure our life and the preservation of our souls and bodies'. Such a practice can be compared to the pre-iconoclast soldier considered above, who carried about with him images of the saints Cosmas and Damian for comparable reasons.

Relics suffered a similar fate to images during the Iconoclast Controversy. Their veneration/worship was banned in 754, reinstated in 787, banned again in 815, and finally restored in 843. But it is much harder for us now to recover the ideas surrounding the visual display of relics – as distinct from church decoration and furnishings – because they received relatively few mentions in the texts.

In reading Byzantine sources about Iconoclasm we have to be always on our guard, for we are left with the version of events that the victorious iconophiles wished to publicize. It would hardly be surprising if they had chosen not merely to suppress certain information, but to exaggerate and embroider their side of the story. The more lurid accounts of how numerous iconophiles fell martyr to iconoclasts are likely to be later inventions. Some, however, most certainly did, and there were undoubtedly times when being a propagandist for images was highly dangerous. There is no particular reason to doubt, for example, the veracity of the main lines of the account concerning the monk–painter Lazarus, found in the continuation of Theophanes' Chronicle:

Inasmuch as the tyrant [the emperor Theophilus, r.829–42] had resolved that all painters of sacred images should be done away with, or, if they chose to live, that they should owe their safety to having spat upon [these images], and thrown them to the ground as something unclean, and trodden on them; so he determined to bring pressure on the monk Lazarus who at that time was famous for the art of painting ... He subjected him to such severe torture that the latter's flesh melted away along with his blood, and he was widely believed to have died.

When [Theophilus] heard that Lazarus, having barely recovered in prison, was taking up his art again and representing images of saints

on panels, he gave orders that sheets of red-hot iron should be applied to the palms of his hands. His flesh was thus consumed by fire … When [Theophilus] was informed that Lazarus was on his deathbed, he released him from prison thanks to the supplication of the empress [Theodora] …

[Despite his wounds Lazarus continued painting images.]

When the Tyrant had died [in 842] and True Faith shone forth once again [after the final rejection of Iconoclasm in 843] it was he who with his own hands set up the image of the God-man Jesus Christ at the Brazen [Chalke] Gate.

Even if artists avoided torture, there were further implications to the argument over the legitimate use of images. The Iconophile Council of Nicaea in 787 established a distinction, in theory at least, between the artist's work in interpreting the requirements of a commission, and the justification for that commission: that it represented a traditional aspect of Church activity. From this it follows that religious art, or at least its content – its iconography – could not be altered beyond certain limits. A religious image had to be recognizable for what it was.

Transgressions of this rule of decorum would not find acceptance. The following is what Abbot Theodore of Stoudios (d.826), a leading iconophile, wrote to a certain holy father (Theodoulos or Theodore):

They alleged that you had represented in the windows angels crucified in the form of Christ, and that both Christ and the angels were shown aged … They said that you had done something foreign and alien to the tradition of the Church, and that this deed was inspired not by God, but surely by the Adversary [ie the Devil], seeing that in all the years that have passed no examples of this peculiar subject have ever been given by any one of the many holy Fathers who were inspired by God.

Even when Iconoclasm was defeated, the idea that the content of religious art should be strictly controlled remained fundamental. As we

shall see in later chapters, however, the Nicene pronouncement must be understood as acting as a restriction on artistic freedom, but not as a straitjacket compelling uniformity.

We have already seen that the final defeat of Iconoclasm in 843 did not mean the immediate redecoration of churches – indeed some, like St Irene in Constantinople, retain their iconoclast apse decoration to the present day. Portable icons were probably the first images to be reintroduced. Doubtless, images that had simply been whitewashed or obscured were cleaned. Artists, whether monks or laymen, could again execute religious images without fear. But large schemes had to wait until the financial and other circumstances were propitious, and this may have taken some decades. The best documented case of new post-iconoclast work is the apse mosaic of St Sophia itself (99).

The mosaic consists of an enthroned Theotokos and Child flanked in the presbytery vault by two archangels, of which only the southern figure is well preserved (100). Because of the huge size of the church, these figures, almost 5 m (16 ft 4 in) tall, look relatively small to the viewer on the ground. An inscription, of which only the opening and closing letters have survived, but the complete text of which is known from written sources, explains them: 'The images which the impostors [*ie* the iconoclasts] had cast down here pious emperors have again set up.' The mosaic, it is agreed, is that described as being '[newly] depicted and uncovered' in a homily preached to the emperors Michael III and Basil I in St Sophia by the Patriarch Photius on Holy [Easter] Saturday, 867. In this case, however, unlike the church at Nicaea, it is not possible to establish what the apse decoration had been between the time of the church's completion in 537 and 867, or even whether the iconoclasts had in fact altered the apse mosaic in some way. The inscription thus appears to be tendentious in implying 'renewal' of the images, when inauguration or innovation of a new apse composition might well have been more accurate terms. Yet 'innovation', as we have seen, would have been totally unacceptable for religious reasons; a return to (pre-iconoclast) tradition was required.

99
The Theotokos and Child, dedicated 867. Apse mosaic. St Sophia, Istanbul

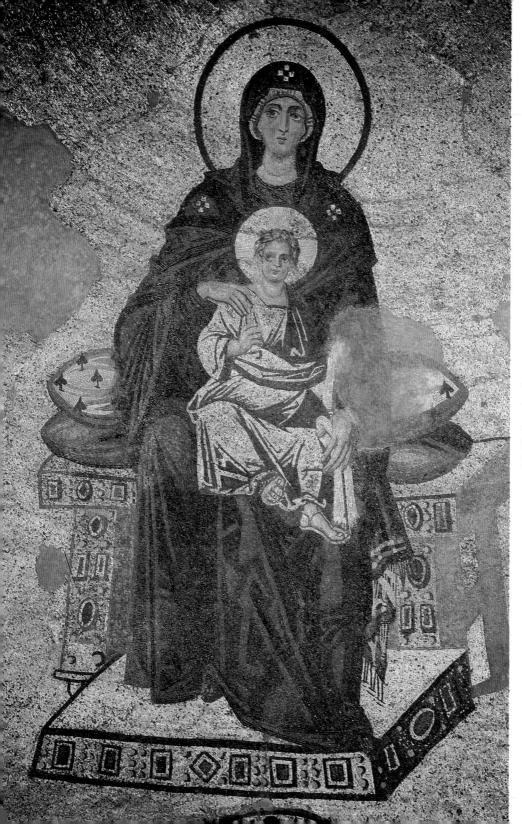

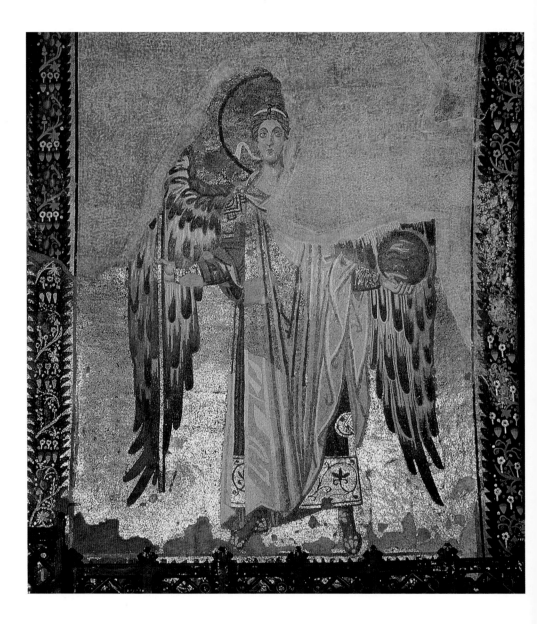

Still in St Sophia, the room called the large *sekreton* was also given a new mosaic decoration at about this time (101). We are told that it had been stripped of its images by the iconoclast Patriarch Niketas in 768/9 (like the small *sekreton*; 92–3), but these images may not have previously been in mosaic. The decoration now survives only in fragmentary patches, but it can be discerned that images of four patriarchs of Constantinople were conspicuous among the ranks of saints. They are identifiable as Patriarchs Germanos (deposed 730), Nikephoros (deposed 815) Tarasios (held office 784–806) and Methodios (held office 843–7). The first two were removed from office by iconoclast emperors; the second two held office when iconoclast policies were overturned. It is hardly surprising that later patriarchs should have chosen to promote the iconophile credentials of their predecessors in this official space. Art had a potent propaganda value.

100–101
Mosaics.
St Sophia,
Istanbul
Left
An archangel,
*c.*867.
Presbytery
Right
Patriarch
Nikephoros,
870s.
Large *sekreton*

Perhaps the most intriguing retrospective view of Iconoclasm is provided in a manuscript known after its nineteenth-century Russian owner as the Chludov Psalter (now in the State Historical Museum in Moscow). It is a worn and damaged book, its text messily overwritten at a later date to aid legibility. The pages are laid out with very broad margins, and these were used to supply small-scale images that act as a sort of learned commentary on the words of the Psalms (a book of this type will be looked at more extensively in Chapter 7). By a subtle process of visual and verbal analogy, the illustrators of the Chludov Psalter were able to make a wide range of points, and some of these specifically concern iconoclasm and iconoclasts.

For example, on folio 67r (102), the text has reached Psalm 68 (AV Ps 69) where in verse 21 we read: 'They gave me also gall for my meat; and in my thirst they gave me vinegar to drink.' At the first level this text was taken as a prophecy of the Crucifixion, for Christ was offered vinegar and gall on the cross (see the account in Matthew 27:34, 48). The adjacent image thus shows a caricatured man lifting the vinegar-soaked sponge on a long 'reed' to the crucified Christ. In the lower margin, however, the artist has supplied a further visual parallel: two iconoclasts, Patriarch John VII the Grammarian (held office 837–43) and a bishop, raise a sponge dipped in lime whitewash to a circular icon of Christ. To emphasize the connection, both white-wash and vinegar are held in similar chalice-like containers. The implication of the images is very clear: to be an iconoclast and white-wash an icon of Christ was to make yourself like the Jews who crucified him.

102
The Crucifixion and iconoclasts, folio 67r, Chludov Psalter, c.850–75. 19·5 × 15 cm, 7¾ × 6 in (page). State Historical Museum, Moscow

Many of the marginal illustrations of the Chludov Psalter show figures holding a circular image of Christ. On folio 23v (103), for example, we see the iconophile Patriarch Nikephoros holding such an icon, while below the emperor Theophilus presides over a council of bishops (the Iconoclast Council of 815), and a similar scene of whitewashing is shown at the right. The normal format for an icon, in the sense of a painting on a wooden panel, was certainly rectangular. But there may be more to the use of the circular form in this manuscript than the convenience for the artist of regarding a halo as

καὶ τὴν ἀλοχίαν μου καὶ τὴν ἔν Τρο
πὴ μου· ἐμαρτιομου ἐνώπιέσ οἱ θλί
βοντές με:

+ Ο ρειϲ δεμουετρ ... δόκινος ρ ἰ ψυχίμου·
καὶ τὰ λαῖπωρίαν· καὶ ὑπενάρος οὐχ
λυπούμενον καὶ οὐ ... τπρϲε: Καὶ
παρακαλούντος καὶ οὐχ εὕρον:

+ Κ αἰ ἔδωκαν ἐστοὺϲ ρωμαμου χολὴν·
καὶ ἐστὴν δίφαν μου ἐπότισαμεοξος:

+ Γ ενηθήτω ... τράπεζα αὐτῶμένω τί
ομ αὐτωὶ εἰς παγίδα καὶ ἐς ανταπα
δοσιν καὶ ἐς σκάνδαλον:

+ Σ κοτισθήτω ... ὀφθαλμοι αὐτῶν
τοῦ μὴ δλεπειν· καὶ ϊον νῶτο μὰι
τω ϊδιαπαντος οὐ καμφομ:

+ Ε κχεὸν ἐπ αὐτοὺϲ τὴν ὀργήν σου· καὶ
ὁ θυμὸς τισοργῆς σου καταλά
βοι αὐτουϲ:

+ Γ ενηθήτω ἡ ἔπαυλιϲ αὐτῶν ἠρημω
μένη· καὶ ἐν ... ϊ κοικιμο ... τωμ
τω μὴ ἐστω κατοικῶν:

+ Ο Τι ὅν σὺ ἐπάταξας αὐτήχαι δι ... ζαν
καὶ επ τωναλ ... ϲ τῶντραυμ ... ωμρ ...

ΚΟΥΤΙΜΗ
ΒΑΝΤΕΣ ΘΙΚΟ
ΥΔΩΡ ΠΟΛΛ
ΚΑΙ Σ ... ΧΟΙ
ΤΟΝ ΕΠΙ
ΤΟΠΟ
ϹΩΠΙΝ

Κρῖνόμ μοι κε ὅτι ἐγὼ ἐν ἀκακίᾳ μου
επορεύθην· καὶ ἐπὶ τῷ κω ἐλπίζων
οὐ μὴ ἀσθενήσω·

Δοκίμασόν με κε καὶ πείρασόν με πύ
ρωσόν τοὺς νεφρούς μου καὶ τὴν καρ
δίαν μου·

Ὅτι τὸ ἔλεός σου κατέναντι τῶν ὀφθαλ
μῶν μου ἐστι· καὶ εὐηρέστησα ἐν
τῇ ἀληθείᾳ σου·

Οὐκ ἐκάθισα μετὰ συνεδρίου ματαιό
τητος· καὶ μετὰ παρανομούντων
οὐ μὴ εἰσέλθω·

Ἐμίσησα ἐκκλησίαν πονηρευομένων
καὶ μετὰ ἀσεβῶν οὐ μὴ καθίσω·

Νίψομαι ἐν ἀθῴοις τὰς χεῖράς μου·
καὶ κυκλώσω τὸ θυσιαστήριόν σου κε·

Τοῦ ἀκοῦσαί με φωνῆς αἰνέσεώς σου·
καὶ διηγήσασθαι πάντα τὰ θαυμά
σιά σου·

Κε ἠγάπησα εὐπρέπειαν οἴκου σου· καὶ
τόπον σκηνώματος δόξης σου·

Μὴ συναπολέσῃς μετὰ ἀσεβῶν τὴν
ψυχήν μου· καὶ μετὰ ἀνδρῶν αἱμά

also defining a medallion. Much debate in the Iconoclast Controversy centred on the circumscribability of God. All Christians believed God to be omnipresent. Therefore to circumscribe him would be to define him as being in a single place, which could be to deny his true divinity by only representing his human nature (the argument put forward by the iconoclasts). The contrary argument was that when God became man in Christ he allowed himself to be circumscribed (because Christ was truly man as well as truly God, he was present in a particular place), and therefore it was quite appropriate to represent God circumscribed in the person of Christ. In terms of images, the language of discussion has a special resonance, for in Greek the verb 'circumscribe' – *perigrapho* – literally means 'I draw round'. So every time an artist took up a pair of compasses to inscribe a halo or a medallion, he quite literally 'drew round' the image within. To represent Christ in a circular image was thus to argue against the iconoclasts by demonstrating God's circumscribability.

103
Patriarch
Nikephoros and
the Iconoclast
Council of 815,
folio 23v,
Chludov Psalter,
c.850–75.
19·5 × 15 cm,
7³⁄₄ × 6 in (page).
State Historical
Museum,
Moscow

It is not known exactly when the Chludov Psalter was made, or even in what context or for what audience – issues that are crucial to a full understanding of its images. But is is certainly a product of the period after the defeat of Iconoclasm in 843, not a work of some underground resistance movement. The proposal that it has connections with the monastery of St John of Stoudios in Constantinople has much to recommend it. The monastery's abbot and second founder, Theodore of Stoudios (mentioned above), was a leading campaigner against the second imposition of Iconoclasm, who was exiled from the city by the emperor Leo V in 815 and regarded as a saint. The use of images in this way, however, as polemical or satirical comments on a text, is one that is known to have begun before 843.

To describe someone today as an 'iconoclast', or their work as 'iconoclastic', usually implies little more than that they have broken with the old and familiar in search of something new, exciting and different. In their desire for recognition, or dissatisfaction with what they see or hear or read, contemporary artists of all sorts may set out to be 'iconoclasts' in this modern sense. Although this may imply a certain aggression on their part, today's 'iconoclasm' is still a

relatively cosy affair. In the Byzantine world, Iconoclasm was an altogether different and more serious matter. One further example will have to suffice. When the emperor Leo V (813–20) ordered iconoclast slogans to be tattooed on the foreheads of the iconophile brothers Theodore and Theophanes (known later as the *Graptoi* – 'the inscribed' – and regarded as saints), it was intended as a mark of public humiliation, not as a fashion statement.

It is often maintained that we owe our flourishing Western artistic tradition to the victory of the Byzantine iconophiles, for had Iconoclasm triumphed would not a version of the arts of Islam have prevailed? This last point seems to me overstated. Artists in western Europe had developed a vigorous tradition (or rather traditions), largely but not entirely independent of Byzantium, in the seventh and eighth centuries. We can ponder the fact that Byzantium produced no Lindisfarne Gospels or Book of Kells, or that the artistic products of the circle of Charlemagne – the first Roman emperor in the West since the fifth century – in the years around 800 are far more impressive than those emanating from Byzantium at around the same time. I do not believe that, had it not been for the arguments of St John of Damascus and the ultimately victorious Byzantine iconophiles, the visual language of western European art would have been restricted to biblical calligraphy. Nonetheless we can be pleased that when art, and ideas about art, were the subject of lengthy and bitter conflict it was the advocates of images who were victorious. Iconoclasm was never forgotten in Byzantium; indeed its defeat was celebrated annually in a special liturgy on the first Sunday in Lent, called the Sunday of Orthodoxy. Celebration seems entirely appropriate.

5

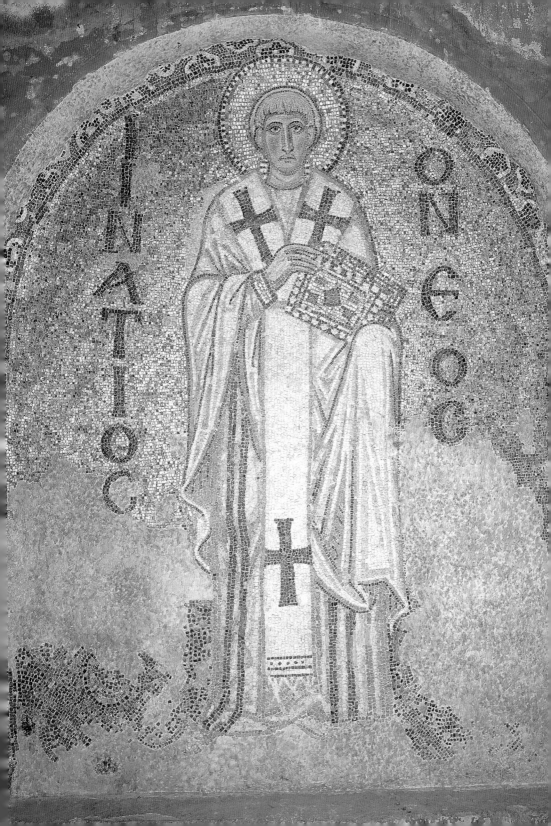

When the Byzantine world emerged from the long century of the Iconoclastic Controversy in the decades after 843 it was changed in many ways. Increasingly powerful Christian kingdoms had grown up in the West. In 800 Pope Leo III had crowned Charlemagne as Roman Emperor in Rome. From that date there were two Christian empires, although the significance of the Western Empire, both as a political entity and as an idea, fluctuated greatly according to the ambitions and successes of the reigning emperor in the following centuries. The emperors in Constantinople, meanwhile, still proclaimed their Romanness on their coinage and in their titles, although theirs had become a predominantly Greek-speaking world.

104
Patriarch
Ignatios,
late 9th
century.
Mosaic.
North
tympanum,
St Sophia,
Istanbul

Despite the changes on every side, the Byzantines maintained a fiction of continuity. Because of the religious foundations of their world, innovation was rejected, as we have seen, since it might have suggested a break with time-honoured orthodox practices. The Byzantines coped with change by ignoring it or disguising it in various ways (as could be quite easily done in their writings, for example). In the field of the visual, which was central to their culture, this mind-set created an especially complex situation. The art and architecture of the ninth, tenth, and subsequent centuries seems quite often to presuppose new ideas, but these were presented in the disguise of continuity with some past 'golden age'. We have already seen this happening in the apse mosaic of St Sophia, which was said to be a replacement for images destroyed by the icono-clasts. But in many other cases, even where we do not have a contem-porary written source to confirm the interpretation, aspects of the art proclaim themselves to be backward-looking. In one sense, indeed, Byzantine artists never escaped from the shadow of Iconoclasm, for they were always required to work within certain conventions and to satisfy certain conditions. What is intriguing is that despite these strictures their art never became predictable or

purely repetitive. They were experts in presenting the novel or innovative as the traditional and orthodox.

Taking the long view, it can be seen that the period after 843 was one of consolidation followed by slow but steady expansion in the political power of the Byzantine Empire, notably from the middle of the following century. Bari (in southern Italy) was recaptured from the Arabs in 873, the island of Crete by 963, Cyprus (a kind of demilitarized zone) by 965, and the city of Antioch by 969. The Bulgarian threat was neutralized by 1018 (a euphemism for Emperor Basil II's decision to blind the 14,000 Bulgarian soldiers captured in battle in 1014, leaving every hundredth man with one eye to guide his companions back to Tsar Samuel, who died of shock at the sight). By the early eleventh century the Byzantine emperor once more controlled the Balkans as far north as the Danube, the southern Crimea, Asia Minor, and a significant part of southern Italy.

In one important way Byzantine art is, I believe, easier to understand as a unity in the centuries after Iconoclasm than before. Iconoclasm was the last great religious controversy to rack the empire, and in subsequent centuries the orthodox position of the seven ecumenical councils (of which the Second Council of Nicaea, in 787, was recognized as the last) was not seriously challenged. Art proclaimed this orthodoxy to a nominally orthodox world. Issues such as the divine/human nature of Christ remained complex, but were no longer the focus of controversy. It is thus less difficult to discern the range of ideas brought to bear on any image by its makers and viewers.

The principal problem in understanding the art of the post-iconoclast centuries is posed by the sheer volume of surviving material. Much is lost, of course, but Byzantine art after 843 can still only be treated selectively – whether it is in a book for a wide readership, or in the most refined work of scholarly research – and this inevitably influences our views. In the first place, therefore, it is in part a matter of convenience to divide the material as I have done in this and the following chapters. Between 843 and the sack of Constantinople by the Crusaders in 1204 there is no perceptible break in Byzantine history, and this period is often treated as a unit and termed 'Middle

Byzantine'. Alternatively, the families of the principal imperial dynas-
ties can be used to define the period as 'Macedonian' and
'Komnenian'. For present purposes it will be helpful to follow a
modified dynastic model, and to look first at the art of the period of
the Macedonian emperors from about the 860s to the 960s.

The mosaic (re)decoration of St Sophia (see 33), the cathedral church
of Constantinople, inaugurated in 867, seems to have continued into
the tenth century. If there was a unified scheme this is no longer
discernible, and probably the sheer size of the structure, together
with the fact that – as far as we can tell – it had not been designed to
display figured mosaics, would have made such a plan unfeasible.
Instead, certain areas of the building were selected for decoration
with a view to making specific points. On the vertical wall surfaces of
the north and south tympana (beneath the dome), figures of Old
Testament prophets, saints, patriarchs of Constantinople, and metri-
cal inscriptions were inserted. Of these mosaics, the only substantial
parts to have survived are in the lowest section, which probably dates
from shortly after 877. Here it is remarkable to find (104) alongside
the fathers of the early church, such as St John Chrysostom (d. 407),
images of the near contemporary Patriarchs Methodios (d. 847) and
Ignatios the Younger (d. 877). The inclusion of such images has a
parallel in the large *sekreton* in the south gallery of St Sophia, proba-
bly decorated shortly after 870 with figures of iconophile patriarchs
(101). It emphasizes St Sophia's special role as the principal church
of the patriarchy, a point that patriarchs were understandably keen
to put across.

At a level much closer to the viewer, and indeed conspicuous to
anyone entering the church, are the mosaic panels over two of the
doors: the principal door from the *narthex* into the main body of
the church, and that from the southwest vestibule into the *narthex*.
The first (105) shows a bearded emperor kneeling in the form of
obeisance known as *proskynesis* before an enthroned figure of Christ.
Christ lifts his right hand in blessing, and with his left holds an open
book with the text 'Peace (be) unto you [John 20:19 etc.]. I am the
light of the world [John 8:12].' Flanking Christ's throne are two

large medallions. At the left is the Theotokos, her hands in a gesture of prayer that precisely echoes that of the emperor; at the right is an archangel. The emperor is not identified by inscription, and there is controversy among modern scholars as to the image's meaning.

At one level it was certainly intended to represent here the bond of piety and subservience between the emperor (any emperor) and Christ. The image was a reminder to everyone who saw it of a 'special relationship'. It also emphasized how the Mother of God, the special protectress of Constantinople, prays to Christ on the emperor's behalf. To what extent, however, might the image have meant more than this to the emperor in whose reign it was set up? Does it perhaps represent Emperor Leo VI (r. 886–912) atoning for his father Basil I (r. 867–86, the founder of the Macedonian dynasty), who murdered his co-emperor, Michael III (842–67)? If the archangel is Michael, it would support this interpretation. Or is the emperor perhaps Constantine VII (r. 913–59), seeking to atone for the actions of his father, Leo VI, who married four times, contrary to church law, in his desire for a male heir (the future Constantine)? Or is this an image set up by the patriarch to remind one of those emperors of his constant need for repentance and prayer, and more generally of the need for humility before God? In my view, the mosaic does not intrinsically require a single answer, and we would be mistaken to try to define any one reading as *the* intended meaning of this panel. Its lack of inscriptions makes its range of meanings wider. And given that the Byzantines paid special attention to inscriptions, their absence in this image should not be taken as a mere oversight.

The second panel (106) is straightforward in comparison, for conspicuous inscriptions leave the viewer in no doubt as to how the image is to be understood. On entering the church the visitor is confronted by an enthroned Theotokos and Child, in many ways similar to the apse mosaic within (99). Large medallions to left and right identify Mary as the Mother of God (MHP ΘV = *Meter Theou*). The Christ Child blesses with his right hand. To the left as we look (the position of higher status, because at the right hand of Christ) stands the emperor Justinian, holding a large model of St Sophia which he offers to the

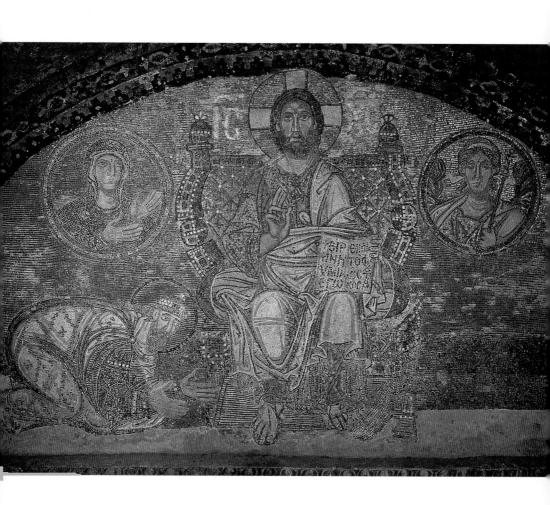

105
Christ and
an emperor,
late 9th or early
10th century.
Narthex mosaic.
St Sophia,
Istanbul

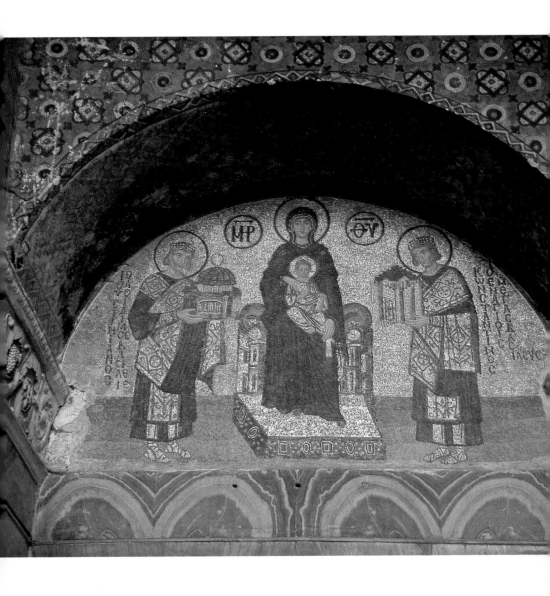

Theotokos and Child. He is identified as 'Justinian the Glorious King'. To the right stands Constantine, holding a model of the walled city of Constantinople, its golden gates decorated with crosses. He is identified as 'Constantine the Great King, numbered among the Saints'. (The lettering of both inscriptions was partially restored in the nineteenth century.) Both Justinian and Constantine wear the type of imperial dress known as the *loros*, a broad scarf-like textile woven with threads of gold and silver. Both are represented beardless, with a similar hairstyle: a short fringe at the front and a heavy curling bob at the back of the neck. These features distinguish them from contemporary Byzantine emperors, who grew beards and wore their hair long.

The primary meaning of the image is that Justinian and Constantine not only offer the church and city to the Theotokos and Child, but by their gesture entreat the blessing of Christ upon them. Christ is seen to respond. This image again expresses a 'special relationship', that of the church and city with God and his Mother. It also stresses continuity: the viewer stands in the very church that Justinian built, within the city founded by Constantine, and now ruled by the successor of those two emperors. As Christ blesses them, so – the image implies – He will continue to bless the church, the city and the emperor.

From the last decades of the ninth century there were major new building campaigns in Constantinople, which included the construction of mosaic-decorated churches such as that of St Mary of the Pharos, built by Emperor Michael III (r. 842–67) in the imperial palace, or the Nea (New) Church built by Emperor Basil I. Although neither church has survived, we know about both of them from descriptions: they were domed structures, lavishly decorated with gold mosaics, marble revetments and silver fittings around the altar. In order to discover what their mosaic images might have looked like, one course is to look at surviving buildings outside the capital.

The cathedral of the empire's second city, Thessaloniki, was also called St Sophia, and had been rebuilt in the late eighth century by the imperial pair Irene and Constantine VI. A mosaic (107) depicting

the Ascension was placed in the dome, probably in 885/6. This was an apt use of the spatial possibilities – at the time of Christ's ascent two angels appeared to the apostles and enquired: 'Why stand you gazing up into heaven?' (Acts 1:11), and to view the images in the dome the spectator must also lift his or her head to gaze up at the ascending Christ. This was, nevertheless, an unusual scheme for a dome mosaic, since the standard post-iconoclast formula employed the medallion bust of Christ alone, in the form we call 'the Pantokrator' (we know this from descriptions of churches in Constantinople; see also Chapter 6).

A parallel for the Thessaloniki Ascension can be found in a very different location: a rock-cut church in Cappadocia in central Asia Minor (now Turkey) – somewhat further from Constantinople in the opposite direction, but still well within the borders of the empire. The soft volcanic tufa of the region, often eroded into steep-sided valleys and isolated outcrops, facilitated excavation, and rock-cut spaces created for every domestic and religious purpose have been identified. These range in design from the simplest shapes to carefully planned churches or chapels with domes 'supported' on excavated columns in close imitation of built structures. Such churches and chapels were generally plastered and painted inside (but never decorated with mosaics). The church in question is known as Ayvalı Kilise, and is in Güllü Dere, near Çavuşın (it is also referred to as Güllü Dere No. 4, or St John). An inscription reveals that it was dedicated to St John in the reign of an Emperor Constantine, presumably Constantine VII, which would date it between 913 and 920. Not far from Ayvalı Kilise, in the Göreme Valley, is a church known as Tokalı Kilise (it was probably dedicated to St Basil). This was created in two phases, both of which were decorated with wall-paintings. The earlier is closely related stylistically to Ayvalı and was probably the work of the same unknown artist. Even more remarkable, however, is the second phase (called the New Church, or New Tokalı) which contains wall-paintings of high quality (108), comprising a long cycle of scenes from the life of Christ together with numerous images of saints.

107
The Ascension, c.885. Dome mosaic. St Sophia, Thessaloniki

Art after Iconoclasm

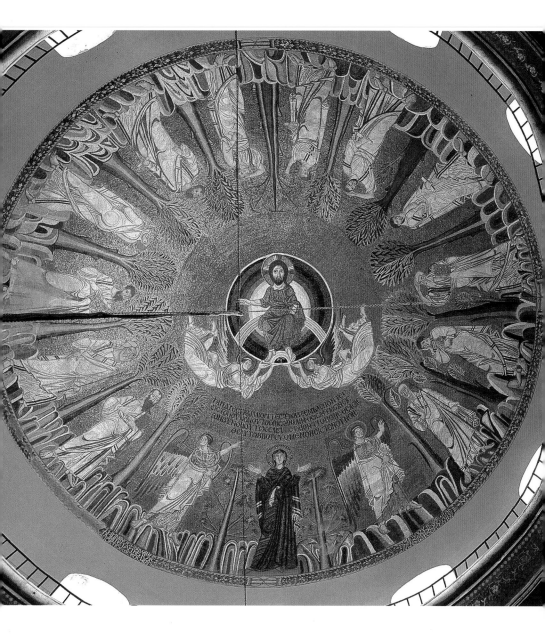

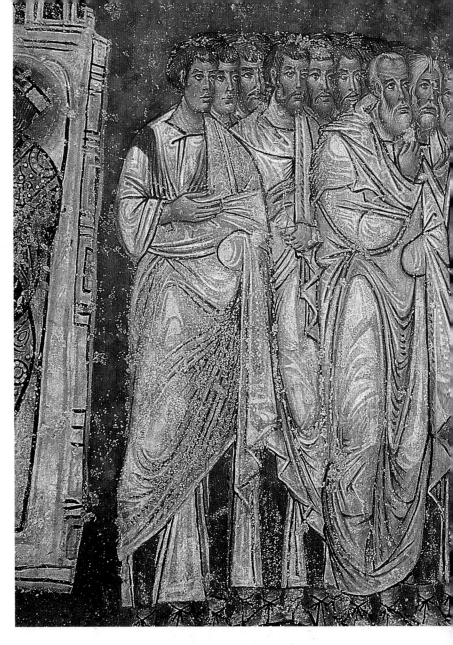

108
St Peter
Ordaining the
First Deacons,
c.920–40.
Wall-painting.
Tokalı New
Church,
Göreme Valley,
Cappadocia,
Turkey

The main body of Tokalı New Church is about $10 \times 5{\cdot}5\,\mathrm{m}$ $(33 \times 18\,\mathrm{ft})$, and it is more than $7\,\mathrm{m}$ $(23\,\mathrm{ft})$ high, making it an excavation of imposing dimensions. According to painted inscriptions it was decorated by a certain Nikephoros, for a certain Constantine and his son Leo. Despite the fact that the church was not a built structure but merely tunneled out of the soft rock, Nikephoros was paid to use the finest

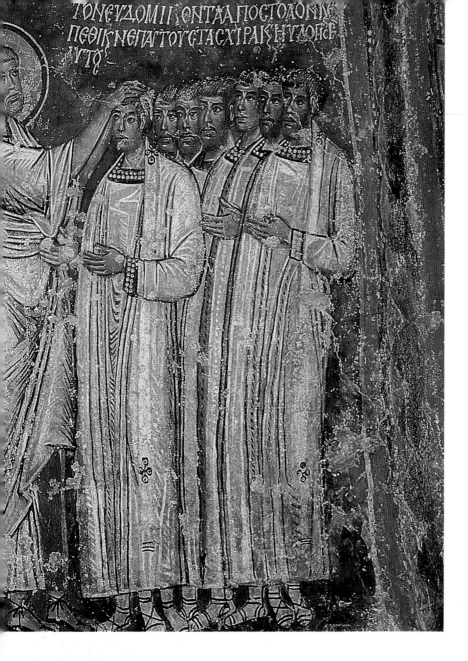

materials: gold leaf for some of the halos, and a lavish application
of lapis lazuli for the backgrounds. As lapis lazuli is a semi-precious
stone, the cost of the programme must have been considerable.
Clearly Nikephoros was no rural artisan; he was a talented artist who
painted in a metropolitan style and technique such as we might
expect to find in a major church in Constantinople or Thessaloniki.

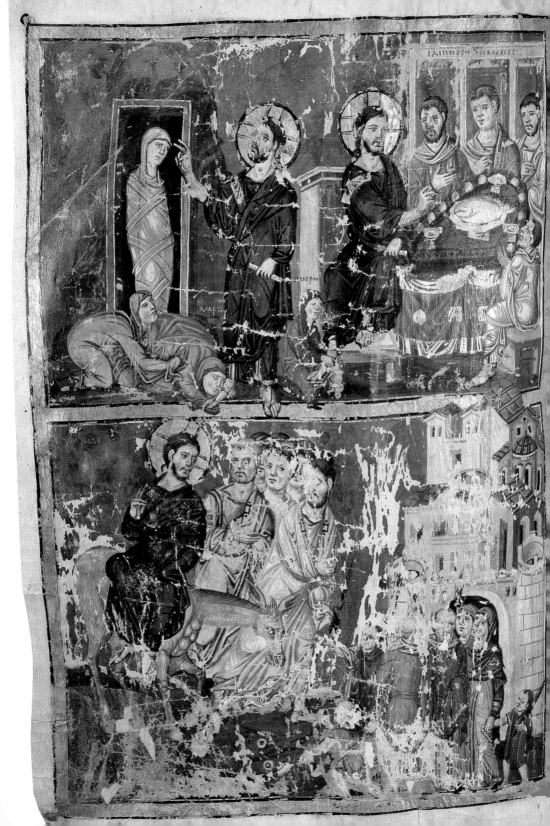

These examples from Thessaloniki and Cappadocia can be taken to represent styles and techniques deriving from the imperial capital, and they suggest that in the post-iconoclast centuries Constantinople was a centre of such wealth and power in comparison to virtually any other place in the Byzantine world that it must have acted both centripetally, drawing craftsmen and patrons from all parts into the city, and centrifugally, dispatching them throughout the empire with Constantinopolitan ideas and images in their heads.

One type of artwork from this period that survives in sufficient numbers to give an idea of the wide range of activities of the Byzantine painter is the illuminated manuscript. Although the paintings these books contain are necessarily small-scale, and cannot be compared in terms of cost to the building and decorating of a major church, their expense and value – both to those who made them and to us – should not be underestimated. The finest artists were called upon to paint in books; and emperors both received and presented illustrated books, as did all those individuals and groups who could afford them. The decoration of most of the churches for which such books were made has long perished, but many books have survived.

One of the most intriguing of such books is a huge volume containing homilies (sermons) of the fourth-century bishop St Gregory of Nazianzos. The manuscript is usually referred to as the 'Paris Gregory' (it is in the Bibliothèque Nationale, Paris). Unfortunately the book's condition is perilous, for pigment easily flakes off its many painted pages, and for that reason for many years it has not even been opened, let alone examined by experts or exhibited to the public; our discussions therefore have to be based on photographs. The book opens with full-page images that proclaim its imperial connections. On the left-hand page Emperor Basil I is shown flanked by the Prophet Elijah and the Archangel Gabriel (the page is very flaked). On what would originally have been the facing page is a comparable image of Basil's wife, the empress Eudokia, with their children Leo and Alexander (110). These images allow the book to be dated between 879/80 and 883.

109
Scenes from the life of Christ, folio 196r, Paris Gregory, 879–83. 43·5 × 30 cm, 17⅛ × 11¾ in (page). Bibliothèque Nationale, Paris

Most of the illustrations take the form of individual full-page frontis-pieces to the various homilies. These are very varied in layout and content. A few are single-subject images (like the imperial frontis-pieces), but most are divided into numerous smaller scenes, and it is often difficult to understand precisely what the connection between such scenes and the following homily can be. For example, the image

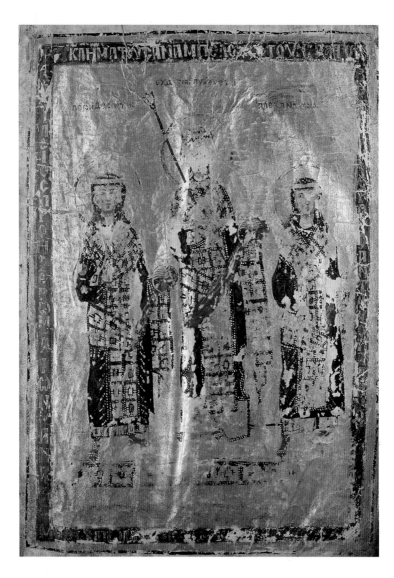

110
Empress
Eudokia with
her sons Leo
and Alexander,
folio Br,
Paris Gregory,
879–83.
43·5×30 cm,
17⅛ × 11¾ in
(page).
Bibliothèque
Nationale, Paris

facing the start of Gregory's second homily, 'On the Son', combines the Raising of Lazarus with the Anointing of Christ's Feet and the Entry to Jerusalem (109). These are not in themselves unusual images, but it is odd to find them linked together in this way; and of the three events Gregory's complex text mentions only the Raising of Lazarus (and the reference is near the end). The most plausible explanation is that the image is responding to the sense rather than the words of Gregory's sermon, focusing on the build-up to Christ's Passion. It has been suggested that the learned Patriarch Photius might have been responsible for devising this often abstruse cycle of images.

Because the Paris Gregory contains so many multi-scene images, the range of its pictorial content is far larger than any work surviving from before Iconoclasm. The conceptual technique of its illustration is also different from that found in earlier manuscripts, whether it be the marginal psalters, such as the Chludov Psalter, or the surviving pre-iconoclast books. Perhaps the artists of the Paris Gregory were in effect assembling an anthology of existing images from earlier sources, or were supplementing relatively meagre pictorial sources by creating new images that are consistent with an ancient tradition.

The issue of conscious archaism – as it appears to a modern viewer – is particularly important in two magnificent books of the mid-tenth century. The earlier is the surviving first volume of a two-volume Bible, now in the Vatican Library. It is usually known as the 'Leo Bible', after the person for whom it was made. A pair of frontispieces, not unlike those of the Paris Gregory in conception, show the donor, Leo *patrikios praipositos sakellarios* (his titles identify Leo as one of the highest ranking officials in the imperial administration and palace household). In one (111) Leo himself, shown as a beardless eunuch, offers his book in a gesture of prayer to the Theotokos, who invokes Christ's blessing. On the facing page (112) a monk and layman kneel at the feet of St Nicholas. The figure at the right is identified by inscription as the late Constantine, brother of Leo the *sakellarios*, and the founder of the monastery of St Nicholas. To the left is the monastery's abbot, Makar. The image is one of prayer, and St Nicholas responds with a blessing. Note how the viewer's

111–112
Overleaf
Leo Bible,
c.930–40.
41×27 cm,
16⅛×10⅝ in
(page).
Biblioteca
Vaticana, Rome
Left
Leo presents
the Bible to
the Theotokos,
folio 2v
Right
St Nicholas
with Abbot
Makar and
Constantine,
folio 3r

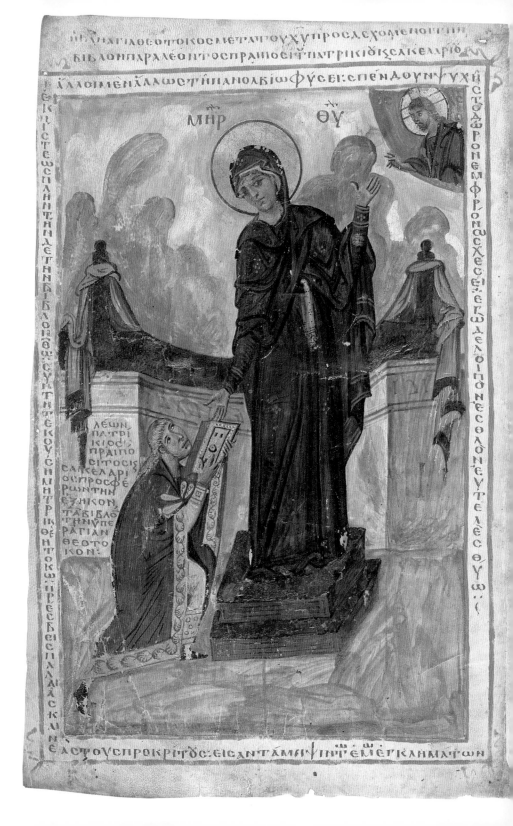

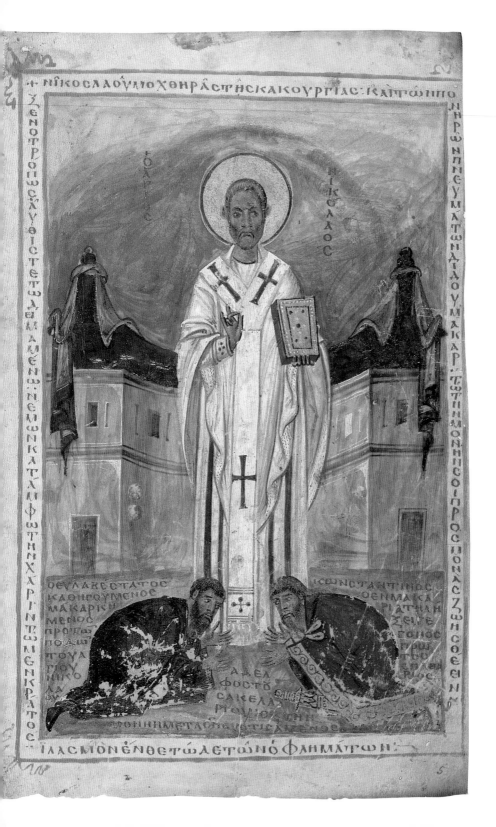

ΝΙΚΟCΑΛΟΥΜΟΧΘΗΡΑCΤΗCΚΑΚΟΥΡΓΙΑC·ΚΑΙΤΟΠΟ

ΖΕΝΟΤΡΟΠΩCΛΥΘΕΙCΤΕΤΗΛΘΜΑΜΕΝΩ·ΝΕΜΩΝΚΑΤΑΜΦΩΤΗΝΧΑΡΙΝΤΩΙΓΕΝΚΡΑΤΟC

ΝΗΡΩΝΠΝΕΥΜΑΤΩΝΔΙΑΟΥΜΑΚΑΡ·ΤΩΤΙΜΩΝΗCΟΙΠΡΟCΠΟΝΑCΖΩΗCΟΘΕΗΝΝ

Ο ΑΓΙΟC

ΝΙΚΟΛΑΟC

ΘΕΥΛΑΚΕCΤΑΤΟC
ΚΑΘΗΓΟΥΜΕΝΟC
ΜΑΚΑΡΙΚΗ
ΜΕΝΟC
ΠΡΟΤΩ
ΠΟΔΩ
ΤΟΥΑΓΙ
ΟΥΝΗΚΟ
ΛΑΟ

ΚΩΝCΤΑΝΤΙΝΟC
ΟΕΝΜΑΚΑ
ΡΙΑΤΗΛΗ
ΞΕΙΤΕ
CΤΟΠΟC
CΡΟΜΙ
CΤΩΔΩ
CΠΛΑΤΗ
ΡΙΟC

ΑΔΕΛ
ΦΟCΤΟ
CΑΚΕΛΛΑ
ΡΙΟΥΟCΤΗΝ
ΜΟΝΗΜΕΤΑΟΠΟΥCΤΙΣΑΙΡΕΝΟC

ΙΛΑCΜΟΝΕΝΘΕΤΩΛΕΤΩΝΟΦΛΗΜΑΤΩΗ:

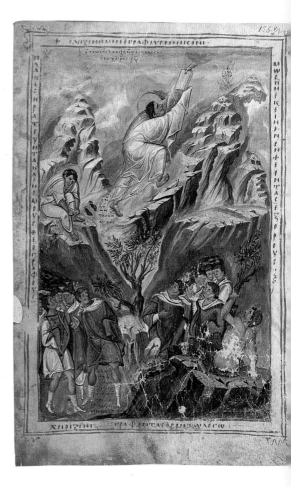

113
Moses Receives
the Law,
folio 155v,
Leo Bible,
*c.*930–40.
41×27 cm,
16⅛×10⅝ in
(page).
Biblioteca
Vaticana, Rome

understanding of the image is carefully controlled by these inscriptions, telling us exactly what the donor and craftsman intended us to know.

The remainder of the illustration in the Leo Bible consists of full-page frontispieces to the various biblical books. For the Book of Deuteronomy, for example, there is an image of Moses receiving the Law on Mt Sinai (113). The event is set in a carefully painted rocky landscape. Around the image are verses (it is assumed that they were composed by Leo) explaining the image to the viewer:

The painter has shown us in image the famous inspired Moses on the mountain taking possession of the tablets and the laws divinely composed in miraculous handwriting by the unutterable Word.

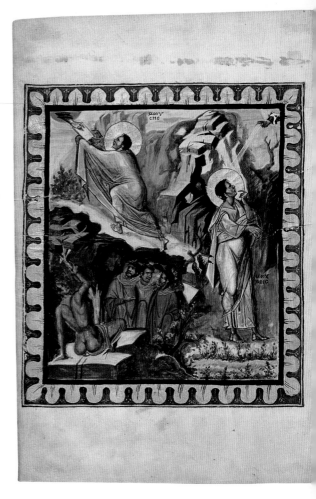

114
Moses Receives
the Law,
folio 422v,
Paris Psalter,
c.950–70.
37×26·5 cm,
14⅝×10⅜ in
(page).
Bibliothèque
Nationale, Paris

An image (114) related closely to that in the Leo Bible can be found in the 'Paris Psalter' (now in the Bibliothèque Nationale, Paris), as an illustration to the second Canticle of Moses (Deuteronomy 32:1–43). This version lacks Leo's poem, and the format is altered towards a square. The image is reorganized too: now Moses appears a second time at the lower right. He looks up towards heaven, points at his mouth with his left hand, and at the earth with his right. These odd gestures are explained by the opening words of the Canticle: 'Give ear, O ye heavens, and I will speak; and hear, O earth, the word of my mouth.' This translation of words into images is reminiscent of the technique of illustration found in the Chludov Psalter, although here it has been adapted to a full-page image, and creates a completely different effect.

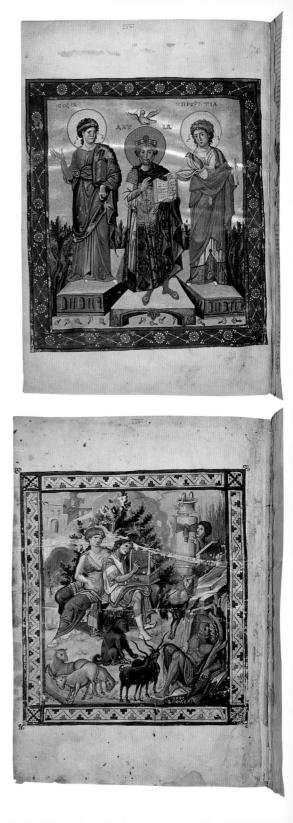

115–116
Paris Psalter,
c.950–70.
37×26·5 cm,
14⅝×10⅜ in
(page).
Bibliothèque
Nationale, Paris
Above
David with
Wisdom and
Prophecy,
folio 7v
Below
David with
Song,
folio 1v

The Paris Psalter has (or had) other frontispiece images, gathered together at the opening of the book, before the start of Psalms, and before the other Canticles (which follow the Psalms). Unlike the Leo Bible (or Paris Gregory) it does not reveal in any surviving image the circumstances of its commission or destination. But the last frontispiece, it has been argued, provides a clue. The image shows David in the guise of a Byzantine emperor of the early period, standing between personifications of Wisdom and Prophecy (115). The open book he holds – to be understood as the Book of Psalms – displays a surprising text, the start not of Psalm 1 but of Psalm 71 (note again the difference from the Authorized Version, where this is Psalm 72): '[For Solomon] Give the king [*basileus*] thy judgements, O God, and thy righteousness unto the king's son.' The *basileus* in question has been explained as an oblique reference to Emperor Constantine VII, and this would make 'the son of the *basileus*' Constantine's son Romanos, the future emperor Romanos II. (The first Byzantine emperor to adopt the title *basileus* officially was Heraclius, in 629.) This would date the making of the book to the 950s. If the Paris Psalter was indeed intended for Romanos, and is not (as it might be) a slightly later copy of such a book, it is remarkable that it was thought appropriate to give him a version of the Psalms accompanied by a vast body of learned theological commentary.

The first frontispiece of the Paris Psalter (116) shows David playing his psaltery in the presence of an accompanying personification of Song (Melodia). This looks more like an illustration to some Greek legend than to a biblical book, with its idyllic pastoral landscape, its gods and nymphs, and its Orpheus-like musician. The Chludov Psalter has a similar pastoral image at the end of the Psalms, although in that case David is inspired – more appropriately – by the dove of the Holy Spirit, which perches on his psaltery, rather than by the langorous Melodia. There is no question that the artist of the Paris Psalter was trying very hard in this picture to produce an archaizing work. The image itself was probably based on a surviving work of Late Antiquity, but we need to bear in mind the likelihood that the tenth-century artist was able to manipulate his sources and the viewer's response in a variety of ways. David is presented in this book as

timeless and contemporary, pastoral and imperial, inspired by song but also by wisdom and prophecy. The style of the images is an aspect of their meaning, not merely the expression of the individual artist's preferences.

The most astonishing of the archaizing works of the mid-tenth century is a long parchment scroll in the Vatican Library. It consists of a continuous picture frieze, illustrating scenes from the Book of Joshua, together with some excerpts from the biblical text. It is usually called the 'Joshua Roll' (but its constituent parts have been separated into individual sheets for reasons of conservation). The landscape settings are suggested by delicate washes. The narrative moves vigorously from left to right, one episode divided from the next by a tree, a hillside, or a small architectural fantasy. Half-naked personifications appear from time to time. The third surviving sheet contains parts of three events (117). At the left the Israelites are passing over Jordan led by Joshua, who is identified by an inscription (part of Joshua 4:11–13 is written below). In the centre Joshua places the topmost stone on a monument at Gilgal – these are the twelve stones brought from the dried-up bed of the Jordan. A figure inscribed 'Galgal' reclines above (the text below is Joshua 4:20–22). At the right Joshua follows the Lord's command: 'Make thee sharp knives and circumcise again the children of Israel the second time' (Joshua 5:2–3 is written below). Above is a figure identified as 'the hill of the foreskins'. The artist in this instance has not illustrated the words of the text, but its painful (if unrecorded) result.

The motivation for making a roll of this sort continues to baffle scholars: there is nothing quite like it with which to make a comparison. For many years it was believed to be the only survivor of the type of picture scroll which, it was thought, must lie behind the making of the giant historiated columns of Rome (or Constantinople). Trajan's Column, according to this theory, was a monumental version of such a scroll, as it were unwound in a spiral around the column. This theory no longer commands support, although a workshop sketch in roll form seems plausible enough. As a result the Joshua Roll remains in isolation. It is in all likelihood a facsimile of a

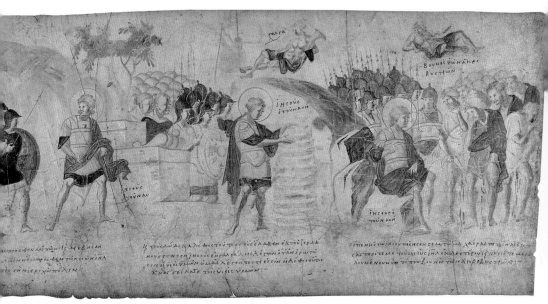

117
Joshua and
the Israelites,
sheet III,
Joshua Roll,
mid-10th century.
31 × 65 cm,
12¼ × 25½ in.
Biblioteca
Vaticana, Rome

pre-iconoclast curio (there are signs that the model was illegible in places), and may have been made as an act of antiquarian enthusiasm in around 950. But, if so, why was the original scroll made? Was it perhaps the design for a frieze around the walls of some room in the imperial palace? Was it intended itself to be displayed? The question remains open.

In addition to working in mosaic and fresco, and to painting images in books, Byzantine artists continued the other crafts and techniques that had been practised in earlier centuries: notably icon painting, ivory carving, metalworking and enamelling. We shall look at each of these in turn.

The potent combination of images and relics had been exploited long before the post-iconoclast period in such works as a reliquary of the sixth century preserved in the Sancta Sanctorum of the Lateran (118). This object was constructed as a shallow box, divided into compartments mainly containing stones from holy places (*Loca Sancta*) associated with Christ's life, such as the Mount of Olives, Bethlehem and Sion. The well-preserved paintings are on the inside of the sliding cover, and do not seem to be arranged in any narrative sequence. The Crucifixion is the dominant image in the centre, with the Nativity and Baptism below, and the Marys at the Tomb, and Ascension above. Similar images were moulded on the faces of small lead flasks (*ampullae*) which contained 'oil from the holy places', and were carried back by pilgrims in the sixth century.

The interest in such objects continued after Iconoclasm, as we can judge by another object from the treasury of the Lateran. Although often described as a box (like the sixth-century reliquary), it is in fact a thick panel with a sliding lid, in which a cross relic was housed in a cross-shaped cavity (119). When closed the reliquary thus looks like an 'ordinary' icon. Although undated, it is painted in a style that is strongly reminiscent of the Leo Bible and Tokalı New Church, and so is perhaps a work of the 920s or 930s. A Crucifixion (121) is painted on the outside of the lid, helping to identify what lies within. But the content of the images, outside and in, is odd in a number of ways. In particular, the prominent position given to St John Chrysostom on

the inside of the lid (120) seems to demand explanation. He holds an
open book displaying the text: 'The Lord said to his disciples, These
things I command you, that you love one another' (John 15:17 –
the opening words 'The Lord said …' are a liturgical formula).
It has been argued that the relic and its box were sent to Rome
from the Patriarchate in Constantinople after a council in 920 which
marked a highpoint of conciliation between the patriarch and the
pope. The papacy had established its independence of Byzantine
control during the Iconoclast Controversy. Thereafter, a mixture of
doctrinal and practical matters provided a source of frequent dispute
between pope and patriarch and between pope and emperor. The
legacy of these disputes is still with us today. Perhaps St John

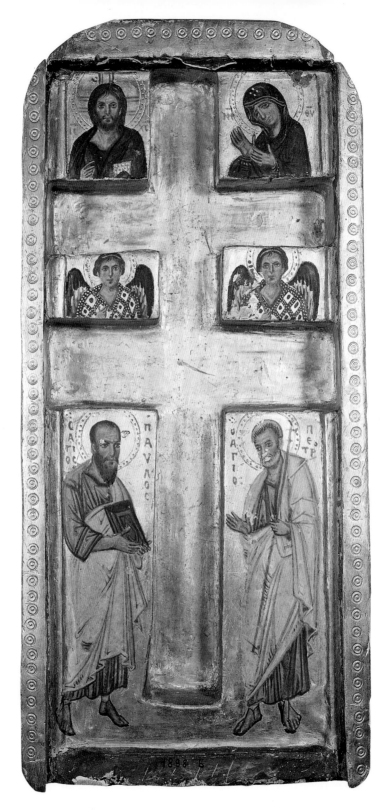

119–121
Cross reliquary,
*c.*920–30.
Painted and
gilded wood;
26×12·5×2·5 cm
10¼×5×1 in.
Vatican
Museums, Rome
Left
Interior with
cavity for relic
Right
St John
Chrysostom
(inside of lid)
Far right
The Crucifixion
(outside of lid)

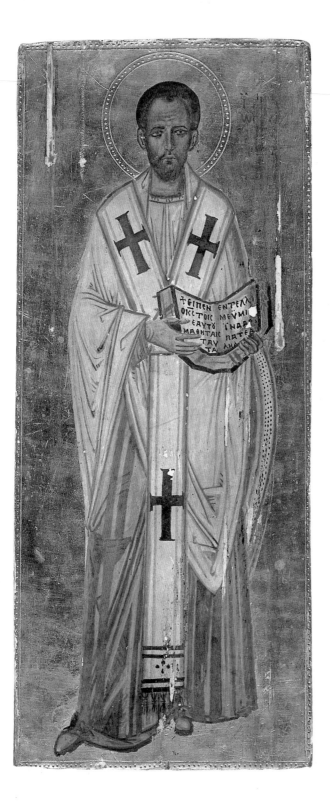

Chrysostom, who had been Patriarch of Constantinople (d. 407), was pictured speaking these words of Christ to the apostles' sucessor in Rome, as a reminder of the need for *agape* (a complex word approximately equivalent to 'love'). It is difficult to see the image of Chrysostom as having a specific connection with the relic of the True Cross, but the making of the object may recall a tradition of donations to the papacy: the earliest surviving reliquary cross sent to the popes was a gift of Emperor Justin II (r. 565–78) and his wife Sophia (and we previously encountered a cross relic sent by Patriarch Nikephoros in 811).

There are relatively few surviving painted icons from the century or more after the end of Iconoclasm in 843, and it is not immediately clear why this should be so. One possibility is that works in ivory, gold, enamel and other materials came to be used increasingly as icons, instead of wooden panels decorated with pigments and gold leaf, in the desire to make these objects as precious as possible. The characteristic ivory of the early period is the diptych (*eg* 43), but after Iconoclasm that position is taken by the triptych. An example is the Harbaville Triptych (named after a nineteenth-century owner) now in the Louvre in Paris. On the outside of its wings (122) are two ranks of saints, separated by a row of medallions. Most of the saints are bishops, but Cosmas and Damian also appear. On the back is a cross above luxuriantly flourishing plants. When the object is opened (123), the principal panel shows the Deesis: a prayer of intercession to the enthroned Christ by John the Baptist (called the Prodromos – the 'forerunner' of Christ) and the Theotokos on behalf of the viewer. Beneath are five apostles: Peter flanked by James and John, Paul and Andrew. The inside faces of the wings are similar in layout to the outside, but military saints rather than bishops predominate.

An ivory like this is very different in conception from the sort of composition found, for example, on a book-cover in the early period (compare 44). This triptych is an object on which the viewer is to focus prayer. Its images are not telling a story, or even making a doctrinal point. They act as a reminder of the hierarchy of saints, of their power, and of their willingness to pray for the viewer in the

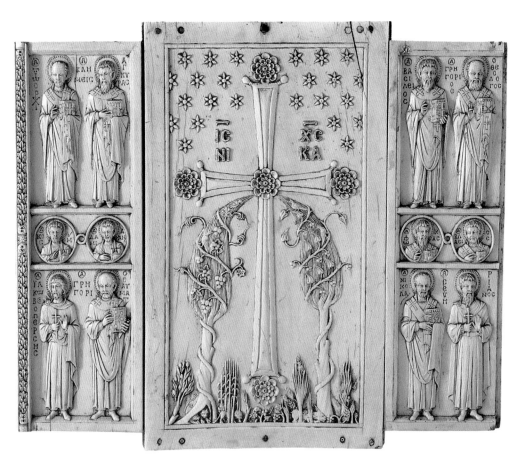

122
Bishop saints
and the Cross,
Harbaville
Triptych,
back with
exterior of wings,
10th century.
Ivory;
24 × 14·3 cm,
9½ × 5 in (central
panel).
Musée du Louvre,
Paris

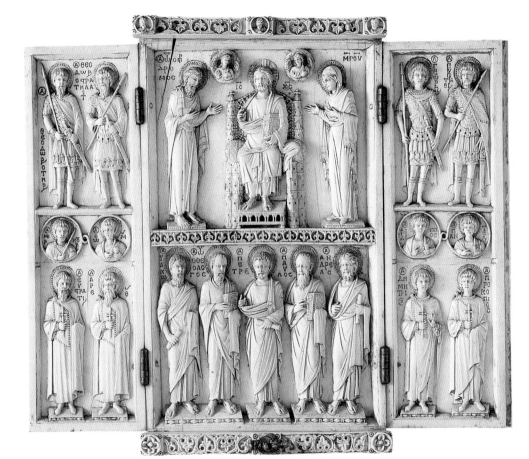

123
Deesis and saints,
Harbaville
Triptych,
front with
interior of wings,
10th century.
Ivory;
24×14·3 cm,
9½×5 in (central
panel).
Musée du Louvre,
Paris

presence of God. There are very similar triptychs now in the Vatican and the Palazzo Venezia Museum in Rome. A question that all three raise is how and where they were intended to be displayed. Because the wings are shorter than the main panel, even if swung forward to 45 degrees they could not act as supports. Each must therefore have had a special stand. Because they are relatively small (each 24–5 cm, 9½ in tall), they could only have been used for individual devotion – most likely in a church, either on an altar or on a special 'lectern' or icon-stand, but also possibly in a private context.

An ivory triptych (124) known as the Borradaile Triptych now in the British Museum must have focused a Byzantine viewer's thoughts in a different way. (Its wings, canted forward, would allow it to stand freely on a flat surface.) In terms of its iconography, the wings are treated in a similar fashion to the Harbaville Triptych, but the central panel is entirely occupied by an image of the Crucifixion. Mary lifts part of her veil with one hand and stares fixedly to the right. St John seems by his gesture to accept the event, while averting his eyes. The words of Christ from the cross are inscribed beneath its arms: '[Woman] behold thy son! [Then saith he to the disciple,] Behold thy mother!' (John 19:26–7). The Crucifixion image invites meditation on the life of Christ, and focuses on the coexistence of the human and the divine. It is a reminder of Christian truths, and in this context the flanking saints are present as witnesses to that truth.

This scheme too is found repeated and adapted to make slightly different points, as in the ivory triptych (125) now in the Cabinet des Médailles of the Bibliothèque Nationale, Paris. Striking in this case is the inclusion of Constantine and his mother Helen – a reference to the discovery of the True Cross, and the cult of its relics. Note how the imperial pair are here dressed as contemporary Byzantine rulers.

An ivory which by its shape would appear to be the central panel of a triptych, but which lacks any trace of wings, adapts the Crucifixion type to make a very different point (126). Inscriptions identify the flanking figures as Romanos and Eudokia, king (*basileus*) and queen 'of the Romans'. Assuming the Romanos in question to be the son of Constantine VII (*ie* Romanos II), the ivory was made between 944 and

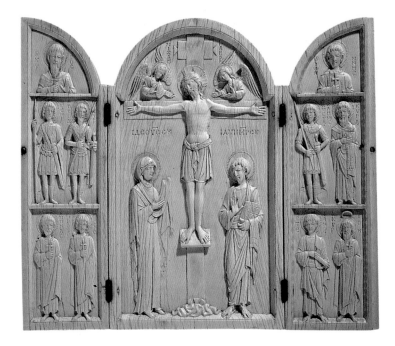

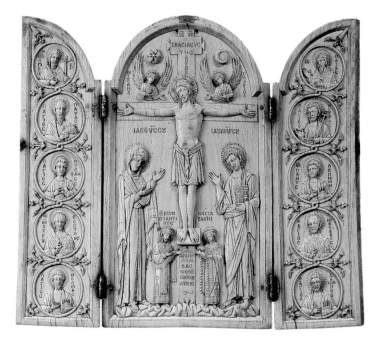

124
Above
The Crucifixion
and saints,
Borradaile
Triptych,
10th century.
Ivory;
27·2 × 15·7 cm,
10³⁄₄ × 6¹⁄₄ in
(central panel).
British Museum,
London

125
Below
The Crucifixion
and saints,
10th century.
Ivory triptych;
25·2 × 14·5 cm,
10 × 5³⁄₄ in
(central panel).
Cabinet des
Médailles,
Bibliothèque
Nationale, Paris

126
Right
Christ Crowns
Romanos and
Eudokia,
the 'Romanos
Ivory', 944–9.
24·6 × 15·5 cm,
9³⁄₄ × 6¹⁄₈ in.
Cabinet des
Médailles,
Bibliothèque
Nationale, Paris

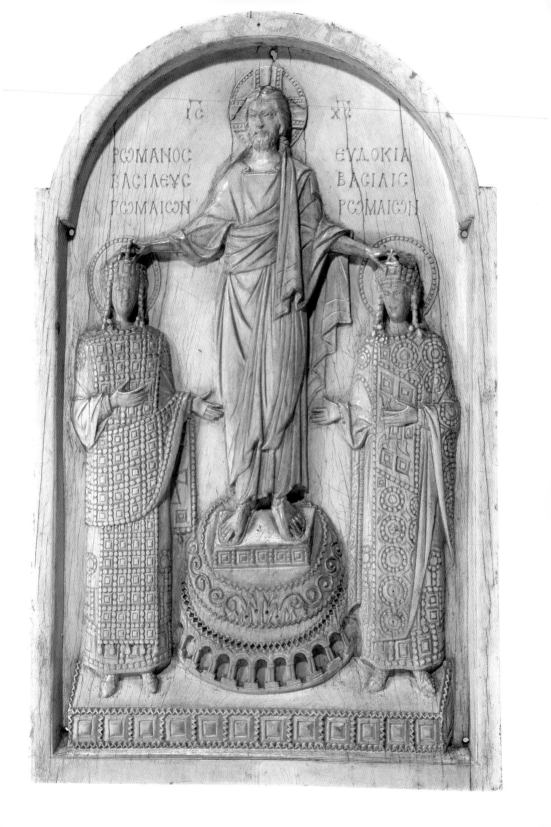

949 (the identification and date have been disputed, however). Romanos and Eudokia are shown in the same position as Constantine and Helen (see 125), but between them, instead of the Cross, stands the living Christ on a tall plinth. With a gesture reminiscent of the Crucifixion he stretches out his hands to place crowns on the heads of the emperor and empress. Although this is often said to be an image of coronation, and hence to refer to a specific moment, in fact it makes a much more general point by showing that the couple receive their crowns, and hence rule the empire, with Christ's assistance. This image might seem to us to risk censure by adapting Christian imagery so blatantly to endorse imperial power, but to a Byzantine viewer it must have been acceptable. Observe how the imperial couple do not humble themselves at the feet of Christ (contrast 105) but stand on a jewelled plinth. Nor are they diminutive figures in comparison to Christ – like Constantine and Helen – but have the same stature as Mary and John in Crucifixion groups of the Borradaile Triptych type. Indeed, were Christ not raised up he would scarcely be able to reach the imperial crowns.

Because most Byzantine ivories preserve at best only a few traces of their original gilding and colouring, it is impossible to know the full visual effect they originally had. These features survive in cloisonnée enamel, however, making it possible to identify a major change of taste, or at least of technique, in the decades around 900. A crown of Emperor Leo VI (r. 886–912), now in the treasury of St Mark's, Venice (127; note that it has been adapted at some stage for a different use), shows a highly refined version of the technique practised earlier in the ninth century (compare 96–7 and 98). The individual enamel panels are small, the surface is entirely coloured, and the figures are set against a background of translucent dark green. Later enamels, however, are almost always set against gold backgrounds, with the enamelling reserved for the central figure, enabling much larger panels to be made. Although such enamels often appear to be inlaid in blocks of solid gold, the effect is usually achieved more economically by the use of thin plates of gold for the front, back and sides, with a hollow interior.

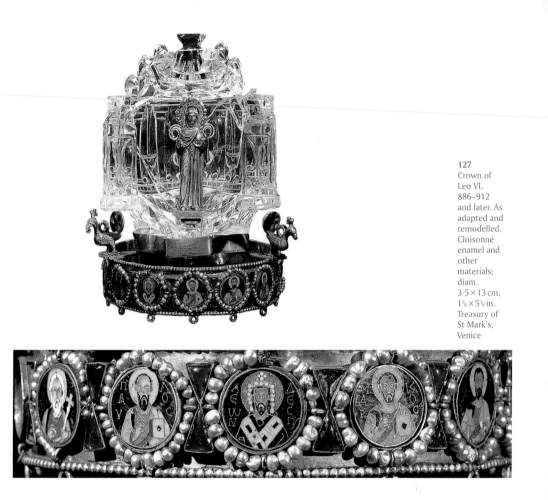

127
Crown of
Leo VI,
886–912
and later. As
adapted and
remodelled.
Cloisonné
enamel and
other
materials;
diam.
3·5×13 cm,
1⅜×5⅛ in.
Treasury of
St Mark's,
Venice

We have already looked at cross reliquaries in various techniques. One of the finest examples, in which the new enamelling procedure (or aesthetic preference) is apparent, is preserved in the Diocesan Museum at Limburg an der Lahn (128–9). Known as the Limburg Reliquary or *staurotheka* (cross-receptacle), it was taken to Germany from Constantinople after the city was sacked in 1204 (see Chapter 9). It measures 48×35×6 cm (19×13¾×2⅜ in), and was presumably intended for display like an icon. The hoop at the top could have been used to suspend or carry this 'reliquary icon' in processions. It is constructed with a sliding lid that can be removed to reveal the relic that is housed in a hollowed-out space within (129).

The outer framing element on the cover is a long iambic inscription, naming the donor, the imperial official Basil the *proedros* (president),

128–129
Overleaf
Limburg
Staurotheca,
968–85.
Hammered gilt
metal, enamels,
gems, on a
wooden core;
48×35×6 cm,
19×13¾×2⅜ in.
Diocesan
Museum,
Limburg an
der Lahn
Left
Exterior
(lid closed)
Right
Interior
(lid removed),
cross relic of
945–59 within
enamelled
setting of
968–85

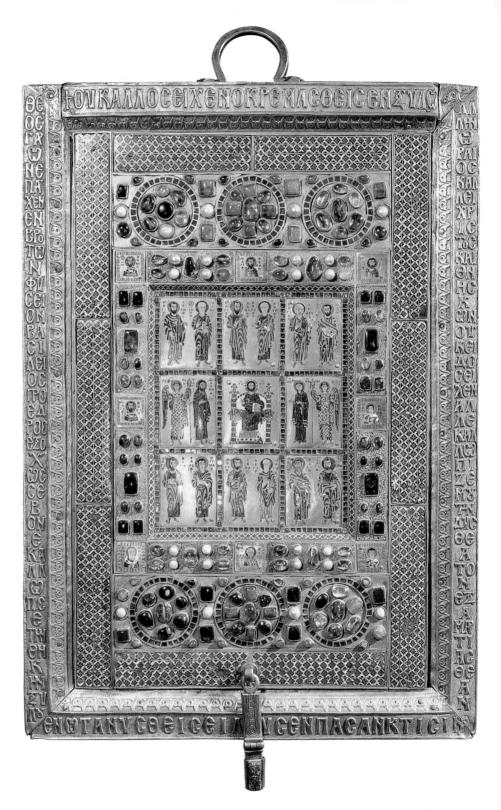

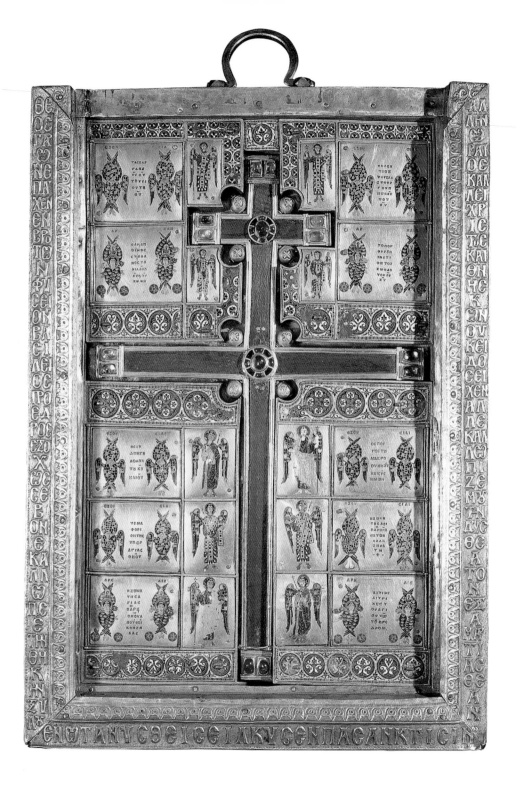

and playing on the word *kallos* (beauty). The lengths to which Basil goes to emphasize his beautification of the relic leave no doubt that in its own time (as now) this would have been considered a work of unsurpassed visual appeal. Basil, the illegitimate son of the emperor Romanos I (r.920–44), is known from other surviving works as an important commissioner of art. The title *proedros* was invented and given him by Emperor Nikephoros II Phokas in 963, and the reliquary must antedate his fall from favour in 985.

The remainder of the cover is assembled from smaller elements. Long strips of cloisonnée enamel forming stepped patterns provide an inner frame. Within this are settings of precious stones and eight small enamels with busts of saints. Finally, in the centre is a pattern of nine enamel plaques: at the centre the enthroned Christ, flanked by St John the Baptist, the Theotokos, and two archangels (an expanded Deesis). Above and below are twelve apostles in pairs. A striking element of the decoration of the reliquary cover is that it makes no visual reference to the relic within. Perhaps the shape of a cross can be read in the nine enamel plaques, but had the artist wanted to emphasize this it could easily have been done more conspicuously. The reliquary when closed, therefore, was a focus of prayer. With its cover removed, the object looks completely different. A removable cross dominates the setting (the relic of the 'precious wood', as the Byzantines termed it, consists of seven small slivers hidden beneath the central jewel of the cross). The cross has an inscription around its edge (not visible until it is lifted out of its setting) recording that it was adorned by the emperors Constantine and Romanos (hence in 945–59) and was intended 'to crush the barbarians'. The contribution of Basil the *proedros* was thus in part to provide a magnificent setting for a quite recently constructed imperial relic.

The reliquary cross is flanked by decorative enamelled borders and by ten angels (or archangels). There are also ten further panels, arranged symmetrically to either side. Pairs of seraphim and cherubim with wheels (called Principalities and Powers, later identified among the nine orders of angels; compare Colossians

1:16) flank inscriptions. As is always the case in Byzantine art, inscriptions have a definite purpose, in this case revealing that each panel covers a further relic: of the Crown of Thorns, of Christ's purple robe, of the *maphorion* (veil) of the Theotokos, of the hair of John the Baptist, and so on. (The Fieschi-Morgan Reliquary had similar flanking compartments, although they now lack lids.) The Baptist's hair is especially relevant, since it was brought to Constantinople only in 968 (or 975): Basil's enamelled setting must thus postdate its arrival.

Once again the imagery does not by itself identify the object, it emphasizes instead its power, through connecting it with God. Both iconoclasts and iconophiles, as seen in Chapter 4, had accepted the Cross as an image of God. The implication of these enamels is that the viewer looks with the angels, the powers and dominions, not only at a relic of Christ's Cross, but at an image of God himself. Like the cross of Constantine VII and Romanos II that it houses, Basil's reliquary will thus be able to crush the enemies of the empire. Perhaps, it has been suggested, it was intended to be carried by the emperor on campaign.

A further technique, allowing the production of large-scale icons, was the use of *opus sectile* (decoration using shaped slabs of coloured marble). This had been widely employed in the early period for geometric and non-figural decoration, as in St Sophia, or in Ravenna or Poreč. How widespread the making of figural images in this technique might have been, either before or after Iconoclasm, is hard to say – probably it was always a rarity.

In excavations in the church in Constantinople founded by the imperial official Constantine Lips and dedicated in 907, a well-preserved panel of St Eudokia was discovered in 1929 (130). It is now in the Istanbul Archaeological Museum. It shows the saintly empress, wife of Theodosius II (r. 408–50), standing in an orant pose. The Prokonnesian marble plaque was very carefully cut, and a variety of coloured marbles used as inlays to fashion the figure. Smaller fragments of similar plaques were discovered at the same time. The overall height of the panel is about 68 cm (27 in), suggesting that it

might have been incorporated in the church's marble revetment, relatively close to the viewer, but a lack of comparable *opus sectile* panels makes it difficult to be certain. Some fragments of painted ceramic revetments and icons of saints (for example those now in the National Museum of Archaeology in Sofia, Bulgaria; the Musée National de la Céramique at Sèvres, France; or the Walters Art Gallery in Baltimore, USA) may be considered a less costly imitation of this technique.

The St Eudokia panel acts as a reminder that our ability to know about what artists were producing in these centuries is always determined (in ways that we cannot avoid) by what happens to have survived. This, however, is not a counsel of despair – on the contrary, it should inspire us to greater efforts to understand what we have.

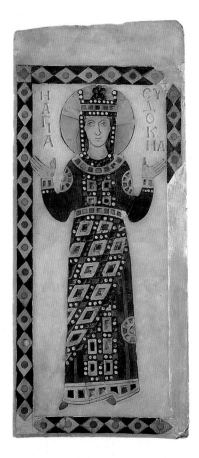

130
St Eudokia, 907.
Marble and *opus sectile*; 57·5 × 27 cm, 22⅜ × 10⅝ in (framed area). Archaeological Museum, Istanbul

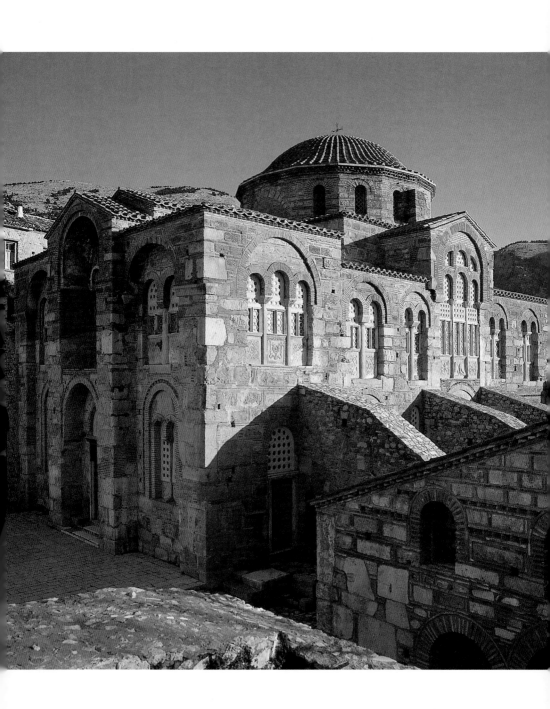

No two Byzantine churches are, or were, the same. Differences of
site, of plan, of financing, of use, of decoration, of subsequent history
and many other factors when taken together ensure that every build-
ing needs to be considered on its own terms. Nonetheless, certain
shared features of Byzantine churches of the post-iconoclast period
distinguish them, for example, from those of the same period in
western Europe as well as from those of the early Byzantine period. It
is, therefore, worth looking at a few churches in detail, not because
they are normative and dictate what others will be like, but because
they are symptomatic – others will resemble them to some degree.
The monuments considered in this chapter are later than those
encountered in Chapter 5. This is in part due to accidents of survival,
and in part in order to gain a broader view of Middle Byzantine art.
The period covered is from approximately the 960s to the early
1100s, or in dynastic terms from the later Macedonian emperors to
the first of the Komnenians.

131
Katholikon,
Osios Loukas,
Greece,
early 11th
century.
Southwestern
exterior

Because the interior decoration of the great aristocratic and imperial
foundations in Constantinople in this period are known, if at all,
largely from descriptions alone, we must look outside the capital
for surviving examples. On a sloping site in the foothills of Mount
Hellikon, some 80 km (50 miles) by road to the west of Thebes
(northwest of Athens), is the monastery of Osios (sometimes written
Hosios) Loukas (Saint, or Holy, Luke; 131) The walled enclosure is
dominated by what appears to be a complex and irregular church
(132), which turns out on closer inspection to be two adjacent
buildings (most clearly seen in the plan, 133). The principal church,
or Katholikon, is the structure to the south with the larger dome. Its
interior contains extraordinarily rich decoration of marble-revetted
walls and mosaic-covered vaults (134). But how and why should
such a costly undertaking have been associated with a little-known
saint (for Loukas is not the evangelist of the same name) in an

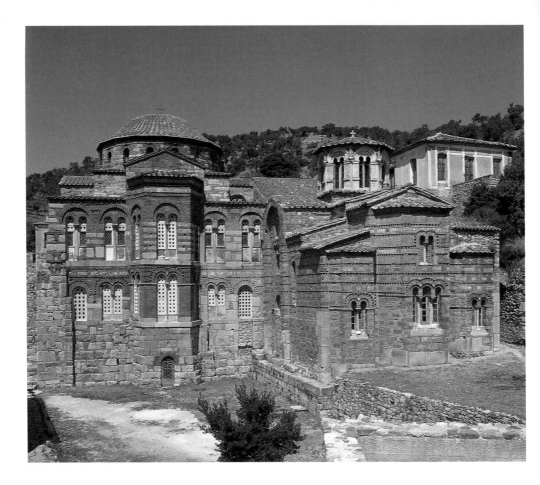

out-of-the-way setting? Fortunately we can piece together some answers, although not by any means the whole story. Before doing that, however, we should examine the Katholikon more closely.

The principal architectural feature of the Katholikon is its large dome, almost 9 m (30 ft) in diameter. This is supported on a square base, the transition from square to circle being made via an octagon created by squinches. Below this the church's eastern end opens into the *bema* (the Byzantine term for the sanctuary or presbytery), which is covered by a domical vault and terminated by the apse with semi-dome above. The remainder of the main body of the church, the *naos*, is divided into two storeys by a gallery supported on piers and columns. The structure is massive, but lit by numerous windows which enliven the reflective curving surfaces of the mosaic and the

132–133
Katholikon
and Panaghia
church,
Osios Loukas,
late 10th and
early 11th
century
Left
Eastern
exteriors
Right
Plan of both
churches

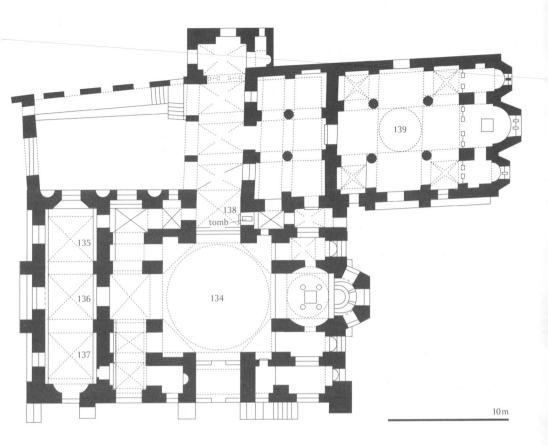

gleaming walls of polished marble. The church is entered from the west through a *narthex* (the Byzantine term for this type of vestibule). The vaults of the *narthex* are low (due to the gallery above), and the viewer is at once confronted by powerful mosaic images. A large bust of Christ Pantokrator (136) is placed over the door to the *naos*, displaying the text: 'I am the light of the world; he that followeth me shall not walk in darkness but shall have the light of life' (John 8:12). To either side are scenes from the life of Christ: the Crucifixion (135) and Anastasis (137). The Washing of the Feet, and Doubting Thomas are to north and south. The scenes are treated with a minimum of extraneous detail, and the gold setting dominates all. The vaults are filled with busts of the Theotokos, archangels and numerous saints; the transverse arches with the apostles.

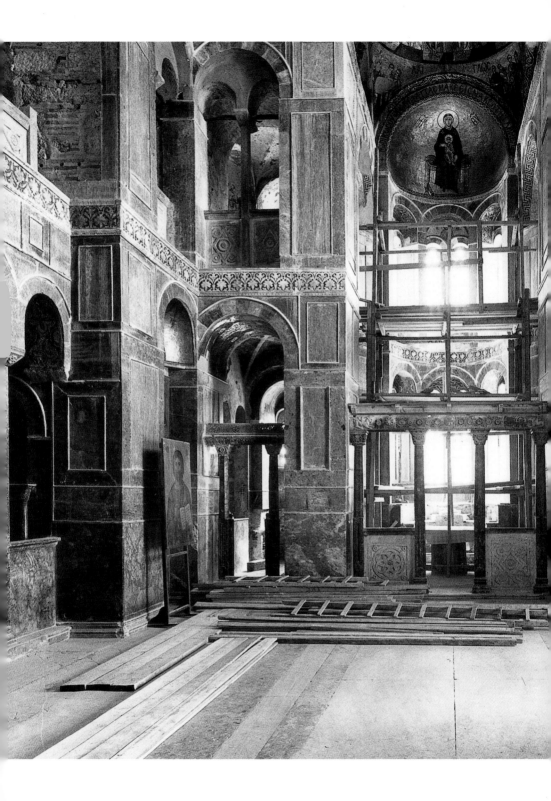

134
Katholikon,
Osios Loukas,
before 1048.
Looking east

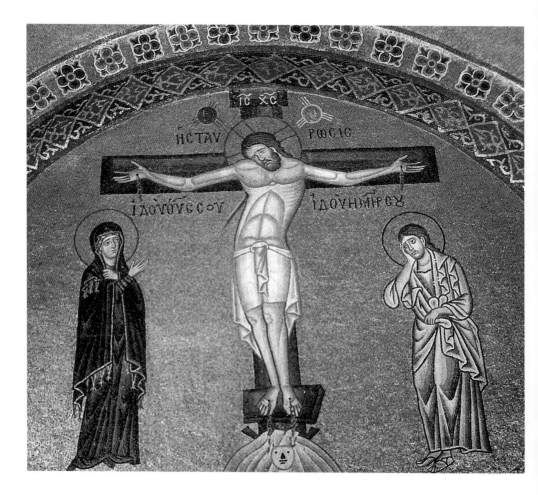

135–136
Narthex mosaics.
Katholikon,
Osios Loukas
Above
The Crucifixion
Right
The Pantokrator

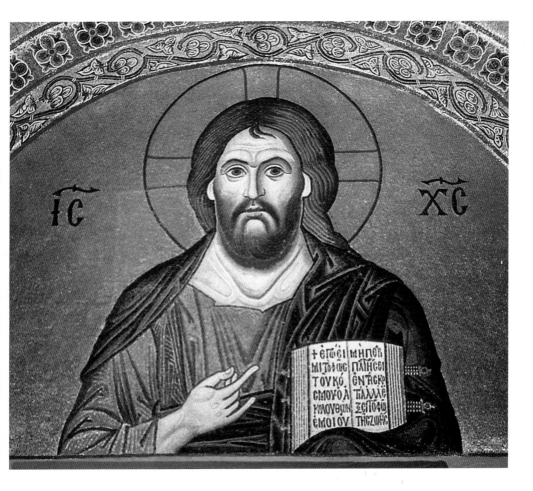

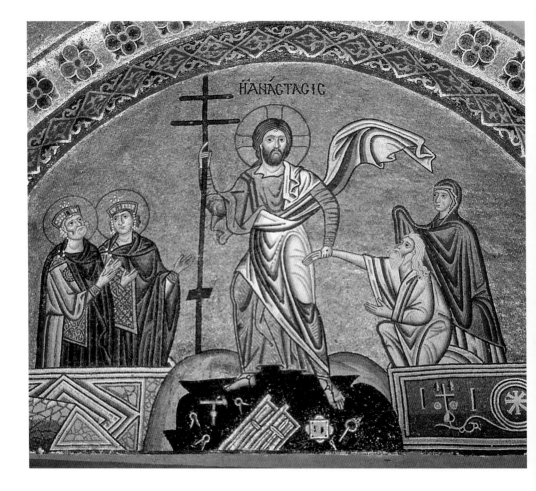

On entering the *naos* (134), the eye is drawn to the apse mosaic: an enthroned Theotokos and Child. An image of Pentecost fills the domical vault above the altar. The dome mosaics were destroyed by an earthquake in 1593, but it is thought that a painted decoration reproduced what was there before: a central Pantokrator with the Theotokos and five angels below, and prophets between the windows of the drum. Moving down, the squinches are occupied by further scenes from Christ's life: the Annunciation (lost), Nativity, Presentation and Baptism. Throughout the rest of the church the decoration consists of many further images, principally of saints in mosaic or, in the less well-lit side chapels, in fresco. Of special significance to the site is the image of Osios Loukas himself (138), above the space where his relics are preserved. This space was obviously intended to receive and focus devotion on the holy man around whom this impressive religious complex grew up.

137–138
Mosaics.
Katholikon,
Osios Loukas
Left
The Anastasis
Above
St Loukas

According to the text of the *Life* (Greek *Bios*, Latin *Vita*) of Osios Loukas, written in the decade after the saint died in 953, Loukas had been born locally and at the end of an eremitic life returned to this particular place in 946. Because of his miracles, a church was erected near his cell at the expense of the military commander of the *thema* (the Byzantine administrative province) of Hellas (corresponding to east-central Greece), whose residence was at Thebes. This church was dedicated to St Barbara. After Osios Loukas's death, and probably in 961–6, a 'most beautiful, cross-shaped eukterion [martyrium]' was built over his tomb, which was on the site of his cell. This is said to have been donated by Emperor Romanos II in gratitude to the saint, who had prophesied the recapture of the island of Crete from the Arabs (in 961). Some thirty years later, perhaps at the expense of the empress Theophano, widow of Romanos II, the original church was rebuilt in a much grander manner and dedicated to the Panaghia (all-holy) Theotokos. In the next generation, and before 1048, the present Katholikon was built, incorporating it would seem the crypt and some upper parts of the cross-shaped *eukterion*. Regrettably, the precise date and patronage of the Katholikon are uncertain, although it is possible, even if the evidence of prior imperial involvement is at best slender, that an emperor or empress was among the benefactors.

Until the present Katholikon was built, the Panaghia or Theotokos Church (the smaller of the two surviving structures) would have been the main church (*katholikon*) of the monastery, and it is worth examining the ways in which it differs from its successor. Its interior is now quite bare (139), with no trace of marble revetment or mosaics, and only some small areas of later frescos (it was stripped of later accretions for reasons of conservation in 1971). The carved *templon* screen, however (see Chapter 9), suggests that no expense was spared to achieve an impressive effect, and this is confirmed by the treatment of the exterior (132). The individual ashlar (squared stone) blocks are each surrounded by thin bricks on all sides in the technique called 'cloisonné brickwork'. The treatment of the wall surface becomes increasingly decorative with height, and specially moulded bricks were used to provide kufesque patterns (based on the kufic version of Arabic script). The windows of the tall dome are

flanked by decorative marble panels and surmounted by marble hoods. Originally the interior, too, would surely have been lavishly decorated.

The interior space of the Panaghia Church is organized in what is known as the cross-in-square plan. Working from the top of the building downwards, the dome is small (only about 3·4m, 11ft across) and central (133). It is supported on pendentives, which make the transition from a circle to the four corners of a square. At this level the central square is then opened into an equal-armed cross by four high barrel vaults. Beneath, it is supported on four columns, allowing the lower parts of the cross to be opened up by arches so as to include the outer square formed by the exterior walls. To the east are three apses. On either side of the central *bema*, and connecting with it, are chapel-like spaces called *pastophoria*: to the left (north) the *prothesis*, where the priest prepared for the liturgy, and to the right (south) the *diakonikon*, which acted as a sacristy. This arrangement of triple apses is characteristic of Byzantine churches after Iconoclasm, although its origin is in the early period. To the west is a *narthex* that was extended at a later date. The church is tall, especially beneath the dome and crossing, but not very large. Even with the extended *narthex* it could never have accommodated the numbers that the Katholikon, with its additional gallery, would have accepted.

One of the strangest features of the two churches at Osios Loukas is the way that the Katholikon was built up against the southwest corner of the Panaghia Church. There is no doubt that this was due to the desire to retain the connection with the holy site of the saint's cell and tomb (marked on the plan, 133). Pilgrims could easily circulate around the tomb through the various doors and openings between the two churches. Meanwhile, the crypt beneath the Katholikon – an unusual feature for a Byzantine church, but one necessitated by the sloping site and the complex building history – was used as a burial chapel for the monastery's abbots, and richly decorated with wall-paintings closely related to the mosaics in the church above.

A final remarkable feature of Osios Loukas is the sheer volume of building activity that was generated around the cult of a popular saint. The monks of Osios Loukas must have grown used to the sight of the massive wooden scaffoldings required for such building operations. They must frequently have been in use from the 960s perhaps to the 1040s. The buildings constructed by the Byzantines of these centuries may have been on a smaller scale than in the time of Justinian, but they were built to last. Massive buttresses now support the Katholikon on its south side, but to erect these tall domed and vaulted structures at all – on a hillside in a region prone to severe earthquakes – was bold. Those who promoted and financed the project doubtless believed that Osios Loukas would help to preserve his church.

The mosaic decoration of the Katholikon of Nea Moni (New Monastery) on the Aegean island of Chios (140) presents a range of interesting contrasts to and comparisons with Osios Loukas. The imperial patronage of Nea Moni is as certain as that of Osios Loukas is obscure. About thirty surviving or postulated chrysobulls – imperial documents authenticated with a gold (*chrysos*) seal (*boulla*, Latin *bulla*) – deal with the monastery. The two earliest date from 1044, and are in the name of the emperor Constantine IX Monomachos (r. 1042–55). But the monastery must have been founded before Constantine married the empress Zoe, who had reigned briefly in her own name with her sister Theodora (r. 1042), after the death of her second husband, Michael IV (r. 1034–41), for there are references to a chrysobull from that period. Construction of the Katholikon may not have begun until 1043, for it is said to have taken twelve years and to have been completed in the sole reign of Empress Theodora (r. 1055–6).

Nea Moni, like Osios Loukas, has an eremitical connection, but in this case not with a single holy man but with three hermits: Niketas, John and Joseph. They are said to have found a miraculous icon of the Mother of God, marking a site on Mount Probateion at which a church in her honour was to be constructed. The monastery thus came to be dedicated to the Theotokos, but it was never a major goal

140–141
Nea Moni,
Chios, Greece,
1042–55
and later
Above
View from
the south
Below
Plan

10m

of pilgrimage. The interest of Constantine Monomachos in Nea Moni is said to date from his period of exile on the nearby island of Mytilene (1035–42), when the hermits prophesied that he would attain the throne and gained the promise of his support. (This tradition glosses over the prior support of the empresses Zoe and Theodora.) The founding fathers seem to have worked hard to win and maintain imperial favour, and they were able to keep up their connections with the palace after 1042 by maintaining a residence in Constantinople.

Architecturally, Nea Moni is related to the Katholikon of Osios Loukas only in its use of a large dome on an octagonal base. The result in spatial terms is entirely different (141). The Katholikon of Nea Moni has no aisles or galleries. The *naos* is approximately square in plan, about 8·4m (27ft) per side. It consists of a large open space, roughly cubic in proportions, which is transformed in its upper parts into an octagon by eight conches, those at the corners of the square deeper than those on its sides. The octagon is then rounded into the base for the large dome. The present dome replaces one brought down by an earthquake in 1881, and is about 6·5m (21ft) in diameter (it is no longer circular). Because it covers virtually the entire width of the *naos*, from the exterior the dome looks disproportionately large. The dome that fell in 1881 was somewhat lower than its replacement; its internal height of some 15·62m probably represents 50 Byzantine feet.

To the east the *naos* opens into the three apses of the *bema* through a low arcade. In plan this looks like the arrangement in the Panaghia Church at Osios Loukas (133), but in elevation, and in practice, the result is completely different from either church at Osios Loukas: the apse is not viewed through a high vaulted space but is screened by a low arch that rises to only 3·4m (11ft). As a result the apse mosaic only becomes visible from close to, and the viewer's attention is largely restricted to contemplation of the central domed space of the *naos* (142). To the west, a single door leads from the *naos* into an inner *narthex*, which has a blind (or windowless) dome – in contrast to the domical vault at Osios Loukas. To the west of the inner *narthex*

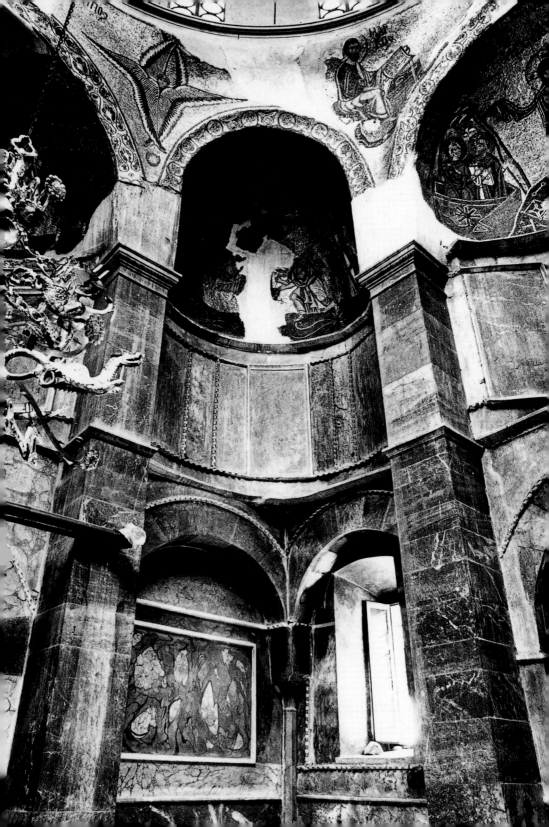

is an outer *narthex* surmounted by three domes, with large apsidal projections to north and south. This structure seems to have been an afterthought, although part of the original building campaign, and to have functioned at first as a porch.

Later tradition provides an intriguing insight into the origin of the plan for the Katholikon of Nea Moni. We are told that the founding fathers were permitted by Constantine IX Monomachos to copy the plan of any church in Constantinople (except St Sophia) for their own, and that they chose 'the smaller church of the Holy Apostles'. It has recently been argued that this description identifies the model as the Mausoleum of Constantine, known to have been a domed, central-ized structure, attached to the cruciform church of the Holy Apostles. Perhaps the choice was prompted by a desire to flatter the current emperor by reference to his illustrious namesake. In any event, we can assume that the concept of 'copying a plan' was interpreted freely by the eleventh-century architect.

142
Nea Moni,
Chios.
Interior
looking
northwest

The mosaic decoration is found in all parts of the building except the outer *narthex*, above the remains of a rich marble revetment. As at Osios Loukas, collapse of the dome has meant loss of the mosaics of that area, although these had probably already been destroyed by fire in 1822. But earlier descriptions reveal that there was a central image of Christ Pantokrator, presumably in a medallion, with standing angels below. The original dome, as revealed in photographs of 1881, was constructed with nine sides and nine windows, although it now has twelve. Since the decision to place a nine-sided dome on a square base must have caused the builders some problems, and the only other surviving Byzantine nine-sided dome is in the church of Holy Apostles at Pyrgi on Chios, which is a close copy of Nea Moni, the use of this highly unusual form requires explanation. The motivation must have been not architectural but decorative, with the design of the dome selected specifically to allow the mosaicists to set up images of the nine orders of angels (as discussed, for example, by St Dionysius, who wrote a long text on the celestial hierarchy around the year 500). This would have been one of the ways in which the architect was required to modify whatever plan he had derived from

the 'smaller church of the Holy Apostles' in order to satisfy local requirements. It follows, too – and this is worth emphasizing – that the overall plan for the mosaic decoration of the building must already have been worked out before construction had reached the dome. The architecture was conceived as a setting for the images it was to contain.

Where the mosaics survive it can be seen that they differ in various ways from those at Osios Loukas. In the conch of the main apse is a standing Theotokos with her hands raised in a gesture of prayer (rather than an enthroned Mother of God and Child). The figure of an orant Theotokos in the apse has precedents, but in this case the choice may have some connection with the miraculous icon that led the founding fathers to the site, for this is specifically said to have represented the Theotokos 'without the Holy Infant'. The mosaic of the vault over the altar (a Pentecost at Osios Loukas) is lost. Bust-length figures of the archangels Michael and Gabriel occupy the conches of the apses to either side. In the curved spandrels beneath the dome were the four evangelists (Matthew is lost) and seraphim. The eight conches beneath are decorated with eight scenes from Christ's life (the squinches at Osios Loukas only provide room for four): the Annunciation, the Nativity (now lost), Presentation in the Temple, Baptism, Transfiguration, Crucifixion (144), Descent from the Cross (142, an unusual choice – there is a painted example in the crypt of Osios Loukas), and Anastasis (143). The spaces are awkward – wide, shallow niches alternating with narrower deeper ones. In comparison with Osios Loukas, these scenes at Nea Moni contain more figures and more indications of landscape and setting. The often encountered idea that images such as these from the life of Christ form a sort of calendar of the main feasts of the Church year is called into question by the inclusion of the Descent from the Cross. In festal terms, this cannot be distinguished from the Crucifixion – both occur on Good Friday. They must, therefore, have been selected for inclusion on other grounds.

A surprising feature of the Anastasis (143) is that Solomon is shown with a dark beard (in the mosaic he is the king closer to Christ on the

143–144
Mosaics,
1042–55.
Nea Moni,
Chios
Above
The Anastasis
Below
The Crucifixion

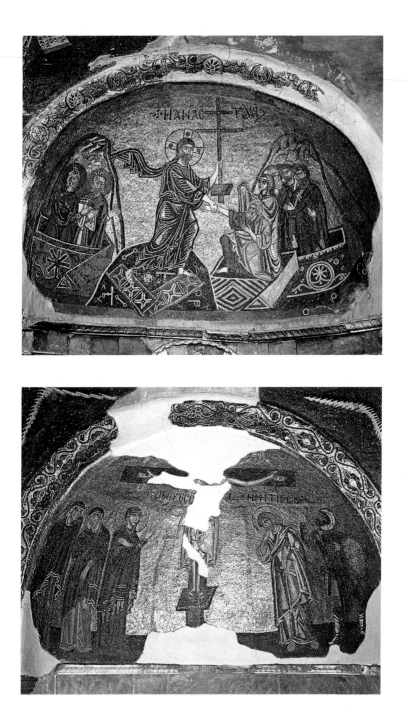

left). Elsewhere in Byzantine art he is always young and beardless
(*eg* 137), in contrast to the grey-bearded image of his father, David
(the only other known case of a bearded Solomon in the Anastasis is
on a fifteenth-century icon). It has been proposed that the bearded
Solomon at Nea Moni was introduced specifically to draw a flattering
parallel between the biblical king and the current Byzantine emperor,
Constantine IX Monomachos. Were this the case (and there must be
some special reason for Solomon's beard), it is important to remem-
ber that the intended viewers of this image of imperial ideology were
the monks of Nea Moni, not the emperor himself. Like the nine-sided
dome, the idea could have come from outside, but it seems more
likely that it was a requirement or suggestion put forward locally by
the founding fathers.

The *narthex* of Nea Moni is treated more like the Katholikon of Osios
Loukas. Of the semicircular panel over the door from the *narthex* into
the *naos* – a key image because of its visibility – little remains. But
this was certainly an image of Christ, as at Osios Loukas, although
the text in the open book is said to have been 'Come unto me all ye
that labour and are heavy laden and I will give you rest' (Matthew
11:28; an unusual choice). At Nea Moni the Theotokos in the centre of
the blind dome of the *narthex* is surrounded by images of standing
saints, and further busts of saints in medallions abound (reminiscent
of Osios Loukas). Awkward tall, narrow spaces beside windows conve-
niently accommodate busts of stylite saints atop their columns.
There are also further scenes from Christ's life: the Raising of Lazarus,
Entry into Jerusalem, Washing of the Feet (with the figure of Christ
repeated in three preparatory episodes above), the Prayer in the
Garden of Gethsemane (with a very long biblical inscription), the
Betrayal, Ascension and Pentecost. Thus, although the arrangement
here is a little like Osios Loukas (*eg* the Washing of the Feet is on the
north wall in both), the details of the choice and disposition of the
figures and scenes are mostly different. The images of Christ prepar-
ing to wash the apostles' feet are unique in Byzantine art, leaving
aside a single example in another church on Chios (the Panaghia
Krina), certainly based directly on Nea Moni.

The question of Solomon's beard at Nea Moni raises the issue of whether it is legitimate to interpret every small detail of a Byzantine image on the assumption that it has an intended meaning. Did the Byzantines look at or use images in this way? Evidence that they did is provided by a mosaic panel of precisely this period in the gallery of St Sophia in Constantinople (145, and see plan, 90). It shows an enthroned Christ, blessing and holding a closed book. He is flanked by the standing figures (the lower part of the mosaic is lost) of an imperial couple. They are identified by conspicuous inscriptions. The bearded emperor is: 'Constantine in Christ God Emperor (*Autokrator*), Faithful King (*Basileus*) of the Romans, Monomachos'. The fresh-faced empress is: 'Zoe Most Pious Empress (*Augousta*)'. The emperor holds a bulging money-bag, the empress a scroll on which the emperor's name and royal title are repeated. The motivation for setting up this mosaic was as follows: Constantine IX Monomachos made a major donation (the money-bag) to St Sophia, enabling the Eucharist to be celebrated every day instead of only on Saturdays and Sundays, and the scroll held by the empress records the details of the donation. The mosaic would have been set up by the patriarch in an area reserved for imperial use as a permanent reminder of imperial piety and generosity. The imperial couple seek Christ's blessing through their gift; the image shows that they receive it.

But the most curious aspect of this panel is that it has been extensively and skilfully altered. On looking carefully it can be seen that the mosaic heads of Christ and the emperor, the face of the empress, and the names 'Constantine' (which occurs twice) and 'Monomachos' have all been reset. This is most obvious in the large inscription, where the replacement letters at the start and finish are conspicuous. In the case of the heads the evidence is only visible in a break or disturbance of the tesserae running around the area in question (as in the mosaics altered as a result of Iconoclasm at Nicaea, or in St Sophia itself: compare 87 and 92). The bodies of the figures were untouched, as was the inscription identifying the empress as Zoe. The explanation must be that the panel we see was originally set up to record a donation to St Sophia by one of Zoe's previous husbands, probably her first, Romanos III (r. 1028–34). The name of her second

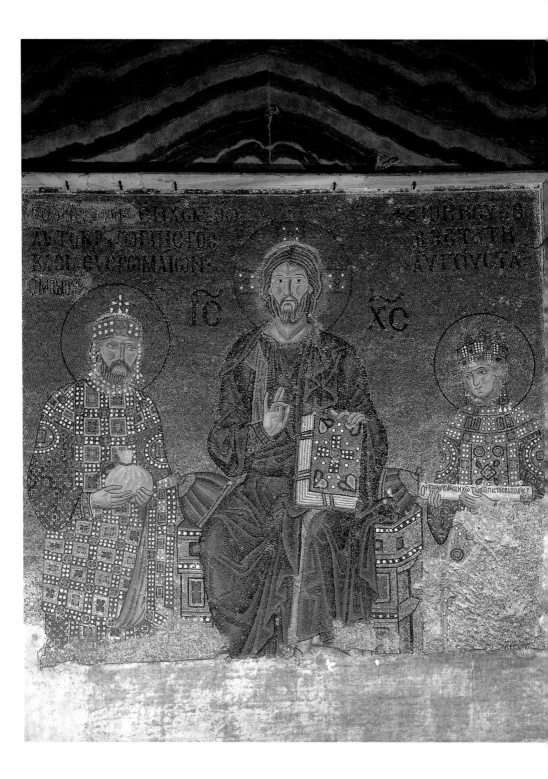

husband, Michael IV (r. 1034–41), would probably have been too short to have occupied the space where the name Constantine was inserted. A plausible motive for the first phase of the panel can also be established: after his accession, Romanos III endowed St Sophia with an annual income of 80 lb (36 kg) of gold, and it was during his reign that the church's capitals were gilded. After 1042, it was felt appropriate to alter the emperor's head, and the other heads were changed too. Perhaps it was thought fitting to flatter the empress Zoe by making her younger and more beautiful in her new image (she was already sixty-four when she married Constantine in 1042). At the same time the head of Christ was remade. Perhaps the reason for that change was that the mosaicist wished to introduce the pink cheeks that are a conspicuous stylistic trait of the faces of the imperial couple. The head of Christ was not altered so as to make him resemble the emperor (in my view at least), but all three heads conform to a stylistic convention that must have altered over the twenty or so years between the two phases of work.

Constantine Monomachos, in the judgement of contemporaries, spent vast sums on the building and decoration of churches. His foundation of St George of Mangana, near the imperial palace in Constantinople – which does not stand – was exceptionally luxurious, and large by Byzantine standards, perhaps approaching 30 m (100 ft) square, with a central dome 10 m (33 ft) in diameter, to judge from the excavation plans. Apart from his documented support for Nea Moni, he funded works inside and even outside the borders of the empire. He sponsored a major restoration project at the church of the Holy Sepulchre in Jerusalem, which had been severely damaged by the caliph al-Hakim in 1009. He even sent an annual gift of 2 lb (just under 1 kg) of gold to the abbey of St Benedict at Montecassino in Italy, beginning in 1054: not much compared to the money being poured into St Sophia, it is true, but doubtless very welcome nonetheless. But the most intriguing case of Constantine IX's art diplomacy, if that is what it was, concerns the building and decoration of the church of St Sophia at Kiev, which is agreed to have a connection with him despite the lack of surviving documentation.

The Prince of Rus' (the word for both the people and their territory, and the forerunner of modern Russia), Vladimir (sole ruler, 980–1015), was converted to Christianity in connection with his marriage to Anna, sister of the Byzantine emperor Basil II, an event traditionally dated 989. At the small settlement of Kiev he had a church dedicated to the Mother of God built by craftsman brought from Byzantium (often called the Tithe Church, it was destroyed in 1240). This church, of cross-in-square type, was the first masonry structure in Rus'. Vladimir's son Yaroslav (r. 1019–54) vastly increased the size of Kiev, which he built as a capital on the lines of Constantinople as the names he chose makes clear: the cathedral was dedicated to St Sophia, there was a Golden Gate to the city, even a monastery of St Irene. Work on Kiev's St Sophia probably began in 1037, and may have been largely completed in the 1040s (the first consecration was in 1046). It was built as the seat of a metropolitan bishop, and the first incumbent was a Byzantine, Theopemptos, sent from Constantinople. Kiev's St Sophia is a building with strong connections with Constantinople, and the senior craftsman and some of their materials probably came from there, although once on site the Byzantines doubtless hired or trained local assistants, and the bricks were made locally. Such a pattern of work is well attested through the *Paterik* ([Lives of] the Fathers) of the Cave Monastery at Kiev, founded in 1051, which has a number of accounts of artists travelling with their materials from Constantinople to work in the monastery. It does not follow that relations between Constantine IX and Yaroslav were always cordial; indeed in 1043 they fought a bitter war, although later in the 1040s it seems that a daughter of Constantine was married to a son of Yaroslav.

Architecturally, St Sophia at Kiev has parallels but no precise equivalents. It is of great interest to see how a Byzantine architect of the eleventh century coped with the requirement to build a structure capable of holding a really large congregation. The core of the plan is a cross-in-square church (146), not unlike the Panaghia Church at Osios Loukas, but employing brick piers rather than columns to support a central dome about 7·5 m (25 ft) in diameter. Around this core were added further aisles to north, south and west, terminating

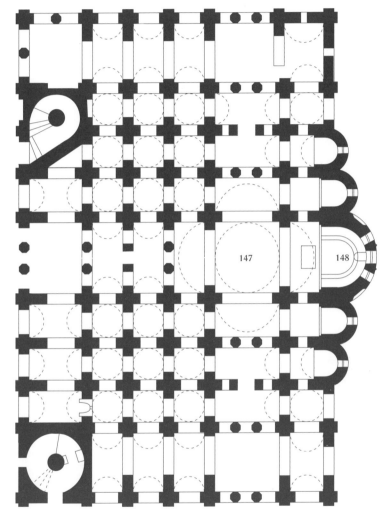

146
St Sophia,
Kiev.
Plan

147

148

10m

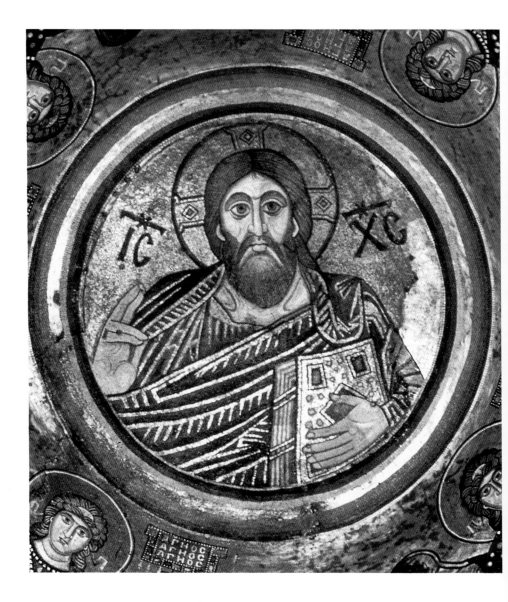

in additional apses to the east. The aisles were surmounted by a gallery, leaving the central cross open to the high vaults. There was a further ambulatory on three sides. The building had thirteen domes in a pleasingly pyramidal arrangement. The effective buttressing provided by the concentric nature of the construction enabled the builders to raise the central dome almost 30 m (100 ft) above pavement level, a height doubtless determined by its equalling the width and overall length of the five-aisled, five-apsed core. The church was further extended in the later eleventh century by an additional even wider ambulatory, but extensively remodelled in the late seventeenth century.

A combination of mosaic and wall-painting was used for the decoration, with mosaic reserved for the more important surfaces. Apart from a small area around the synthronon in the apse (the curving bank of seats for the senior clergy), there was no revetment, and marble seems to have been used only for the *templon* screen – there were neither columns nor capitals in the main body of the church. The entire wall surface thus seems to have been plastered and painted (or set with mosaic). Unfortunately the paintings are now in poor condition, although the extensive nature of the programme is not in doubt. There are many figures of saints, scenes from the life of Christ, and scenes from saints' lives. In the west arm of the *naos*, in the zone immediately above the arcade supporting the gallery, Yaroslav was depicted offering a model of the church to an enthroned Christ. He was balanced by his wife Irene, and they were followed in a procession by their sons (behind Yaroslav) and daughters (behind Irene). These frescos were placed in a very conspicuous location. Doubtless Constantinople provided the precedent for this display of the imagery of rulership.

Mosaics were used in the dome, crossing and *bema* at Kiev's St Sophia. In the dome is a Christ Pantokrator (147), supported by angels, of which only one survives. Between the twelve windows of the drum of the dome were apostles – part of St Paul survives. In the pendentives beneath the dome are the four evangelists. Medallions of saints are placed on the soffits of the supporting arches to north and

147
The Pantokrator. Dome mosaic. St Sophia, Kiev

south, with the angel and the Mary of the Annunciation visible across the opening into the *bema*. The mosaics on the eastern arch and *bema* vault are lost. The apse is dominated by an orant Theotokos (148), 5·45m (18ft) high (there was probably an orant Theotokos already in the apse of Vladimir's Tithe Church). She is surmounted by a Greek inscription, with a Deesis in three medallions above. Below the Theotokos is the Communion of the Apostles, with Christ ministering from an altar to two files of disciples. Those at the left process forward to receive the bread, while those at the right approach the wine. Below, to either side of a triple window, is a rank of bishop saints, flanking the two deacons, saints Stephen and Lawrence. The Bishop of Kiev took his seat beneath images of the great bishops of the early Church, among them Nicholas, Basil, John Chrysostom and Gregory of Nazianzos.

The reason for supposing that Constantine Monomachos must have played some role in sponsoring the work on Kiev's St Sophia is not merely because the master craftsmen came from Constantinople, nor even because of the cost of the project, high as it doubtless was. Such sponsorship would have been seen as combining imperial piety with imperial diplomacy. The building that resulted was one specially adapted to the requirements of the task (in this sense like Osios Loukas and Nea Moni). Any Byzantine entering it would have found it familiar. Only the conspicuous presence in the frescos of Vladimir and his family would have called for special comment. And they doubtless had their parallels in the various churches, chapels and reception rooms of the imperial palace(s) of Constantinople.

An intriguing aspect of Kiev's St Sophia, with implications for the study of Byzantine mosaics in general, is that technical examination has revealed the speed at which the mosaics were executed. All Byzantine mosaics were laid in a similar fashion: a preliminary layer of plaster, thickly applied, covered the inconsistencies of the wall surface (it is about 2·5cm, 1 in thick at Kiev). A second finer layer of plaster, about 1·5cm (5_8 in) thick, was laid on this, and the scheme of the decoration sketched out. The final layer, again about 1·5cm thick, was the setting bed for the mosaic tesserae. Because the tesserae had

148
The Theotokos. Apse mosaic. St Sophia, Kiev

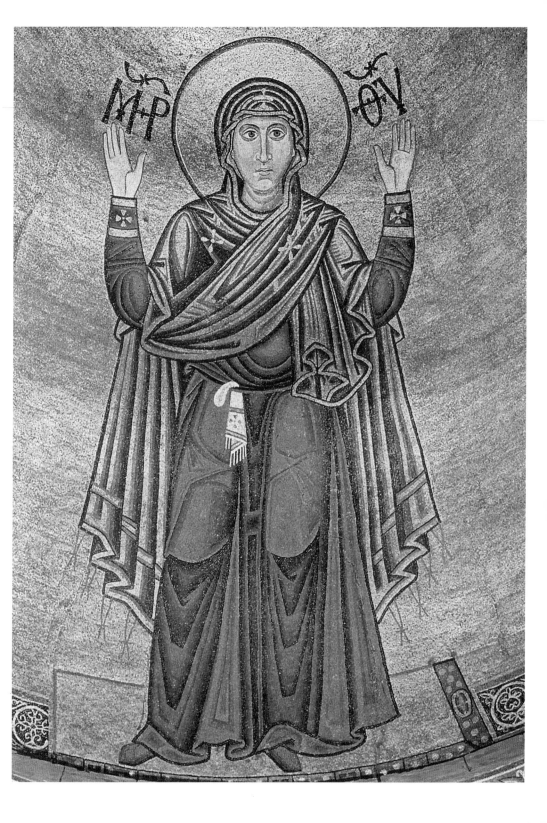

to be pressed into the plaster before it hardened, only as much of the setting bed as could be covered before it dried was plastered. These patches are sometimes termed *giornate*, by analogy with Italian fresco painting practice, and conventionally indicate a day's work. In practice, the conditions in different churches on different days, and even in different parts of the same building, will have affected the plaster's drying rate. Nonetheless, it is reasonable to assume that craftsmen would have preferred to cut away any unused plaster at the end of each day, and start again with fresh plaster the next morning. On this final plaster layer the mosaicist then painted, with great rapidity no doubt, the design he was intending to cover with tesserae. In other words he executed a fresco before covering it with mosaic. There were two reasons for this: it provided a guide, and it ensured that plaster visible between the tesserae would tone in with them (red was used under the gold). Until the moment that tesserae began to be set, the procedures for a mosaic were identical to those for a wall-painting. Every Byzantine mosaicist was thus also a master wall painter.

The mosaic cubes or tesserae, made of either glass or stone, were sorted (we can assume) into trays arranged by colour, with perhaps some further subdivision by size and shape, so that the craftsmen could select an irregular tessera if one was required. If the mosaic surface would be seen only from a great distance the craftsman economized by packing the tesserae less densely, and generally using somewhat larger cubes. In the case of gold backgrounds seen at a steep angle (compare 105), the tesserae might not only be well spaced apart in horizontal lines, but also set at an angle so that the viewer would see their reflective top surfaces, rather than their dark edges. The tesserae used in the faces were usually smaller, and this was always the most carefully worked area.

In the same way that the painter established his composition by drawing in its main lines, the mosaicist first set rows of tesserae to establish outlines, and the main drapery folds in figures. These were usually trimmed by one or two further lines of tesserae, set parallel. This is especially obvious at the junction between a figure and the

background. Gold backgrounds were then laid in horizontal lines, halos in concentric ones, and the outlined areas of figures filled in. It is often possible by looking closely at photographs to establish the relative order of work in different parts of a mosaic by studying how the tesserae were fitted in.

At Kiev, the areas worked in 'a day' varied between 1·36 and 3·75 sq.m (15 and 40 sq.ft), depending on the complexity of the design. All the work was done from scaffolding, of course, and the practicalities of cooperation between craftsmen in these circumstances have to be borne in mind – for example it would be tricky for two people to work rapidly on a surface measuring only 1·36 × 1 m (5 × 3 ft), unless one was right-handed and the other left-handed. On larger areas, however, it would be relatively easy for one person to fill in the background, while another (the master craftsman) did the tricky bits. If there was more than one master mosaicist, work could proceed in different areas of the building at the same time.

If we take 2 sq.m (22 sq.ft) as a rule of thumb for a *giornata*, the 640 sq.m (nearly 7,000 sq.ft) originally covered by mosaic at Kiev represents 320 'days' of mosaic setting. Mosaic work, like wall-painting, was a seasonal activity. It could not be carried out in the winter. At Kiev, the working season may have been April to September, somewhere between 100 and 150 working days. It is conceivable, therefore, that a team of master mosaicists – say three or four – each with an assistant, plus local labour for fetching and carrying, could have executed the entire work in one season. It is perhaps more likely, however, that two seasons would have been required.

This pattern of work characterized by the high speed and superlative craftsmanship of a small numbers of artists working freehand on the scaffolding is one that should be borne in mind whenever a Byzantine mosaic is considered.

The final mosaic decoration to be considered in this chapter is probably the best known to non-specialists, for it is in a church only a few kilometres from the centre of Athens, at Daphni. Nevertheless, it is the one that now presents the greatest challenge to our

understanding, because there is very little information about the building's early history, and its current state has been altered in a variety of ways. The church was the Katholikon of a monastery dedicated to the Theotokos (150), which had existed since at least the mid-eleventh century. There are no documentary sources for dating the present structure and its decoration, but a date of around 1100 is currently accepted.

Architecturally Daphni represents yet another variant of the characteristic Byzantine church type (149). The central feature, as before, is a large dome, here some 7·5 m (25 ft) in diameter. This is supported on squinches (as at Osios Loukas) with high arches opening up the central cross (151). The outer rectangles of the square (again as at Osios Loukas) are treated as subsidiary chapels. There is a large western *narthex*. Mosaics survive in the main body of the church and the *narthex*. The dome is the site for a large Pantokrator (153). Separated from this by a broad band of gold ground are sixteen Old Testament prophets (between the sixteen windows), each holding a text. The spandrels are small, and their mosaic surface is lost. In the four squinches below are scenes from the life of Christ: the Annunciation, Nativity, Baptism and Transfiguration (157). Looking towards the east,

149–150
Daphni,
near Athens,
*c.*1100
Below
Plan
Right
Northeastern
exterior

10 m

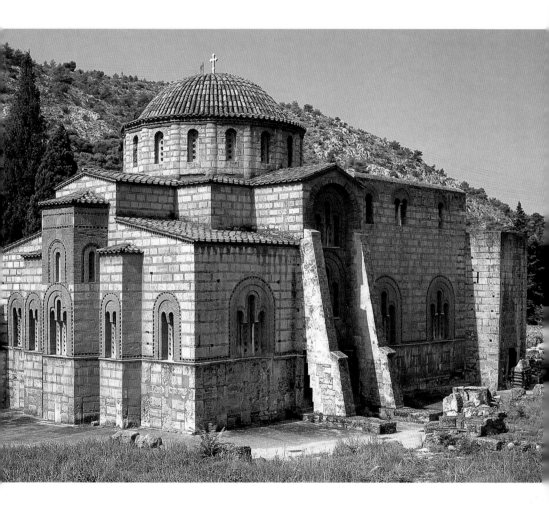

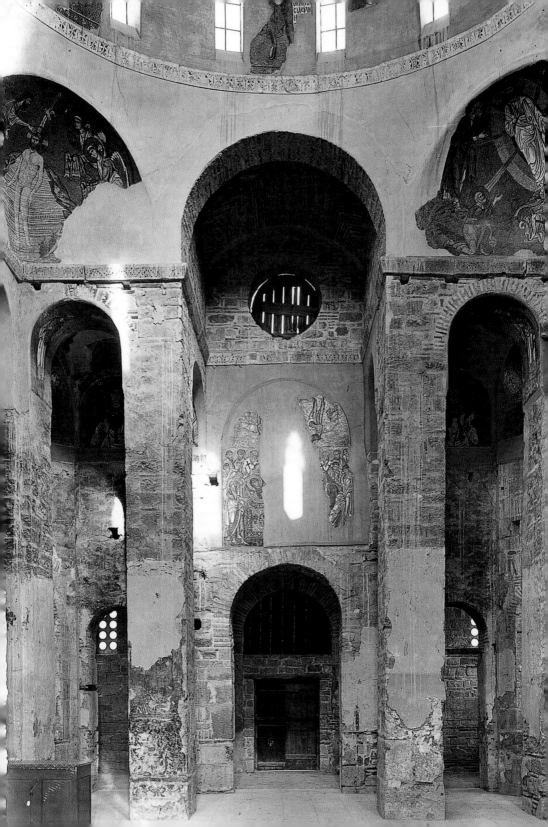

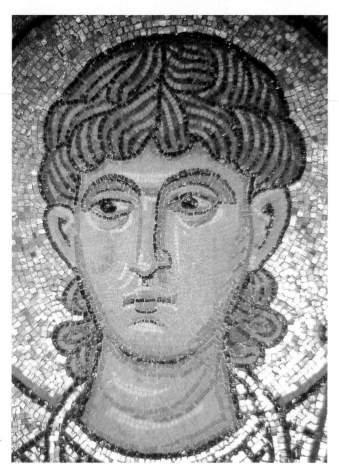

151–152
Daphni
Left
Interior
looking west
(photographed
c.1900)
Right
St Bakchos/
Bacchus (detail).
Mosaic

the apse is occupied by an enthroned Theotokos and Child.
Archangels Michael and Gabriel are to either side in the *bema*, but
the adjacent vault mosaic is lost. Elsewhere the surviving decoration
consists of images of saints (152), with further scenes from Christ's
life in the north and south arms of the cross: the Birth of Mary,
Adoration of the Magi, Presentation in the Temple, Raising of
Lazarus, Entry into Jerusalem, Crucifixion (154), Anastasis (155) and
Doubting Thomas. On the western wall, above the central doorway, is
the Koimesis, or Dormition of the Theotokos (151). In the *narthex* the
cycles of the life of the Theotokos and Christ were supplemented by
further large scenes: the Prayer of Anna and Annunciation to Joachim
(156), Mary Blessed by the Priest, Mary Presented in the Temple,
Christ's Betrayal, the Washing of the Feet, and the Last Supper.

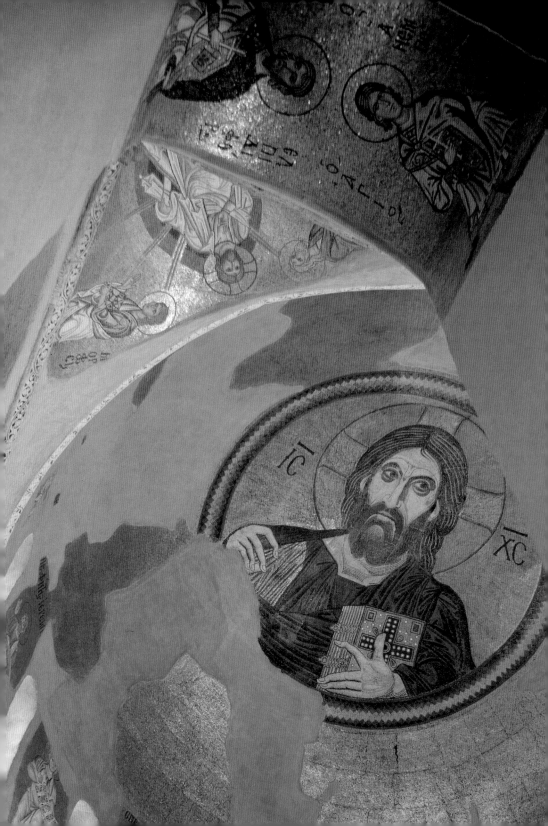

153–155
Mosaics, Daphni
Left
The Pantokrator.
Dome mosiac
Below left
The Crucifixion
Below right
The Anastasis

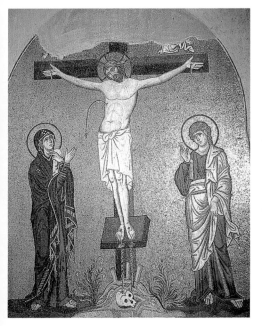

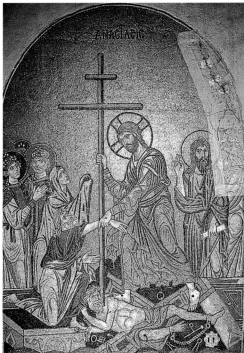

156
Overleaf
The Prayer
of Anna and
Annunciation
to Joachim of
the Birth of
Mary.
Narthex mosaic.
Daphni

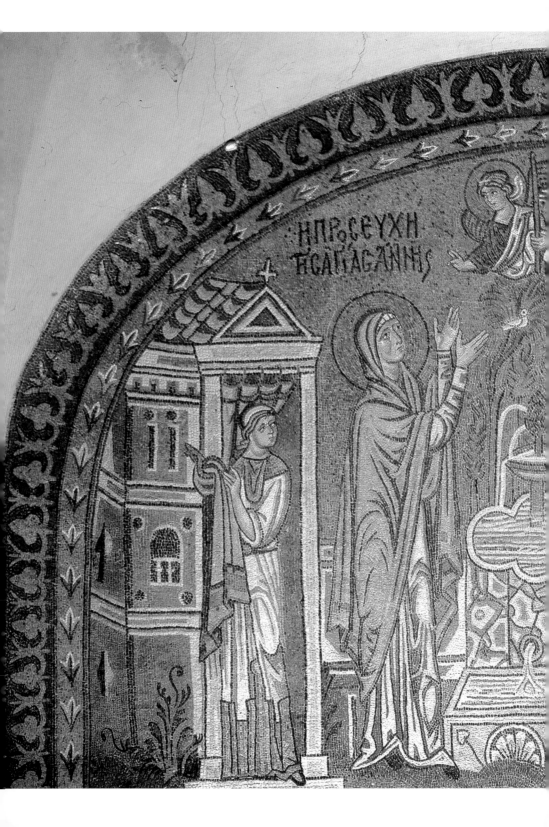

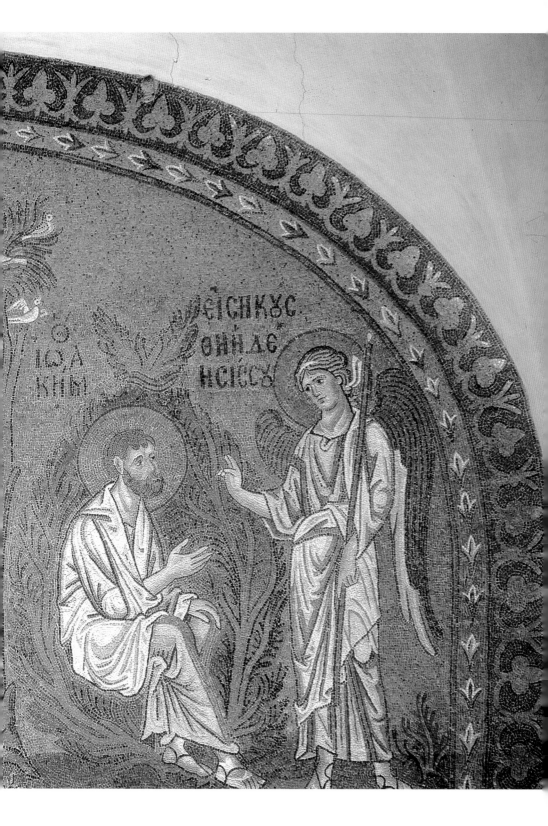

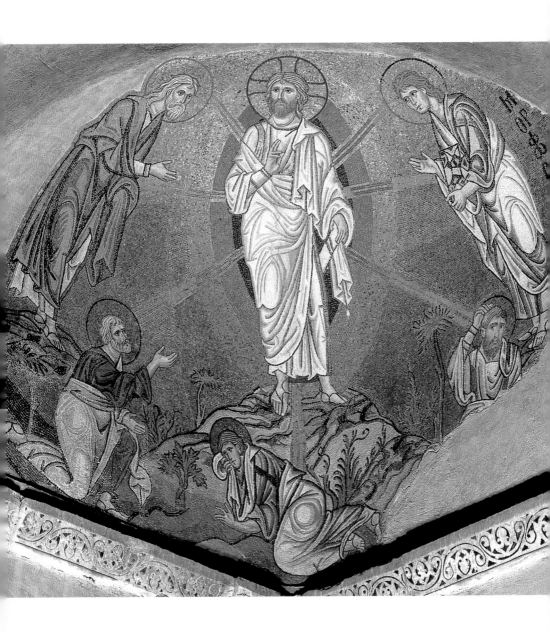

The preponderance at Daphni of large multi-figured images, in preference to medallions of saints, is striking. The contrast with Nea Moni or Osios Loukas is not, however, one of liturgical development: it is not that the extra images chosen at Daphni are ones that had become more important in the life of the church during the eleventh century. The change is essentially aesthetic, relating to new ideas of how a church should be decorated. Stylistically, the slim, elegantly

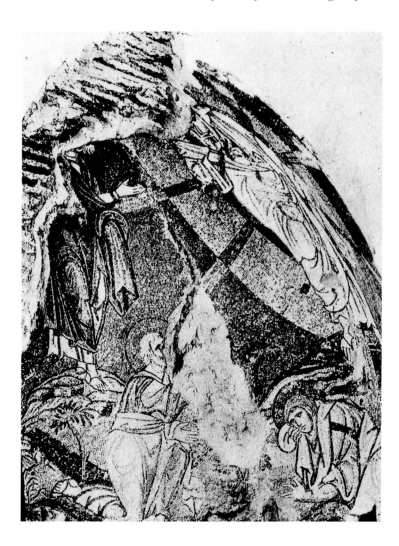

7–158
saics.
ohni
t
e Trans-
uration
rrent state)
ht
e Trans-
uration
otographed
891)

swaying figures at Daphni contrast with the rather stocky proportions at Nea Moni or Osios Loukas. This development is sometimes called 'hellenizing' or 'classicizing', but such terms are better avoided, for there is no evidence that Byzantine artists at this date had suddenly started imitating specific examples of Hellenistic or Classical Greek art.

The final point to bear in mind is that the mosaics of Daphni were restored in the 1890s after serious earthquake damage. If we look at old photographs (compare 157 and 158) it can be seen that some important areas of the mosaics we see now are modern imitations or completions of the originals. Furthermore, the marble revetment that plays a crucial role in organizing the wall surface at Osios Loukas and Nea Moni is lost. Its place is taken now by neutral plaster or the structural masonry. Finally, the church's current status as a museum has given the interior an atmosphere of rather clinical emptiness, which is undoubtedly alien to what was intended – as though the mosaics were now objects of purely aesthetic significance.

7

Β ουρομενος ο κς λιμ̄ και θ̄ ω πληρ̄ω σαι πασαν δικαιο
σύνην. και παντα ταυτα τον ιουδαιων πρ̄θημα και τον τῑ
ποιοι μαμιν· τος θαντων μβ̄ λον τ̄ αντι θεος ά̄. και τον
γεαρ οντ̄ο τ̄ παρα τον νομον θ̄ ουμωσ ο νομου υραν
τι αφερμει· ιδ̄αρ τοισ ιουδαιοισ υρχομ̄ενοισ προσ ῑα
αλμμ̄ τον ναπτιζ̄ην και απι ζ̄ομ̄ενοισ εισ τον ιορ
αλλην ποταμον. προσ υρχεται κ̄ αι αυτοσ τω ιω̄ανη
λεγων· ελθε να πτισ̄υμε· ουχ ω̄σ δε̄ομενον καθαρ̄
σεωσ· αλλα ω̄σ καθαραι βο̄ λοντα τον κοσμον τ̄ην
αμαρτιαν· οθ̄ ε ιωανης γ̄ινωσκω και τον μος ταρ Ο
φ̄ ητης ο διατου αγιου π̄σ̄ οτι ιδ̄ αυτ̄ του θ̄υ. ουκ εολ̄
μα ναπτῑ ζαι αυτον· οτε δε ειδ̄ εν αυτον μ̄ι ᾱρ ι ζ̄ ομβ̄
νον· και τ̄υρος ταεορταυτου. επ̄ αιπ̄ τῑ ε μ̄ια δο
μον και τρ̄ομου· και ειδθ̄ ενο̄ σαιβ̄ς χθ̄ οισαμ̄οι ουρᾱ
μοι· και η̄ λ̄ θ̄ εφαν η̄ εκτ̄ον ουρανων λ̄ ε γ̄ουσα·
ουτος αστι ν ο ϋ̄σ̄ μου ο αγαπ̄ η τος εν ω̄ ϋ̄ δᾱ δ̄ οκηοα·

Books – or manuscripts as we often call them to distinguish the handwritten from the printed variety – are by far the richest and most plentiful source for the study and enjoyment of Byzantine art in the post-iconoclast period. Although many have been destroyed over the centuries, thousands still exist. Whereas a determined traveller could see every surviving Byzantine mosaic in a matter of weeks, a lifetime of systematic investigation would not be enough to see every illumination in every Byzantine manuscript. So it is necessary to be highly selective, especially in a context like this, and that means there is a danger of presenting a misleading picture. To try to avoid this danger, I shall approach the subject by showing how the paintings that Byzantine artists executed in books were intended to be viewed by the people for whom a specific book was made. This implies that every book (like every church or monastery) has its own history, while at the same time having at least some elements in common with other manuscripts. The manuscripts to be considered in this chapter are approximately contemporary with the churches discussed in Chapter 6: in terminology that is now familiar, they are Middle Byzantine works of the later Macedonian to early Komnenian period.

It is easy to understand how a large church, decorated with marble revetment and mosaics, was a very costly undertaking. A book with painted and gilded images was certainly much less costly, but it was nevertheless still expensive. Luxury books took time to make, had to be carefully planned, and were expected to last indefinitely. They were also important in a way that is now hard to imagine. Religious books – and virtually all illustrated Byzantine books were broadly speaking religious in content – were believed to contain the very words of God and his saints. To produce them was an act of piety, to commission them was an act of devotion, to present them to a church or monastery was an act of expiation, and to study them was

159
The Baptism, Menologion of Basil II, p.299, late 10th or early 11th century. 36×28 cm, 14¼×11 in (page). Biblioteca Vaticana, Rome

an act of duty. No Byzantine sinner wanted to suffer an eternity of torture in the fashion imaginatively displayed in Last Judgement images (see 176), and the making of books was thus deeply serious. The images they contain are small-scale, as dictated by the form and materials, but the finest artists were called on to work in books, which were often highly prestigious commissions.

Let us look first at a few pages of a book made for the emperor Basil II (r. 976–1025), now in the Vatican Library. Its connection with Basil is established conspicuously and beyond question by a frontispiece page which contains a dedicatory poem written entirely in gold. The wording suggests that the poem orginally faced a full-page image of the emperor (but this does not survive). The verses ask that Christ, the Theotokos, the prophets, martyrs, apostles, all the righteous, angels and archangels 'portrayed in colours' will be:

active helpers and sustainers of the State, allies in battle, deliverers from sufferings, healers in sickness, and above all eager mediators before the Lord at the time of Judgement, and providers of ineffable glory and the Kingdom of God.

Whether the book was made before or after Basil's blinding of the 14,000 captured Bulgarian soldiers, a ruthless if pious military commander might well be thought (by us at least) to need the army of heavenly supporters conjured up by the verses on the Day of Judgement.

What follows is a sort of picture-book. Each page is arranged in the same way, divided half-and-half between image and text. So that the images do not rub one another, they alternate between the upper and lower half of facing pages. The book is the surviving first volume of a two-volume religious calendar or synaxarion, following the year day by day from 1 September (the start of the civil year in the Byzantine reckoning) to 28 February. For each day there are commemorations of one or more saints or feasts (the most for any day is eight, hence eight pages), with an accompanying image, and a text that has to fill exactly sixteen lines. The book runs to 430 pages. It is usually called the 'Menologion of Basil II'.

On 6 January is the feast of the Baptism (159), and this is what we see on page 299. The small icon-like image is adapted to the horizontal format required by the layout of the page. In addition to the Baptist, Christ and two angels, the artist has included the apostles Peter and Andrew at the left – they were the first to be called as disciples after the Baptism. The text above, however, is not the account given in any one of the Gospels (compare Matthew 3, Mark 1:1–11; Luke 3:1–22; John 1:6–34), although it is fairly close to them and borrows various phrases. It reads as follows:

Our Lord and God wished *to fulfil all righteousness* [Matthew 3:15] and all the customs and forms of the Jews, lest anyone amongst them say that he was the anti-God and thought things contrary to Moses the lawgiver. When he saw the Jews going to John the Baptist and being baptized by him in the River Jordan he too approached John and said, 'Come, baptize me', not because he needed cleansing but because he desired to cleanse the sin of the world. John, as a prophet, recognized him through the Holy Spirit as the Son of God, and did not have the courage to baptize him. But when he was strengthened and commanded by him he baptized [him] with fear and trembling. Straightway the heavens were opened, *and there came a voice from heaven saying 'This is my beloved Son in whom I am well pleased'* [Matthew 3:17].

Every Byzantine in the years around 1000 knew the story of Christ's Baptism, and was familiar with the standard image. The text that Basil II would have read or heard sounds like a short sermon, mixing the biblical narrative with comment and explanation. It is not a description of the accompanying image; nor does the image seek to illustrate this particular text.

Some less usual images or events were thought appropriate for inclusion in this imperial book. Some of the commemorations were indeed so unusual that the scribes were unable to provide a suitable text: on fifteen pages the image is accompanied by a blank space, and two of the images lack even their titles. What did the viewer – let us assume it was Basil II himself – make, for example, of the commemoration (160) on the fifth and last page for 8 February?

(This ought to be the martyr St Philadelphos.) The question is worth asking, even if it cannot be answered.

Other images are of interest because they show events particularly connected with Constantinople (161), such as the commemoration of the great earthquake of 740 (which destroyed the church of St Irene). Would Basil II have paid particular attention to them? This is what the text for 26 October says:

Commemoration of the Great Earthquake

In the twenty-fourth year of the reign of Leo the Isaurian, the ninth indiction, the twenty-sixth of the month of October, on the memorial of St Demetrios there occurred a great and fearful earthquake in Constantinople, and all the houses and churches fell down, and many were buried by the collapse and died. On account of which, celebrating the memory of that terrible earthquake we pray in a procession, setting off for the great and holy church of our wholly-undefiled supremely-glorious Mistress Mother of God and ever-virgin Mary in Blachernae, earnestly entreating and importuning her, and calling the one born of her, begotten without seed and without loss of virginity for us sinners, our Lord Jesus Christ, to deliver us from his righteous anger raised against us. Therefore remembering the suffering at that time, we gratefully celebrate the present festival every year, praying that such a punishment not befall us.

The image shows a stylized version of the church of Blachernae (in which the most precious relic of the Theotokos, the *maphorion* or veil was preserved) at the right. At the left the procession is led by a haloed priest (the patriarch), holding a book of the Gospels, and swinging a censer. Immediately behind him a deacon carries a magnificent jewelled processional cross, and he is followed by a crowd of worshippers holding candles. What is surprising about this text is that it involves the reader or listener directly: '*we* pray … *we* remember … *we* celebrate'. That reader/listener, Emperor Basil II, is addressed as if he were a participant in the processional liturgy (or *lite*). But according to Byzantine ceremonial, the emperor would have been celebrating the feast of St Demetrius on that day, not commem-

160–161
Menologion of
Basil II,
late 10th or early
11th century.
36 × 28 cm,
14¼ × 11 in
(page).
Biblioteca
Vaticana, Rome
Above
St
Philadelphos(?),
p.386
Below
Commemoration
of the earthquake
of 740,
p.142

orating the earthquake of 740. The 'we' of the text thus implies the writer and his fellows, and may not be intended to include the reader, or at least not the emperor as reader.

An intriguing and unique detail of the Menologion of Basil II is the presence of 'signatures' beside the images. These were all written by the scribe, and follow the same pattern. There are eight names in total: Pantaleon, Michael of Blachernae, George, Symeon, Little Michael, Menas, Nestor and Symeon of Blachernae. On the first occurence of each name the formula is '[A work] of the painter X', thereafter it is simplified to 'Of X' or 'Of the same' (where there is a sequence of works by the same name). Among the three pages illustrated here (159–61) the first is by George, and the other two by Symeon of Blachernae. The apparently irregular distribution of the names has been explained by the proposal that the sheets of parchment from which the book was assembled were distributed to different artists. The difficulty the modern viewer has is in distinguishing between what are said to be the works of different artists. If the 'signatures' are to be taken at face value, then we have to conclude that Byzantine artists were supremely skilful in suppressing whatever personal traits they had in order to make their style indistinguishable from that of the craftsman in charge of the project, in this case Pantaleon.

But there are other possibilities: we could suppose that this book was copied by a smaller number of artists from another book, which had images by the eight names, and that the signatures were copied at the same time (a possible but unlikely scenario, since this is a special presentation book for the emperor without obvious precedent). Or could these be the names of the artists of famous images in Constantinople, of which the book contains small-scale versions? (Unlikely, given the way the names are distributed.) The question of the signatures thus remains open, and, whatever the true answer, it is clear that the evidence does not reveal these artists as individuals with personalities or careers that can be reconstructed through their signed works.

We also need to ask how the book might have been used by Emperor Basil II. It was certainly not intended to be employed in the services of a church or monastery. Most likely, in my estimation, it was intended primarily for display on a stand or lectern in some chapel of the imperial palace, as a sort of book of icons. The pages could be turned every day, and the images for that day taken by Basil as the subject for prayer. The accompanying short text could have been read either by the emperor or to him. If he was in a hurry, even the reading was not strictly necessary: glancing at the title alone would have been enough to establish the names of the saints, or the nature of the commemoration, as the subject for a brief prayer. Secondarily, when the emperor was away from Constantinople on campaign, as he often was, this book and its companion volume could have been transported in the imperial baggage train and would have provided the pious commander with ready access to innumerable saints. The poem at the book's start would support such an interpretation. On any day of the year, if battle was about to be joined, the emperor could use this book to help visualize and enlist a range of divine supporters.

Let us turn to a book that is unquestionably connected to the services of a monastic church, the so-called Theodore Psalter. This book contains the text of Psalms and various psalm-like songs or prayers excerpted from the Old and New Testaments: the Odes or Canticles. Recitation of the Psalms is at the heart of the daily monastic offices (services), and from the internal evidence of inscriptions, poems and images, we know a lot about this particular psalter, now in the British Library in London. It was written by a certain monk Theodore, who had the senior rank of *protopresbyter* in the monastery of St John of Stoudios in Constantinople.

Study of the book's layout shows that Theodore must also have been the principal artist. He was proud of coming from Caesarea in Cappadocia, whose most famous son was St Basil, bishop and 'shepherd' in Theodore's words. The book was made at the command of the monastery's abbot, Michael, 'best shepherd of this flock', and completed in February 1066. Michael offered the book to God

Ψαλμος ΛΔ

Κρινον με κ(υρι)ε οτι εγω ακακια
μου επορευθην :·
Κ(αι) εν τ(ω) κ(υρι)ω ελπιζων ου μη ασθενησω :·
Δοκιμασον με κ(υρι)ε και πειρασον με :
Πυρωσον τους νεφρους μου και την
καρδιαν μου :·
Οτι το ελεος σου κατεναντι των οφθαλμων μου εστι :·
Και ευηρεστησα εν τη αληθεια σου :·
Ουκ εκαθισα μετα συνεδριου ματαιοτητος :·
Και μετα παρανομουντων ου μη εισελθω :·
Εμισησα εκκλησιαν πονηρευομενων :·
Και μετα ασεβων ου μη καθισω :·
Νιψομαι εν αθωοις τας χειρας μου :·
Και κυκλωσω το θυσιαστηριον σου κ(υρι)ε :·

ΝΙΚΗΦ ο π(ατ)ριαρχ(ης)

ο σ(ωτη)ρ

ο σ(ωτη)ρ ελεγχων μετα τ(ου)
π(ατ)ριαρχ(ου) τον εικο-
νομαχ(ον)

οι εικονομαχοι

χοι

through the mediation of the monastery's most famous previous abbot, the artist/scribe's namesake St Theodore (whom we met in Chapter 4). There is thus no doubt that the book was intended to stay in the Stoudios Monastery. It would be studied and admired, we can guess, by Abbot Michael and his successors, and by senior monks or distinguished visitors.

In its layout and scheme of decoration, the Theodore Psalter bears a general resemblance to the Chludov Psalter (compare 102–3). For example, the images accompanying Psalm 25:4, 5 ('I have not sat with the council of vanity', 'I have hated the assembly of wicked doers, and will not sit with ungodly men') are immediately recognizable. But in the Theodore Psalter (162) the round icon of Christ, held by Patriarch Nikephoros alone in the earlier manuscript, is held jointly by the Patriarch and St Theodore (inscribed 'the holy father'). And below, where Emperor Theophilus was shown seated in a council of icono-clast bishops – the wicked and ungodly – in the Chludov Psalter, the Theodore Psalter shows him addressed by St Theodore and Nikephoros (inscribed 'The holy father with the patriarch refutes the icon-fighters'). The iconoclasts whitewash an icon of Christ at the right in the same way in both books. It is clear that St Theodore has been given a more important role in the images, as we might expect in a book for his monastery, intended by the current abbot to elicit that saint's support, and made by another Theodore.

If we open the book, for example at the start of Psalm 71 (163–4), it is at once obvious that these images cannot be apprehended in the same way as those of, for example, Basil II's Menologion. It takes con-siderable time to work out what is going on, but the Byzantine view-er was undoubtedly expected to do this, and to some extent we can follow the process. Indeed, if we do not, we shall never approach an understanding of what the artist was attempting to achieve. Let us try to recapture what a Byzantine would have seen on these two pages.

Psalm 71 begins on the left (163) with its title written in large gold capitals: 'For Solomon a Psalm by David'. To the left is a standing figure, dressed as a Byzantine emperor in purple and gold. An inscrip-tion above identifies him as 'Solomon', and a red line makes a link to

162
Iconoclast
Council of 815,
folio 27v,
Theodore
Psalter,
1066.
23·1 × 19·8 cm,
9 × 7¾ in (page).
British Library,
London

the opening words of Psalm 71: 'O God, give thy judgement to the king, and thy righteousness to the king's son' (note that the Authorized Version is different). Above is a medallion of Christ. The idea proposed in these images is that the God of Psalm 71:1 to whom David appeals on behalf of himself and his son Solomon is not the God of the Old Testament Jews, but the Christian God of the New Testament, the God – we might say – of the Byzantines. A further implication or visual argument – for it is not spelled out in the text – is that the righteousness that comes from God to Solomon also comes from Christ to the Byzantine emperor.

Immediately below Solomon's feet is a blue segment with a red star, a convention representing heaven. From heaven a hand stretches down with only the index and little fingers extended – this must be the hand of God. Below at the left is another king in a different variety of Byzantine imperial costume. He looks and points upwards with the same gesture as God. The red inscription above him is: 'David says'. To know what David says we must follow the curving red line which leads to the text where we read: 'He shall come down as rain upon a fleece' (Psalm 71:6; note that in the Authorized Version the rain comes down 'upon the mown grass' – here the danger of using the 'wrong' text is especially obvious). The Psalmist (David) is referring to an event in Judges 6:36–8, where it is narrated how Gideon asked God to manifest his support by making a fleece wet with dew while leaving the surrounding threshing floor dry. Returning to the images in the margin, we see that David is balanced by an aged man with long grey hair and a grey beard, in classical dress. The inscription above him says: 'Gideon before the fleece'. Gideon appears to start back in amazement, yet before him is not the fleece but a medallion with the Theotokos and Child. The explanation for this lies in a tradition of Byzantine biblical exegesis, according to which the fleece that was wet when all around remained dry prefigured the Incarnation, by which Mary conceived while yet remaining a virgin. Thus by visual means a Christian interpretation has been put on the words of both David and Gideon: both are found to have prophesied the Virgin Birth. The hand of God sends down dew upon the fleece, but also Christ to be born of Mary.

The neighbouring image of the Annunciation (identified by an inscription) helps to make the point secure. The angel advances from the left and addresses Mary. She is seated and spinning a brilliant red thread. This represents the moment at which she is told that she will conceive by the Holy Spirit without knowing a man, thus fulfilling the prophecy found in the Old Testament story of the fleece. The Annunciation image thus adds a further level to the visual argument by itself acting as a sort of commentary on or explanation of the adjacent scene, which was itself commenting on and interpreting the Psalm text.

The Annunciation led to the Nativity, and the Nativity to the Adoration of the Magi, which is what we see on the facing page (164). But although the composition appears to continue across the bottom margin and then up to the right, this is a purely visual device, for the Adoration has its own justification in the nearby text of the Psalm. An undulating red line behind the Theotokos and Child draws our attention to the verse: 'The kings of the Arabians and Saba shall offer gifts' (Psalm 71:10; note that the Authorized Version differs again). Here the Psalmist (*ie* David) was paralleling a passage in Isaiah 60:6: 'And all from Saba shall come bearing gold and shall bring frankincense and they shall announce the good news [the Gospel; *evangeliountai*] of the salvation of the Lord.' It is this passage that also lies behind the account in Matthew's Gospel of how the Magi presented gold, frankincense and myrrh after the birth of Jesus (Matthew 2:11) – the Magi were confirming that Jesus was the Messiah (*ie* Christ) by fulfilling an Old Testament prophecy about him. We can now see how the Byzantine artist's mind was working, for at the top of this page is a standing figure, looking rather like Gideon, but holding a scroll. He is identified by inscription as 'the Prophet Isaiah'. The speaking gesture of his right hand indicates that his are the words quoted in the Psalm. The correct interpretation of these words is shown visually by the Adoration, and the inscriptions ensure we make no mistake in identifying 'the Mother of God', and 'the Magi Bringing Gifts'. Being short of space, the artist has had to group the Magi as a somewhat awkward composite of three heads, two bodies and three legs.

ΙC ΧC

cαλομων·

ο̅ Δα̅δ

Ο ΓΑΡ ΑΙ ΧΜ ΘΟΟΙ ΚΑΙ ΘΥ ΤΡΑΜ ΠΟΟΙΝ
ΟΙ ΖΗ ΤΟΥΝ ΤΟ ΤΑ ΙΑ ΙΑ ΜΟΙ ⁘

ΘΕCCΑΛΟΜΩΝ ΨΑΛΜΟC Ο̅Α̅Δ

Ο Θ̅C ΤΟ ΚΡΙ ΜΑ COY ΤΩ ΒΑCΙΛΕ ΔΟC ⁘
Κ ΑΙ ΤΗΝ ΔΙ ΚΑΙΟCΎΝΗΝ COY ΤΩ ΥΙ̅Ω ΤΟΥ
ΒΑCΙΛΕΩC ⁘
Κ ΡΙΝΕΙΝ ΤΟΝ ΛΑΟΝ COY ΕΝ ΔΙΚΑΙΟCΎΝΗ
Κ ΑΙ ΤΟΥC ΠΤΩΧΟΎC COY ΕΝ ΚΡΙCΕΙ ⁘
Α ΝΑ ΛΑΒΕΤΩ ΤΑ ΟΡΗ ΕΙΡΉΝΗΝ ΤΩ ΛΑΩ
ΚΑΙ ΒΟΥΝΟΙ ΔΙΚΑΙΟCΎΝΗΝ ⁘
Κ ΡΙΝΕΙ ΤΟΥC ΠΤΩΧΟΎC ΤΟΥ ΛΑΟΥ ΚΑΙ
CΩCΕΙ ΤΟΥC ΥΙΟΎC ΤΩΝ ΠΕΝΉΤΩΝ ⁘
Κ ΑΙ ΤΑΠΕΙΝΏCΕΙ CΥΚΟΦΆΝΤΗΝ ΚΑΙ
CΥΜΠΑΡΑΜΕΝΕΙ ΤΩ ΗΛΙΩ ⁘
Κ ΑΙ ΠΡΟ ΤΗC CΕΛΉΝΗC ΓΕΝΕΑC ΓΕ
ΝΕΩΝ ⁘
Κ ΑΙ ΚΑΤΑΒΗCΕΤΑΙ ΩC ΥΕΤΟC ΕΠΙ ΠΟΚΟΝ ⁘
Κ ΑΙ ΩC CΤΑΓΩΝ Η CΤΑΖΟΥCΑ ΕΠΙ ΤΗΝ ΓΗΝ ⁘
Α ΝΑ ΤΕΛΕΙ ΕΝ ΤΑΙC ΗΜΈΡΑΙC ΑΥΤΟΥ ΔΙ

ΓΕΔΕΩΝ ΕΙC ΤΟ ΠΟΚΟΝ

Ο ΧΑΙΡΕ ΠΕCΙ

Καὶ ὁ σιων ::

Κ | δι ... λή θος εἰρήμη νος ... ου ἁμ ... ρι
ε ... θην ... ο ...

Κ | δι ... ται κυρι ... σ ... θαλάσσης
ἕ ... ο θαλάσσης ::

Κ | δι ἀπὸ ... ταμ ... ρ ... ο ... ω βραί ... ωμ
τ ... ος οἱ ... ω ... ω ... ης ::

Ε | μό ... ο ... ται τοῦ ... ρο ... ο ... ται αἱ
δι ... το ::

Κ | δι οἱ ἐ χθροὶ αὐ τοῦ χοῦ ... λ ... ξ ουσιν ::

Β | οἱ βασιλεῖς θαρσὸ καὶ ... νῆσοι δῶ ρα
... ρο ... σουσιν ::

Β | οἱ βασιλεῖς αἀράβων καὶ σαβὰ δῶ ρα
... ρο ... άξ ουσιν ::

Κ | δι ... ρο ... κυ νήσουσιν αὐ τῷ ... τα ... τ
οἱ ... ω οἱ βασιλεῖς τῆς γῆ(ς) ::

Π | ... τὰ ... α ε ... θ ... ν δουλ ... ουσιν αὐ τῷ ::

ΠΟΚ | ... τι ... ρ ... ύ σα ... το πτω χὸν ... τ ... κ δυ νάσ τ ... ::

ΚΕ | δι ... ω θύρ ... τ αι οῦ χ ... τω ... ρ χ ... ν τος ::

Κ | ... ς αι ... πτω χοῦ ... τ ρ ... τος ... αι ... τυχ

Looking now at the lower margin of the page it appears that the Journey of the Magi was not prompted by any text, for there is no reference to it. In this case, it would seem, the artist must have been taking advantage of the available space to provide a lively and eye-catching composition. Everything here is carefully considered: if we look closely we can see, for example, that the beast of burden that walks behind the prancing horses has been distinguished as a mule by its large ears. The first magus points ahead, and looks back at his companions. They appear to converse as they follow, and our eye too follows their journey up towards the Adoration. Yet the image is no mere space-filler; it helps to unify the opening by linking the Annunciation with the Adoration, and it extends the scope of the ideas presented to the viewer by adding a further reminder of the story of Christ.

If we imagined that a Byzantine image could be – or was intended to be – understood by an untutored gaze, looking at this single opening of an illustrated text should dispel our illusions. The ideas that underlie the making and viewing of this art are subtle and wide-ranging. There is a constant interplay between the images, the accompanying text, and further texts or ideas which are not present on the page but which the viewer needs to know. The act of viewing the images and reading the text, or rather speaking it, cannot be separated. We must imitate the image of David who speaks through the caption ('David says') the written word of the Bible text. The images require our active participation to fulfil their purpose.

The Theodore Psalter, like the Menologion of Basil II, is a special case. But so is every illustrated Byzantine manuscript. The nearest the Byzantines came to producing a standard type of book was in copies of the Four Gospels. These survive in far larger numbers than any other category of book, and many of them follow a familiar pattern, albeit one that was never reproduced so precisely that we could exchange one book for another. Since these Gospel Books must have been more familiar to the Byzantines than any other type, we can infer that they would have had a much greater influence on people's perceptions and expectations of the visual than would the more

165
Canon Table,
folio 6r,
Gospel Book,
11th century.
19 × 14 cm,
7½ × 5½ in
(page).
Bibliothèque
Nationale, Paris

166–167
Overleaf
St Mark,
headpiece
and opening of
his Gospel with
commentary,
Gospel Book,
folios 87v-88r,
11th century.
24 × 18·5 cm,
9½ × 7¼ in
(page).
Österreichische
Nationalbiblio-
thek, Vienna

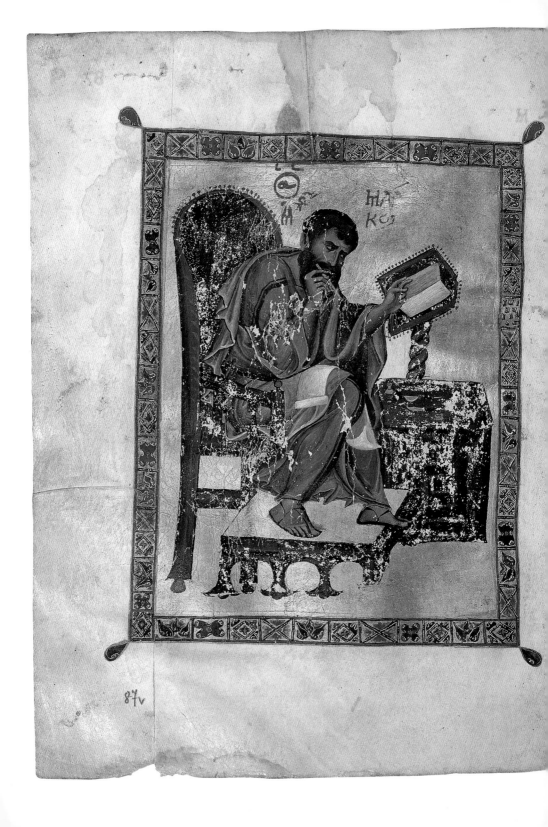

ΜΑ΄Ρ
ΚΟ΄

87v

Μάρκ ὁ εὐαγγελια ἀπὸ τοῦ προφητικοῦ πρό τῆς υἱοῦ... τὴν ἀρχὴ ἐχαρακτήρισατο... καὶ... κατὰ... ἐν καιρῷ... προφη... τῆν περικοπὴν ἐκ τῆς ἀπαρχῆς... διὰ τὸ... συ τὸμον καὶ τα ρατρεχο τῆ κατηγγελῇ ποιοῦνται· προφητικῇ τῇ χαρακτηρ... δι... εις... τὸ ἀκαδιαση τιουδαιαν γραμματι... τῆ τρ... αρχ... καιμεσα... καιτελ... ιτον... τῆ... αρα διαση κν αρχ... τῷ αὐτῷ... ιωάννην... σω... τὰ... τῆ τέλη πολαιαα...

ΕΥ ΑΓΓΕΛΙΟΝ ΚΑΤΑ ΜΑΡΚΟΝ

Ἀρχὴ τοῦ εὐαγγελίου ιῦ χῦ υἱοῦ τοῦ θῦ· ὡς
γέγραπται ἐν τοῖς προφήταις· ἰδοὺ
ἐγὼ ἀποστέλλω τὸν ἄγγελόν μου πρὸ προ
σώπου σου· ὃς κατασκευάσει τὴν ὁδόν
σου ἔμπροσθέν σου· φωνὴ βοῶντος ἐν
τῇ ἐρήμῳ· ἑτοιμάσατε τὴν ὁδὸν κυ· εὐθεί
ας ποιεῖτε τὰς τρίβους αὐτοῦ· ἐγένε
το ιωάννης βαπτίζων ἐν τῇ ἐρήμῳ
καὶ κηρύσσων βάπτισμα μετανοίας εἰς
ἄφεσιν ἁμαρτιῶν· καὶ ἐξεπορεύετο πρὸς
αὐτὸν πᾶσα ἡ ιουδαία χώρα· καὶ οἱ ιε

στι ἡ προφητεία· μὴ ευ τῇ ελ... λη ευ γὴ ολ... θς· τὰ τε θθ α σοις· ἀλλ ἐν τῇ ἐρήμῳ· ... α... τὴ... ηγωρίαν καὶ βδ· ἐπι ε κατι τὸ φ... ου· κηρι... ω... τ ὁριαμὸ παραχ ἐν τῇ ἐρήμῳ τοῦ ιορδαν επι... καὶ ἡ δόξα τοῦ χῦ... μ... ωσ... αὐτοῦ... ναι αρ του ιω α δι η μη... υ ορι μ... ου... ερημουμενω τε... ολογ· καὶ τῇ ἐρήμῳ μετανοίας... παραλ... μο σε
δῆ κ... ιστ... ἐ... αὐτ... τὰ δια τρ... ποιητο· η ἐ τοῖς ἐρήμ
προτικῶς· τὰς ἐρήμου τω τοῦ δαβιδ
υργωντι χω αρ :·

unusual productions. Here it is important to remember the differences in viewing conditions affecting, for example, a mosaic image in a church as against an image in a book. Monumental art was visible to many; manuscripts only to a few. An unusual mosaic might be viewed by thousands of people, an unusual illuminated manuscript only by the maker and the person for whom it was made. Only a book of which there were thousands of copies would be seen by thousands of people.

The usual Byzantine Gospel Book contained three main decorative elements accompanying the text of the Four Gospels. At the start were Canon Tables (165), as in this example in the Bibliothèque Nationale, Paris. These are merely columns of numbers (for which the Byzantines used letters, $\alpha = 1$, $\beta = 2$, etc.). Their purpose was to indicate the parallels between numbered passages in the different Gospels according to a scheme devised by Eusebius of Caesarea in the fourth century. They often received magnificent decoration. Columns, capitals and bases can look convincingly architectural. Yet they usually support a canopy which is decorated in a technique reminiscent of cloisonnée enamel, as if assembled from a multitude of smaller pieces. This upper area resembles the surface of a reliquary, rather than a decorated section of a church (an arcade or niche, for example). Finally the top provides a groundline on which there may be a cross or a fountain, or, as in this example, a variety of humans, birds and beasts. This seems to negate both the 'architectural' reading of the frame below, and that of the panel above as an enamel. Finally, although Christian meaning can be read into the images at the top – for example, any fountain can be seen as 'the fountain of life' – the principal motivation for their inclusion seems to have been a desire to enrich and to enliven, rather than to preach or to interpret. Such decoration is not primarily concerned with the correct understanding of the nature of Christ or the events of his life.

The opening of each of the Gospels was generally alotted two facing pages of the book, with an image of the evangelist on the left (166), and the start of the text beneath a decorative headpiece on the right (167), as in this example in the Österreichische Nationalbibliothek in

Vienna. The evangelist is usually shown seated, at work on the start of his Gospel. The background may be entirely of gold leaf, with perhaps a setting suggested by incised lines. Or it may be much more fully worked out, with writing tools on a desk, and a complex architectural backdrop. The headpiece was usually a panel of pure ornament, often appearing again to imitate cloisonnée enamel work. In practice, however, it is doubtful that Byzantine enamels were ever as complex as some of these paintings. The title of the book ('The Gospel According to St Mark', or a similar formula) is usually set out in decorative gold capitals above, below, or in a framed panel within the headpiece. The text then commences with an enlarged initial, sometimes formed of figures, or even a miniature image of the evangelist. In the Vienna manuscript figures of Isaiah and the angel (mentioned in Mark 1:2) flank the marginal commentary.

The idea of the prefatory image of the author at work on his text, made familiar through innumerable Gospel Books, was readily adaptable to provide an illustration to many other types of manuscript. For example, a copy of the Homilies of St Gregory of Nazianzos (168), now in the Bodleian Library at Oxford, shows the author in the form adopted for the evangelists – he has the familiar writing desk, with its instruments and bottle of ink; there is a fish-shaped stand to the lectern, and a convenient suspended lamp. Gregory writes the opening of the first homily in the collection, the one for Easter. He is immediately recognizable as not being an evangelist because of the clothing he wears: the dark monastic *phelonion* (cape) over a brown *sticharion* (tunic). Note also that he is not dressed as a bishop (which was an alternative); in all likelihood, therefore, this book was intended for use in a monastery. Lest any viewer should be in doubt as to who this figure was, a conspicuous inscription identifies him by name. On the facing page is a headpiece, such as could be found in a Gospel Book, enclosing the title 'Homily of our Father among the Saints Gregory, Archbishop of Constantinople, the *Theologos*, for Holy Easter and for tardiness [a vice to avoid]'. Below this, the initial A of the word *Anastaseos* is cleverly formed by a diminutive image of the Anastasis (the Easter image), with a flying angel above to provide the soft breathing sign.

168
Overleaf
St Gregory,
folios 2v-3r,
Homilies of
St Gregory of
Nazianzos,
c.1100.
31·5×24 cm,
12⅜×9½ in
(page).
Bodleian
Library, Oxford

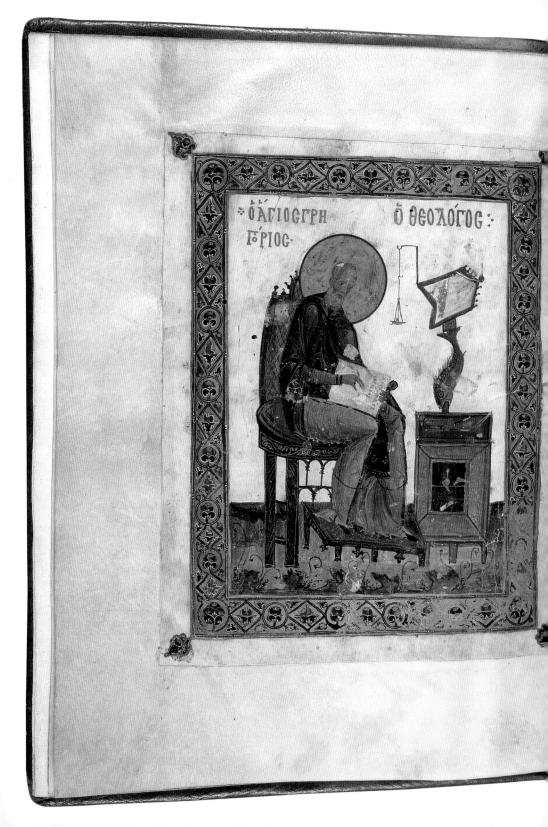

† τοῦ ἐν ἁγίοις π(ατ)ρ(ὸ)ς ἡμῶν Γρηγο
ρίου ἀρχιεπισκ(όπου) κ(ωνσταντινουπόλεως) τ(οῦ) θε
ο(λόγου) λόγος πασχε ἐ β ρα τη τα

ρα τα ο βα σ ἡμέρα
καὶ ἡ ἀρχιδοξία·
καὶ ῥαμε τωριμ δωμεν
τῇ πανηγύρει ἐαι
ὁ μῆ οισ ωβρι οσιν
χοιευθω· Εἰ πανϊμ
ἀδελφοι καὶ τοιο με
σου στρημαῖο μεκοτι
τοισ διαρ πο λιωντι
τα ωωοικηκοσιν ὑπο
πον θέοσ οιχαρϊ
στε ευ πω αμ πα τι
α μα ται ο σ δ ωρε η

σιγ γρ α μη μ α λλήλοισ·
Ἐν ω τ ο οτ ι ραμ μη τ λις
τηρ κα ι λων ω ραμ μ
δα· τουτο γαρ μ ω πω
τι θ λεμ καὶ ε ι ε ο
ὁ λη μ ω σ τυραμ μ ησ
σα ρ τ ο εἰ τ ι σ ω μεν
θ ε ι ο θ τη οισ η ρα δυ
τ ι τ ο σ· ωσ ι χ αρ
κ ρ ε ι τ τ ωρα τ η κ α ι
η μ ι σ ο τ ρα δ ωσ ε
ι ξ εμ ω ντ αχ υ τη τ ο σ
Ἀγαθὸν γαρ καὶ ῑ ωσ

The Gospel Book formula could also be adapted in other ways, most obviously perhaps by the addition of further images. A Gospel Book now in the Biblioteca Palatina in Parma has three pages each divided into four panels and illustrated with scenes from the life of Christ (169–70). With their richly decorated frames these look like separate icons. (They are bound in before the Gospel of Mark.) These images focus the viewer's attention on the principal moments in the narrative of Christ's life, but are not a cycle of images of the great feasts of the church. Nor are they simply illustrations of the Gospel Book they accompany: as we have noted before, the stories of the Ascension and Pentecost (on the second page) are not even narrated in the Gospels, but in the first chapters of Acts. To a certain extent, therefore, the images operate independently of their context.

169–171
Gospel Book,
c.1100.
30×23·1 cm,
11¾×9 in
(page).
Biblioteca
Palatina, Parma
Below
Scenes from
the life of
Christ,
folios 90r-90v
Right
Christ in
Majesty,
folio 5r

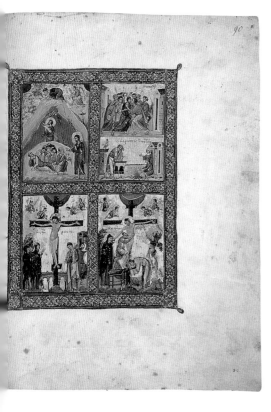

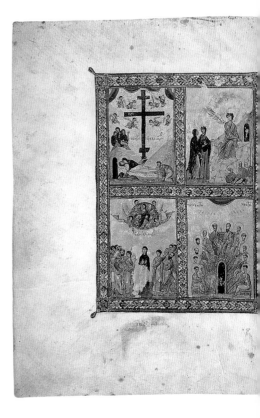

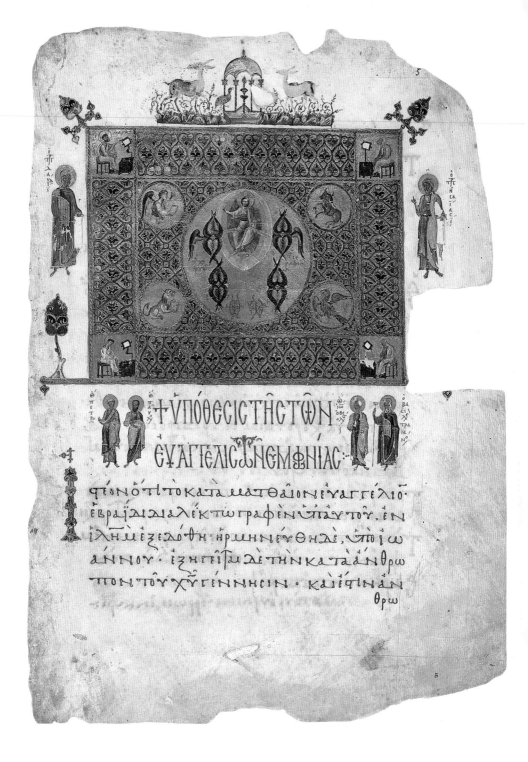

✝ ΥΠΟΘΕCΙC ΤΗC ΤΩΝ
ΕΥΑΓΓΕΛΙΟCΤΩΝ ΕΜΦΗΙΑC·

ἰϲτέον ὅτι τὸ κατὰ ματθαῖον εὐαγγέλιο[ν]
ἑβραΐδι διαλέκτω γραφὲν ὑπ᾽ αὐτοῦ. ἐν
ἰλ̅η̅μ̅ ἐξεδόθη ἡρμηνεύθη δὲ, ὑπὸ ἰω
άννου· ἐξηγεῖται δὲ τὴν κατ᾽ ἄνθρω
πον τοῦ χ̅υ̅ γέννησιν· καὶ εἰ τίνα ἄν
θρω

In a superbly decorated volume like this, even the prefaces to the Gospels can receive their own images (171). Here David and Isaiah, in the margins, witness Christ in Majesty. He sits on a rainbow, surrounded by heavenly beings, the symbols of the evangelists, and the evangelists themselves. The title below is flanked by Peter and Paul, John and Emperor Trajan (he is termed *basileus*). The image is constructed around elements in the prefatory texts, so that, for example, the intriguing presence of Trajan is explained in a somewhat banal way by the mention that St John wrote his Gospel 'in the time of Trajan'.

Another variant was the adaptation of the Gospel Book scheme to a volume containing only a special selection of readings from the Gospels for use in the liturgy, called the Gospel Lectionary. Because this type of book was organized to follow the church year, beginning at Easter, it invariably opens with the start of the Gospel of John (not Matthew), which is the text prescribed for reading on that day. One of the most magnificent illustrated Gospel Lectionaries is now in the Dionysiou Monastery on Mt Athos, but is thought to have been made for use in St Sophia. It has images of all formats: from full

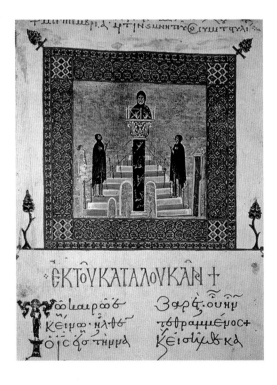

172
St Symeon
the Stylite,
folio 116r
(detail), Gospel
Lectionary,
c.1100.
39·5 × 29·5 cm,
15½ × 11⅝ in
(page).
Dionysiou
Monastery,
Mt Athos,
Greece

pages down to decorated initials. In addition to readings for selected days in the movable calendar, calculated from the (movable) date of Easter, it also contains an important section based on the fixed calendar, beginning at 1 September (the *synaxarion*). This part begins with an image of St Symeon, on top of his column, flanked by a monk and a nun (172). The ascetic elements suggested by the simple dress of the three figures contrasts with the extraordinary richness of the enamel-like frame, and the exceptional care of the craftsmanship throughout.

A magnificent Gospel Lectionary now in the Vatican Library goes even further in the *synaxarion* section by containing images of standing saints or narrative scenes for every day of the fixed calendar from September to the end of January, and a selection thereafter (173). These are not framed like individual icons, but were doubtless intended to be small-scale reminders of the sort of images seen in mosaics and wall-paintings in churches, or on wooden panels. New research suggests that this book, too, may have been made for use in St Sophia.

173
Saints for
9–10
September,
folio 248r,
Gospel
Lectionary,
c.1100.
35 × 26·5 cm,
13¾ × 10½ in
(page).
Biblioteca
Vaticana,
Rome

Only on rare occasions, to judge by what has survived, did the Byzantines set out to produce a manuscript with a really extensive series of images. The demand for such books seems to have been limited. Most remarkable, therefore, is a group of manuscripts containing the first eight biblical books (from Genesis to Ruth) called the Octateuchs. Each of these Octateuchs originally had more than 350 images painted in spaces of varying size and shape that the scribe had left for the artist at the appropriate point. They range from commonplace scenes, like the Crossing of the Red Sea, to images of biblical texts illustrated nowhere else in Western art.

A scene such as God's Covenant to Noah in a manuscript in the Vatican Library (174) is a fairly literal attempt to provide an image to accompany the text of Genesis 9:8–17. Entitled 'The manifestation of the rainbow in the heavens', it illustrates how God sent the rainbow after the flood. We see the hand of God 'speaking' to Noah and his sons (verse 8), but also Noah's wife, who is not mentioned in the text. It can be noted that there is no apparent attempt here to interpret the event in some way, for example as a prophecy of the New Testament. In this sense it is a 'pure' illustration. In stylistic terms, the treatment of the landscape in the early images of this Octateuch manuscript has some parallels in such pre-iconoclast manuscripts as the Vienna Genesis (compare 47–8), although in terms of content neither the Vienna Genesis nor the Cotton Genesis provided a model.

174
God's Covenant with Noah, text of Genesis and commentary, folio 31r, Octateuch, c.1050–75. 36 × 28·5 cm, 14¼ × 11¼ in (page). Biblioteca Vaticana, Rome

Four other illustrated Octateuchs were made in the twelfth and thirteenth centuries; each was a major production and they will be considered from different points of view in chapters 9 and 10. In view of the great length and complex layout they require, it is not surprising to discover that all five Octateuchs together form a closely related family. The first illustrated Octateuch of this type is now believed to have been made at around the time of the Theodore Psalter, not, as used to be thought, in the early period.

A related illustrative technique was used for two surviving Gospel Books, but in them the images were unframed and run together like a frieze across the page. Because all four Gospels were illustrated, some images, like the Descent from the Cross, occur four times. But

ΚΖ +ΤΡΙΤΟΣ ΧΡΗΜΑΤΙΣΜΟΣ ΠΕΡΙ ΔΙΑΘΗΚΗΣ ΠΡΟΣ ΝΩΕ

Καὶ εἶπεν ὁ θεὸς τῷ Νωε καὶ τοῖς υἱοῖς αὐτοῦ μετ᾽ αὐτοῦ λέγων· ἰδοὺ
ἐγὼ ἀνίστημι τὴν διαθήκην μου ὑμῖν, καὶ τῷ σπέρματι ὑμῶν μεθ᾽ ὑμᾶς,
καὶ πάσῃ ψυχῇ ζώσῃ μεθ᾽ ὑμῶν, ἀπὸ ὀρνέων καὶ ἀπὸ κτηνῶν, καὶ πᾶσι
τοῖς θηρίοις τῆς γῆς ὅσα μεθ᾽ ὑμῶν ἐστιν, ἀπὸ πάντων τῶν ἐξελθόντων
ἐκ τῆς κιβωτοῦ· καὶ στήσω τὴν διαθήκην μου πρὸς ὑμᾶς, καὶ οὐκ ἀπο-
θανεῖται πᾶσα σὰρξ ἔτι ἀπὸ τοῦ ὕδατος τοῦ κατακλυσμοῦ, καὶ οὐκ ἔτι
ἔσται κατακλυσμὸς ὕδατος τοῦ καταφθεῖραι πᾶσαν τὴν γῆν. καὶ εἶπε
κύριος ὁ θεὸς πρὸς Νωε· τοῦτο τὸ σημεῖον τῆς διαθήκης ὃ ἐγὼ δίδωμι ἀνὰ
μέσον ἐμοῦ καὶ ὑμῶν, καὶ ἀνὰ μέσον πάσης ψυχῆς ζώσης ἥ ἐστι μεθ᾽ ὑμῶν εἰς
γενεὰς αἰωνίους· τὸ τόξον μου τίθημι ἐν τῇ νεφέλῃ, καὶ ἔσται εἰς σημεῖον
διαθήκης ἀνὰ μέσον ἐμοῦ καὶ τῆς γῆς. καὶ ἔσται ἐν τῷ συννεφεῖν με
νεφέλας ἐπὶ τὴν γῆν, ὀφθήσεται τὸ τόξον μου ἐν τῇ νεφέλῃ· καὶ
μνησθήσομαι τῆς διαθήκης μου, ἥ ἐστιν ἀνὰ μέσον ἐμοῦ καὶ ὑμῶν, καὶ
ἀνὰ μέσον πάσης ψυχῆς ζώσης ἐν πάσῃ σαρκί, καὶ οὐκ ἔσται ἔτι τὸ
ὕδωρ εἰς κατακλυσμόν, ὥστε ἐξαλεῖψαι πᾶσαν σάρκα.

∴ Η ΤΟΥ ΤΟΞΟΥ ΕΝ ΟΥΡΑΝΩ ΑΝΑΔΕΙΞΙΣ ∴

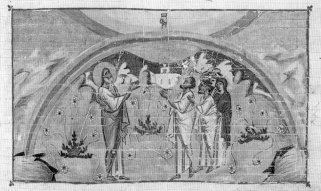

† ō ✶ π τῶν ιαθ ειπ τωι ρ̄ω οικ χω ππ θέωτ +:—

Κ αι ελθο το ι̅ς̅ εἰ τιν οἰκιαν π̅ρ̅ου, ειδε τιν περ
θερ ρ̅ αυτου λε βαμε ερι ω και πυρ ε σσοψαμ· και
η ψατο τῆς χειρὸ αυτῆς, και αφη κε αυτην ο πω
ετο· και ητ θηκ και διηκο ρει αυτω :—

Ο ψ ιαῖ δε ρερο μενη, προ σ γ κ ε ρα αυτω λαιμε
ριο λε ερο πολλοῖ· και εξ ιας ε τα π ραα λο
γωι· και πα γτας τοι κα λω ε χον τας, εθερα πεν
σεν · οπω πλ ερω θῆι το ρ η θον, δια το η σα ιου του
π ρ φη του ε γον τος · αυτο τας α θε νειασ η εμω
ελαι ε, και τας ρο σου ε βα σταξεν· ιδω ρ αε δ ις
Π ολλο ο οχλου περι αυτον, ε κε λ ευ σεν απε λ θ ειν
εἰς το περαν :—

Κ αι προσ ελθ ο ρει ς γρ αμ α τεὺς εἰπ ναι αυτωι· δι δα

† ρ̄ι̅ ✶ π̅ τ̅ο̅υ̅ ε̅ πι τραπε ν α κολ ου θειν +

this is less striking to the user of the book (who could not look at all four Gospels simultaneously), than the dense sequence of images. For example (175), on folio 15v of the manuscript now in the Biblioteca Medicea Laurenziana in Florence, there are three strips of illustration corresponding to three short *kephalaia* ('chapters' – but because these differ so much from the chapter divisions in our Bible it is useful to retain the Byzantine term). In the first, we see Christ in Peter's house (symbolized by the architecture at the right) healing Peter's wife's mother. While Peter watches at the left, Christ first touches her hand, and then she rises and offers a dish – 'she ministered unto them' *ie* she served them. The *kephalaion* is just two verses of our Bible (Matthew 8:14–15), and it is the text that occupies the four lines immediately below.

That text is followed by four lines of blank space which the artist filled with an image of Christ healing a group of men possessed by devils (they have manic hair, bound wrists, and are naked except for loincloths), observed by Jews with covered heads. On the right Christ commands a boatman in his craft – he will cross the Sea of Galilee. A figure standing in the margin at the left, holding a scroll, is the prophet Isaiah, for the Gospel explains that Christ's healing is fulfilling one of Isaiah's prophecies. These images are followed by the next *kephalaion*, which corresponds to Matthew 8:15–17, and is the narrative that has been illustrated.

There is then another strip of illustration, occupying four lines left blank in the text. At the left we see an image of Christ's words to the scribe 'The foxes have holes and the birds of the air have nests' (Matthew 8:20). At the right the figures illustrate 'And another of his disciples said unto him, Lord, suffer me first to go and bury my father' (Matthew 8:21). Beneath is the first line of another short *kephalaion,* corresponding to Matthew 8:19–22, which ends over the page. On this page, therefore, almost every phrase of the text that can readily be converted into an image has received illustration. But the crucial factor in deciding where to place illustrations was the division between *kephalaia*. Had the scribe left the same amount of space for the artist after each *kephalaion,* but the *kephalaia* been much

175
Matthew
8:14–19
with images,
folio 15v,
Gospel Book,
c.1050–75.
20×16 cm,
7⅞×6¼ in
(page).
Biblioteca
Medicea
Laurenziana,
Florence

ότ ἀπο ερι θήσο νται και αὐτοῖς ιδον τό +
ΚΕ· πότ θ σε ἑ δον πεινω ντα · ἢ δι ψω ντα
ἢ ξέμον · ἢ γυμνόμ · ἢ ἀσθενῆ · ἢ ἐν φυλακῆ · ϗ
οὐ δι ηκο νή σαμέν σοι + τότ ἀπο κρι θή
σε ται αὐτοῖς λέγον + ἀμὴ λέγω ὑμῖν + ἐφ ὅ
σον οὐκ ἐ ποι ή σα τε ἑνι τούτον τῶ ἐ λα χί στον ·
οὐ δὲ ἐμοι ἐ ποι ή σα τε + και ἀπελ ευ σον ται
οὖτοις εἰς κό λα σιν αιω νιον · οἱ δὲ δι και οι · ἐσ
ζο ην αι ω νιον · +

longer (as they are in St John's Gospel, for example), it can be readily appreciated that the density of illustration to text would have been much reduced. Nonetheless, to illustrate the Gospels in this fashion, rather than merely supplying four images of the evangelists, was a major undertaking.

A second very similar Gospel Book is now in the Bibliothèque Nationale in Paris. In addition to the narrow bands of illustration, however, in this book a much larger space, some two-thirds of the page, was left before the start of the *kephalaion* at Matthew 26:1. (A more compressed version is also found in Mark's Gospel, before the equivalent *kephalaion* which commences at Mark 14:1.) Certainly, to be able to leave such a large space the scribe must have anticipated the artist's requirements: a major image of the Last Judgement (176). In this case the illustration refers not to the text that follows, but to the final verses above on this page, ending at Matthew 25:46: 'And these shall go away into everlasting punishment; but the righteous into life eternal.'

176
The Last
Judgement,
folio 51v,
Gospel Book,
c.1050–75.
23.5×19 cm,
9¼×7½ in
(page).
Bibliothèque
Nationale,
Paris

The image is a complex one, and contains far more detail than the text supplies. At the top is Christ enthroned in a mandorla, flanked by the Mother of God and John the Baptist (a sort of Deesis). Six apostles sit to either side, with a host of angels behind. Beneath are heavenly beings – cherubim and seraphim – and wheels. An angel at the left rolls up the heavens like a scroll (Revelation 6:14), while at the right tombs and wild animals give up the dead as they rise at the sound of an angel blowing on a horn (Revelation 20:13). Further below to the left stand four groups of the righteous – bishops, rulers, laymen and laywomen – their hands raised in prayer. A river of fire (Daniel 7:10) descends from Christ to an empty throne (compare Psalm 103:19) and in a lake of fire the damned are pushed by two angels towards a figure of Hades mounted on a beast. Small black demons assist. At the bottom left is a representation of paradise. A seated Abraham, at the left, is surrounded by child-like figures, one of which he clasps in his bosom ('Lazarus' – compare Luke 16:22); the Theotokos is shown enthroned; and St Peter opens the gate of heaven to a group of the saved. In the centre two devils attempt to unbalance

καὶ ὁ Ἰωσ..λεδ σαφμωμε
κοιμήθημετὰτῶντρῶν
αὐτοῦ· καὶ ἐβασίλευσεν
ροβοαμὁ υἱὸς
αὐτοῦ ἀν...
τά...
το
✝

Καὶ ἐπορεύθη ὁ βασιλεὺς
ροβοαμ εἰς σίκιμα· ὅτι
εἰς σίκιμαἤρχοντο πᾶς
Ἰηλ βασιλεῦσαι αὐτόν· καὶ
ἐλάλησεν ὁ λαὸς πρὸς τὸν
βασιλέα ροβοαμ λέγοντες·
ὁ πατήρ σου ἐβάρυνεν τὸν κλοι-
ὸν ἡμῶν· καὶ σὺ νῦν κούφι-
σον ἀπὸ τῆς δουλείας τοῦ
πρός σου τῆς σκληρᾶς· Καὶ
ἀπὸ τοῦ ζυγοῦ αὐτοῦ τοῦ
βαρέος οὗ ἔδωκεν ἐφ' ἡμᾶς·
καὶ δουλεύσομέν σοι· Καὶ
εἶπεν πρὸς αὐτούς· ἀπέλ-
θετε ἕως ἡμερῶν τριῶν· καὶ
ἀνάστρεψατε πρός με· Καὶ
ἀπῆλθον· Καὶ ἀπήγγειλεν
ὁ βασιλεὺς ροβοαμ τοῖς
πρεσβυτέροις οἳ ἦσαν παρ-
εστηκότες ἐνώπιον σολο-
μὼν τοῦ πατρὸς αὐτοῦ ἔτι ζῶν-
τος αὐτοῦ λέγων· πῶς ὑμεῖς
βουλεύεσθε· καὶ τί ἀποκρι-
θῶ τῷ λαῷ τούτῳ λόγον· καὶ
ἐλάλησαν πρὸς αὐτὸν λέ-
γοντες· εἰ ἐν τῇ ἡμέρᾳ ταύ-
τῃ ἔσῃ δοῦλος τῷ λαῷ τούτῳ·
Καὶ δουλεύσῃς αὐτοῖς· καὶ
λαλήσῃς πρὸς αὐτοὺς
λόγους ἀγαθούς· καὶ ἔσονται
σοι δοῦλοι πάσας τὰς ἡ-
μέρας Καὶ ἐγκατέλιπεν τὴν
βουλὴν τῶν πρεσβυτέρων
τὰ ῥάβδα οἱ συνεβουλεύσαντο

the scales in which an angel weighs a soul. And at the right the wicked are tormented in six different zones of hell (compare Mark 9:43–8).

Last Judgement images are found on a monumental scale, as in the *narthex* of the church of the Panaghia Chalkeon in Thessaloniki, dated 1028, as well as at a smaller scale in icons and ivories (as in an example in the Victoria and Albert Museum, London). It seems likely that the Last Judgement was included in such works as the Gospel Book now in Paris, because of its familiarity from other contexts, for as an image it works in a completely different way from the strips of illustration on other pages with their close connection to the words of the Gospel. We can suppose that the person for whom the Paris Gospels was made specifically required these images, which were added to the planned strips. Unfortunately there is no way of knowing who this person was.

There is also a single example, now in the Vatican Library, of a volume containing only the four Old Testament books of Samuel and Kings (I–IV Kingdoms in the Greek Bible). It was begun with a plan to provide an image within the text for every *kephalaion*. The plan was over-ambitious, and the density of illustration declined rapidly after I Samuel had received seventy-four images. The creation of these images from standard formulae, for example for an entombment and the elevation of a ruler, can be seen at the break between I Kings 11:43 and 12:1 (177). Above is the death of Solomon, who is laid out in his tomb. Beneath is the elevation of his son Rehoboam, who is shown like a Byzantine emperor, lifted on his shield and acclaimed by his followers.

The interest in producing very densely illustrated manuscripts, like these Gospel Books, the Octateuchs, or the single example of the Books of Kings, seems to be part of a related movement. There are stylistic connections to the Theodore Psalter of 1066, suggesting all these books are products of Constantinople at around this date, although not necessarily of the Stoudios Monastery. But whereas the Theodore Psalter has obvious precedents in such books as the Chludov Psalter of the mid-ninth century, the others do not. It is true that the underlying idea that hundreds of images could be integrated

into the biblical text had been worked out as long before as the late-fifth or sixth century, as in the Cotton Genesis, but the mid-eleventh century books imply a new enthusiasm for the possibility of integrating images with words in ways that had not been tried before. They were a move away from the predominant use of full-page frontispieces as seen in books like the Paris Gregory or Bible of Leo of the late ninth and tenth century.

In one conspicuous way examples of Byzantine painting in manuscripts are more accessible to a modern viewer than are, for example, Byzantine mosaics or frescos, for the majority (like Byzantine ivories or enamels) are now in public collections, scattered all over the world. But whereas an ivory or piece of enamel can be thoroughly (if not completely) studied as it lies in a museum case, the same cannot be said for a book, even if it is exhibited (and few are). For a start, it takes special skills to be able to read what is going on on the page. And then you can only see those two pages. Just imagine that the nearest you could get to reading a book was seeing it lying open in a bookshop window – it would be reasonable for you to feel that you needed to see a great deal more! Illuminated Byzantine manuscripts are thus the richest source for the study of Byzantine art and ideas, but also the most demanding.

So far, we have looked deeper and deeper into Byzantine art, trying as best we can to recover and imitate Byzantine modes of thinking and looking. But we need also to spiral outwards, away from the personal response of a single viewer to one image, so as to consider broader cultural phenomena. Byzantine art was never solely a matter of the individual confronting the divine through contemplation of the visual. It was the art of a sophisticated culture which was appreciated, viewed and used in a whole range of ways by all those varied people who came into contact with it. It is time now to turn to this broader perception and reception of Byzantine art, especially as exemplified in the period of approximately the twelfth to fifteenth centuries. This will be the subject of the remaining three chapters, which will take us from Middle to Late Byzantine art, or, using dynastic labels, from Komnenian to Palaiologan art.

8

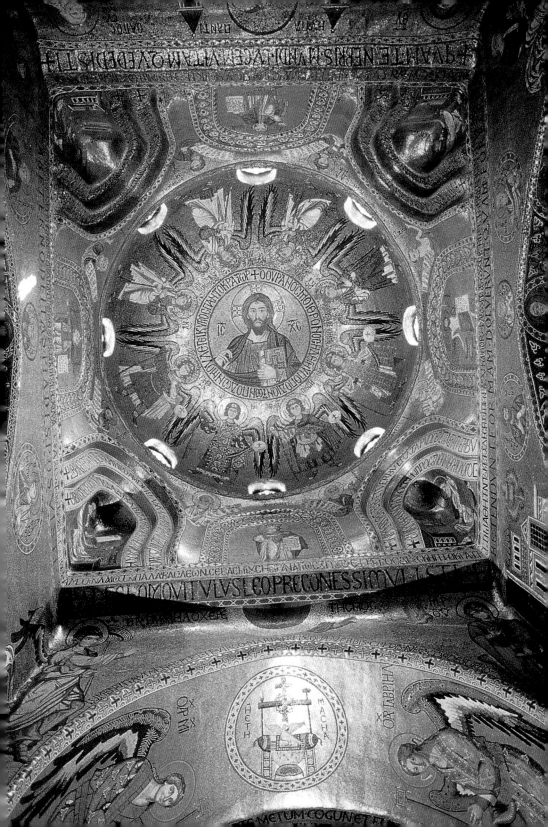

The richly fertile island of Sicily stands like a tollbooth at the cross-roads of Mediterranean trade. As a result its possession was frequently contested in the long period covered by this book. Sicily was conquered from the Romans by the Vandals and then ceded to the Ostrogoths in the fifth century, reconquered by Belisarius for Emperor Justinian in the sixth, raided by Arabs from the seventh century, and slowly conquered by them in the ninth and tenth, invaded and conquered by the Normans in the eleventh, and controlled successively by Hohenstaufen (German), Angevin (French), and Aragonese (Spanish) rulers in the thirteenth. In religious terms, the island's rulers, although not necessarily all its populace, were Christian, then pagan, then Christian, then Muslim, then Christian again, with the added difference that from the eleventh century they looked to Rome rather than to Constantinople as the seat of authority. The world of this chapter, as well as chapters 9 and 10, was often racked by political conflict in which there were strong religious, linguistic and cultural elements. This chapter, however, focuses primarily on a relatively short period of calm and stability when Norman rule in Sicily was unchallenged, from the 1140s to the 1180s.

During this period, Sicily's Norman overlords undertook ambitious architectural projects. A familiar fusion of power and piety is evident in the following lines:

Whereas others among the kings [*basileon*] of old erected other vener-ated places to the saints, I King Roger [*Rogerios Rex*], sceptred ruler [*skeptokrator*], [erect this] to the chief of the Lord's disciples, the princi-pal shepherd and leader Peter on whom Christ established the Church which he himself had founded by shedding of [his] wonderful blood [text lost] the indiction thrice [doubled, *ie* the sixth indiction] of the year by accurate reckoning (6651) [=1142/3 AD].

178
The
Pantokrator,
angels and
prophets,
1142/3.
Dome mosaics.
Cappella
Palatina,
Palermo

The Greek verses translated here are set in mosaic around the square base of the dome of the principal church of King Roger II's palace (now generally called the Cappella Palatina or Palatine Chapel) in the seaport city of Palermo in Sicily. In the centre of the dome (some 6 m, or 20 ft in diameter, and rising to a height of some 20 m, or 65 ft) is a Pantokrator (178), surrounded by the Greek inscription '"The heaven is my throne and the earth my footstool" saith the Lord Omnipotent [Pantokrator]' (Isaiah 66:1, quoted in Acts 7:49). The Pantokrator is surrounded by eight angels. Beneath the dome the transition from circle to square is made through an octagon created by squinches at

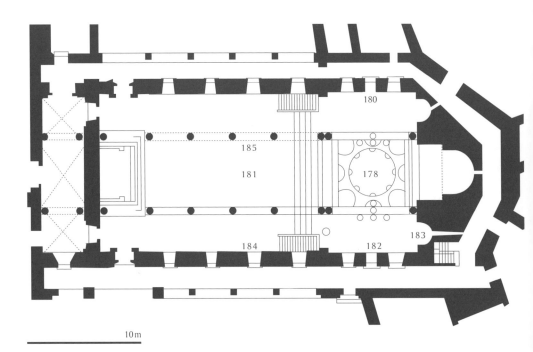

10 m

the corners. In the squinches are the four evangelists. Between them are full-length figures of four prophets (including John the Baptist), and in the eight pendentive-like spaces above are a further eight busts of prophets. All the prophets hold scrolls bearing texts in Greek. The square base is supported on arches that are themselves supported by four columns. Looking towards the east the arch is spanned by the Annunciation, while towards the west there is the Presentation in the Temple. These spill over on to the north and south arches, leaving space for three medallions of further prophets

(without texts) on each. Medallions of saints are set in the soffits of the arches that lead to the north, south and west, but towards the east the arch is extended into a vault that leads to the apse (see 179).

To stand in the Cappella Palatina and look up into the dome is to see Byzantine mosaics in what appears to be a Byzantine church. But if the viewer now looks to the east (181), the apse is dominated by a second Pantokrator, with a seated Virgin (or even Madonna in this case) flanked by saints below. The Pantokrator looks Byzantine enough, although very few Byzantine churches have a Pantokrator in the apse in this way. He holds an open book with a Greek text on the left page, and the same text in Latin on the right: 'I am the light of the world; he that followeth me shall not walk in darkness but shall have the light of life' (John 8:12). The discordant style in which the Virgin below is executed marks it out at once as an eighteenth-century replacement, and it blocks what was originally a window.

179
Cappella
Palatina,
Palermo.
Plan

On the west, is a short basilical nave of five bays (some 20 m, 65 ft long), with the western wall dominated by another figure of Christ, this time enthroned, and flanked by angels and Saints Peter and Paul. Aragonese coats of arms at the left testify to a restoration in this area in the fourteenth century. Above is a magnificent gilded wooden ceiling of Islamic 'stalactite' (*muqarnas*) design (visible in 181), which has a painted Latin inscription recording a restoration in 1478. The combination of basilical nave and Islamic ceiling is certainly unlike anything to be found in any Byzantine church interior.

Still standing under the dome, turning now to the south (182), the viewer sees three registers of mosaics with scenes from the life of Christ: Joseph's Dream, the Flight into Egypt, the Baptism, Transfiguration, Raising of Lazarus, and Entry into Jerusalem, the last of these flanked by two windows and by two standing bishop saints: Dionysius and Martin. To the north the viewer sees no scenes from the life of Christ, but a strange landscape with John the Baptist at the left (180, the work of various restorations). Beneath are five standing bishop saints: Gregory of Nyssa, Gregory of Nazianzos, Basil, John Chrysostom and Nicholas. The zone of the five bishops is divided by

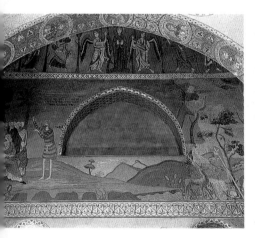

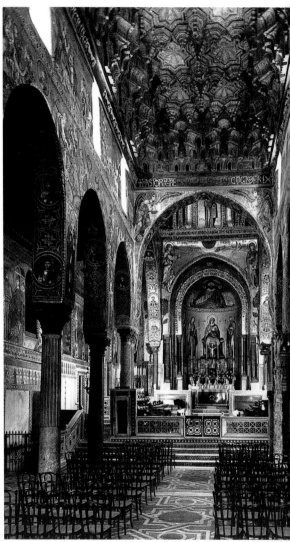

180–182
Cappella
Palatina,
Palermo
Above
Landscape
with John
the Baptist.
Mosaic.
North wall
Right
Interior
looking east
Opposite
Interior
looking south

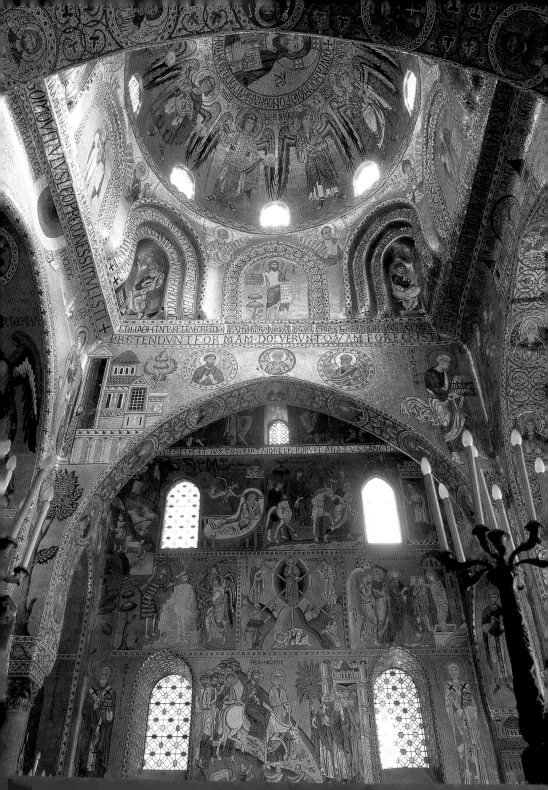

two windows (as on the south wall). All these scenes and figures, with the exception of St Martin, would have been familiar to a Byzantine viewer, but the way that they are organized on the wall surfaces would not. In particular, the lack of balance in the treatment of the two walls is conspicuous. This has been explained by the proposal that the mosaics on the south wall were specially chosen and organized to present a significant ensemble to a royal viewer looking across from the north side.

If the modern viewer now looks more carefully at the mosaics in the eastern part of the Cappella Palatina, the feeling of puzzlement grows. There is even another Pantokrator, holding the same text

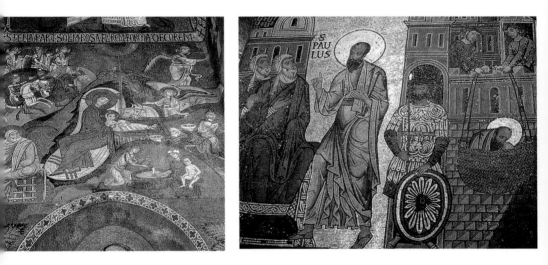

('I am the light of the world; he that followeth me shall not walk in darkness but shall have the light of life'), above the southern apse. In the northern apse a standing Virgin and Child have been awkwardly set off-centre. Narrative scenes, like the Nativity (183), are wrapped around corners and stilted to fit tricky spaces. All the mosaic surface is complete, but it is obvious that much has been clumsily restored.

In contrast, the mosaics in the nave and its flanking aisles (181), appear to have been more clearly organized (although clumsy restoration is apparent in places here as well). There is evidence of a single homogeneous plan for the nave mosaics, and all the

inscriptions are in Latin. On the outer aisle walls are rectangular panels illustrating scenes from the lives of St Peter and St Paul, occupying the spaces between the windows. For example (184), St Paul is shown confounding two Jews of Damascus with his preaching about Christ (Acts 9:22), and then escaping from the city hidden in a basket (Acts 9:25).

In the main body of the nave a continuous cycle of scenes from the Old Testament unfolds in two registers, the upper one interrupted by the windows, the lower one fitted (often skilfully) into the awkward spaces above the arcade. Consider, for example, the way the artist has positioned the figures in the Sacrifice of Isaac (185), narrated in

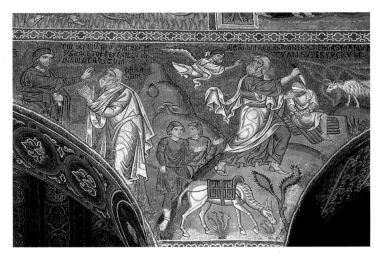

183–185
Mosaics.
Cappella
Palatina,
Palermo
Far left
The Nativity
Centre
St Paul
Confounding
the Jews and
Escaping from
Damascus
Left
The Sacrifice
of Isaac

Genesis 22:1–13. The narrative runs from the beginning of Creation (the first words of Genesis), through the stories of Adam and Eve, Noah, Abraham, Isaac and Jacob, ending with Jacob Wrestling with the Angel (Genesis 32:25). It moves consistently from left to right, starting at the eastern end of the southern wall, and ending at the eastern end of the northern wall, first in the upper register and then following the same direction in the lower (it omits the western wall). Beneath, on each of the tall narrow piers placed on top of the reused Classical columns from which the arcade springs (thus raising the height of the arcade without the need for taller columns), is a standing bishop saint.

In stylistic terms the nave mosaics do not differ greatly from those of the dome or eastern parts. Yet a basilical arrangement like this does not call to mind any recent Byzantine church, but rather the interior of surviving churches built six or seven centuries earlier, in Rome or Ravenna, for example. And the specific combination of a long series of Old Testament scenes with those from the lives of Saints Peter and Paul seems to hark back to what is known (or hypothesized) of the decoration of the naves of two famous Roman churches of the early period: St Peter's and St Paul's *fuori le mura* (outside the walls). Closer both geographically and in date to the Cappella Palatina, the lost decoration of the abbey church of Montecassino in southern Italy, dedicated in 1071, might have provided a stimulus or precedent.

While admiring the Cappella Palatina mosaics we need to consider how and why these works should seem at the same time to be both profoundly Byzantine and insistently un-Byzantine. We can start by going back to the mosaic inscription. The *Rogerios Rex* who built this church was Roger II, recognized as King of Sicily by Pope Anacletus II in 1130. In 1091, Roger's father, Roger d'Hauteville (Roger I) had completed the Norman conquest of Sicily, ruled by Muslim Arabs since they had finally wrested it from the Byzantines in 965. Roger II's uncle, Robert Guiscard, had similarly conquered much of southern Italy from the Byzantines and Lombards in 1074. In Sicily as in eleventh- and twelfth-century England, a small Norman ruling class was successful in running a relatively compact but highly prosperous territory, but there were also many differences. William I was crowned King of England on Christmas Day 1066, having landed in September of the same year, whereas when Roger II became King of Sicily the Normans had been carving out their southern kingdom for more than a century. In England a thick veneer of Norman French ideas overlaid the stubborn remnants of Anglo-Saxon culture, but in the more cosmopolitan context of southern Italy and Sicily elements of Norman culture were absorbed into an existing heady blend of indigenous and imported ideas. A building decorated in the manner of the Cappella Palatina would have been inconceivable in twelfth-century England.

The Cappella Palatina was endowed and consecrated on 28 April 1140 according to surviving documents, but the first phase of mosaic decoration was completed a little later. The date was calculated in Byzantine style, and corresponds to the period 1 September 1142 to 31 August 1143 by modern reckoning. Given the relatively small area of the mosaic surfaces around the dome, this first campaign could certainly have been executed over a short space of time (say one season). The remainder of the work in the Cappella Palatina, it is agreed, was pursued more slowly and probably in two distinct phases. First came the completion of the church's eastern parts under Roger II (d.1154); then the mosaics of the nave were set under his son William I (r.1154–66), who, according to the chronicler Romuald of Salerno, decorated the church with 'wonderful mosaics' and a precious marble revetment. That the decoration took so long to complete suggests either that there were several short bursts of intense activity, interspersed with periods when nothing much was going on, or that there was a more leisurely but continuous progress, perhaps because only a few craftsmen were involved.

Not far from the Cappella Palatina in Palermo is a small church now generally known as the Martorana. It is in many ways a contrast to the Cappella Palatina, except that it also contains a mosaic decoration that has many Byzantine features. Broadly speaking, it looks even more Byzantine than the Cappella.

Originally the church was of the familiar Byzantine cross-in-square type (the core of a much-enlarged building; 186). The internal dimensions of the square are about 10·4 m (34 ft) per side. Above is a small central dome about 3·8 m (12 ft) in diameter (rising to a height of some 15 m, 50 ft). This is supported on an octagonal drum, itself supported on squinches which make the transition to a square with four columns beneath. In the late sixteenth century, however, the church was drastically altered by the demolition of its western wall and *narthex*, and their replacement by a columned hall-like interior. More changes were to follow, and in the late seventeenth century the main apse was demolished and replaced by a chapel. The experience of visiting the church is thus now very different from the impression

conveyed by photographs of the mosaics, which by focusing on the artistic images avoid the most striking architectural alterations.

In the centre of the dome is an enthroned figure of Christ (187), surrounded by the familiar inscription in Greek: 'I am the light of the world; he that followeth me shall not walk in darkness but shall have the light of life.' An oddity of the inscription is that it was set upside down in relation to the figure of Christ, and has to be read anti-clock-wise (contrast the inscription in the Cappella Palatina, 178). It is also unusual, but not unparalleled, to find an enthroned Christ rather

10 m

than a bust-length figure in a Byzantine dome. Beneath are four bowing angels; in trying to allow for the optical distortion caused by the shape of the dome the mosaicist seems to have seriously miscal-culated and the angels' torsos appear much too long. It must always be borne in mind that Byzantine mosaics are frequently set on awkward curving surfaces, as with the evangelists in the squinches in 178 or 187, and could not have been viewed from the ground by their makers until the necessary scaffolding had been dismantled. It is a

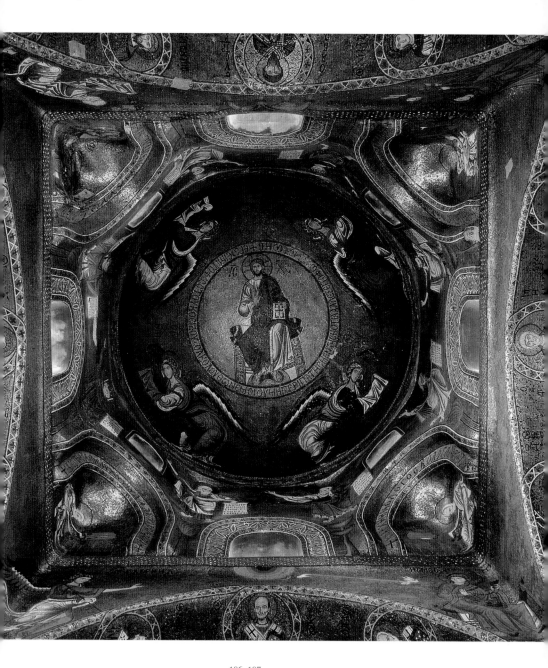

186–187
Martorana,
Palermo,
*c.*1143 and later
Left
Plan
Above
The Pantokrator,
angels and
saints.
Dome mosaics

measure of the success of most Byzantine monumental artists that the viewer is rarely aware of the intentional distorting of proportions that often took place to compensate for the effect of varying curvatures when seen from below.

Beneath the Christ is a zone of standing prophets holding inscribed scrolls, with the evangelists in the four squinches below. There are medallions of saints on the arches, and an Annunciation towards the east, and a Presentation towards the west (as in the Cappella Palatina). The presbytery vault has standing figures of the archangels Michael and Gabriel. The apse mosaic is lost, but doubtless it was a

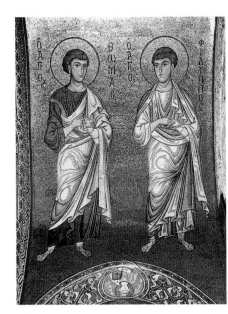

188–189
Mosaics.
Martorana,
Palermo
Left
St Thomas
and St Philip
Right
The Nativity

190–191
Overleaf
Mosaics.
Martorana,
Palermo
Left
Christ with
Roger II
Right
The Theotokos
and Georgios
of Antioch

Theotokos, or Mother of God and Child, for not only was the church dedicated to St Mary, but the flanking apses of the *prothesis* and *diakonikon* have mosaics of Mary's parents: Joachim and Anna. In the vaulted cross-arms to north and south of the central dome there are pairs of standing apostles, making eight in total (188); when added to the four evangelists in the squinches the total becomes twelve. The apostles of the cross-arms look very large in this small church. The vault to the west has two narrative scenes: the Nativity (189) balancing the Dormition of the Theotokos. We can also note that all the inscriptions throughout the building are in Greek. Comparing

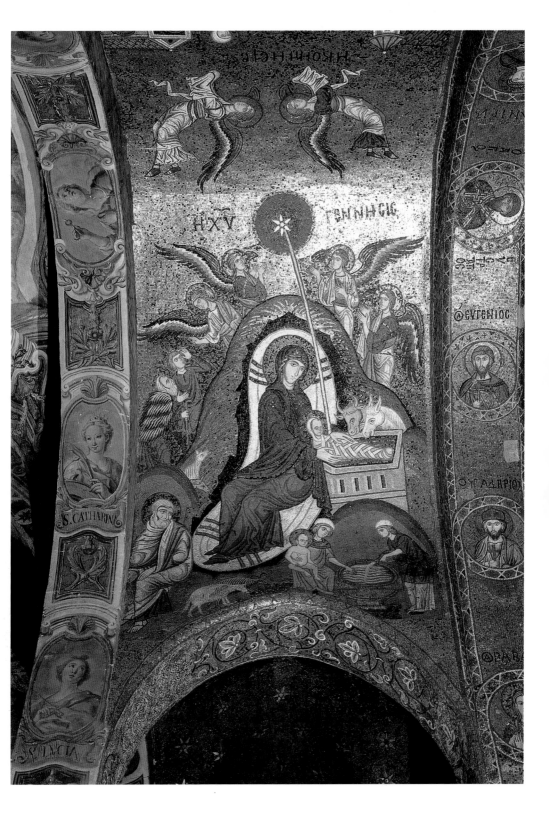

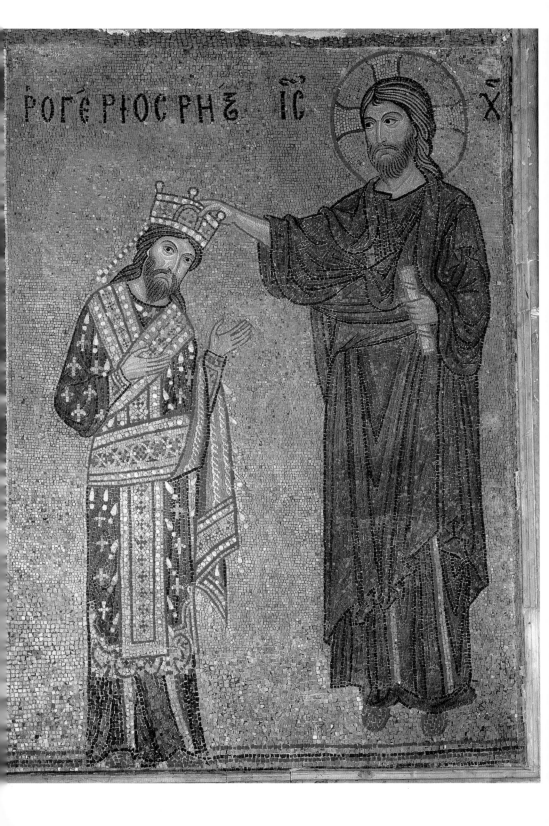

the Nativities of the Martorana and Cappella Palatina (183, 189), there can be no doubt of the close relationship between the two.

Of special interest, and unlike anything surviving in the Cappella Palatina, are two mosaic panels cut from their original locations and now displayed in the outer aisle of the new part of the Martorana. The first panel (190) shows a standing figure of Christ with his hand on the crown of a somewhat smaller ruler, dressed in the Byzantine imperial *loros*. The (Greek) inscription above identifies this ruler as *Rogerios Rex*, that is King Roger II. With his long hair and dark beard, the image of King Roger makes him look distinctly Christ-like.

The second panel (191) is dominated by a standing figure of the Theotokos, holding a long inscribed scroll. Its text reads:

O Child, shield from all adversity Georgios, the first of all Archons, who has built me this house from the foundations, and also all his family. Grant [him] absolution from [his] sins. For thou, O Word, as the only God, hast the power.

At Mary's feet kneels a grey-haired and bearded figure, his crouched body incompetently restored and now looking like a carapace. The inscription above states: 'Prayer of your servant Georgios *Amer*'. At the top right a small figure of Christ blesses His mother. Taking the texts and gestures together it appears that Georgios prays to Christ through the Theotokos for protection and forgiveness, and that Christ duly blesses him. These two panels were perhaps orginally in the (demolished) *narthex* of the church. The Byzantine formula showing the donor with the Mother of God is one we have already encountered, for example in the Bible of Leo (111).

We know from inscriptions and documents that this church was the *katholikon* of a nunnery dedicated to St Mary, 'built and endowed' by Georgios in 1143. It could have been begun in 1140, in response to his mother's deathbed wishes. The mosaic decoration need not have taken long to complete – one season perhaps? Georgios (who died in 1151), his parents and family were buried in the church. Georgios' family came originally from Antioch (which fell to the Seljuk Turks in 1084). He had served the Muslim prince of al-Mahdiah, near Kairouan

in modern Tunisia, before travelling to Palermo where he rose to become Roger II's chief minister. His grandiose titles, 'Archon of Archons' (commander of commanders) and 'Emir of Emirs' (latinized as *Ammiratus Ammirati* – admiral of admirals), reflect the trilingual Greek/Arabic/Latin culture of Sicily at the time. But in contrast to the Cappella Palatina, where we see a sort of visual parallel to linguistic trilingualism, the decoration of the Martorana avoids Latin and Arabic echoes in favour of consistently Greek – that is Byzantine – forms. Nonetheless, since the mosaic decorations of the two buildings must be contemporary, it would be surprising if some of the same craftsmen had not worked in both.

At Cefalù, some 75 km (46 miles, by modern road) along the coast east of Palermo, King Roger II built a major cathedral church dedicated jointly to the Saviour (Christ) and St Peter and St Paul. This too was decorated with mosaic, but only in the easternmost bay of the presbytery area. In comparison with either the Cappella Palatina or the much smaller Martorana the cathedral of Cefalù is a vast and imposing structure, with an interior length of over 70 m (230 ft, for plan see 192). The mosaic decoration begins only some 8·6 m (28 ft) above floor level, and the vault above, rising to about 26 m (85 ft), creates a feeling of enormous height above the rather narrow

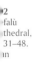

192
Cefalù
Cathedral,
1131–48.
Plan

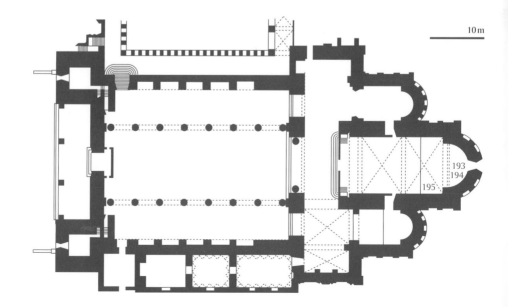

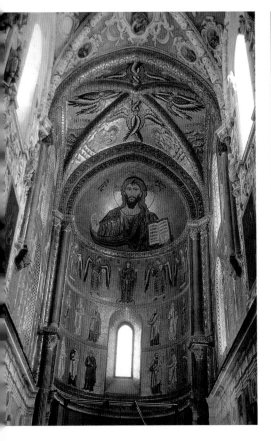
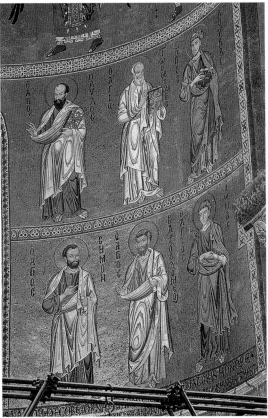

193–194
Mosaics.
Cefalù
Cathedral, 1148
Left
The Pantokrator,
Theotokos,
angels, saints
and apostles
Right
Six apostles

presbytery (about 10m, 33ft wide). The architecture of Cefalù is decidedly French rather than Byzantine in style and spatial organization, but many of its mosaics are nevertheless conspicuously similar to those in the two buildings in Palermo.

The date and patronage of the building and its mosaics are made explicit in a long mosaic inscription in Latin at the base of the apse (193). It reads:

The illustrious King Roger [*Rogerius Rex*], full of piety, moved by zeal for the Deity, built this temple. He endows it with various properties, and adorns it with varied ornament. He glorifies [it] in honour of the Saviour. Therefore Saviour for so great a builder help [him] that he, modest in heart, may retain those subject to him.

In the year from the Incarnation of the Lord 1148, the eleventh indiction, truly the eighteenth year of his reign, this work of mosaic was made.

The mosaic decoration is focused on the huge image of Christ Pantokrator in the semidome of the apse. He holds an open book with once again the text 'I am the light of the world; he that followeth me shall not walk in darkness but shall have the light of life' in Greek and Latin on facing pages. Immediately below is the orant Mother of God, flanked by four archangels. The two lower zones flank a central window and consist of the twelve apostles in four groups of three. These are virtually twins of the same figures in the Martorana, although Philip seems to have become Thomas, and vice versa (compare 188 and 194). The most plausible explanation for these striking similarities is to suppose that some of the same craftsmen worked in both buildings.

The quadripartite presbytery vault has angels, seraphim and cherubim. In the first two zones beneath, to either side of windows, there are ten prophets, with medallions of Abraham and Melchisedek at the top. Beneath on the north presbytery wall (also flanking a large window, but not aligned with the window above) are four deacon saints, and below them four 'Latin' bishops (Gregory, Augustine, Silvester and Dionysius). This scheme is balanced on the south wall

(195) by four military saints, and four 'Byzantine' bishops (Nicholas, Basil, John Chrysostom and Gregory of Nazianzos). It is conspicuous that there are no scenes from the life of Christ, indeed no narrative elements at all in these mosaics.

Although the apse mosaics at Cefalù are securely dated 1148, work on the church had been begun by Roger II in 1131, and the first document of endowment dates from 1132. The foundation of this new bishopric was an overtly political move, intended to weaken the power of the Archbishop of Palermo (an example of the often complex motives behind the founding and decorating of prestige buildings). Cefalù was colonized by Augustinian canons from Bagnara (on the Calabrian coast of Italy just north of the Straits of Messina), and that community's prior became the first bishop. Roger II also intended the cathedral as a dynastic burial place, and in 1145 (even before the church was completed) had 'established' a pair of massive porphyry sarcophagi intended for the choir. The curiously unfinished

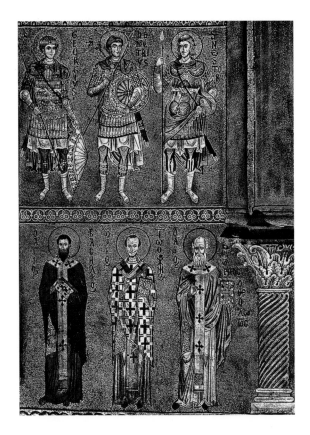

195
Military saints
and bishops
(detail),
c.1150s.
Wall mosaics.
South
presbytery,
Cefalù
Cathedral

and piecemeal look of the building is explained by the lack of inter-est in it shown by Roger II's successors. Indeed, on his death in 1154 Roger II was not even entombed in his sarcophagus at Cefalù but buried in the cathedral of Palermo. And his son, William I, was buried in the crypt of the Cappella Palatina on his death in 1166.

The last surviving major mosaic scheme erected by the Normans in Sicily is at the monastic church and later cathedral of Monreale (a contraction of in Monte Regali – Mount Royal), built on a terrace on a hillside less than 8 km (5 miles) southwest of Palermo. Monreale is a basilical church on a vast scale, its interior some 82 m (270 ft) long, the central vessel of its nave about 14·5 m (48 ft) wide (196). It has been calculated that the mosaic decoration covers an area of approxi-mately 7,600–8,000 sq. m, ie over 0·75 ha or about 1·5 acres of mosaic tesserae! The production of at least 100 million glass and stone tesserae (my rough estimate of the total number needed) would clearly have required a major commitment of labour and materials.

Although covering a vastly greater area than in the Sicilian churches already discussed, the mosaics at Monreale follow a familiar scheme. In the semidome of the apse is an image of Christ inscribed (in Greek) 'the Pantokrator' (198), displaying the by now predictable bilingual text 'I am the light of the world; he that followeth me shall not walk in darkness but shall have the light of life.' This time the Latin is on the left page, the Greek on the right. On the vault above (only this part of the church is vaulted) are archangels, cherubim, seraphim and the empty throne (compare Psalm 103:19).

There are two zones of mosaic on the vertical surfaces below the Pantokrator. In the upper zone an enthroned Virgin and Child (contrast the orant Virgin at Cefalù) is inscribed in Greek 'the Panachrantos' (the wholly immaculate). The choice of this epithet suggests that the mosaicists may have had in mind a specific icon of the Theotokos. She is flanked by archangels, and then by the twelve apostles, in two groups of six that extend on to the side walls of the presbytery (compare the lower zones at Cefalù). Below, flanking a central window, are various figures of holy bishops, deacons and monastic saints. Taken together, these constitute a surprising

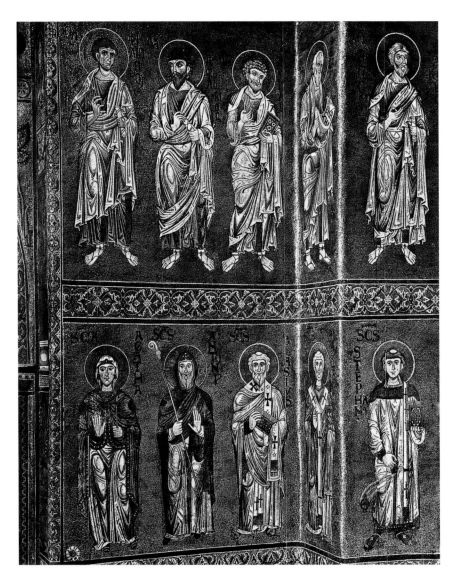

196–198
Monreale
Cathedral,
*c.*1175–90
Above left
Plan
Left
Apostles and
saints, 1180s.
Mosaic.
North pres-
bytery wall
Right
The Pantokrator,
Theotokos,
angels, apostles
and saints,
1180s.
Apse mosaics

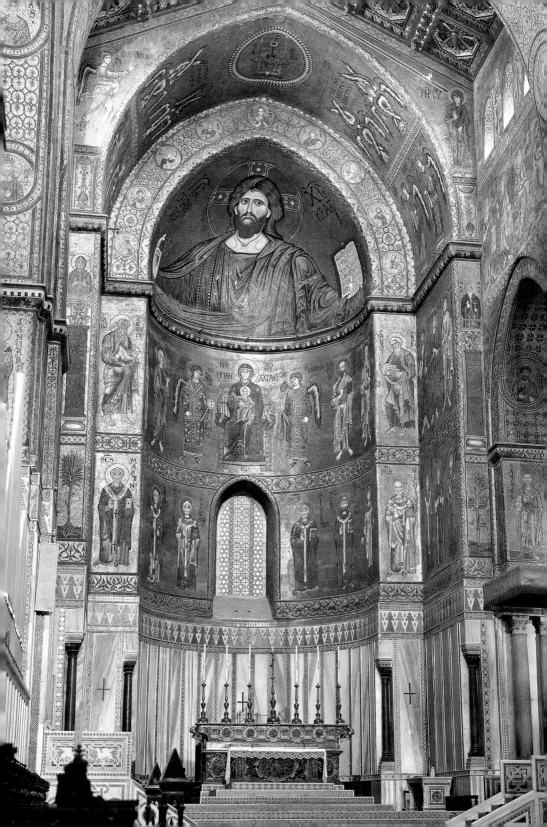

mixture. Reading outwards from the centre, on the northern side (197) we have Clement (a pope), Peter (Bishop of Alexandria), Stephen (the first martyr; see Acts 6–7), Martin (Bishop of Tours), Blaise (Bishop of Sebaste), Antony (founder of monasticism), and Agatha (martyr of Catania in Sicily). These are balanced by a group on the south wall comprising Sylvester (a pope), Thomas (Becket) of Canterbury (a bishop, martyred in 1170), Lawrence (a deacon), Nicholas (Bishop of Myra), Hilary (Bishop of Poitiers), Benedict (founder of western monasticism at Montecassino) and Mary Magdalene.

Some of the saints on the north and south presbytery walls can be paired off: Clement with Sylvester (both popes), Stephen with Lawrence (deacons), Antony with Benedict (monastic founders), Martin with Hilary (French bishops), Agatha less comfortably with the only other woman, Mary Magdalene. It has also been argued (not entirely convincingly) that one motive for making the selection was that it recorded some of the dedications of churches and monasteries endowed by William II to Monreale. Thomas Becket's presence (197), however, is hard to explain by such means: his inclusion must have been motivated by some personal devotion. (William II was married in 1177 to Joan, daughter of Becket's adversary, King Henry II of England.) Even accepting the choice of saints, it is still puzzling why they were arranged in this particular order on the walls. Was Becket really to be ranked above Saints Nicholas, Benedict or Stephen, as his position nearer the centre of the apse implies? Or did the planners of the layout not think, as the Byzantines did, in such clearly defined hierarchical terms?

The easternmost presbytery bay is followed by a short bay opening through tall arches to north and south and giving access to the apsidal chapels. Here the upper wall surfaces contain mosaics of twelve prophets. Further to the west is the crossing, which is formed by a very large oblong bay. When seen from the nave, it appears that there ought to be a dome over this space, by analogy with the Cappella Palatina, but this was never the intention. It follows that there is no central focus to the decoration in this area, which consists of scenes from the life of Christ on the vertical wall surfaces. Narrative cycles

199–200
Mosaics.
Monreale
Cathedral
Right
Scenes from
the life of
St Paul
Far right
The Sacrifice
of Isaac

involving Saints Peter and Paul are located in the vicinity of the southern and northern apsidal chapels. These cycles follow the Cappella Palatina closely, as we can see by comparison of the scenes of St Paul's confounding of the Jews and escape from Damascus (199; compare 184).

The arcade of the eight-bay nave is supported on massive reused granite columns, appropriated from some Classical site. Genesis scenes, from the Creation to Jacob Wrestling with the Angel, run round the upper wall in two zones exactly as in the Cappella Palatina. But here at Monreale they also include the western wall in their progress. It is striking that despite the much larger area available at Monreale, the mosaicists made few additions to the Genesis cycle of

the Cappella Palatina, preferring instead to spread out the same scenes over a larger area. The Sacrifice of Isaac (200), for example, is recognizably a reworking of the same image in the Cappella Palatina (185). But the previous scene, in which God instructs Abraham to sacrifice his son (Genesis 22:1–2), was alotted its own half-spandrel at Monreale, whereas in the Cappella Palatina it was necessary to cut off the figures rather awkwardly. It was in the transepts and on the nave aisle walls at Monreale that the mosaicists went far beyond anything previously attempted in Sicily. Here they provided a very extensive cycle of scenes from the life of Christ.

A conspicuous feature at Monreale is the presence of two thrones on the wall surface at the entrance to the presbytery. Of the two, only that on the northern side is in part original. Above it is an image of an enthroned Christ (201), displaying (again) the text 'I am the light of the world; he that followeth me' (there was no space to complete the quotation). Christ places his hand on the crown of a ruler identified by inscription as King William II (compare King Roger II in 190). Two angels fly down with further symbols of kingship: a standard and a jewelled orb. Immediately above Christ's hand is the conspicuous inscription 'For my hand shall aid him' (Psalm 88:22 in the Vulgate [Latin] version – the text of the Authorized Version is different). On the southern wall King William II (the portrait type is surprisingly different) offers a model of a church (this church) to the seated Mother of God (202), to whom it was dedicated. She stretches forward to receive the model, and the hand of God is extended in blessing towards William II. Originally there was an ambo (pulpit) beneath this panel.

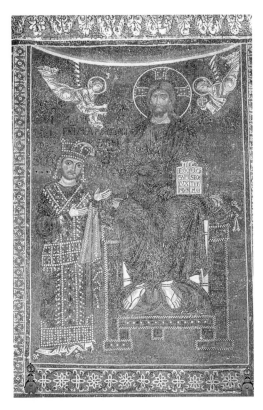
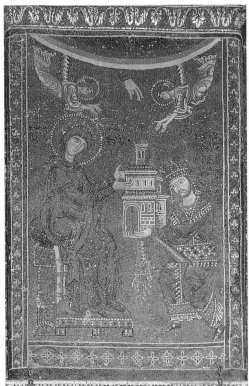

The Benedictine monastery of Monreale was founded by William II before 1174 and endowed by him in 1176. It was colonized in the same year by a hundred monks from the monastery of the Holy Trinity at La Cava, near Salerno south of Naples (a daughter house of the reformed Benedictine community at Cluny in Burgundy). In 1183 its abbot was created archbishop of the new see of Montis Regalis. We do not know how work on the mosaics progressed, but – justifiably or otherwise – the fact that the bronze doors for the west end of the cathedral were dated 1186 by their maker Bonannus of Pisa is often taken as evidence that the church was fully functional at that time. The speed of completion of the mosaics would have depended on how many craftsmen were employed, but even a relatively small team might have been able to do the job in ten seasons (extrapolating from the evidence found at St Sophia in Kiev). And the size and layout of the building would have permitted several teams to work concurrently in different areas, if sufficient skilled manpower was available and rapid completion was required. As for the origin of the craftsmen, it is most unlikely that any of those who had worked in the first phase of the Cappella Palatina, or in the Martorana or at Cefalù, would have still been active some forty years later when the mosaics of Monreale were being set. Even though the later work in the Cappella Palatina, as well as elsewhere in Sicily, would have provided employment and training for mosaicists, it is generally agreed that additional mosaicists from the Byzantine world would have had to be brought in to work in Monreale.

201–202
Mosaics.
Monreale
Cathedral
Far left
William II
and Christ
Left
William II and
the Theotokos

On his death in 1189 William II was buried in Monreale. It seems likely that (as was the case with Roger II's cathedral at Cefalù) his foundation was in part intended to curb the power of the Archbishop of Palermo, who at precisely the same time (1172–85) was rebuilding the city's vast cathedral. To promote a new archiepiscopal see only a short walk from the gates of Palermo must have been viewed as an obvious challenge. Palermo Cathedral (dedicated to the Assumption of the Virgin) certainly also had a mosaic decoration, although this does not survive. It is recorded that in the dedicatory inscription of its apse, Archbishop Walter addressed himself to *Christus Rex*, not to the *Rex Guillielmus Secundus* conspicuous at Monreale.

To understand why the Normans should have wished to decorate their Sicilian churches with Byzantine-style mosaics it is necessary to take a broader view of what was happening in the Italian peninsula at around this time. We can look first towards Venice, and mosaic decoration in churches in the Venetian lagoon, in particular S. Marco (St Mark's). Venice, some 120 km (75 miles) north of Ravenna on the Adriatic coast, was the principal long-term beneficiary of the Byzantine Empire's loss of northern Italy to the Lombards. Venetia had been a province of Ravenna, ruled by a *dux* (doge), and it remained a Byzantine dependency even after the fall of Ravenna in 751. In practice, however, Venice became increasingly independent as successive doges skilfully played off the distant power of Constantinople against local threats. Over time the city grew immensely wealthy on the profits of long-distance trade.

203
St Mark's,
Venice,
c.1063–1090
and later.
Plan

The first church of St Mark was built in the 830s to house the relics of St Mark the Evangelist, which were said to have been brought from Alexandria where he was believed to have been the first bishop. This was in part an attempt to eclipse the status of the see of Grado (some 90 km, 56 miles by sea across the head of the Adriatic), whose connection with St Mark had been recognized long before by the emperor Heraclius (r. 610–41), who had presented the bishopric with the Alexandrian *cathedra* of the evangelist (a throne sheathed with ivories). The first church of St Mark was destroyed by fire in 976 and rebuilt. This second church was itself replaced by the present St Mark's, perhaps begun in 1063 and probably completed structurally in the 1090s, but much modified later. The third St Mark's, like its predecessors, was based on the plan of the Justinianic church of the Holy Apostles in Constantinople, being cruciform in shape with a central dome and four further domes over the four cross-arms (203). It functioned not only as a martyrium church for St Mark, but as a kind of palace chapel for the doges, and from the second half of the twelfth century as in effect a cathedral, housing the *cathedra* of the Bishop/Patriarch of Grado.

It seems probable that the second St Mark's (built after 976) would have had mosaic decoration, although there is no record of this.

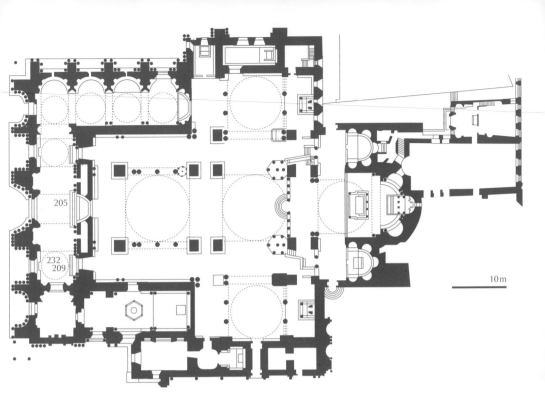

And before mosaic work on the third St Mark's began, craftsmen had been at work in the apses of the cathedral of Torcello (an island in the Venetian lagoon), perhaps in around the 1060s (204). The southern apse of that church has a mosaic decoration in the vault that is a conscious revival of a much earlier Ravennate scheme, whereas the row of standing apostles in the main apse is reminiscent of what might be found in a Byzantine church at this period. The standing Virgin and Child above are a replacement of late twelfth-century date.

The earliest part of the mosaic decoration of St Mark's is in the main porch and consists of standing figures in niches, probably of the late eleventh century (205). The standing figures of the main apse, and the prophets of the earlier part of the dome over the presbytery seem to be early twelfth-century work. Thereafter work continued in St Mark's into the late twelfth century, along with new work in Torcello (the apse and Last Judgement on the west wall), and in the apse of the nearby island church of Murano. There was also renewed work in

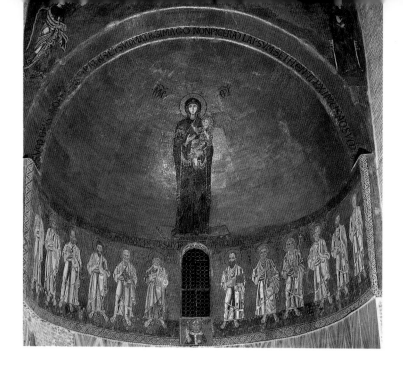

St Mark's, after a break, in the early thirteenth century. Numerous later intrusions and restorations, however, make the study of St Mark's highly complex.

To grasp the possible motivation and mechanics for artistic contacts between Sicily or Venice and Constantinople, an especially valuable source is the chronicle of the abbey church of Montecassino (in southern Italy), by the monk Leo of Ostia. Leo describes how Abbot Desiderius, in organizing the decoration of the new monastic church, sent envoys to Constantinople sometime after 1066:

to hire artists who were experts in the art of laying mosaics and pavements. The [mosaicists] were to decorate the apse, the arch, and the vestibule of the main basilica ... The degree of perfection which was attained in these arts by the masters whom Desiderius had hired can be seen in their works.

The reason for importing Byzantine craftsmen, according to Leo, was that there was no locally available alternative. But Desiderius took advantage of the situation to have monks trained:

204
Left
The Theotokos
and Child, late
12th century,
apostles, mid-
11th century.
Apse mosaic.
Torcello
Cathedral

205
Right
St Mark,
late 11th
century.
Porch mosaic.
St Mark's,
Venice

And since Mistress Latin Christendom [*Magistra Latinitas*] had left uncultivated the practice of these arts for more than five hundred years [here the chronicler exaggerates] … the abbot in his wisdom decided that a great number of young monks in the monastery should be thoroughly initiated in these arts.

The mosaics of the Veneto and Sicily presuppose a parallel situation: master craftsmen were presumably hired in Constantinople because there was no locally available alternative, but they employed and trained local artists who became capable of working in the Byzantine mode. Where we draw the line between 'Byzantine' and 'Sicilian' or 'Venetian' art of this period will thus remain a matter of somewhat empty controversy. What is beyond doubt, however, is that the mosaics of Sicily and the Veneto presuppose a thorough knowledge of Byzantine techniques and ideas.

It goes without saying that rulers as ambitious and wealthy as the doges of Venice or the kings of Sicily – or in a different way Abbot Desiderius of Montecassino – would not have wanted the products of Byzantine craftsmen had they not been acknowledged as providing

a setting for religious activity of the utmost splendour, and hence most likely to impress God (not to mention one's fellows). And the taste for such splendour was certainly not restricted merely to a desire for mosaics. When it came to the most impressive portable fixtures or fittings for a church, these too were often imported Byzantine products. In this case, however, it was not usually necessary to import craftsmen to produce the artworks *in situ*, and the most practical procedure was to purchase the objects in Constantinople, then ship them to the west. The chronicler Leo of Ostia records that:

> Desiderius [of Montecassino] sent one of the brethren to the imperial city with a letter to the emperor and thirty-six pounds of gold, and had made there a golden antependium [altar frontal] decorated with beautiful gems and enamels. In these enamels he had represented some stories from the New Testament and almost all the miracles of St Benedict.

In this case the monk/ambassador must have been required not merely to negotiate with the emperor, but also to instruct the Byzantine craftsmen, with sketches or by other means, in the required content of the object (especially its inscriptions), for 'the Miracles of St Benedict' would not have been a familiar subject to an artist in Constantinople.

The gold and enamel antependium made in Constantinople for Montecassino does not survive, but in St Mark's at Venice it is possible to gain an idea of what such a work might have been like. The object now called the Pala d'Oro (a golden altar retable, later refashioned and placed at the back of the altar; 207) is now an assembly of works of different periods. It is very large, about 2·1×3·15m (6ft 10³⁄₄ in × 11 ft 5³⁄₄ in) overall. Its beginnings seem to lie in an antependium made in Constantinople on the orders of Doge Piero Orseolo in 976, that is to say a frontal for the high altar of the second church of St Mark. This antependium was then remade as a *pala*, according to an inscription, in 1105 on the orders of Doge Ordelafo Falier. That there was Byzantine imperial involvement is suggested by the enamel image of Empress Irene (206), and it is assumed that a

206
Empress Irene, c.1105 (and later). Enamel detail from the Pala d'Oro; 17·4×11·3cm, 6⁷⁄₈×4¹⁄₂ in. St Mark's, Venice

207
Pala d'Oro, dated 1345 but incorporating earlier material. Enamels of various dates, precious stones, gilt metal

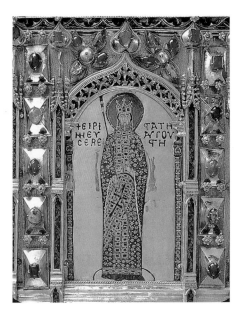

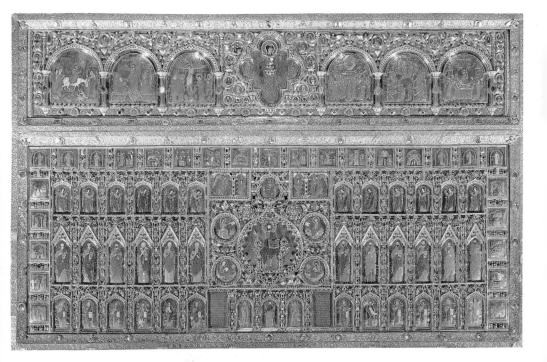

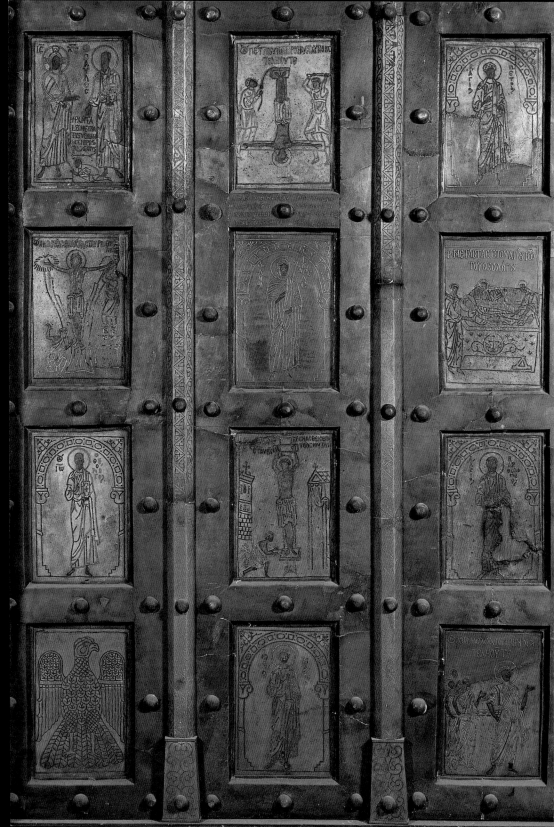

balancing enamel of her husband Emperor Alexios I (r.1081–1118) was removed at a later date. The doge also had himself represented in enamel as part of this scheme of donors, but his head was later replaced. The *pala* of 1105 was itself remade in 1209 (see Chapter 9), and again in 1345.

A further area of artistic activity that links together these various Italian churches (in places which, it must be remembered, were now outside Byzantine political control) with Constantinople is provided by the fashion for costly bronze doors. Leo of Ostia tells the following story:

> While visiting Amalfi, Desiderius saw the bronze doors of the cathedral of Amalfi and as he liked them very much he soon sent the measures of the old doors of Montecassino to Constantinople with the order to make those now existing.

208
Bronze doors
inlaid with
silver (detail),
1070.
St Paul's
fuori le mura,
Rome

The doors still survive, although reassembled. They bear inscriptions giving the date 1066, and the information that they were donated by Mauro, the father of Pantaleone, Count Maurone. (Note that Leo in his account gives all the credit to Abbot Desiderius – we must be cautious in taking such writings at face value.) The doors were remade in the fourteenth century, the original figured panels reversed and carved with a list of the abbey's properties. On their backs is the original decoration, consisting of incised figures with inlaid silver heads, hands and feet (most of the silver, however, has been removed).

The Maurone family of Amalfi were wealthy merchants with a settlement in Constantinople, and over a short period organized the provision of similar bronze doors with silver inlay not only for the cathedral of Amalfi (the set seen by Desiderius), but for the abbey church of St Paul's *fuori le mura* at Rome (the doors are dated 1070; 208), and the pilgrimage church of Archangel Michael at Monte S. Angelo (dated 1076). The inscriptions on the last are the most explicit. They state not only that the doors were given by Pantaleone, but that they were made 'in the royal city of Constantinople', and should be cleaned once a year 'so that they may always be bright and

shining'. The effect of eight centuries of regular (or even very irregular) polishing can be seen on the two sets of similar bronze doors that were made for St Mark's in Venice (209). The modelling of the features in the inlaid silver panels (softer than the surrounding bronze) has been almost entirely rubbed away.

We can imagine that the order for doors of this sort would need to be accompanied not only by overall measurements (as Leo of Ostia describes), but by detailed instructions as to what selection of figures or scenes was required, and what the accompanying inscriptions should be. We can judge this from the fact that each set of doors was 'custom-made' to suit local requirements: the doors at Monte S. Angelo feature miracles of St Michael with long Latin inscriptions (the church was dedicated to the archangel); those for St Paul's *fuori le mura* have scenes from the life of Christ with brief titles in Greek. At St Mark's, the smaller doors have inscriptions entirely in Greek, and were presumably made in Constantinople. The larger doors contain a panel showing the donor kneeling at St Mark's feet, and the inscription 'Leo da Molino ordered this work to be made' (in around 1112, or perhaps later), and it is thought that they could have been made in Venice. Be that as it may, the Venetians, we can be sure, did not negotiate the purchase of such doors through rival Amalfitan merchants. But nonetheless they were responding, doubtless in a spirit of rivalry, to what was happening in other major Italian cities and churches.

When King William II of Sicily had bronze doors made for Monreale he did not need to import them from Constantinople. The set for the west portal made by Bonannus of Pisa bears the date 1186; the other pair were made by Barisanus of Trani for the door on the north side that gives into the nave (the alternative entrance to the church). Bonannus and Barisanus (Bonanno and Barisano) were metalworkers who had learned not directly from Byzantine craftsmen, but by applying their observations of imported Byzantine doors to a long-standing local tradition of metal-working. Barisanus, whose doors also survive at Ravello Cathedral (dated 1179) and at Trani itself, stayed particularly close to Byzantine patterns, although working in low relief rather than with silver inlay. One advantage of the relief technique was that

209
St Theodore,
Porta di
S Clemente
(detail),
c.1080.
Bronze inlaid
with silver.
St Mark's,
Venice

he was able to reuse some of the moulds he had made so as to produce identical panels for more than one door with little extra labour.

It is not perhaps surprising that the Prince of Rus' should have invited Byzantine craftsmen to Kiev (as considered in Chapter 6), for there had been no tradition in that area of building in masonry, let alone a tradition of church architecture and decoration, before Vladimir's conversion to Christianity around 989. The 'Early Christian' period in Kiev, we could say, was the tenth and eleventh centuries (parallel to the period of Middle Byzantine art – the danger of these labels is evident!). But the situation in the Italian peninsula in the eleventh and twelfth centuries was entirely different. Here there was a sophisticated tradition of church building and decoration as long as Christian art itself, and there can thus be no doubt that the import of Byzantine objects and craftsmen, doubtless at great cost, was intended to supply specific requirements that could not be met locally. The surviving art is the best indicator of what these non-Byzantine consumers wanted: products of the most difficult techniques in the most expensive materials, works that would survive to impress God, the saints, ambitious rivals and future generations.

It is true that not a single document records the circumstances in which the churches of Norman Sicily came to be decorated with mosaics. We do not know for certain where the craftsmen came from, when they arrived, or where they went; and we have no way of establishing what the programmes they executed would have cost in terms of materials and labour, nor how long they would have taken to complete. The situation for Venice is only slightly less murky. Yet there is no doubt that master craftsmen came from the Byzantine world, most of them presumably from Constantinople; that some of them settled in the Greek-speaking communities of Sicily and Venice, or went wherever there was attractive employment; and that they trained local assistants in their craft. The situation can be expressed as a paradox. Those outside Byzantium who hired Byzantine artists wanted to look at a Byzantine art that would express their often un-Byzantine ideas.

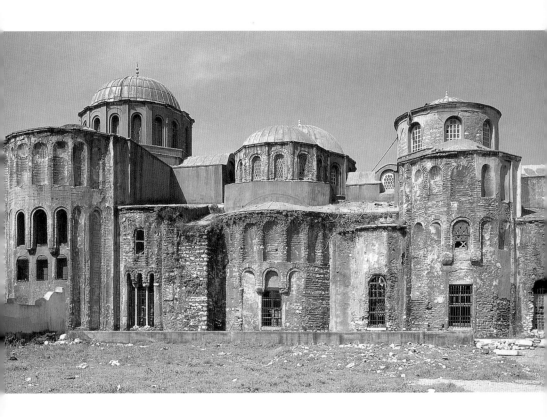

Quickly and greedily Abbot Martin plunged both hands in and, girding up his loins, he filled the folds of his gown with the holy booty of the church which, laughing happily … he carried back to his ship.

The year is 1204. The location: the imperial monastery of the Pantokrator in Constantinople (210). The circumstances: the city has been captured by western Crusaders who are proceeding to loot its treasures, and the Byzantine emperor has fled into exile. The protagonist, Martin, is abbot of a Cistercian monastery at Pairis in Alsace, and the chronicler is the monk Gunther. Martin has just threatened an aged monk of the Pantokrator with instant death unless he reveals the whereabouts of precious relics. Three-eighths of the city's plunder will be granted to the Venetians under Doge Enrico Dandolo, and within a month Baudouin (Baldwin) of Flanders will be crowned in St Sophia as Emperor of *Romania* – a Latin empire based on Constantinople. The chronicler Geoffroy de Villehardouin (*maréchal* of Champagne) will later declare with enthusiasm that 'so much booty had never been gained in any city since the creation of the world'. A very different view will be expressed by another eyewitness, the Byzantine imperial official Niketas Choniates (whose life was saved by a Venetian merchant), for whom the devastation wreaked on Constantinople was far worse than that sent by God upon Sodom and Gomorrah (compare Genesis 19:24–5).

Before considering some of the results of the conquest and pillage of Constantinople, it will be helpful to look more broadly at Byzantine art in the period before 1204. We can begin by considering (but less quickly and greedily than did Abbot Martin) the city's Pantokrator Monastery. Not only does the building survive (it is now known as Zeyrek Kilise Camii; the title 'Camii' – mosque, pronounced Jah-mee – indicates that the building was converted after the city's capture by the Muslim Ottoman Turks in 1453), but we also have the

210
Pantokrator
Monastery
(Zeyrek Kilise
Camii),
Istanbul,
c.1120–36.
Eastern
exterior

monastery's *typikon*, a legal document dated 1136 establishing how it was to be organized and to function. From this we know that it was the foundation of Emperor John II Komnenos (r. 1118–43). The monastery's most important structure is a complex of three domed churches built side-by-side (211). Including the original ambulatory to the south, the interior breadth of these spaces is some 48 m (157 ft) – very large by Byzantine standards.

The church to the south was dedicated to the Pantokrator, and had been built and endowed by John II's wife, the empress Irene, who died in 1134. Its dome, some 7 m (23 ft) in diameter, was supported on four columns of red marble, removed in the Turkish period. Of its

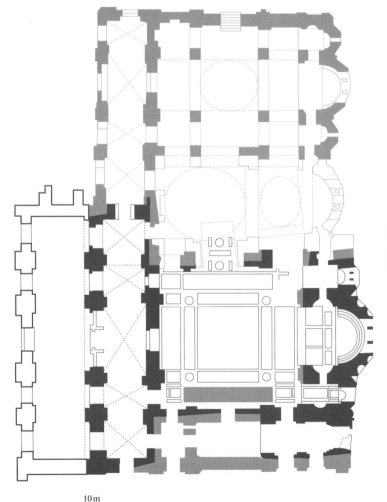

211
Pantokrator Monastery, Istanbul. Plan

10 m

decoration only a magnificent *opus sectile* floor and some marble revetment has survived *in situ*. John II added a church to the north, dedicated to the Theotokos Eleousa (the Merciful), while between the two was a chapel with two domes, dedicated to Archangel Michael. This contained the marble sarcophagi of the emperor and members of his family – the monastery was not merely an imperial foundation, it was to be an imperial mausoleum as well. The burial chapel in due course received various precious relics, including the porphyry slab on which Christ himself (it was believed) had been laid after removal from the Cross. The monastery, intended for eighty monks, also housed a number of charitable institutions caring for the sick (there was a fifty-bed hospital), and the needy (there was a hostel with twenty-four beds for old men).

Doubtless all the interior walls of the church complex of the Pantokrator Monastery were originally revetted with marble, and the domes and vaults decorated with mosaic, like the churches of Daphni, Nea Moni or Osios Loukas (which were considered in Chapter 6). Unlike those buildings, however, traces were also found during excavation and conservation of the extensive use of coloured glass in the windows of the south church. It is not certain that this glass dates from the 1120s/30s, but given that both the south and north churches were constructed with unusually large apsidal windows (now largely blocked, see 210), an original plan for painted glass seems plausible. Of all this decoration, however, little survives except fragments.

The only surviving twelfth-century mosaic work in all Constantinople is a single panel in St Sophia (212). It is in the south gallery, adjacent to the panel of Constantine IX Monomachos and Zoe (compare 145). As in the eleventh-century panel, the emperor, in this case John II Komnenos, carries a money-bag (*apokombion*), and his wife, the empress Irene, a rolled document. The accompanying inscription identifies John by the same formulae as Constantine Monomachos – 'in Christ God faithful King (*basileus*) Emperor (*autokrator*) of the Romans' – adding the term *porphyrogenetos*, 'born in the purple' – meaning that he was born to a reigning emperor, Alexios I Komnenos

(r. 1081–1118), the founder of a dynasty that ruled the Byzantine Empire for most of the twelfth century. To the right of the standing Theotokos and Child is the empress Irene, her title – 'most pious *Augusta*' – identical to that of the empress Zoe. Further to the right the mosaic continues somewhat awkwardly on to the side of a pilaster, which provides space for a mosaic image of the couple's eldest son, inscribed 'Alexios in Christ Faithful King of the Romans, Born in the Purple'. Note that only the father, John II, has the supreme title of *autokrator*. Alexios was proclaimed co-ruler in 1122, and as Irene died in 1134 the mosaic must have been set up between these dates. It was presumably to acknowledge a major donation to St Sophia, but of this no other record has survived. Irene's large

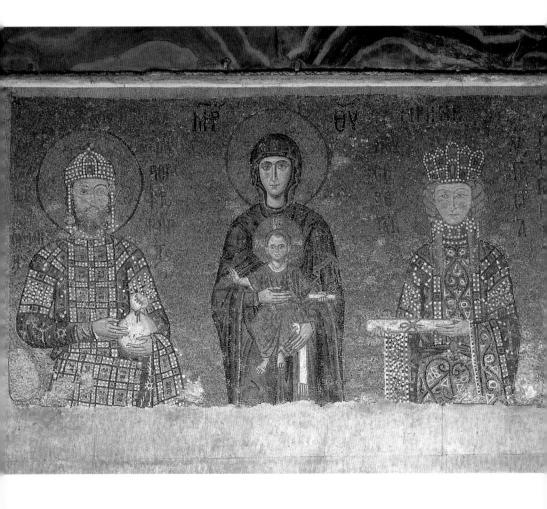

earrings and long braided hair readily distinguish her from Zoe, but it cannot be assumed that the image was intended to be a life-like portrayal of the empress.

Even outside Constantinople, the lack of surviving mosaics from this period is striking. There is a Communion of the Apostles in the apse of the cathedral church at Serres, some 95 km (60 miles, by modern road) northeast of Thessaloniki. That apart, we must leave Byzantine territory (as we did in Chapter 8) to find mosaics. In Kiev, Prince Svjatopolk (r. 1093–1113) built a church dedicated to St Michael, dated 1108. It was barbarically demolished in 1935, but the mosaic of the Communion of the Apostles from the apse was first removed and has been preserved (in St Sophia, Kiev). It is undoubtedly the work of

212
Left
The Theotokos and Child with John II and Irene, 1122–34. South gallery mosaic. St Sophia, Istanbul

213
Right
The Theotokos and Child with archangels, c.1130. Apse mosaic. Gelat'i, Georgia

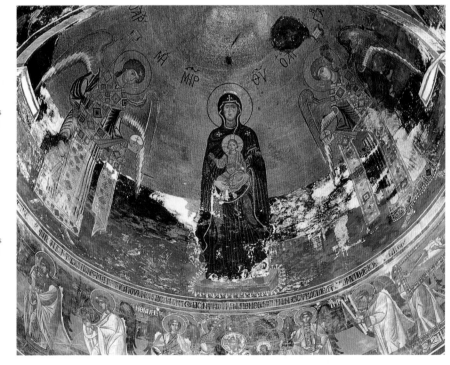

Byzantine mosaicists (the same composition had been used at Kiev's St Sophia). In the *katholikon* of the monastery (Academy) at far-away Gelat'i (the 'G' is hard) in Georgia there is further evidence of Byzantine artists working abroad. The fragmentary apse mosaic consists of a Mother of God and Child, flanked by archangels, in a familiar composition (213). With its Greek inscriptions it looks thoroughly Byzantine. The church complex was founded in 1106 by King David 'the Builder' (or Restorer), but work continued under his successor, King Demetrios (r. 1125–56), and the mosaic is generally thought to date from around 1130. Religious, political and cultural connections between Georgia and Byzantium were strong, and there were certainly Byzantine artists who spoke Georgian as a first language at this time. Whether the mosaicists called to Gelat'i spoke Greek or Georgian as their mother tongue, however, is less important than the deduction that they presumably came from Constantinople, and the observation that they produced a conspicuously Byzantine work.

The paucity of mosaics within the Byzantine world in these decades must be due in large part to accidents of survival, and gives a misleading impression. We would certainly be mistaken were we to deduce that every available Byzantine mosaicist must have left Constantinople to seek work in Venice, Sicily, Russia, Georgia or elsewhere. Nonetheless, the number of master craftsmen working in mosaic at the time may not have been very large.

To understand what the decoration of a twelfth-century church would have looked like we have to leave Constantinople, and consider wall-paintings rather than mosaics. This was a period of vigorous activity in the construction and decoration of churches and monasteries throughout the Byzantine world. Broadly speaking, these followed the architectural and decorative norms of the post-iconoclast centuries. Churches were generally of the domed cross-in-square type, although there were local variants, and they were painted with the familiar but not stereotyped combination of images of Christ, the Theotokos, prophets, apostles, saints and a variety of scenes (considered in Chapter 6). In part this consistency in church

decoration was doubtless because 'the traditional', which was by its nature 'orthodox', was preferable to innovation, which might be considered heterodox or even heretical. A further factor, however, operating at a different level of perception, seems to have been the cultural dominance of Constantinople. For example, Isaak Komnenos *sebastokrator* (an imperial title), the younger brother of the emperor John II and like him 'born in the purple', rebuilt the monastery church of Christ in Chora at Constantinople (the Kariye Camii – see Chapter 10), but he also founded a monastery dedicated to the Theotokos Kosmosoteira (Saviour of the world) at Pherrai, midway between Constantinople and Thessaloniki. The surviving *katholikon* is a big church with a dome 7 m (23 ft) in diameter and now-ruined wall-paintings. This was to be Isaak's burial place, and we still have the foundation *typikon,* dated 1152. Although provincial in its location, therefore, this monastery was thoroughly Constantinopolitan and all but imperial in every other way.

The case of the Theotokos Kosmosoteira at Pherrai was not an isolated one. Alexios Komnenos, son of Theodora the sister of Emperor John II, built a church dedicated to St Panteleimon at Nerezi in what is now Macedonia – it was the *katholikon* of a small monastery (215). He may have owned estates in this region, near the town of Skopje. The church was completed in September 1164, as we know from a painted inscription, and the painted decoration has survived in much better condition than in the Kosmosoteira (it was protected by a later layer of decoration, removed in 1927). Perhaps the most striking feature at Nerezi is the extraordinary delicacy of the style, given that we are dealing with painting at a large scale in a technique that demands rapid execution. The figures seem to make a direct appeal for the viewer's sympathy. St Panteleimon (216), with his long thin nose and eyebrows, cheeks streaked with red, and pursed mouth looks a little like a relative of the empress Irene in St Sophia, indicating a conventional element in the painter's personal style. In the Deposition from the Cross (214), the proportions of the figures are exaggeratedly tall and thin, their lined faces dramatically conveying their sorrow.

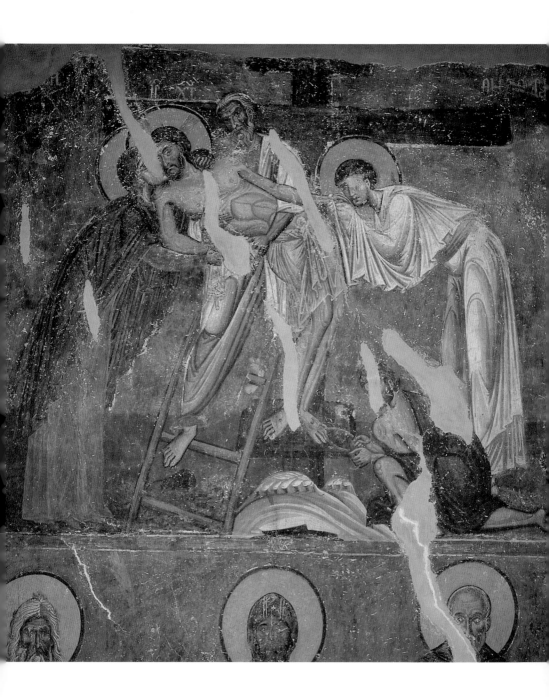

In comparison with the five-domed profile of Nerezi, the little church of St George at Kurbinovo in Macedonia, some 25 km (15 miles, as the crow flies) southeast of Ohrid – the seat of the local metropolitan bishop – looks unimpressive from the outside. It is a single-aisled building with a wooden roof, the rectangular space enclosed by its walls just 8·85×5·3 m (29 ft×17 ft 5 in). Within this unpromising exterior, nonetheless, there is a painted decoration of high quality, which in stylistic terms can be seen as further exaggerating the characteristics of Nerezi (218). At Kurbinovo, the figures are not merely tall and thin, their faces lined and expressive, but the very clothing

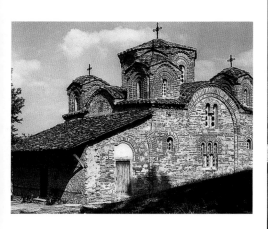

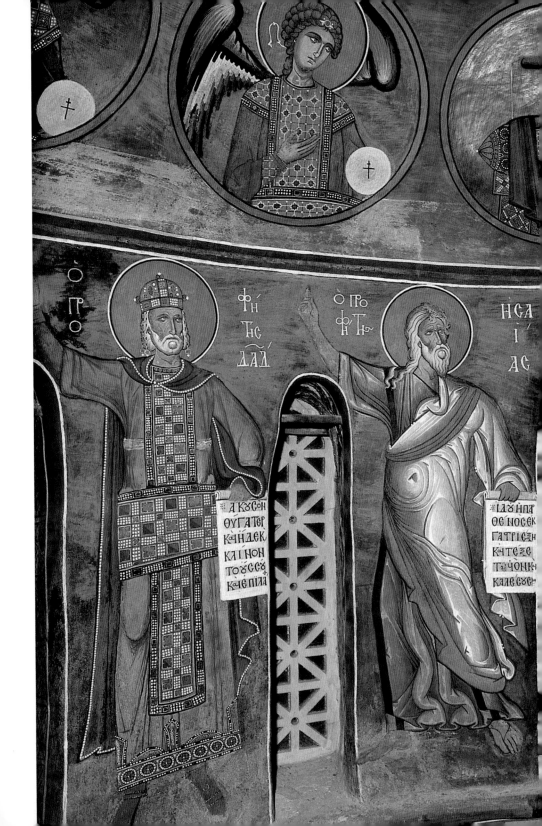

Ὁ ΠΡΟ
ΦΗ
ΤΗΣ
ΔΑΔ

Ὁ ΠΡΟ
ΦΗΤΗ

ΗΣΑΪ
ΑΣ

ΑΚΥCΟΝ
ΘΥΓΑΤΕΡ
ΚΑΙ ΙΔΕ ΚΑΙ
ΚΛΙΝΟΝ
ΤΟ ΟΥCC
ΚΑΙ ΕΠΙΛΑ

ΙΔΟΥ ΠΑ
ΘΟC ΝΟC ΕΚ
ΓΑΤΡΙ ΕΞΗ
ΚΑΙ ΤΕΞΕ
ΤΑΙ ΥΟΝ ΚΑΙ
ΚΑΛΕCΟΥC

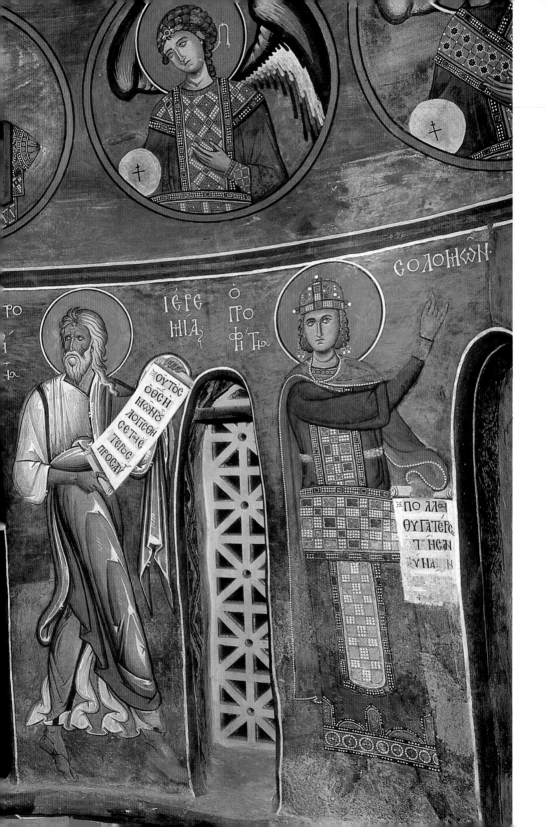

ΙΕΡΕ
ΜΙΑς
Ο
ΠΡΟ
ΦΉΤΗ

ϹΟΛΟΜΏΝ·

ΟΥ ΤΟϹ
Ο ΘϹ Η
ΜΩΝ ΟΥ
ΛΟΓΙΣΘΗ
ϹΕ ΤΑΙ Ε
ΤΕΡΟϹ
ΠΡΟϹ ΑΥ

ΠΟ ΛΛ
ΘΥ ΓΑΤΕΡΕ
Τ ΗϹΑΝ
ΥΝΑΜΙΝ

they wear has taken on a life of its own. It flutters rather than merely hanging down, and often forms extraordinary meandering folds in the small of the back, beneath the arm, or at the lower hem.

Kurbinovo is dated by a painted inscription on the altar to 1191, although we know nothing of who commissioned it. (The painting was begun in April, after the cold wet Balkan winter.) A very similar style is found in a church dedicated to Agioi Anargyroi (*ie* Saints Cosmas and Damian) at Kastoria, some 60 km (37 miles) further south in what is now Greece. But this characteristic style cannot be merely a local phenomenon, nor can it be the personal idiosyncracy of a single artist, for we also find a version of it in Cyprus, as in the

church of the Theotokos near the village of Lagoudera (217 and 219), dated by a painted inscription to 1192. (Here the painting was completed in December – the climate of Cyprus is very different from the central Balkans, and wall-painters could work much later in the season.) The same style can also be found in numerous manuscripts, and on icons, as in the undated and very carefully executed Annunciation panel (220) preserved at Mt Sinai (note how the halos were polished radially to catch and reflect the light – a development of the twelfth century). The most plausible explanation for the occur-rence of this style in differing artistic media and in places separated by great distances at around the same time is to presume that it was

disseminated from a single centre, namely Constantinople. It is also worth noting that the mosaics of Sicily and Venice do not exemplify this style in its most highly developed form, although the Ascension in the central dome of St Mark's comes close. Perhaps the mosaicists were not in touch with this current, or chose to eschew its more extreme features.

There are other ways of looking at Byzantine art in the years before 1204, apart from concentrating on mosaic and wall-painting. The most obvious of these is to look at paintings in manuscripts, because superb examples survive in relatively large numbers. The emperor John II Komnenos with his son Alexios (but without the empress

220
The Annunciation, late 12th century. Painted and gilded wooden panel; 61×42 cm, 24×16½ in. St Catherine's Monastery, Sinai

Irene) appears again in the frontispiece of a Gospel Book (221) now in the Vatican Library. The enthroned figure of Christ is attended by two crowned female figures, who appear by their gestures to recommend the two rulers. The inscriptions identify them as personifying Charity and Righteousness if we assume an overtly Christian reading (as I would), or the same words could be translated as Mercy and Justice, if we assumed a more political overtone to the image. The gesture by which Christ places his hands on the crowns should, as before, not be taken to indicate that the image refers specifically to a coronation (ie that of Alexios in 1122). Rather it shows the way in which John II and Alexios rule in and through Christ's support. As the inscriptions state,

Byzantine Art in a Wider World

221
John II and
Alexios with
Christ,
Gospel Book,
*c.*1125–35.
18·3×12 cm,
6¼×4¾ in
(page).
Biblioteca
Vaticana, Rome

222
Moses
Descends from
Mt Sinai, text
of Exodus and
commentary,
folio 258v,
Octateuch,
*c.*1130–50.
42·2×31·8 cm,
16⅜×12½ in
(page).
Topkapi Saray,
Istanbul

they are faithful kings of the Romans 'in Christ God'. The manuscript is thus dateable to the period of their joint rule (from 1122 until Alexios' death in 1142). It is not certain for whom or why this Gospel Book was made. It might, for example, have been a gift to the imperial family, with its flattering frontispiece showing divine support for the Komnenian family. But it might equally well have been a gift from the imperial family, in which case the same image would have been conceived as a traditional statement of imperial propaganda.

The same artist, it is thought, also worked for other members of the imperial family. For John II's brother Isaak, the founder of the monastery of the Kosmosoteira at Pherrai, he produced around 150 miniatures in a huge copy of the Octateuch (222), now in the Topkapi Museum in Istanbul. In this book he was part of a team of artists, who never completed the illustration that was planned. In comparison with his collaborators, he stands out as a far more accomplished craftsman. The Topkapi Octateuch was one of three such manuscripts produced over a relatively short space of time, all of which attempted in a variety of ways to improve on an eleventh-century model (resembling the Octateuch in the Vatican Library; see 174).

For Irene, who was married to John II's son Andronikos, it is thought the same artist executed the images in two copies of a special collection of Homilies on the Virgin composed by a contemporary monk, James of Kokkinobaphos. The approach of a Byzantine artist to illustrating a new text can be seen in this book, now in the Vatican Library. He worked with familiar conventions for individual figures, groups of figures or scenes. Several images illustrate each homily. One of them in the Homily on the Annunciation refers to the moment at which the Virgin accepts the Incarnation, and joyful angels bear the news to heaven (223). The elements of a standard Annunciation image and the repeated formula for a flying angel are here assembled into a composition that is entirely novel, but yet succeeds in looking traditional within the expectations of religious art – the viewer recognizes and accepts the precedents for its constituent parts.

The image facing the first homily in the Vatican Kokkinobaphos

πῖρα μα καλα μάριον ὅ ἡρεύξατο λόγον, τὸ
πολύ θαύμα τόν τῶ μαι τέ λων δι ήγη
μα, ἰδοὺ φησιν ἡ δούλη κ̅υ̅, γέ μοι τὸ
μοι κατὰ τὸ ῥῆμα σου:–

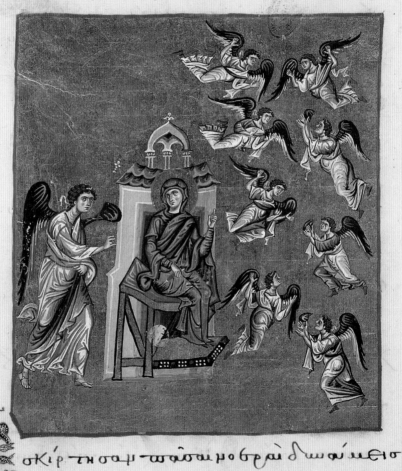

ἐσκίρτησαν ἅπασαι μο θραι δι ωῶν μεισ

manuscript is of an Ascension (224), taking place, it would seem, within a magnificently decorated multi-domed church. A similar scheme was also used for the frontispiece of a superlative copy of the Homilies of Gregory of Nazianzos (225), now at Mt Sinai. A special dedication page records that this book was presented by Abbot Joseph of the Pantokrator Monastery in Constantinople (who died *c.*1155) to the monastery of Aghia Glykeria from which he had originally come – he called himself 'Glykerites'. This book is definitely not by the Kokkinobaphos artist, but whether Joseph had it made within the Pantokrator Monastery, or commissioned it from outside craftsmen in the city, remains a mystery. The artist of the Kokkinobaphos manuscripts seems to have had a number of assistants (or imitators) and to have dominated production of manuscripts in mid-twelfth-century Constantinople. His easily recognizable style, however, does not occur in other media, suggesting he was a specialist in painting in manuscripts. (This artist is referred to conventionally, like most Byzantine craftsmen, as 'he'. The justification is not pure chauvinism, for the statistical record of names shows that the overwhelming majority of artists were male. Nonetheless, it would be unwise to rule out the possibility of female practitioners when looking at an anonymous work, especially a manuscript painting or icon.)

Painting on wooden panels, in the form of icons, also continued in

223–224
Homilies of
James of
Kokkinobaphos,
*c.*1130–50.
32·6×22·7cm,
12¾×9 in
(page).
Biblioteca
Vaticana, Rome
Opposite
The
Annunciation,
folio 127v
Below
The Ascension,
folio 2v

225
Below right
St Gregory,
folios 4v-5r,
Homilies of
St Gregory of
Nazianzos,
1136–55.
32·6×25·4 cm,
12¾×10 in
(page).
St Catherine's
Monastery,
Sinai

this period as before. But there were several developments. The first involved the physical setting of icons. The *bema* or presbytery area of every church had been fenced off from the congregation since the early period (as in St Sophia, see Chapter 2) by a structure usually consisting of waist-high screens on top of which were columns supporting an epistyle (a horizontal beam) at above head height. There was a central opening (with doors) towards the altar. In the standard post-iconoclast Byzantine church this structure was known as the *templon*, and good examples are preserved in the Panaghia Church and the Katholikon of Osios Loukas. The wall surface to either side of the *templon*, as viewed from the *naos*, was a position of special status, and carved marble frames were often provided for images in this position (such as the St Panteleimon at Nerezi, 216), and such images are sometimes called '*templon* icons'. The spaces between the columns of the *templon* were possibly screened by curtains; the practice of mounting icons permanently in these areas is a development of uncertain and hence controversial date (possibly around 1100 or later), although doubtless icons were mounted there temporarily, for example on major feast days, in the post-iconoclast period.

There were silver figures on top of the epistyle at St Sophia in the sixth century. What happened in this location in other churches in subsequent centuries is uncertain, but from around 1100 we have examples preserved at Mt Sinai of series of images (226) painted on a long plank or beam, intended to be placed on the front face or on top of the epistyle of the *templon*. These objects are now generally termed 'iconostasis beams'; they may include the principal Gospel images, from the Annunciation to the *Koimesis* (the Dormition or 'falling asleep' of the Theotokos), or their content may be focused on the cult of a particular saint, presumably for use in a church or chapel dedicated to him or her. It can be noted that placing a series of relatively small images, each perhaps 30–40 cm (11–16 in) high, on an architrave at a height of 2 m ($6\frac{1}{2}$ ft) or more, would have meant that the viewer was impressed more by the overall effect of gold and colour than by the devotional possibilities of any one scene.

As is always the case with Byzantine material, we need to be careful

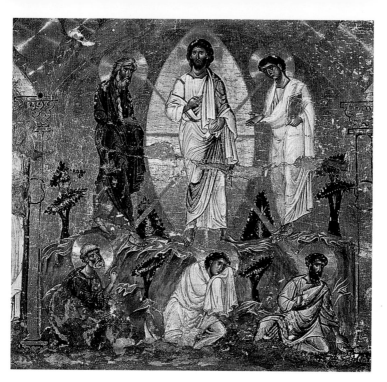

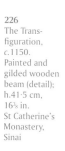

226
The Trans-
figuration,
*c.*1150.
Painted and
gilded wooden
beam (detail);
h.41·5 cm,
16⅜ in.
St Catherine's
Monastery,
Sinai

about our assumptions if they are based only on surviving works. The
English historian Bede (d. 735) records that as early as the 670s
Benedict Biscop brought from Rome to Northumberland a board on
which were painted images of the Virgin and the twelve apostles,
which was to run 'from wall to wall' across the 'central arch' of the
church. Although we cannot be certain as to what this 'board' looked
like, Bede does seem to describe the appearance and function of an
'iconostasis beam'. The Sinai examples, therefore, are probably best
considered chance survivals of what was not only once a widespread
phenomenon, but possibly also a long-lived one.

A development – in this case the term does seem justified – that took
place around 1200 involved the content of the usual rectangular icon.
This came to be expanded by including in the painted border around
the central figure a series of scenes from the saint's life – hence the
modern term 'Vita icon'. An early example is the St Nicholas at Mt
Sinai (227). This is a large panel (82×56·9 cm, 32¼×22⅜ in), and
the small marginal scenes with their explanatory inscriptions lead
the viewer into close observation and devotion. It is of particular

interest that the possibilities of this format were taken up systematically by painters in Italy from the 1230s onwards.

A striking technical innovation of this period was the production of a small number (to judge from surviving examples) of miniature mosaic icons, such as the Transfiguration now in the Louvre, Paris (228). In these icons the minute tesserae (with sides of about 1 mm or less) were set in wax or resin on a wooden panel. Although soft wax must have been a much more forgiving medium in which to work than the drying plaster of a monumental mosaic, these icons are unquestionably products of extraordinary craftsmanship. For example, an area of restoration in the lower part of Christ's robes in the Louvre Transfiguration immediately catches the eye due to the less skilful setting of the tesserae, which the viewer reads as tiny individual blocks of colour, rather than (in the undisturbed part) as painterly areas of light and shade. The overall dimensions of this panel are 52×35 cm ($20^{1}2 \times 13^{3}4$ in), suggesting that it was intended for public display, presumably on a stand. Some later examples are much

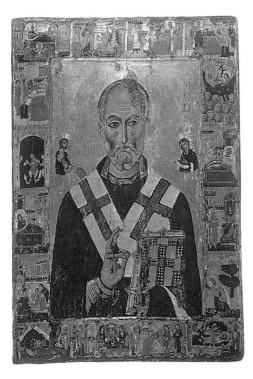

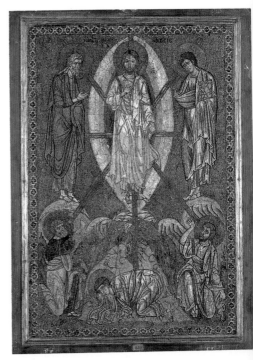

smaller (an Annunciation in the Victoria and Albert Museum, London, is only 15·2 × 10·2 cm, 6 × 4 in, including its broad frame), and they may have been intended to be portable and for private devotion.

In Byzantium, smallness of scale in works of art was generally linked with costliness of materials and perfection of workmanship, not with lack of resources or minor importance. From this it follows that the technique of miniature mosaic would not have been introduced merely so as to provide small-scale versions of monumental mosaic compositions. Rather it made possible the production of icons in an obviously costly fashion – the gold tesserae, for example, are of solid pure metal instead of being of gold leaf in a sandwich of glass – which could be considerably larger than even the very largest enamels, and which at the same time would not be limited by the monochrome effects of icons fashioned of repoussé gold or silver (of which there are surviving examples). We can also note in passing that ivory seems not to have been carved in Byzantium in the twelfth century.

There is a specific technical aspect of these miniature mosaics which deserves to be considered. When looking at monumental mosaics, the modern viewer is struck by a development over time towards the execution of faces not only with much smaller tesserae, but with the stones packed and fitted very closely together (turn the pages of this book and see for yourself). It is difficult to imagine, for example, how the faces of John II and Irene (see 212) could have been set freehand into soft plaster had the mosaicist not been extremely well prepared. It would make sense, in cases like these, for the mosaicist to have first composed the faces at leisure, perhaps using panels inlaid with wax. (Possibly this was an out-of-season activity?) The faces could then be reset in plaster – still a tricky business, but feasible. If this is indeed what happened, the making of miniature mosaics could have begun as a by-product of a new monumental technique, arrived at almost accidentally. Perhaps some wealthy visitor to an artist's workshop saw the preparation of a head for transfer to a wall, and requested something similar, but on a smaller scale. Whatever the true story, the craftsmen who produced monumental and miniature mosaics can hardly have been unaware of each

227
Far left
St Nicholas with scenes from his life, c.1200. Painted and gilded panel; 82 × 56·9 cm, 32¼ × 22⅜ in. St Catherine's Monastery, Sinai

228
Left
The Transfiguration, late 12th century. Miniature mosaic; 52 × 35 cm, 20½ × 13¼ in. Musée du Louvre, Paris

other's work; they may indeed have worked in both techniques, and it would be surprising if they did not apply the new lessons that had been learned.

To look at Byzantine art of the twelfth century is often to feel that, in general terms, little had changed since the end of Iconoclasm; indeed there is no doubt that this was one of the effects that the Byzantines were trying hardest to achieve. The true political situation was very different. In 1095 Pope Urban II had first preached the idea of helping the Christian churches in the East, in response to an appeal from the Byzantine emperor Alexios I Komnenos. The Crusades, as we now call them, began. In 1099 a crusading army captured Jerusalem and carved out a kingdom in the Holy Land. Its fortunes fluctuated over the two centuries until its final overthrow by the Mameluks in 1291. But throughout this period commerce of all sorts – in goods, in people, in ideas – between East and West, both by sea and overland, was sustained and vigorous. The Normans in Sicily and southern Italy, and the great maritime trading cities of Venice, Amalfi, Pisa and Genoa benefited hugely from the increased connections between eastern and western Mediterranean lands.

The Byzantine attitude to this phenomenon, and Western attitudes to Byzantium, fluctuated violently over the same period. For example, the Normans had orginally been hired as Byzantine mercenaries to fight the Lombards and Arabs in southern Italy, before they decided to fight on their own account. They eventually became powerful enough to mount expeditions against the Balkan heartlands of Byzantium (in 1081–5, 1107–8, 1147–8 and 1185). As for the Venetians, the Byzantines had granted them special exemption from taxes (probably in 1082), but they later expelled them from Byzantine territory (in 1171), and massacred them in large numbers along with other Latins – a general term for Westerners – in Constantinople (in 1182). The Byzantines had lost most of central Asia Minor to the Seljuk Turks (the last great wave of invaders from the East) after defeats in 1071 and 1176, but they nonetheless found it expedient at times to seek Muslim support and aid against the Crusaders (as happened in 1189). The Byzantines still maintained claims to an

empire far larger than the southern Balkans and western Asia Minor which formed the bulk of the lands they controlled in the twelfth century, but their expectation that the Crusaders would cede conquered territory ('reconquered' in their view) to Byzantium was disappointed, not surprisingly. Thus after a century of tension, the Venetian-financed crusade against the schismatic Christians of Constantinople in 1203–4 was unforgivable, but not unforeseeable.

The Crusader kingdom with its capital at Jerusalem occupied an intriguing position culturally as well as geographically. The indigenous culture that developed there was eclectic in the extreme. A witness to this mingling of ideas is provided by an illuminated psalter (229), now in the British Library, London. This seems to have been made for Queen Melisende, whose father King Baudouin (or Baldwin) was from Flanders, and whose mother Emorfia was a princess from the Armenian Kingdom of Cilicia (in what is now southern Turkey). The text of Melisende's Psalter was written entirely in Latin, but there is a series of full-page miniatures at the start which look strongly (but not entirely) Byzantine. The choice of twenty-four scenes from the life of Christ, from the Annunciation to the *Koimesis*, is not what you find in any Byzantine Psalter. It resembles more in its effect a sequence of Byzantine icons. The last of these miniatures, the Deesis – a quintessentially Byzantine image – has an inscription (in Latin) incised in the gold ground beneath Christ's feet: 'Basilius made me'. The book thus witnesses to the appreciation of Byzantine art in the twelfth century, without itself being a direct product of that art.

This sort of highly complex situation continued through the twelfth and thirteenth centuries, and involved painting of all sorts, not merely in manuscripts. This art is often termed 'Crusader', but this is misleading in that it implies something imported and Western. The art of the Kingdom of Jerusalem had local sources (whether imported or not) and its own distinctive indigenous character.

When the Crusaders sacked Constantinople in 1204 they were looking for booty. The church of St Mark at Venice benefited most conspicuously from what was found. The four gilded bronze horses,

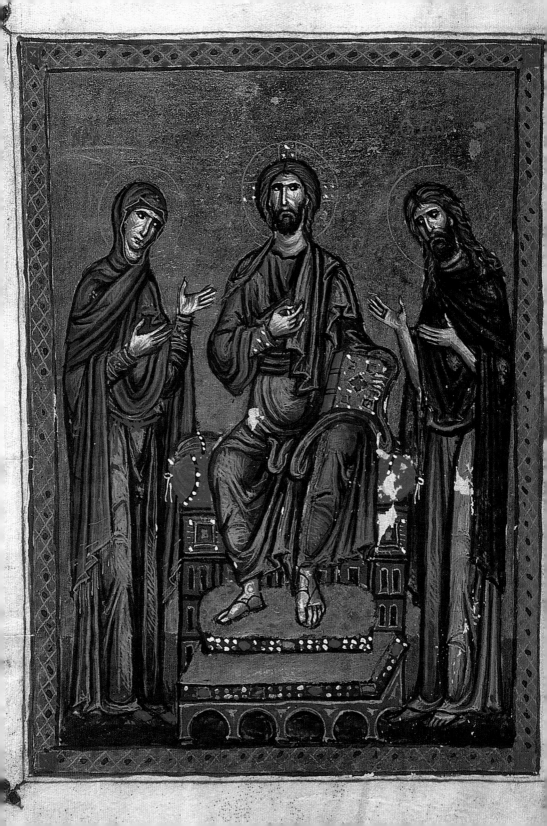

themselves spoils presumably brought to Constantinople in the fourth–sixth century, were removed from – it is thought – the Hippodrome, and set up above the western entrance to St Mark's perhaps in the 1230s or 1240s (they were removed in the 1970s to protect them from atmospheric pollution, and replaced by copies; their origin has not been established). Below them, built into a corner of the atrium, are the porphyry sculptures generally called the 'Tetrarchs'. They probably date from around 300, and they may have been taken from Constantinople's Philadelphion, an open space to which they perhaps gave the name (their gestures could suggest 'brotherly love'). Marble revetments and floors were stripped from the churches of Constantinople and reused, columns with their bases and capitals seized, and many panels of decorative and figurative sculpture suffered the same fate. Entire *templon* screens were disman- tled and their constituent parts reassembled in different combina- tions. For the most part it is not possible to trace the origin of the looted pieces, but capitals and columns (the misleadingly named *Pilastri acritani* outside St Mark's, 36) from the sixth-century church of St Polyeuktos are sufficiently distinctive to be recognizable.

Precious objects in gold and enamel were lustfully snatched up. A principal beneficiary was the Pala d'Oro of St Mark's, which was 'renewed' according to an inscription in 1209. An entire new section was added at the top (see 207 and 231). This comprises six large panels (each about 30 cm, 12 in wide) with scenes from the Gospels (the Entry into Jerusalem, Crucifixion, Anastasis, Ascension, Pentecost and *Koimesis*) flanking an even larger panel of the Archangel Michael (44×39 cm, $17\frac{1}{4} \times 15\frac{3}{8}$ in). A fifteenth-century Byzantine visitor to Venice identified these enamels as coming from the Pantokrator Monastery in Constantinople, and despite some problems with the text this provenance is consistent with their style. It can be assumed that a further six panels would have depicted earlier episodes in Christ's life (probably the Annunciation, Nativity, Presentation in the Temple, Baptism, Transfiguration and Raising of Lazarus), and that together these twelve panels decorated the epistyle of the *templon* of either the Pantokrator's north or south church. Excavations in the south church in 1961–2 brought to light a short section of enamelled

229
The Deesis, folio 12v, Melisende Psalter, 1131–43. $14 \cdot 3 \times 9 \cdot 9$ cm, $5\frac{5}{8} \times 4$ in (image). British Library, London

inscription in a similar technique to those on the Pala d'Oro panels, although it need not have come from the same object. The Archangel Michael in the top centre of the Pala d'Oro would presumably originally have had a companion in Gabriel, and they would have flanked some central composition, but the panel's quatrefoil shape implies it may not originally have been mounted with the twelve scenes, and need not have come from the same *templon*. (The chapel between the Pantokrator's north and south churches was dedicated to St Michael – a possible source?) Compared with this enamelled example, therefore, it can be seen that the painted 'iconostasis beams' at Sinai must have been relatively inexpensive.

The treasury of St Mark's contains numerous other precious objects brought from Constantinople, many of them also 'recycled' although not to the same extent as the marble sculpture and Pantokrator enamels. Enamelled book-covers, for example, were stripped off their original Greek texts and used to decorate Latin ones. The technique of one example (230) marks it out as coming originally from a late ninth- or early tenth-century Byzantine book. It is closely related to the crown of Leo VI, which was also brought to Venice at the same time (see 127).

Relics and the reliquaries that housed them were tampered with less. In such cases the preciousness of the Byzantine setting was obviously considered to add to the relic's value by proclaiming its exotic origin to a Western viewer. The True Cross reliquary now at Limburg an der Lahn (128–9), for example, was Crusader loot from Constantinople, bequeathed to the Augustinian house at Stuben on the Maas by Heinrich von Ülmen in 1208 (it reached Limburg only in 1827). The cathedral of Halberstadt received many relics from the churches of St Sophia and the Holy Apostles. Many of the churches of France benefited greatly: in 1205 King Philippe II – called *Auguste* – presented the Abbey of Saint-Denis with relics sent from Constantinople, including a fragment of the True Cross valued in 1223 at 12,000 *livres* (equivalent to the king's entire household expenses for a year). The cathedrals of Amiens, Beauvais, Chartres, Lyon, Reims, Soissons and Troyes and the abbeys of Clairvaux, Cluny and Corbie (to name but a selec-

230
Far left
The Crucifixion with saints and angels, c.900.
Enamelled book-cover; 26 × 17·5 cm, 10¼ × 7 in.
Biblioteca Marciana, Venice

231
The Anastasis, Pala d'Oro, c.1130 and later.
Enamel; 30 × 30 cm, 12 × 12 in.
St Mark's, Venice

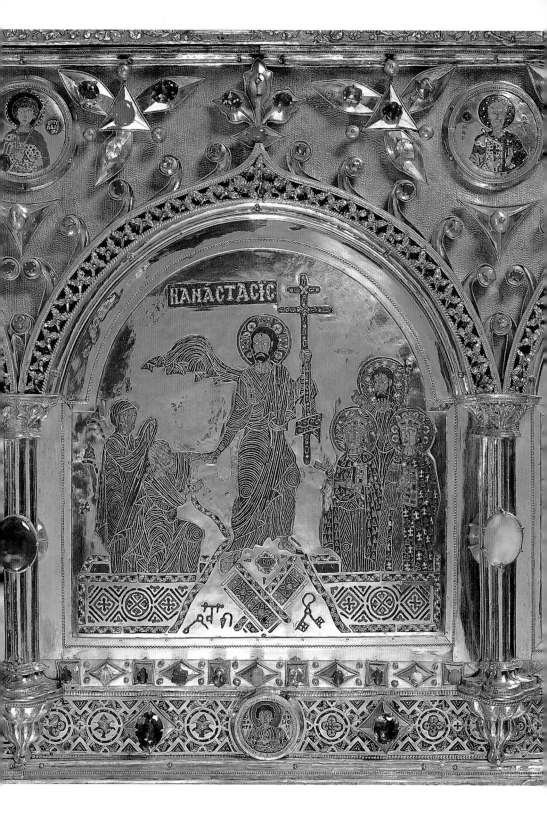

tion) all received important relics from 1205 onwards.

The most precious relics of all, in the eyes of Western Christendom, were those of Christ's Passion, not just the Cross, but in particular the Crown of Thorns, the Nails, the Lance and the Sponge. These had been brought to Constantinople over the centuries, and by the early thirteenth century were kept in a chapel of the Boukoleon palace, termed the *Sainte Capele* by the Picard Crusader Robert de Clari. After 1204 (along with numerous other relics) they were used by the impoverished Latin rulers of Constantinople to raise money, underwrite loans, or generally to buy favour. The Crown of Thorns was pawned to Venetian merchants in 1238. They deposited it in the Pantokrator Monastery, which had been a Venetian possession since 1204. It was redeemed by (*ie* sold to) King Louis IX of France for 13,134 gold *hyperpera* in the same year. The relic was welcomed in Paris in 1239 by special ceremonies, and the Sainte-Chapelle (dedicated in 1248) was built within Louis' palace on the Ile de la Cité specifically to provide a setting for it. The king is said to have spent on the purchase and display of the relics two and a half times what he spent on the building – and no visitor can fail to be impressed by the structure of the Sainte-Chapelle. In this case, unfortunately, the relics were destroyed in the French Revolution, and there is no trace of their Byzantine settings.

Alongside the catalogue of loss and destruction, there is the occasional positive note to be struck. One of the most curious aspects of the preservation of Byzantine art involves the reception given to the sixth-century manuscript known as the Cotton Genesis (mentioned in Chapter 2). Not only did this reach Venice, it was accorded a most remarkable compliment. No less than 110 scenes in the mosaics of the atrium of St Mark's were based directly and closely on the miniatures of the manuscript (compare 232 with the now pitiful fragment in 49). These mosaics were probably begun in the 1220s. At first the mosaicists respected and attempted to reproduce the style of their ancient model with a remarkable degree of fidelity, although the adaptations became freer in (presumably) later mosaics.

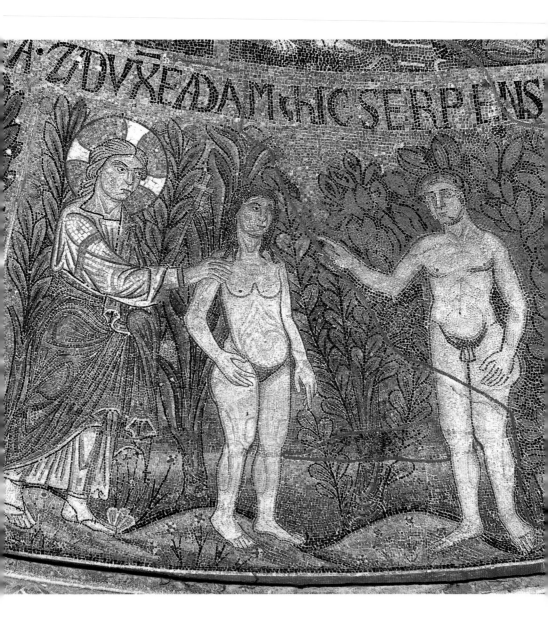

232
God Introduces
Eve to Adam,
1220s.
Atrium mosaic.
St Mark's,
Venice

233
The Colossus of
Barletta,
5th century
(c.457–74).
Bronze.
Barletta, Puglia

It has been suggested that the Cotton Genesis was not loot from
Constantinople (despite the circumstantial evidence of the date of
the mosaics), but was brought from Alexandria, which could have
given it the status of a relic of St Mark. Were this the case it is
perhaps surprising that the manuscript was not preserved in the trea-
sury of St Mark's. Personally, I think it quite likely that the Venetians
may have had it both ways, so to speak, by acquiring the manuscript
from one source and then claiming it was from another – as with the
columns from St Polyeuktos, later said to have been brought from
Acre in the Holy Land. It is also worth noting that the Vienna Genesis
(see 47–8) is known to have been in Venice in the fourteenth century,
and it too may well have come from Constantinople after 1204. Be
that as it may, no other manuscript is known to have performed
quite the same role in providing a source for a major church decora-
tion as the Cotton Genesis did at St Mark's.

Doubtless many of the treasures of Constantinople perished in the rush to loot them, or by accident or misadventure at some later stage in their journey to the West. It would be a pity, nonetheless, to pass over without comment the most curious example of a lucky survivor: the gigantic (5·11 m, 16 ft 9¼ in tall) bronze figure of an emperor, known popularly as the Colossus of Barletta (233). Recent research has concluded that it probably represents Emperor Leo I (r. 457–74), and may have stood atop a column of which the massive capital still survives, relocated in the garden of the Topkapi Saray Museum in Istanbul. The Colossus was loot from Constantinople, on its way by ship to Venice. The ship was driven ashore and wrecked near Barletta, however, and in 1309 the giant bronze still lay at the city's port where it was declared to be the property of the kings of Naples. In the same year its legs were cut off to be melted down and recast as bells for the Dominican church at Manfredonia. They were restored in the second half of the fifteenth century (the left hand and right arm are also restorations), and the statue was erected outside the church of S. Sepolcro.

One effect of the conquest of Constantinople in 1204, therefore, was to make available to Western eyes a vast body of Byzantine material. Some of this had been relatively recently produced (like the enamels from the Pantokrator Church), but overall the booty represented the dispersal of works gradually accumulated in the city since Constantine's time. Crusaders and Venetian merchants did not, we can be sure, make subtle aesthetic judgements about which 'period' of Byzantine art they thought was the best. They were after works in materials which they knew to be precious: gold, silver, bronze, ivory, enamel, silk and marble, as well as relics which were precious for different reasons. But what of the producers of this art? What happened to the artists who had previously made their living in Constantinople? Given that the Latin Empire was chronically short of money, most artists must have had to look elsewhere for employment.

To describe the political situation in the lands of the former Byzantine Empire in the years after 1204 as complicated would be a striking understatement. It is important to understand, nonetheless,

that, until the recapture of Constantinople by the Byzantines in 1261, instead of a single dominant centre there were numerous competitors: at Nicaea and distant Trebizond in Asia Minor; on the Greek islands and mainland, which were split between Latin principalities, Italian trading stations and Byzantine overlords; and in the Balkans, where a Serbian kingdom grew rapidly in importance. The best-preserved examples of the building and decoration of churches in this period are those in (medieval) Serbia, where, as with the Normans in Sicily, the rulers seem to have been delighted to be able to employ Byzantine artists to supply their needs.

The monastery of the Virgin at Studenica, near the long-established Serbian centre at Ras (Raška) between Belgrade and Skopje, was founded by the Serbian Prince (Grand Župan) Stefan Nemanja, who retired to it taking the monastic name Symeon in 1196. Stefan/Symeon moved shortly after to join his younger son, the monk Sava (St Sava), on Mt Athos. After his death, Sava brought his father's bones back to Studenica in 1208, and became that monastery's abbot. The *katholikon* of the monastery was painted, according to an inscription at the base of the dome, in August 1209 (presumably this marked the end of the first season's work). Stefan/Symeon is described in the inscription as 'friend of the Greek Tsar Alexios', and the decoration is said to be the work of his sons Vukan and Sava (*ie* they were the work's sponsors, not its executants). It is surprising that Stefan/Symeon's eldest son, also called Stefan, is not mentioned. This Stefan was married first to a niece of 'Tsar' Alexios I Komnenos, and was granted the imperial title *sebastokrator*, but divorced her around 1200 and married the granddaughter of Doge Enrico Dandolo of Venice (the political realignment involved is at once apparent). But Stefan's absence is probably only due to the fact that the surviving inscription is incomplete.

The careful ashlar construction of the church at Studenica, with its marble exterior and sculpted west portal and east window, looks entirely un-Byzantine. It implies the use of an architect and masons (and sculptors) brought from the Dalmatian coast. But the painting within, despite the Slavonic inscriptions, looks thoroughly Byzantine.

The west wall is dominated by a vast Crucifixion (234). In contrast to the paintings of the previous decade, such as those at Kurbinovo (see 218), the style of Studenica is remarkable for its calmer and more naturalistic effects. Gone are the extraordinary elongation and the contorted folds. Elsewhere in the building the desire to emulate a mosaic decoration is apparent in the use of gold leaf for the backgrounds, overpainted with a network of lines to resemble tesserae.

A similar style is found in a series of mainly monastic churches founded by members of the Nemanja dynasty in the next decades. These were built and decorated against a background of constant political and ideological manoeuvring. For example, in 1217 Stefan promised Pope Innocent III to bring Serbia under the jurisdiction of the papacy in return for a crown, which he duly received (thus founding the Serbian kingdom). But in 1219, the Byzantine ruler at Nicaea, together with the exiled Patriarch of Constantinople, recognized Stefan's brother Sava as an archbishop, no longer under the jurisdiction of (Byzantine) Ohrid. This reflects on yet another complicated power struggle, for the Byzantine ruler of Epiros was a rival to the emperor in Nicaea, and Ohrid was within his territory. Political and religious affiliations were inextricably interwoven.

Looking towards the later period of Latin rule in Constantinople, we can consider briefly the monastery at Sopoćani, to the south of Raška, which was founded by King Stefan Uroš I (r. 1243–76) in around 1255. In 1266 Uroš transferred the body of his father, King Stefan, from Studenica to Sopoćani. The wall-paintings at Sopoćani probably date from around this time. The variety of styles they exhibit is puzzling: from the eccentric curving drapery reminiscent of Kurbinovo, to the smooth heavy folds of Studenica. But the proportions of the figures (as seen for example in the *Koimesis*; 235) have changed again: now they have unnaturally small heads, whereas their bodies are thickened by swelling drapery. As at Studenica, the background of much of the painting was gilded and then painted in imitation of mosaic.

As was the case in Norman Sicily, there is no documentary evidence for the employment of Byzantine artists in the Serbian royal churches

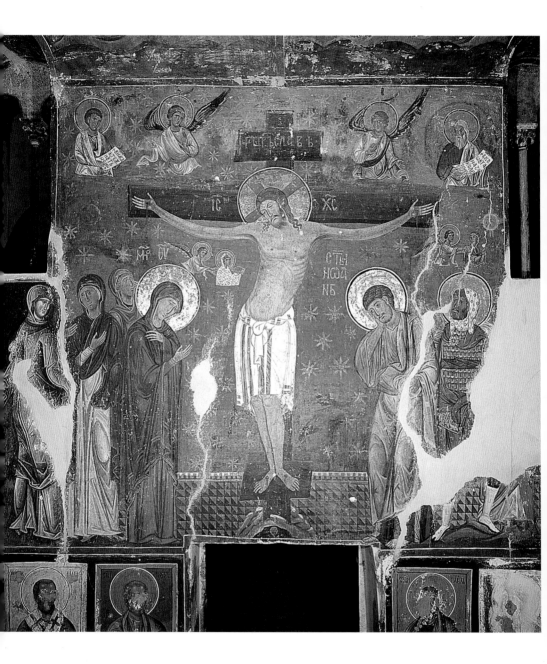

234
The Crucifixion,
1209.
Wall-painting.
Studenica,
Serbia

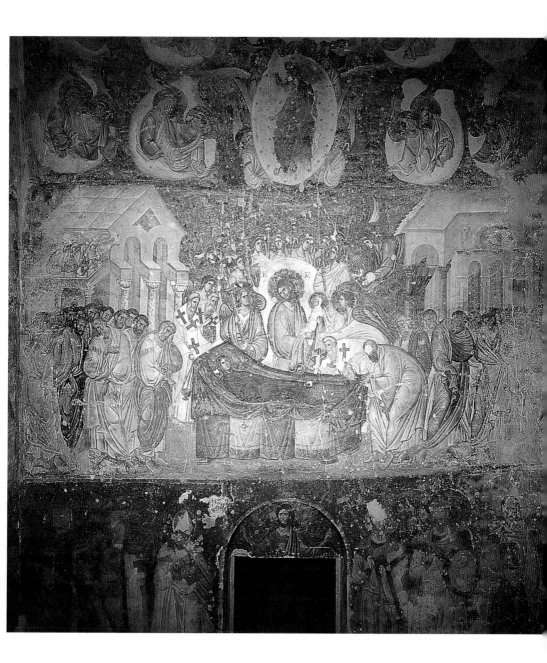

235
The *Koimesis*,
*c.*1266.
Wall-painting.
Sopoćani,
Seprbia

of this period (but compare the situation described in Chapter 10). And in a sense it would be quite correct to term the decoration 'Serbian art'. But as in Sicily, it is inconceivable that these churches would have been painted as they were without a thorough knowledge of and admiration for Byzantine art. The most likely explanation for this phenomenon is that Byzantine artists found employment in Serbia after the sack of Constantinople.

The painting of a manuscript does not require to the same degree a settled political situation or the level of financial investment involved in building and decorating a church. It is not surprising, therefore, that the production of manuscripts seems to have been less affected by the events of 1204 and their aftermath. Nevertheless, there are difficulties for us in appreciating the proper significance of works we know or believe to have been produced at this time, for it is rarely possible to say exactly when, or even in what part of the Byzantine world, a particular example was made. Unlike churches or monasteries, books were and still are eminently portable. Not a single Byzantine manuscript has survived, for example, in Nicaea (modern Iznik), the principal successor to Constantinople in the period 1204–61, although it would be absurd to imagine that none had been made there while the emperor and patriarch made the city their residence for almost sixty years. In theory, the books we have could have been written and decorated in any major centre where Greek was the language of the Church.

A Gospel Book such as one now in the British Library, London, is a case in point (236). It might have been made, according to different experts, in Nicaea, or Cyprus, or the Holy Land, or even in one of the monasteries on Mt Athos. What is not in doubt about this book is that its arrangement, with large images from the Gospel narrative interspersed with the text, was an ambitious undertaking that went well beyond the 'usual' Gospel Book with its four evangelist images and decorative headpieces. The production of such a book can thus be seen as an expression of confidence. There are a considerable number of examples of the more 'usual' books from this period too, such as one (237) now in the Rylands University Library at

236
The *Koimesis*, folios 173v-174r, Gospel Book, late 12th century. 22·5 × 16·5 cm, 9 × 6¾ in (page). British Library, London

Manchester. They may be 'usual' in their content, but this should not be taken to imply that they are predictable, routine, or only of moderate quality. Such manuscripts indicate a continuity of the traditions and skills of Byzantine painting through the confused period that followed the disaster of 1204.

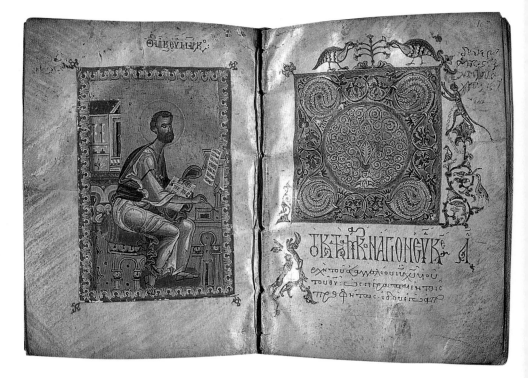

237
St Mark and the opening of his Gospel, folios 107v-108r, Gospel Book, c.1200–25. 23·5 × 17 cm, 9¼ × 6¾ in (page). Rylands University Library, Manchester

IO

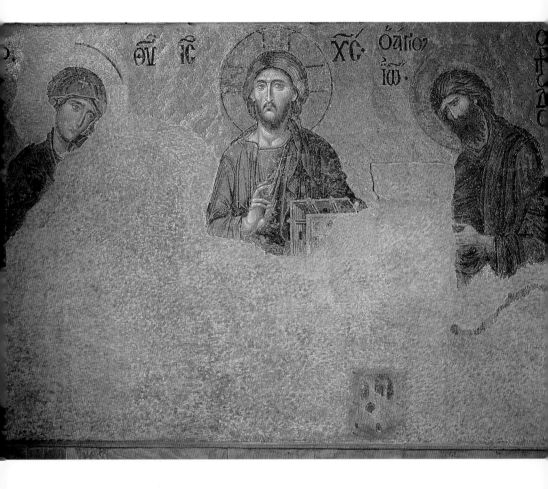

[On 15 August 1261 the emperor Michael VIII Palaiologos entered Constantinople, and] Proceeding on foot, the icon of the Mother of God [*Hodegitria*, brought from the Pantokrator Monastery] was carried in advance. On arriving at the Monastery of Studios the icon ... was left in that place, [the emperor] mounted a horse and came to the holy precinct of the Wisdom of God [St Sophia].

[On 29 May 1453 Sultan Mehmed II, 'the Conqueror'] Made his entry into the city with his viziers and satraps, preceded and followed by his fire-eating slaves ... Proceeding to the Great Church [St Sophia] he dismounted from his horse and went inside.

238
The Deesis,
*c.*1260s,
Mosaic.
South gallery,
St Sophia,
Istanbul

For the Byzantine Empire, the wheel of fortune made two complete revolutions in the period from the mid-thirteenth to the mid-fifteenth century. The city of Constantinople, lost to the Latins in 1204, was recaptured by the Byzantines in 1261, the emperor and the patriarch returned to their palaces, churches were restored or rebuilt. But in 1453 the city was lost definitively to the Ottoman Turks, the emperor slain, many of the churches converted to mosques, and the last remnants of a Byzantine Empire were extinguished within a few years. Surviving art is the product of those changeable times, even if, as we shall see, it continues to give the impression that all was as it had always been. Like Emperor Michael VIII Palaiologos in 1261, let us go at once to St Sophia. As we do so, we can ponder the fact that Michael VIII was a usurper from a distinguished aristocratic family, known already in the eleventh century. He achieved power in Nicaea by murdering (in 1258) the regent of the boy emperor John IV, whom as an eleven-year-old he was to blind and depose before the end of 1261. Although a successful strategist, and the founder of a long-lived dynasty, his crimes were to deny him Christian burial.

In the Great Church's south gallery, in the central bay (see plan 90), a large mosaic of the Deesis is partially preserved on the west wall (238). Only the upper part has survived, but originally the mosaic surface would have extended down to the lowest marble cornice. The three figures – the Theotokos, Christ, and St John the Baptist (*Prodromos*: 'the forerunner') – are identified by inscriptions, but of the lower area only a small part of Christ's throne has been preserved. It would seem possible, given the subject matter, that there was originally a figure kneeling in prayer at the left, between the Theotokos and the base of Christ's throne. And given the content of other mosaic panels in St Sophia, it is conceivable that this figure would have been an emperor.

The Deesis panel is close to a large south-facing window, which provides a strong raking light. Although the panel is flat (rather than being on a curving vault) the light-source is exploited in a variety of ways. The overall repetition of a shell pattern in the gold of the ground breaks what might otherwise be a monotonous surface into a multitude of curving facets. The gold tesserae of the cross within Christ's halo are set at some 30 degrees to the vertical, thus ensuring that they will catch the light in a different way. The tesserae in the ground of the halo are laid in swirling patterns. And the convention in Byzantine art of often shading the face as though lit from the left is here matched by the true light source. In particular, the darker shadows of Mary's face seem fully consistent with her position in the most shadowed part of the wall, the darker inner corner. In one important way, however, no photograph conveys the full effect on the viewer in St Sophia who sees the original figures from close up. They are very large, some two and a half times life-size. The head of Christ in the Deesis, for example, is twice as large as in the Constantine Monomachos and Zoe panel. Even though socket holes in the adjacent floor suggest that at some date there were metal screens to keep the viewer from approaching the wall too closely, there can be no doubt that the Deesis mosaic was intended to overwhelm by its combination of large scale and superlative craftsmanship.

Although there is no internal or documentary evidence on which to date the making of the Deesis mosaic precisely, it is most plausibly connected with the patronage of Emperor Michael VIII, who funded a major programme of restoration work in St Sophia. In the words of a contemporary, 'He restored to its previous condition the entire church which had been altered in many aspects by the Italians.' The work was under the direction of a monk by the name of Rouchas – but whether he was a craftsman or an overseer is unclear. Perhaps like the apse mosaic of St Sophia, which according to its inscription celebrated the triumph of 'pious emperors' over the iconoclasts, the Deesis mosaic was intended to celebrate Michael's triumph over the 'Italians'. Certainly Michael VIII was a triumphalist, who was termed 'the new Constantine' by himself and others. Among his most conspicuous proclamations of his perceived role was a tall column set up near the church of the Holy Apostles, a site strongly connected with Constantine and Justinian. On the top of the column, in imitation of imperial precedents of the early period, was a very large bronze statue of Archangel Michael, with Emperor Michael kneeling at his feet, holding a model of Constantinople (it does not survive).

Compare for a moment the Christ of the Deesis mosaic (238) with the sixth-century icon of Christ at Mt Sinai (see 55). To see them together is to experience the conviction that not only was the production of Byzantine art not interrupted by the Latin occupation, but that it had not been interrupted since the time of Justinian (or before). We know that this continuity is a fiction, and a Byzantine wandering through the ruins of Constantinople in the 1260s knew it was a fiction, but this unbroken link with a past that could be carried back even to the age of the apostles is what the Byzantines wanted to believe in. They used art not only to create their version of history, but to demonstrate their perception of truth.

Where did the artist of the Deesis mosaic come from, and what had he been doing in the years before 1261? One possibility is that he had been working as an icon painter. This theory is suggested by a large panel of the Virgin and Child, now in the National Gallery of Art, Washington, DC, and often referred to after its donor as the Kahn

Madonna (239). The panel (131·1×76·3cm, 51⁵⁸×30 in) is by agreement – supported by technical analysis – somewhere between what is normally accepted as exemplifying 'Byzantine' and 'Italian' (and more specifically Tuscan) art. The face of the Theotokos in particular is closely comparable in the two works. Various explanations for this similarity are conceivable. The current view is that the panel must be the creation of a Byzantine artist who was working in Italy. He must have been responding to the requirement to produce an image 'in the Italian style'. But in comparison with dated or datable Tuscan altarpieces of the Virgin and Child, the Kahn Madonna would seem to be a work of around 1280 at the earliest. The panel may thus have implications for the dating of the Deesis. Should the mosaic also be considered a product of the 1280s, not of the 1260s? Unfortunately, comparative evidence cannot readily answer such a question in the absence, for both works, of any really close parallel whose date or origin is certain.

Some stylistic parallels for the Deesis have been drawn with icon (or panel) painting, and indeed with wall-painting in Serbia, but these overlook one crucial issue – the techniques in which the differing works brought forward for comparison were executed. The craftsman or craftsmen who worked on the Deesis demonstrate a consummate skill that presupposes a long training in and prior experience of mosaic work. Since there were no such large-scale projects in Constantinople in the years 1204–61, could the master perhaps have perfected his technique in the medium of miniature mosaic icons?

One of the obstacles to understanding what was happening in Constantinople in the 1260s and 1270s is that it is only in the 1280s and 1290s that we begin to find a significant body of securely datable material. We can consider the reasons for this in a moment, but it will be helpful to begin by looking at a few manuscripts of the period. These include some of the most skilfully executed and visually satisfying Byzantine works to have survived from any period. A superb Gospel Book (240–1), now in the Vatican Library, was made for a female member of the ruling Palaiologos family (that is a Palaiologina), to judge by the presence of monograms in the Canon

239
The Virgin and Child (the Kahn Madonna), c.1260s/1280s. Painted and gilded panel; 131·1 × 76·3 cm, 51⁵⁸ × 30 in. National Gallery of Art, Washington, DC

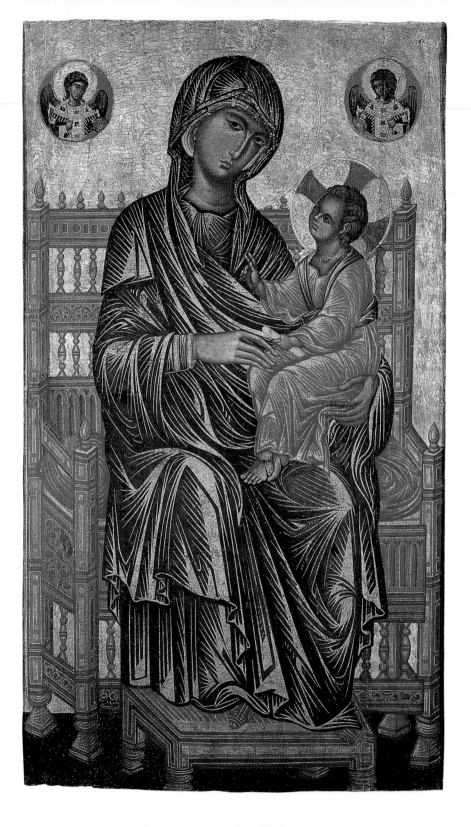

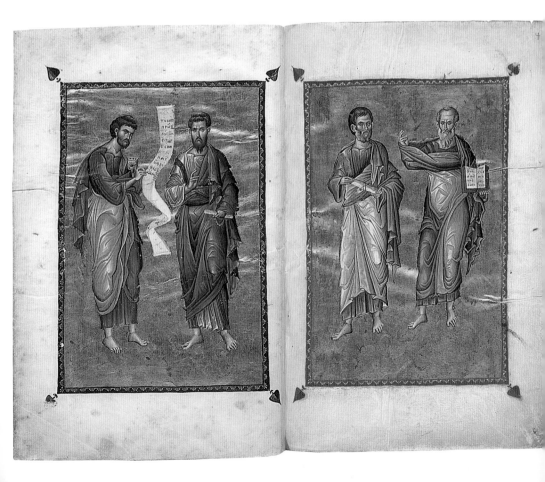

Tables. The book has a set of images of the evangelists, with close relatives in a number of other Gospel Books, one of which is dated to 1285. An even more splendid volume of the Acts and Epistles, with prefatory images of the authors, and its text written entirely in gold (242–3), reached the Vatican at the same time. Both books were presented, probably shortly before 1487, by Charlotte de Lusignan, Queen of Cyprus, who was a Palaiologina on her mother's side. Presumably they had been passed down from one generation to the next for two centuries. The empress Theodora, wife of Michael VIII Palaiologos (and hence a Palaiologina), used some of the same craftsmen to decorate the surviving typikon of the convent of Lips in Constantinople, which she refounded as a dynastic burial church between Michael VIII's death in 1282 and her own in 1303. It is now preserved in the British Library. Perhaps, therefore, she was the original patron of at least some of the other manuscripts in the group.

Looking at the images in the two books in the Vatican, the viewer is struck by a similar disparity in both. In the Gospel Book, St John (241) is a hunched figure enfolded in a curving mass of drapery, the surface of which is broken up by angular highlights. His hands and feet are unnaturally small. St Luke, in contrast (240), is a more upright and naturally proportioned figure, and both the drapery and the flesh (especially the face) in this image were painted in softer and more graded tonalities. In the manuscript of the Acts and Epistles the contrast is less striking, but the Peter and John image (243) has the more angular highlights, whereas the Luke and James (242) on the facing page have the softer and more graded tones. The most likely explanation for this disjuncture is not simply to suppose that we see the differing personal styles of two anonymous artists, but that Palaiologan style in general represents a sometimes precarious symbiosis of ideas derived from studying images of earlier periods, as far back as the tenth century in the case of manuscripts (the source of the more naturalistic style), with contemporary stylistic traits (the enlarged figures and angular highlights). This brings us back to the question of the extent to which Byzantine artists could or did suppress their own style in an effort to imitate a work of a different period.

240–241
Palaiologina Gospels, late 13th century.
23·1 × 18 cm, 9 × 7 in (page).
Biblioteca Vaticana, Rome
Above left
St Luke, folio 196v
Above right
St John, folio 320r

242–243
Acts and Epistles, late 13th century.
27·8 × 19·5 cm, 11 × 7¾ in (page).
Biblioteca Vaticana, Rome
Below left
Sts Luke and James, folio 3v
Below right
Sts Peter and John, folio 4r

There is an interesting case in a manuscript, now in the monastery of Vatopedi on Mt Athos, which although undated is generally agreed to be a product of the late thirteenth century. It is the second volume of an illustrated Octateuch, containing the books of Leviticus to Ruth. It reproduces the text and the many images of a surviving twelfth-century Octateuch (now in the Vatican Library), in a style which for the most part avoids the enlarged waists, small hands and feet, angular folds, and enveloping swirling drapery that are all characteristic of Palaiologan painting. Every now and again, however, the artist's Palaiologan style escapes confinement, as in the figure of Moses (244), when confronted by the priest Aaron and the leprous Miriam (Numbers 12:10–13). Furthermore, in addition to following his twelfth-century model, the artist of the Vatopedi Octateuch also made a careful study of the tenth-century Joshua Roll (see 117), and incorporated elements, even an entire image, derived from that parchment scroll. The fact that these borrowings were made is not known from any contemporary document other than the images themselves. But they are eloquent witnesses to the artist's working methods.

In seeking to understand Byzantine painting around 1261 and later, a Prophet Book (containing the Old Testament Books of the Prophets) which was already in the Vatican in 1455 also suggests some pointers. It has a set of images of the prophets (245) without any really close stylistic parallels in Byzantine art. There are odd technical features too: the inscriptions, for example, were constructed from tiny strips of gold leaf; the halos were drawn freehand, not with a compass; the borders were drawn without use of a straight edge. All these elements suggest an artist unfamiliar with the usual procedures in a Byzantine manuscript. What is particularly intriguing is that in this case (as with the Vatopedi Octateuch) the source from which the text was copied has survived; it is a tenth-century manuscript with a set of full-page images, also by chance now in the Vatican. Yet in this instance the procedure was totally unlike that in the Octateuch. The artist of the Prophet Book did not reproduce the images of the tenth-century model, preferring to do something different. The most plausible explanation is to suppose that this artist was relatively

244
Moses, Aaron and Miriam, folio 136r (detail), Octateuch, late 13th century.
8·9×11·5 cm, 3½×4½ in (image).
Vatopedi Monastery, Mt Athos, Greece

245
Far right
Zechariah, folio 59v, Prophet Book, c.1260–70.
45·6×27·8 cm, 18×11in (page)
Biblioteca Vaticana, Rome

unfamiliar with miniatures, being more at home perhaps in monumental painting. The requirements of his commission would have specified which book would provide the textual model, but it cannot in this case have been a requirement that the artist reproduce the images of that model.

The Vatican Prophet Book and the Vatopedi Octateuch together sound a warning. Just because the artists of works such as these are anonymous, we must not assume that they are not individuals. It would be a grave mistake to assimilate the art we have to some ideal scheme, and to treat it as the product of 'the Byzantine artist', with the implication that there was a standardized training, shared experience and predictable results. The evidence suggests that the more skilful the artist was, the less easy it is to define the range of work he might be capable of producing.

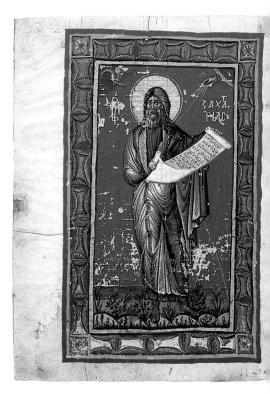

The mind-set of the makers and users of Byzantine art in the years after 1261 is partially revealed in the illuminated books of the period, but it is unlikely that their ideas were formed in that relatively small-scale context. It was, I believe, the state of the buildings of Constantinople that was crucial in forming a Palaiologan conception of art. The city had been so depopulated by 1261 that one of Emperor Michael VIII's first acts was to transfer villagers from the Peloponnese to occupy his capital. There had been devastating fires in 1203 and 1204, which left large parts of the city in ruins. Furthermore, the desperate need to raise money during the Latin Empire had led not only to the sale of relics, 'artworks', and carved marble fixtures and fittings. Churches and other major structures were plundered for saleable material of all sorts. Buildings were stripped of the protective layer of lead from their roofs (for lead was a very valuable commodity). In a location with a mean annual rainfall of more than 70 cm (28 in), and a mean temperature below 10 °C for four months of the year (assuming no great climatic change since the thirteenth century), such an act meant that the standing walls of basilicas would have quickly become rotten, and even domed and vaulted buildings could not have survived long. The upper parts of many vandalized buildings must have collapsed or been seriously damaged within a few years. When we are told that Constantine Palaiologos, one of the sons of Emperor Michael VIII, restored and reroofed the Stoudios basilica in 1293, it is reasonable to assume that this was necessary because the building was at least partially (perhaps entirely) roofless, and probably had been for decades. Like Constantine Palaiologos, the wealthy citizens of Constantinople did not, generally speaking, pull down the old churches and start afresh; they set out, as the emperor had done in St Sophia, to restore them 'to their previous condition'. So far as we can tell this could not be accomplished rapidly (with the exception perhaps of St Sophia – always the exception), presumably due to shortage of money. Most restoration work seems to have happened in the 1280s, 1290s, or even later.

246
Fenari Isa Camii (Monastery of Lips), Istanbul, as rebuilt c.1280–1300. Plan

An example of this type of restoration is the convent founded by the empress Theodora (of which the *typikon* was mentioned above).

Theodora took as her starting point a small domed church of cross-in-square type, dedicated to the Theotokos, and built by the imperial official Constantine Lips in 907 (see Chapter 5). Adjoining this church to the south, she built a second church, dedicated to St John the Baptist, to receive tombs for herself and her family (see 246). The two churches were further linked by an ambulatory on the south and west sides (an arrangement a little like that at the Pantokrator Monastery). Without question, this would have been a magnificently decorated church, but unfortunately only a few fragments of sculpture have survived.

10 m

It is only with churches of Constantinopole of the early fourteenth century that we are able to gain a detailed view of what the richly finished interior of such a building might have been like. The reconstruction of the monastery of the Theotokos Pammakaristos ('wholly blessed'), now known as Fethiye Camii (it still functions as a mosque; 247), was undertaken by a senior imperial official, Michael Glabas. It had been built in the twelfth century by a certain John Komnenos and his wife Anna. A pair of miniature mosaic icons with the Mother of God and Child, and St John the Baptist with an unnamed donor, probably formed part of its original decoration. They are now in the church of the (Greek) Patriarchate in Istanbul, which from 1455 until 1587 occupied the Pammakaristos, after expulsion from St Sophia. Along the southern side of the church restored by Michael Glabas, probably in the 1290s, his widow Maria (who became a nun and changed her name to Martha) built a diminutive domed chapel dedi-

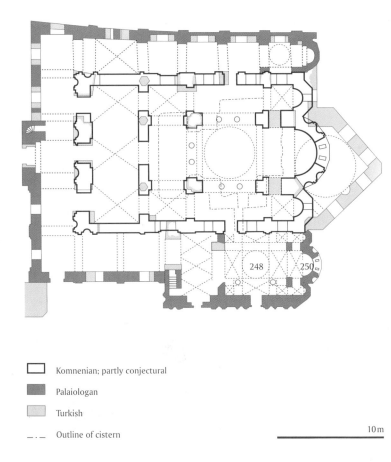

247
Left
Fethiye Camii,
Istanbul
as rebuilt
*c.*1300.
Plan

248–249
Dome mosaics.
Parekklesion,
Fethiye Camii
Istanbul,
*c.*1304–8
Right
The
Pantokrator
and prophets
Far right
Malachi and
Ezekiel

Komnenian; partly conjectural

Palaiologan

Turkish

Outline of cistern

10m

cated to Christ, in which Michael's tomb was placed, it would seem, in an arcosolium on the north side. This *parekklesion*, dateable to *c.*1304–8, retains parts of its mosaic decoration.

In the miniature dome (only about 2·4 m, 7 ft 10½ in in diameter) is a mosaic Pantokrator, with twelve prophets beneath, in a familiar composition. Unfortunately, the decorative marble cornice at the base of the dome projects so far that the prophets are partially obscured when viewed from the ground (248). Seen from scaffolding, as only the craftsmen could have done, the prophets – such as Ezekiel – typify Palaiologan style with their swelling hips and angular drapery folds (249).

It is notable that the decoration of the *bema* of the *parekklesion* was specially adapted for the chapel's funerary function by making an image of the Deesis the focus of the apse. Christ is seated centrally (250), flanked by the Theotokos and John the Baptist in the lunettes to either side (a little like the wall-paintings in the crypt at Osios Loukas). The accompanying inscription terms Christ 'supremely good' (*hyperagathos*). In a long metrical inscription that runs round the apse, Martha offers the church in thanks (or as a pledge) to Christ the Saviour on behalf of Michael, her deceased husband.

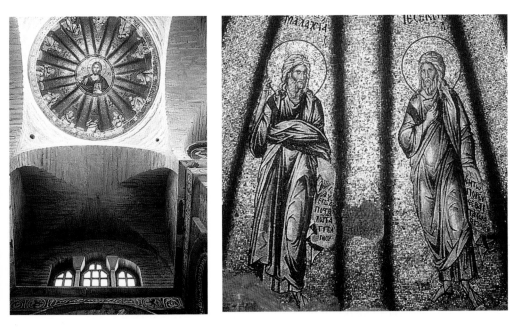

An aspect of the Fethiye *parekklesion* which only a visit to the site can confirm is the difficulty the mosaicists must have experienced working in the often very confined spaces. On the south wall of the *prothesis*, the image of the Bishop St Metrophanes was left as a wall-painting, perhaps because it was felt that no viewer would be able to see whether or not mosaic had been used in this dark corner (a torch will help you to confirm this point).

In 1303, Michael Glabas had sponsored the restoration and decoration with a cycle of wall-paintings of the chapel dedicated to St Euthymios attached to the east end of the great basilica of St Demetrios in Thessaloniki (it can still be visited; and it is worth

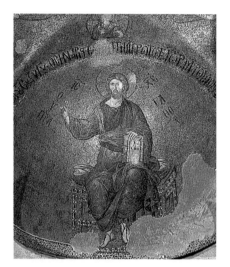

250
Left
Christ,
Apse mosaic.
Parekklesion,
Fethiye Camii,
Istanbul

251–252
Holy Apostles,
Thessaloniki,
1310–14
or later
Right
Northeastern
exterior
Far right
Ezekiel.
Dome mosaic

noting that the Latin Kingdom of Thessalonica, set up by the Crusaders, had lasted only from 1204 to 1224, and the city's churches seem to have suffered much less damage and neglect than those of Constantinople). Also in the early fourteenth century, a church originally dedicated to the Theotokos, now called Holy Apostles (251), was decorated in its central parts with mosaics, and with wall-paintings in the less important areas. The presence of the monograms of Patriarch Niphon of Constantinople (held office 1310–14), and a painted inscription, appear to give a fairly precise date to the structure and its decoration. Dendrochronological (tree-ring) analysis of timbers from the building, however, has

provided a date of '1329 or later', which would be consistent with Niphon's 'rehabilitation' (he had been deposed in 1314 on a charge of simony) by Emperor Andronikos III after the latter's accession in 1328. The disparity between the proposed dates has yet to be satisfactorily resolved, and is an intriguing puzzle. It merits further investigation.

Despite the damage caused in the Holy Apostles by the systematic removal of the gold tesserae of the background by some greedy vandal, it can be seen that the Pantokrator and prophets in the dome follow the familiar Byzantine pattern. Indeed some of the prophets are virtually interchangeable with their counterparts in

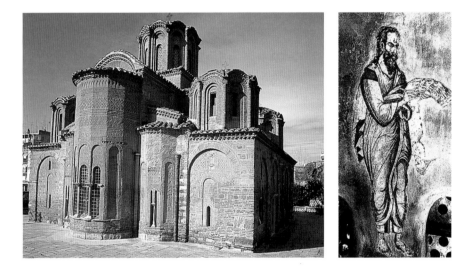

the Fethiye Camii. It seems likely, therefore, that the same team of mosaicists worked in both buildings. But it does not follow that they always worked to the same formula. For example, the Ezekiel of the Holy Apostles (252), even though he holds the same text, follows a different type from the Fethiye Ezekiel (249); in the one his hair and beard are dark, in the other white. The characteristic roll of drapery that runs up from the figure's ankles to his waist, with a spout-like projection at the top (not found in any figure at the Fethiye Camii), is the formula we have already seen used for St Luke (242) in a manuscript painting.

If we suppose that the use of similar stylistic formulae in mosaics of the prophets indicates a shared workshop source, then we can move back in time from the Fethiye Camii as well as forward. An earlier building with related mosaic decoration is the church of the Theotokos Paregoritissa (consolatrix) at Arta, in western Greece. The construction of this church is highly eccentric, with a dome supported on reused columns corbelled out on pairs of column-drums laid horizontally (253). It has surviving mosaics in the area of the dome: a Pantokrator, prophets and fragments of the evangelists in the pendentives below. The building is datable to 1294–6 on the basis of the founder's inscription, which names Nikephoros Komnenodoukas, Despot (ruler) of Epiros, and his wife Anna Palaiologina. In this case it is the Prophet Jeremiah (254) who closely resembles the Fethiye Ezekiel. It thus seems probable that one or more mosaic workshops or teams must have been moving between commissions in Constantinople and elsewhere in the Byzantine world in the late thirteenth and early fourteenth centuries.

To judge from these mosaics and others, it appears that Byzantine artists were in the habit of assembling lesser-known figures from a variety of formulae for heads and drapery. They had no special type, for example, for an Ezekiel. This evidence flatly contradicts the oft-repeated assumption that Byzantine artists worked from written guides, which prescribed what figures and scenes had to look like. This may have happened in certain areas in later times (on Mt Athos in the eighteenth and nineteenth centuries, for example), but the forms of Byzantine art were moulded by the assumptions and expectations of its viewers, not by workshop manuals in the hands of its practitioners. As a result, the most frequently represented saints or scenes were familiar and readily recognizable. In other situations an accompanying inscription was usually sufficient to ensure that the Byzantine viewer knew who or what was represented.

That master craftsmen moved not only within but outside the Byzantine Empire – a possibility also explored in earlier chapters – is shown by the intriguing case of two painters who worked as a team: Michael Astrapas and Eutychios. Their names are found in three

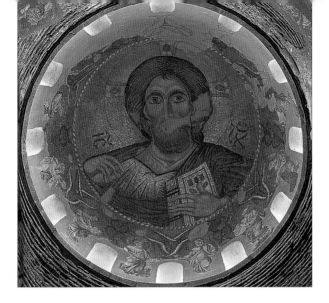

253–254
Dome mosaics.
Church of the
Theotokos
Paregoritissa,
Arta, Greece,
1294–6
Above
The Pantokrator
Below
Isaiah and
Jeremiah

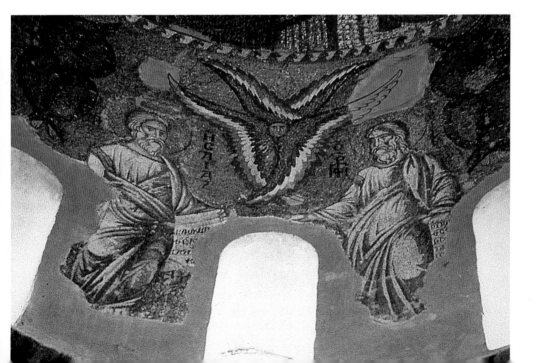

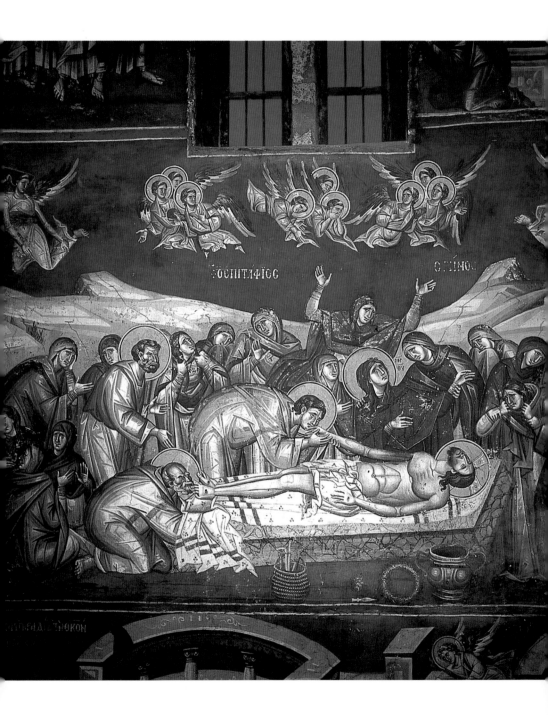

churches with wall-paintings of the highest quality: the Theotokos Peribleptos ('celebrated'; now called St Clement) in Ohrid; St Nikitas at Čučer near Skopje; and St George at Staro Nagoričino, some 40 km (25 miles) further to the northwest. The first is dated by a painted inscription (in Greek) to 1295, the third by similar means (but in Slavonic) to 1317–18, while the second probably dates from after 1307. In addition, a painted inscription in the exonarthex of the church of the Mother of God Ljeviška at Prizren (some 80 km, 50 miles across a mountain range northeast of Skopje) names the painter as Astrapas (the architect's name was Nikolas), and provides a date of 1306/7. At these dates Ohrid lay within the Byzantine Empire,

255–256
Wall-paintings.
Church of
St Clement,
Ohrid,
Macedonia, 1295
Left
The Lamentation
Right
St Demetrios

but the region around Skopje and to the north was in the Kingdom of Serbia (all these sites are in the former Yugoslavia – Prizren currently in the Kosovo province of Serbia, the rest in Macedonia). Michael and Eutychios usually painted their names on the armour or dress of a military saint, suggesting that they took special pride in these figures. Since Michael's name always precedes that of Eutychios, or is cited alone, he was undoubtedly the head of the workshop.

The Peribleptos at Ohrid was built and decorated by the Byzantine imperial official Progonos Sgouros (he had the title of Grand Hetairearch – he would have reported to the emperor in particular on

questions of security and foreigners), according to the painted inscription which also gives the date. It is a domed cross-in-square church of familiar Byzantine type. The interior walls are not revetted, but plastered and painted throughout. On the cloak of St Demetrios, on the southwest pier, can be read 'The hand of Michael the painter' (256). In a similar position on the cloak of St Prokopios on the other side of the same pier we read 'And of me Eutychios'. Stylistically the work is related closely to some of the painting in manuscripts connected with Empress Theodora. The huge Lamentation (called *Epitaphios Threnos*, 'burial lament') on the north wall of the crossing is a highly dramatic and emotional scene (255), the style of the figures characterized by their excessive volume and angular highlights.

The works of Michael and Eutychios in more northerly churches are all associated with the patronage of King Stefan Uroš II Milutin (r. 1282–1321), the exact contemporary of Emperor Andronikos II Palaiologos (r. 1282–1328), son of Michael VIII and Theodora. Milutin consolidated the southward expansion of Serbia, capturing the strategic town of Skopje in 1282, and in 1297 Michael Glabas (patron of the Pammakaristos in Constantinople) led an army against him. In 1299, however, a treaty was arranged through the marriage of Milutin (who was about forty at the time) to Andronikos II's five-year-old daughter Simonis, and relations between Serbia and Byzantium were cordial into the 1320s. Milutin is recorded as a major builder and benefactor of churches not merely in Serbia, but also at Thessaloniki, Mt Athos, Constantinople and Jerusalem. The painters Michael and Eutychios have been viewed as working on a similar, if shorter, axis, for in addition to the signed churches, wall-paintings in a very similar style are found in other churches built by Milutin (notably a small church dedicated to Joachim and Anna – the parents of the Mother of God – added by Milutin in 1314 to the monastic complex at Studenica, and often called the King's Church), as well as in Thessaloniki and on Mt Athos. The most remarkable work in the style of Michael and Eutychios is the little-studied fresco decoration of the Protaton Church at Karyes on Mt Athos (sometimes attributed on the basis of an eighteenth-century source to an otherwise unknown 'Manuel Panselinos').

One of the major problems in studying Byzantine monumental art in the late period is the sheer volume of material. There are far more painted churches, each decorated with a far greater number of images, than survive from earlier periods. For present purposes, however, this is pure gain. The reader is more likely to be able to see a Palaiologan painted church than any other. Let us look at one no doubt exceptional example, with a relatively well-preserved interior. It is one of the supreme achievements of Byzantine art: the church of Christ in Chora at Constantinople, often discussed under its Turkish name as the Kariye Camii (pronounced Ka-ree-ya Jah-mee; 257), but now a museum, rather than a mosque (or church).

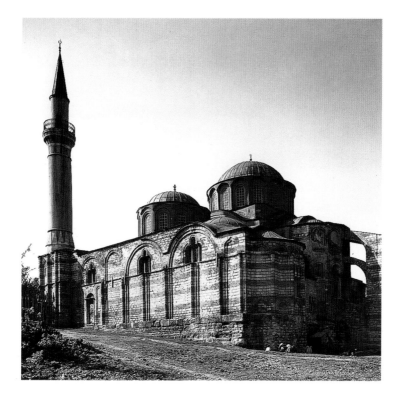

257
Kariye Camii,
Istanbul,
c.1315–20
and other
periods.
Southwestern
exterior

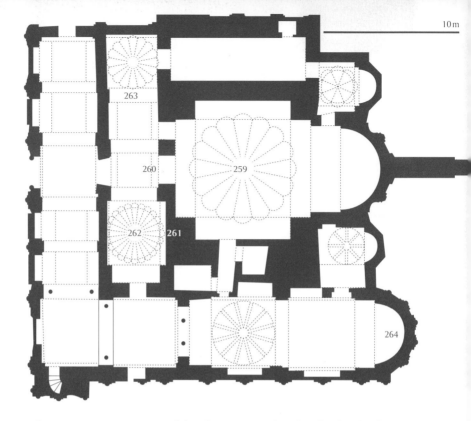

The post-1261 restoration of the Chora was undertaken by the chief minister of Emperor Andronikos II, Theodore Metochites (who had arranged the Serbian–Byzantine dynastic marriage between Milutin and Simonis in 1299). It was described as 'recently completed' in March 1321. Assuming that wall-paintings and mosaics were not executed in the winter months in Constantinople, it was probably finished in the autumn of 1320, and would have been begun a few years before. The core of the building (258) is the church built in the twelfth century by Isaak Komnenos (see Chapter 9). The large dome (almost 7 m, 23 ft in diameter) and part of the vaults were rebuilt by Metochites, and a domed *parekklesion* added to the south. This extends into an ambulatory (or outer *narthex*) across the western side. The inner *narthex* also dates from Metochites' reconstruction, and it communicates additionally with a long rectangular chamber on the north side. In contrast to the *parekklesion* at the Fethiye Camii, which is small in comparison to the Komnenian church, at the Kariye Camii the *parekklesion* is spacious, with four large arcosolia for the

258–259
Kariye Camii,
Istanbul
Left
Plan
Right
Marble
revetment
and *Koimesis*
mosaic.
Interior of
the *naos*
looking west

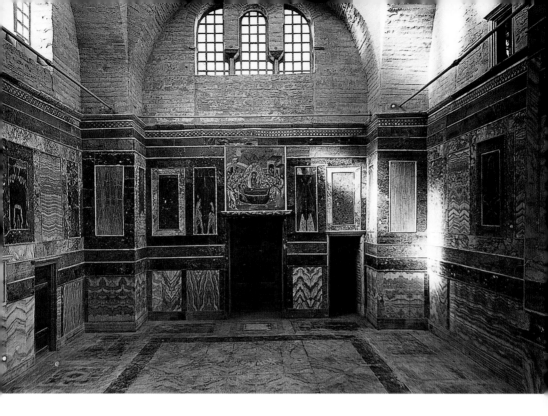

tombs of the founder and his relatives. Although much of the decoration of Metochites' church has been destroyed, notably in the *naos* and *bema*, the narthexes and *parekklesion* are well preserved.

Undoubtedly the most important decoration of the Kariye was in the main church, but there only three panels remain, surrounded by a superb marble revetment (259). On either side of what was the *templon* screen are framed mosaic panels of Christ and the Theotokos and Child. The image of Christ is inscribed 'the *chora* of the living' a quotation from Psalm 114:9 (Authorized Version, Psalm 116:9), where the reference is to salvation and paradise in 'the land (*chora*) of the living'. The Theotokos is inscribed 'the dwelling-place (*chora*) of the uncontainable (*achoretou*) [*ie* God]' a formula already used to describe the mystery of the Incarnation in the fifth century. Doubtless Metochites enjoyed these linguistic games with the name of his monastery, the Chora. The third surviving image is the *Koimesis* immediately above the west door.

On entering the church from the west the viewer does not enter the *naos* directly, but is first confronted by a large Pantokrator over the door into the inner *narthex*, inscribed (again) 'the *chora* of the living'. Through this doorway is another, leading into the *naos*, with above it a further image of Christ enthroned (260), yet again inscribed 'the *chora* of the living'. The viewer's attention, however, is drawn to the kneeling figure at the left, who proffers a model of the church. His enormous gold and white hat or turban catches the eye amid the generally sombre tonality and shell pattern of the gold setting. The figure is inscribed 'The founder, *logothete* [controller] of the treasury, Theodore Metochites'.

Below and to the right is a very large panel with the Theotokos and Christ, looking somewhat like two-thirds of a standard Deesis composition (261). Christ is here inscribed 'the *Chalkites*' in reference to the famous image of the Chalke Gate of the imperial palace (see Chapter 4). The standing figure is over 4 m (13 ft) high, and very close to the viewer. The lower body is disproportionately short, and the overall effect is unsettling. Two small figures kneel in prayer at either side. At the left is a crowned and bearded figure inscribed 'The son of the most high king [*basileus*] Alexios Komnenos, Isaak born in the purple'. In this image, therefore, Metochites is paying tribute to his twelfth-century predecessor – not without an element of snobbishness, it would seem (Metochites married his daughter to the emperor's nephew). To the right is a nun. Unfortunately the start of the inscription is lost, but it can be reconstructed as '[The daughter/sister of the most high king] Andronikos Palaiologos, Lady of the Mongols, Melane the nun'. The title 'Lady of the Mongols' could refer to either of two Maria Palaiologinas: one was married to the Great Khan of the Mongols, Abaga, in 1265; the other to the Mongol Khan of the Golden Horde, Tuktai, in the 1290s (dynastic marriages played a significant role in Byzantine diplomacy, as in the West). It remains unclear, however, what Melane's importance was to Metochites or the Chora, and why she should be represented here.

One of the most remarkable features of the Kariye Camii is the treatment of the two domes over the inner *narthex*. These are of different

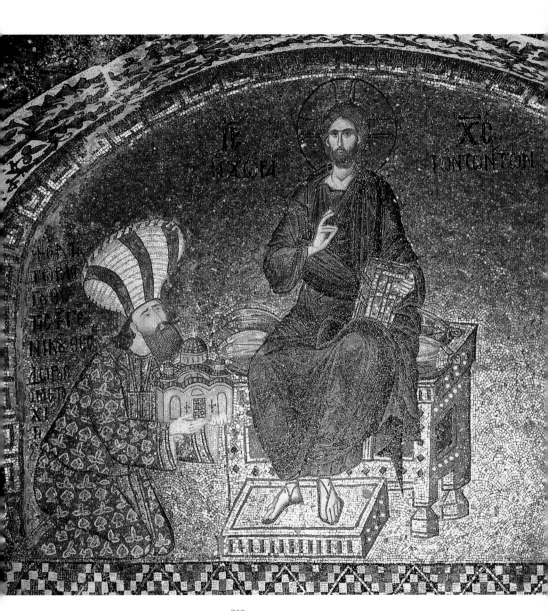

260
Christ with
Theodore
Metochites.
Inner narthex
mosaic.
Kariye Camii,
Istanbul

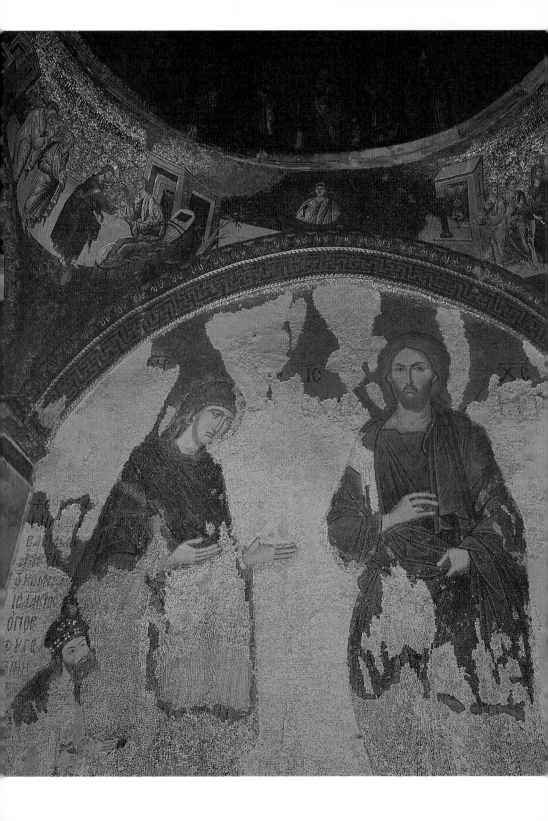

sizes, arranged asymmetrically over bays that do not correspond, and built with a different number of flutes and windows. The larger southern dome (262) has twenty-four flutes and nine windows, whereas the northern dome has only sixteen flutes and five windows. When the viewer looks into these domes, however, the motivation for some at least of the oddities becomes apparent. The domes were specially created to provide the ideal setting for the mosaic images of

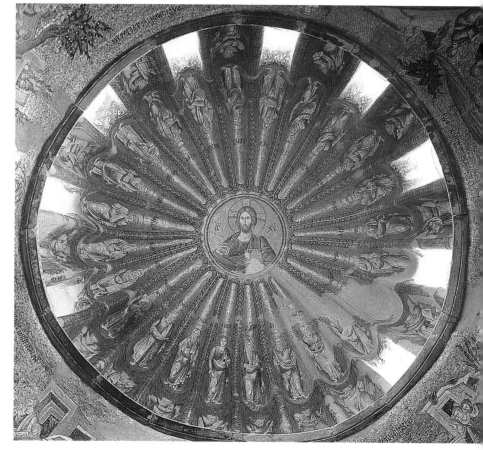

261–262
Inner *narthex* mosaics. Kariye Camii, Istanbul
Left
Christ and the Theotokos
Right
Christ with ancestors. South dome

the Ancestors of Christ. Nor is the viewer likely to be disturbed by the differences, since it is only possible to see one dome at a time. The observation can serve as a reminder of the extent to which Byzantine architecture after Iconoclasm was geared towards providing the ideal spaces in which to display images (you may recall, for example, the nine-sided dome at Nea Moni on Chios).

The remaining vaulted spaces and adjacent tympana in the inner and outer narthexes are given over to a very extensive cycle of scenes from the life and ministry of Christ, and the life of Mary. The mosaicist at the Chora is interested in three-dimensional effects, notably in the fantasy architecture at the left or the fountain at the right of the Annunciation to Anna (263), an approach that can be contrasted with the mosaics of Daphni, where the Prayer of Anna is also depicted (compare 156). The figures are also much smaller in relation to their setting than was the case at Daphni. But the dense arrangement of numerous small scenes flowing into one another in the narthexes of the Chora, very different from the more isolated images at Daphni, may only have been characteristic of these subsidiary areas. The *naos* would have had the usual images of the major feasts – doubtless the Annunciation, Nativity, Baptism, Transfiguration, Crucifixion, etc. – and they might well have been treated in a different way.

Whereas the main church and narthexes were decorated with mosaic, the *parekklesion* of the Chora was painted. Many possible explanations for this change in medium can be suggested, but what is certain is that the content of the decoration appropriate to a burial chapel was carefully thought out, doubtless by Metochites himself. The apse of the *parekklesion* is dominated by a huge Anastasis (264), which has justifiably become one of the most famous images of Byzantine art

since its cleaning and conservation in the 1950s. The resurrected Christ, dressed in white and set against a white and blue mandorla decorated with gold stars, lifts both Adam and Eve from their tombs. The image is very carefully composed and achieves an arresting effect of energy and movement. The artist's style is not emotionally charged, in the way that the sorrowful and elongated figures of Kurbinovo, for example, appeal to the viewer, and yet the effect is extraordinarily powerful. It is an image that demands to be viewed. The rest of the chapel is given over to scenes of the Last Judgement, images from the Old Testament that were understood as prefigurations of the Incarnation, and numerous saints.

In 1321 a civil war broke out between Emperor Andronikos II and his grandson, the emperor Andronikos III. This was only settled in 1328 by Andronikos II's forced abdication. With the benefit of hindsight we can see that it marked the beginning of a terminal decline in the fortunes of the empire, marked by further civil war, civic uprising and growing helplessness in the face of external threats. The culmination was the final cataclysm of 1453. Against the background of these troubled times (not of course a mere background if you were living through them) Byzantine artists sought work where they could find it.

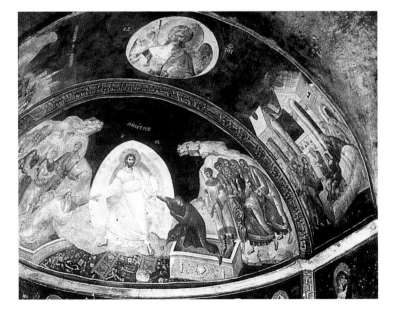

264
The Anastasis.
Wall-painting.
Parekklesion,
Kariye Camii,
Istanbul

Russia provides a well-documented case, although the evidence is now preserved for the most part only in laconic accounts in chronicles. In 1344, Greek painters started and finished the decoration of the church of the Mother of God in Moscow. In 1348, Isaias the Greek was commanded by Prince Basil to paint the church of the Entry into Jerusalem in Novgorod (he began work on 4 May). In 1378 the Greek master Theophanes painted the church of the Transfiguration at Novgorod (some fragments survive). Theophanes is also recorded as having painted the church of the Nativity of the Mother of God in the Moscow Kremlin in 1395 (he began on 4 June), and the church of St Michael in the Kremlin in 1399. In 1405 he painted the church of the Annunciation in the Kremlin with two other masters, the monks Prokhor and Andrej Rublev. They began work in the spring and finished in the same year. In a letter to Metropolitan Cyril of Tver', written around 1415, Theophanes is described as having been 'a famous illuminator of books and an excellent religious painter who painted with his own hand more than forty churches' in Constantinople, Chalcedon, Galata and (leaving Byzantium for the Crimea) at Kaffa, Novgorod the Great, Nizhniy Novgorod and Moscow. Presumably it was in the long winter months, when wall-painting was impossible, that Theophanes turned his hand to decorating manuscripts, and doubtless to painting icons.

Throughout the fourteenth century, Constantinople must have remained the most important centre for Byzantine craftsmen. When in 1346, for example, the great eastern arch of St Sophia collapsed, bringing down the eastern semidome and about a third of the main dome, the resources and skills were available to repair the damage. By 1355 the dome mosaic of the Pantokrator had been restored, and new mosaics of the Theotokos, the Baptist, and Emperor John V Palaiologos were set in the eastern arch (the latter were uncovered only in 1989). The city's importance at the very end of the century is reflected in the interesting case of a church near Tsalenjikha in Georgia. This contains the remains of a fresco decoration of high quality, and painted inscriptions in Greek and Georgian. These identify the painter as Manuel Eugenikos, and describe how Vamek Dadiani, Eristav (Prince) of Samegrelo (r. 1384–96), had sent two

monks to bring Manuel from Constantinople. The cycle painted by Manuel is of a standard Byzantine type, and Vamek was represented as donor in Byzantine imperial costume.

A few other centres were sufficiently prosperous to be able to maintain a local tradition of architecture and decoration over an extended period. The city of Mistra in southern Greece is a case in point. From the 1290s into the 1420s a series of churches and monasteries were built and decorated in the shadow of the Frankish fortress erected in 1249. Mistra owed its importance to its status as *de facto* capital of the Peloponnese, first after its recapture in 1262 as the seat of a Byzantine military governor, and then from 1348 as the residence of a Despot (ruler), who enjoyed considerable autonomy from Constantinople. The city fell to the Turks in 1460. The last securely dated ecclesiastical construction is the monastery of the Theotokos Pantanassa (Queen of all), apparently dated 1428. Numerous inscriptions record that it was the foundation of John Phrangopoulos, chief minister of Despot Theodore II Palaiologos (r. 1407–43).

Even more remarkable than any mainland site in this period, however, was the situation on the island of Crete. More than 600 painted churches survive there. Most of them, it is true, are very small, but nonetheless the fact that the vast majority were decorated in the fourteenth and fifteenth centuries implies a flourishing trade for painters. With the help of inscriptions it is possible, for example, to trace the long career of a painter named John Pagomenos, whose work is documented in eight surviving churches in western Crete. But as these are spread over thirty-five years, from 1313 to 1347, we can certainly imagine that he painted (or could have painted) very many more: perhaps at least one a year. During this long period of prosperity and artistic activity, however, Crete was not a part of the Byzantine Empire. It had been ceded to Venice in 1204 (and occupied from 1210). It was not recaptured by the Byzantines before or after 1261. And it remained a Venetian territory until falling to the Ottoman Turks in 1669.

It is a mistake to seek to define when or where Byzantine art concluded, for history does not come packaged with beginnings,

endings and precise limits. The situation, however, is not one that we should regret for it is often precisely in those liminal areas, where definition and certainty are hardest to find, that history is most intriguing. We can see, for example, that the art of Russia or of Venetian Crete are unimaginable without the activities of Byzantine artists. But at what point did such art and the artists who produced it become 'Russian', 'Cretan' or 'Venetian' rather than 'Byzantine'? These are questions worth pondering, but best left open. As we began, therefore, so we shall end, not by searching for a single work that we can define as 'the last creation of Byzantine art', but by taking one instance that can provide an insight into Byzantine art in this phase.

In 1408 the Byzantine scholar Manuel Chrysoloras, acting as legate of the emperor Manuel II Palaiologos (r. 1391–1425), presented to the Abbey of Saint-Denis, near Paris, a superb copy of the works of St Dionysius the Areopagite (an author believed by the Byzantines to be the convert of St Paul and first Bishop of Athens, but now known as the 'Pseudo-Dionysius' or 'Pseudo-Areopagite' and relegated to the sixth century). The manuscript is preserved in the Louvre. It contains added images. The first (265) shows St Dionysius dressed as a Greek bishop holding a book (his writings). It is an image of the sort that could be found in innumerable Byzantine churches over the centuries. The second shows the imperial family with the Theotokos and Child (266). The figures are identified in heavy gold inscriptions. The imperial couple are 'Manuel Palaiologos in Christ God faithful King and Emperor of the Romans, and perpetual *Augustos*' and his wife 'Elene Palaiologina in Christ God faithful *Augusta* and Empress of the Romans'. The emperor's three sons, reading from left to right (in order of precedence) are 'John in Christ God faithful king, his son', 'Theodore born in the purple, fortunate despot, his son', and 'Andronikos nobly born Palaiologos, his son'. With her outstretched hands the Mother of God touches the crowns of Emperor Manuel II and Empress Elene, and with a similar gesture the Christ Child blesses them both.

Like the image of the bishop saint, the image of the emperor ruling with the support of the deity is one that we have often seen in

265
St Dionysius, folio 1r, Works of Dionysius the Areopagite, c.1403–5. 27×20 cm, 10⅝×7⅞ in (page). Musée du Louvre, Paris

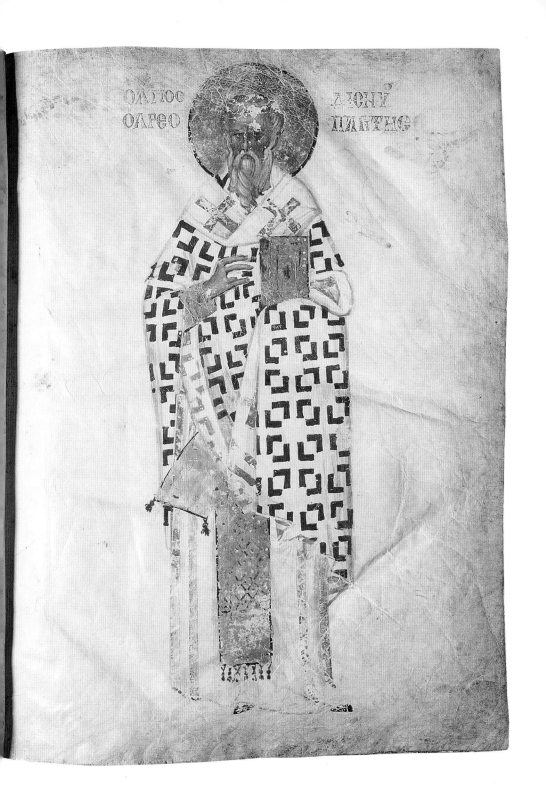

previous centuries. The same proud titles, the same bold claims. But by the time this book was made the situation in what little remained of the Byzantine Empire was desperate. In 1399, Jean le Meingre, Maréchal de Boucicaut, acting for King Charles VI of France, had broken the Turkish blockade of Constantinople. Manuel II set out with Boucicaut on a three-year mission to the West, in the hope of raising the vast sums of money and numbers of soldiers needed to support the empire. He was treated respectfully in Italy, France and England, but his fund-raising efforts were largely in vain. The despatch of the manuscript in 1408 was a follow-up, a gift but also a gentle reminder. It was intended to please the French, who claimed St Dionysius (St Denis) as the apostle of France and first Bishop of Paris, buried like the kings of France at Saint-Denis (the legends associated with several different saints called Dionysius had become merged into one).

The gift was also a follow-up with a much longer historical perspective. A manuscript of St Dionysius' works had been presented to Saint-Denis by the emperor Michael II some six centuries before, in 827 (it too survives in Paris in the Bibliothèque Nationale). But the reception of the two books was strikingly different. On the very night of its arrival at Saint-Denis in 827, Michael II's gift caused eighteen miraculous cures among supplicants attending the abbey to celebrate the saint's feast day. In 1408 Manuel II's book was received warmly, but no miracles followed either in Paris or in Constantinople. By 1408 the rulers of western Europe no longer looked to the Byzantine world, as they had done in earlier centuries, with that complex mixture of awe, disapproval, greed, curiosity, ignorance, suspicion and desire. Nor did they appreciate contemporary Byzantine art as they once had done. The Maréchal de Boucicaut had a painter working for him (the so-called Boucicaut Master) who doubtless felt he had nothing to learn from Byzantium. But in eastern Europe, in the Balkans, in Russia, the situation was altogether different.

In 1453 Constantinople fell to the Ottoman Turks, and after more than a thousand years the Byzantine Empire perished. Artists sought work where they could, and artefacts of all periods met a variety of

266
Manuel II
and his family,
folio 2r,
Works of
Dionysius the
Areopagite,
c.1403–5.
27 × 20 cm,
10⅝ × 7⅞ in
(page).
Musée du
Louvre, Paris

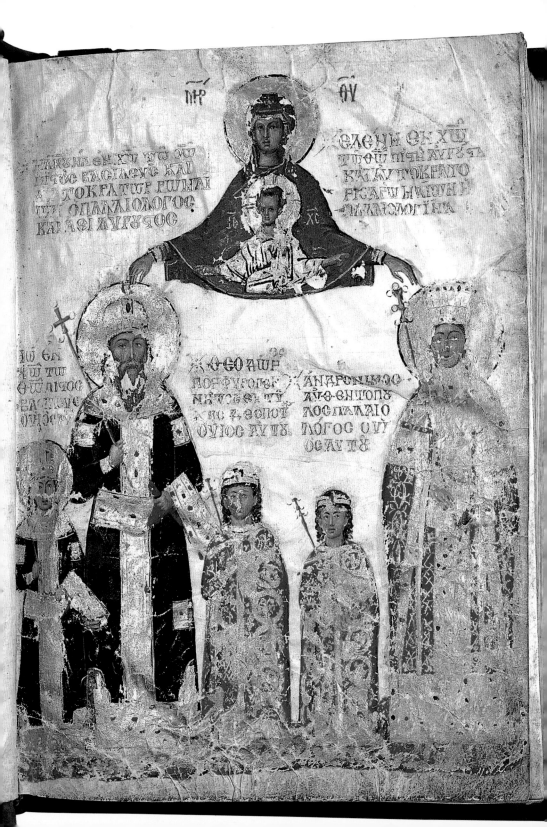

ΜΡ ΘΥ

ΜΑΝΟΥΗΛ ΕΝ ΧΩ ΤΩ ΘΩ
ΠΙΣΤΟΣ ΒΑCΙΛΕΥΟ ΚΑΙ
ΑΥΤΟΚΡΑΤΩΡ ΡΩΜΑΙ
ΩΝ Ο ΠΑΛΑΙΟΛΟΓΟC
ΚΑΙ ΑΕΙ ΑΥΓΟΥCΤΟC

ΕΛΕΝΗ ΕΝ ΧΩ
ΤΩ ΘΩ ΠΙCΤΗ ΑΥΓΟΥCΤΑ
ΚΑΙ ΑΥΤΟΚΡΑΤΟ
ΡΙCΑ ΡΩΜΑΙΩΝ Η
ΠΑΛΑΙΟΛΟΓΙΝΑ

ΙΩ ΕΝ
ΧΩ ΤΩ
ΘΩ ΠΙCΤΟC
ΒΑCΙΛΕΥ
C Ο ΥΟC

ΘΕΟΔΩ
ΡΟC Ο ΠΟΡΦΥΡΟΓΕΝ
ΝΗΤΟC ΕΝ ΤΥ
ΧΩ Ζ ΔΕCΠΟΤ
Ο ΥΙΟC ΑΥΤ8

ΑΝΔΡΟΝΙΚΟC
ΑΥ Θ ΕΝ ΘΩ Ο
ΛΟC ΠΑΛΑΙΟ
ΛΟΓΟC Ο ΥΙ
ΟC ΑΥ Π8

fates. Early Christian and Byzantine ideas, however, endured. By this time they had been propagated so widely and accepted so thoroughly over many centuries that they formed part of the bedrock of European visual culture. As a result, the lasting contribution of Early Christian and Byzantine art, whether openly acknowledged or not, can be found throughout the Western tradition.

267
Dionysiou
Monastery,
Mt Athos,
mainly 16th
century and
later

Ambo A type of pulpit usually in the form of a raised platform in the part of a church occupied by the congregation; principally used to deliver the biblical readings of the liturgy.

Anastasis The principal Byzantine image of Christ's Resurrection, and hence closely associated with Easter Sunday.

Annus mundi 'Year of the world'. A chronological system calculating from the supposed date of the world's creation, in later centuries in Byzantium usually reckoned as Sunday 25 March 5508 BC.

Augustus/Augusta A title of the Roman emperor/empress, it remained in use throughout the Byzantine period, rendered into Greek as *Augoustos/Augousta*. See also **Caesar**.

Bema The area in a church around the altar, often raised one step and enclosed by a chancel barrier, later called the **templon**.

Basileus King. The principal official title of the Byzantine emperor from the time of its adoption by Heraclius in 629.

Caesar A title of the Roman emperor, used by Diocletian to designate a junior emperor ranked below the Augustus. The Byzantines retained the title, although its use changed over the centuries.

Catacomb Now used as the generic term for an excavated subterranean burial area consisting of corridors, rooms (*cubicula*) and burial niches (*loculi* and *arcosolia*). They were used widely in the Roman world until the sixth century, most notably around Rome itself.

Cathedra A bishop's throne. In the early period located at the centre of the apse at the top of the tier of curving seats called the *synthronon*. By extension the bishop's church became the 'cathedral'.

Chrysobull A document authenticated by the emperor's gold seal.

Ciborium A structure usually consisting of four columns supporting a domed or pyramidal roof above an altar or sometimes over a tomb. Some ciboria were sheathed with silver.

Cloisonné A type of enamel work in which the fields for the glass are divided by thin partitions (French *cloisons*), usually of gold.

Deesis Literally 'entreaty' or 'petition'. In modern use an image of the enthroned Christ, flanked by the **Theotokos** and John the Baptist, who raise their hands in a gesture of intercession.

Despot 'Lord, Master'. As a title in the Byzantine hierarchy it was first used in the twelfth century.

Diakonikon The usual Byzantine church has a main apse flanked by smaller apses, the *pastophoria*. The space to the left called the *prothesis* was used primarily in the preparation of the liturgy, and that on the right, the *diakonikon*, as a sacristy.

Enkolpion 'On the chest'. A term for an object with Christian imagery worn suspended from the neck, in use from the fourth century onwards. Some *enkolpia* also contained relics.

Halo Or nimbus. An indication of power in the form of a cloud or aureole about a figure's head. Ubiquitous in the form of a coloured disc from the sixth century on, and in later centuries restricted to representations of holy persons and the imperial family.

Hodegitria An icon of the Theotokos. The original believed to have been painted by St Luke showed Christ as a child sitting upright and held in her left arm, and was the most widely copied such image.

Icon Literally 'image'. In modern use usually an image painted on a wooden panel. The word is complex – see Chapter 4. From it were created words such as 'iconoclast' ('a breaker of images') and 'iconodule' ('a servant of images').

Iconostasis 'Image-stand'. In modern use refers to a tall wooden structure covered with icons that separates the congregation from the **bema** of a church. The date at which the **templon** of the Byzantine church turned into the iconostasis remains controversial.

Indiction A chronological indication of a year within a fifteen-year cycle, originally introduced for tax purposes by Emperor Constantine I in September 312. The Byzantine calendar year followed the indiction and ran from 1 September to 31 August.

Katholikon A modern Greek term for the main church in a monastery.

Kephalaion A chapter, specifically a chapter in the Greek version of the Old or New Testament. These differ from modern usage. Because each *kephalaion* has its own title, often conspicuous on the page, these influenced the way the Byzantines thought about the Bible.

Koimesis The Byzantine term for the Dormition (death) of the Virgin, celebrated since the sixth century on 15 August, and

for its image, which is first known after Iconoclasm. Both are based on accounts first found in apocryphal legends.

Lectionary A type of book containing readings, usually from the Bible, for use in the liturgy. Visually the most important such book was the Gospel Lectionary.

Lite or **Liti** Either a liturgical procession, or (in modern Greek usage) an enlarged **narthex** used during church services.

Mandorla In images an almond-shaped aureole, usually around the figure of Christ, for example in the Anastasis.

Maphorion A veil; the veil of the Virgin, miraculously preserved and taken to the church of the Theotokos in Blachernai, Constantinople in the fifth century, and one of the city's most precious relics.

Martyrium A shrine or building at a site associated with the life of Christ or with the life or cult of a saint, often symmetrical in plan about a central point – circular, octagonal, quatrefoil, cross-shaped, etc – *ie* 'centrally-planned'.

Menologion A manuscript book containing saints' lives arranged according to the church calendar. The *Menologion* of Basil II is in fact a **synaxarion**.

Mother of God The usual inscription in images of the Virgin Mary after the early period, the words abbreviated as **MHP ΘY** and placed either side of her head perhaps in imitation of the abbreviated form IC XC used in the same way for images of Christ.

Naos In a Byzantine church that part occupied by the congregation and separated from the **bema** by a chancel barrier or **templon** screen.

Narthex In a Byzantine church a vestibule, preceding the **naos**, usually running the full width of the church on its western side.

Octateuch A volume containing the first eight books of the Old Testament. Important illustrated examples survive.

Orant 'Praying'. A figure, especially in pre-iconoclast art, represented as standing to pray with arms outstretched and hands open.

Panaghia 'All-holy'. A standard epithet for the Virgin Mary from the early period.

Pantokrator Used as an epithet of God in the New Testament (Revelation 19:6), where it is usually translated 'Almighty' or 'Omnipotent' (literally 'All-sovereign'). In Byzantine art the term is generally used to refer to a frontal bust-length image of Christ, holding a book in his left hand and blessing with his right, but 'Pantokrator' as the inscription on such an image first occurs only in the twelfth century.

Parekklesion A subsidiary chapel. At the Fethiye Camii and Kariye Camii in Istanbul the *parekklesion* is a funerary side-chapel built alongside an earlier church.

Patriarch Primarily a title of the bishop of one of the five chief sees: Rome, Constantinople, Alexandria, Antioch and Jerusalem. In Byzantine studies an unqualified reference to 'the patriarch' can be taken to refer to Constantinople. His cathedral was St Sophia, his palace was located on that church's south side.

Phelonion Similar to the western chasuble, a priestly or episcopal vestment circular or (later) semicircular in shape, pulled on over the head.

Porphyrogenetos 'Purple-born'. An epithet for a son or daughter born to a ruling emperor, widely used from the tenth century onwards.

Proskynesis A gesture of supplication or reverence. In Byzantine art usually associated with images of humble prostration, as of an emperor before Christ in St Sophia.

Prothesis See **Diakonikon**

Protopresbyter A senior priest.

Psalter A volume containing the Old Testament Book of Psalms, together with a selection of Psalm-like canticles or odes, and usually a range of other prayers and devotional material. After the Gospel Book the most commonly illustrated Byzantine manuscript.

Stavrotheka A receptacle for a relic of the True Cross.

Synaxarion A Byzantine religious calendar, usually comprising only brief indications of the appropriate feast, saint and lection.

Templon A version of the chancel screen in which waist-high marble slabs with columns supporting an epistyle divided the sanctuary area around the altar (**bema**) from the congregation. Curtains or images could be hung in the intercolumniations, or they could be left empty. See also **iconostasis**.

Theme A division of Byzantine territory, developed during the seventh-eighth centuries and later, in which a general had administrative as well as military command.

Theotokos 'God-bearing'. An epithet defining Mary as Mother of God, endorsed by the Council of Ephesus in 431.

True Cross The wooden cross, or a fragment of it, on which it was believed Christ was crucified. Relics were in circulation from the fourth century, and Byzantine craftsmen were called upon to make magnificent reliquaries, in every size from tiny **enkolpia** to large panels.

Typikon A document regulating the administrative and liturgical organization of a Byzantine monastery. Since there were no monastic orders (such as the Carthusians, Cistercians, etc., known in the West) such documents are very varied.

Constantine I (as sole ruler)	324–337
Constantine II	337–340
Constans I	337–350
Constantius II	337–361
Julian	361–363
Jovian	363–364
Valens	364–378
Theodosios I	379–395
Arkadios	395–408
Theodosios II	408–450
Marcian	450–457
Leo I	457–474
Leo II	473–474
Zeno	474–491
Basiliskos	475–476
Anastasios I	491–518
Justin I	518–527
Justinian I	527–565
Justin II	565–578
Tiberios I	578–582
Maurice	582–602
Phokas	602–610
Herakleios	610–641
Herakleios Constantine and Heraklonas	641
Constans II	641–668
Constantine IV	668–685
Justinian II	685–695
Leontios	695–698
Tiberios II	698–705
Justinian II (again)	705–711
Philippikos	711–713
Anastasios II	713–715
Theodosios III	715–717
Leo III	717–741
Constantine V	741–775
Leo IV	775–780
Constantine VI	780–797
Irene	797–802
Nikephoros I	802–811
Staurakios	811
Michael I	811–813
Leo V	813–820
Michael II	820–829
Theophilos	829–842
Michael III	842–867
Macedonian Dynasty	**867–1056**
Basil I	867–886
Leo VI	886–912
Alexander	912–913
Constantine VII	913–959
Romanos I	920–944
Romanos II	959–963
Nikephoros II	963–969
John I	969–976
Basil II	976–1025
Constantine VIII	1025–1028
Romanos III	1028–1034
Michael IV	1034–1041
Michael V	1041–1042
Zoe and Theodora	1042
Constantine IX	1042–1055
Theodora (again)	1055–1056
Michael VI	1056–1057
Isaac I	1057–1059
Constantine X	1059–1067
Romanos IV	1068–1071
Michael VII	1071–1078
Nikephoros III	1078–1081
Komnenian Dynasty	**1081–1185**
Alexios I	1081–1118
John II	1118–1143
Manuel I	1143–1180
Alexios II	1180–1183
Andronikos I	1183–1185
Isaac II	1185–1195
Alexios III	1195–1203
Isaac II (again) and Alexios IV	1203–1204
Alexios V	1204
Theodore I	1205–1221
John III	1221–1254
Theodore II	1254–1258
John IV	1258–1261
Palaiologan Dynasty	**1259–1453**
Michael VIII	1259–1282
Andronikos II	1282–1328
Michael IX	1294/5–1320
Andronikos III	1328–1341
John V	1341–1391
John VI	1347–1354
Andronikos IV	1376–1379
John VII	1390
Manuel II	1391–1425
John VIII	1425–1448
Constantine XI	1449–1453

Key Dates

Numbers in square brackets refer to illustrations

Early Christian & Byzantine Art	A Context of Events
	33 (or 30) Jesus of Nazareth crucified at Jerusalem in the reign of Tiberius
	46 St Paul begins his missionary journeys
	64 Persecution of Christians in Rome by Nero; possible date of martyrdom of Sts Peter and Paul
113 Dedication of the Column of Trajan	**111–13** Pliny the Younger writes to Trajan about Christians
118 –before 128 Reconstruction of the Pantheon Temple at Rome by Hadrian	
c.200–50 Earliest phases of Christian painting, for example in the catacombs of Rome [11–12]	**250ff.** Persecution of Christians by Decius
c.256 Destruction of Dura-Europos with its painted synagogue and Christian building [6–10]	
c.250-300 Increasing numbers of, for example, sarcophagi with Christian content [13–14]	**c.285** St Anthony retreats into the Egyptian desert; the first Christian monastic community is formed around him by c.305
	292 Diocletian divides the empire between four rulers
c.300 Galerius constructs an arch and the rotunda at Thessaloniki	**c.300** Christians very numerous throughout the empire
	303–4ff. Severe persecution of Christians under Diocletian and his successors, notably Galerius and Maximin in the East
	311 Galerius issues an Edict of Toleration to Christians
312 Constantine's victory associated with Christian God symbolized by Chi-Rho. Possible start of construction of Constantinian basilica ('the Lateran'), Rome	**312** Constantine defeats Maxentius at the battle of Milvian Bridge (outside Rome)
313–5 Arch of Constantine, Rome [16]	**313** Constantine and Licinius allow freedom of worship ('Edict of Milan')
324 Foundation of Constantinople	**325** Ecumenical Church Council of Nicaea under Constantine I; Arianism condemned
by 329 Construction of St Peter's, Rome [15]	
c.330 Construction of churches at the sites of the Crucifixion and Holy Sepulchre, Jerusalem	**330** Dedication of Constantinople
by 333 Construction of the church of the Nativity, Bethlehem (reconstructed by Justinian after 529)	

	Early Christian & Byzantine Art	A Context of Events
c.350	Construction of Sta Costanza, Rome [17–19]. Constantius builds the cross-shaped church of the Holy Apostles, Constantinople (rebuilt by Justinian)	
359	Sarcophagus of Junius Bassus [27]	
360	Dedication of first St Sophia, Constantinople, by Constantius (burned down in 404)	
		381 Ecumenical Church Council at Constantinople under Theodosius I
385	Theodosius I begins construction of St Paul's *fuori le mura*, Rome	
386–93	Column and arch of Theodosius I, Constantinople	392–3 Pagan cults banned, Olympic Games suppressed
c.402	Construction of Basilica Ursiana (the cathedral), Ravenna	402 Honorius retreats from Milan to Ravenna
404	Column of Arcadius, Constantinople	
		410 Rome sacked by Visigoths under Alaric. Galla Placidia taken hostage
412/3	Construction of new land walls at Constantinople by Theodosius II [32]	
415	Dedication of second St Sophia, Constantinople, by Theodosius II (burned down in 532)	
c.425–50	Quedlinburg Itala manuscript [31]; Mausoleum of Galla Placidia, Ravenna [62–3]	
after 425	Galla Placidia constructs S. Giovanni Evangelista, Ravenna [61]	
		431 Ecumenical Church Council at Ephesus under Theodosius II; Mary declared 'Mother of God'
432–40	S. Maria Maggiore, Rome [28–30]	
c.450	Construction of Theotokos Acheiropoietos basilica at Thessaloniki; median of proposed dates for mosaics of Hagios Georgios [3–5]	451 Ecumenical Church Council of Chalcedon under Marcian; Monophysitism condemned
		455 Rome sacked by Vandals under Genseric
c.458	Remodelling of the cathedral baptistery, Ravenna, by Bishop Neon [64–5]	
459	Death of St Symeon the Stylite, followed by construction of pilgrimage church at Qalat Seman [37]	
493–526	Construction of 'S. Apollinare Nuovo' by Theoderic at Ravenna [70–3]; probable date of the 'Arian' cathedral and baptistery [74]	493 Theoderic becomes ruler of Ravenna
494–519	'Cappella arcivescovile' added to the Cathedral of Ravenna, by Bishop Peter II [66]	
c.512	Presentation of the Vienna Dioskurides manuscript to Juliana Anicia [52–4]	
c.524–7	Construction of St Polyeuktos, Constantinople, by Juliana Anicia	
		529 Justinian closes the last pagan school of philosophy, at Athens
537	Dedication of third St Sophia, Constantinople [33–5]	
		540 Belisarius recaptures Ravenna from the Ostrogoths

543–53	Construction of Basilica Eufrasiana at Poreč [84–5]	
547	Dedication of S. Vitale, Ravenna [75–81]	
548–65	Construction of St Catherine's Monastery, Sinai [40]	
549	Dedication of S. Apollinare in Classe [82–3]	
		553 Ecumenical Church Council at Constantinople under Justinian
558	Collapse of dome of St Sophia, Constantinople (rededicated in 562)	
c.561	Remodelling of mosaics at 'S. Apollinare Nuovo', Ravenna [71–3]	
c.570	Silver gifts to the church of Holy Sion, near Antalya [41]; construction of a new cathedral at Grado	
577	Riha silver paten [42]	
586	Completion of the Rabbula Gospels [51]	586 Thessaloniki first besieged by Avars and Slavs
		614 Jerusalem sacked by Persians
		626 Constantinople besieged by Persians and Avars
		628 Persians defeated by Heraclius
		632 Death of Mahomet at Medina
		636 Heraclius defeated by the Arabs at Yarmuk, followed by the loss of Antioch (637/8), Jerusalem (638), Alexandria (646), etc.
673–9	Mosaic panel installed in S. Apollinare in Classe by Bishop Reparatus	674–8 Arabs besiege Constantinople for first time
		680–1 Ecumenical Church Council at Constantinopleunder Constantine IV, its canons completed by the synod 'in Trullo' (692) under Justinian II
		717–8 Arabs besiege Constantinople
726	Image of Christ above the Chalke Gate of the imperial palace removed (replaced after 787, removed in 814, replaced in 843)	726 Earthquake in Constantinople; start of Iconoclasm
730	Leo III requires the removal of religious images from all churches	730 Patriarch Germanos deposed
		731 Pope Gregory III condemns Iconoclasm
740	Start of rebuilding of St Irene, Constantinople, after a major earthquake [88]	
		751 Loss of Ravenna to the Lombards
		754 Church Council at Hiereia palace under Constantine V declares Iconoclasm orthodox
768/9	Destruction of images in the small sekreton, St Sophia, Constantinople [91–3]	
787–97	Mosaics of apse of St Sophia, Thessaloniki [89]	787 Iconoclasm condemned at the Second Ecumenical Church Council of Nicaea, under Irene and Constantine VI

		800 Charlemagne crowned Emperor of the Romans by Pope Leo III
817–24	Enamelled reliquary crosses associated with Pope Paschal I [96–7]	**815** Second Iconoclast Church Council at Constantinople under Leo V; Patriarch Nicephorus deposed; St Theodore of Stoudios exiled
827	Michael II sends a manuscript of St Dionysius to Saint-Denis (see also the year 1408)	**827** Start of Arab conquest of Sicily (completed in 902)
830s	Construction of first church of St Mark, Venice (destroyed in 976 and rebuilt)	
after 843	Restoration of mosaics at Nicaea [87]	**843** Veneration of images restored by Theodora and Michael III
		860 First Russian attack on Constantinople
867	Dedication of apse mosaic of St Sophia, Constantinople [99]	**873** Bari recaptured
880–3	Paris Gregory manuscript [109–10]	
c.885	Dome mosaic of St Sophia, Thessaloniki [107]	
886–912	Enamel crown of Leo VI [127]	
907	Dedication of church of Constantine Lips; *opus sectile* [130]	
		913 Bulgarian army under Tsar Symeon reaches the walls of Constantinople (and again in 924)
c.920–30	Bible manuscript of Leo *patrikios* [111–13]; decoration of Tokalı New Church [108]	
944–9	Romanos and Eudokia ivory [126]	
c.950	Paris Psalter manuscript [114–16]	
		961 Crete recaptured
		962 Foundation of the Lavra Monastery on Mt Athos by St Athanasios
968–85	Limburg reliquary [128–9]	
		972 Marriage at Rome of the future Western emperor Otto II to the Byzantine princess Theophanou
		989 Baptism of Prince Vladimir of Kiev
990s	Construction of the Panaghia church, Osios Loukas [139]	**992** Treaty between Venice and Byzantium
c.1000	Menologion manuscript of Basil II [159–161]	
		1016ff. Norman mercenaries fighting in southern Italy
		1018 Bulgarians defeated by Basil II
1028	Decoration of the Panaghia Chalkeon, Thessaloniki	
1037–46?	Construction of St Sophia, Kiev [146–8]	**after 1028** Romanos III endows St Sophia with an annual income of 80 pounds of gold
after 1042	Adaptation of the Zoe mosaic panel in St Sophia, Constantinople [145]	
before 1048	Construction of Katholikon of Osios Loukas [131–8]	
1042–55	Construction of Nea Moni, Chios [140–4]; St George of Mangana, Constantinople	

	Early Christian & Byzantine Art	A Context of Events
*c.*1050–75	Illuminated Octateuch manuscript, Vat.gr.747 [174]	1061 Normans begin conquest of Sicily (completed in 1091)
*c.*1063	Construction of third St Mark's, Venice, begins	
1066	Completion of the Theodore Psalter [162–4]; bronze doors of Amalfi Cathedral cast at Constantinople	1066 Normans invade England – defeat Harold at Battle of Hastings
1070	Bronze doors made for St Paul's *fuori le mura* , Rome [208]	
1071	Dedication of Abbot Desiderius' new church at Montecassino, Italy	1071 Normans capture Bari, last Byzantine foothold in southern Italy. Turks defeat Romanos IV at Manzikert (in Asia Minor)
1076	Bronze doors for Monte S. Angelo	
		1082? Venice granted exemption from trading taxes
		1084 Seljuk Turks capture Antioch
		1091 Normans complete conquest of Sicily
		1096 First Crusade reaches Constantinople
		1099 First Crusade captures Jerusalem
*c.*1100	Mosaic decoration of Daphni [151–8]	
1105	Reconstruction of enamel antependium of St Mark's, Venice as a *pala*; subsequently remade in 1209 and 1345 [206–7]	
1108	Dedication of St Michael, Kiev	
1122–34	John II and Irene mosaic at St Sophia, Constantinople [212]	
*c.*1130	Apse mosaic at Gelat'i, Georgia [213]	1130 Roger II recognized as King of Sicily by Pope Anacletus II
1131–43	Psalter of Queen Melisende made at Jerusalem [229]	
1136	Foundation of the Pantokrator Monastery in Constantinople by John II Komnenos [210–11]	
1140	Consecration of Cappella Palatina, Palermo, by Roger II	
1142/3	Dome mosaics of the Cappella Palatina, Palermo [178]	
1143	Martorana, Palermo, 'built and endowed' by George of Antioch; mosaics completed before 1151 [186–91]	
1148	Apse mosaic of Cefalù Cathedral [193–4]	
1152	Theotokos Kosmosoteira at Pherrai founded	
before 1155	Sinai Gregory manuscript [225]	
1164	Decoration of St Panteleimon, Nerezi [214–16]	
before 1174	William II founds Monreale	1171 Venetians arrested and their goods seized throughout the empire
		1176 Byzantines defeated by Turks at Myriokephalon

	Early Christian & Byzantine Art	A Context of Events
		1182 Latins massacred in Constantinople
		1185 Sicilian Normans capture Thessaloniki
1186	Bronze doors for Monreale by Bonannus of Pisa	
1191	Decoration of St George, Kurbinovo, Macedonia [218]	
1192	Decoration of the Church of the Theotokos, Lagoudera, Cyprus [217, 219]	
1204	Sack of Constantinople; export of objects to the West begins [230–1]	1204 Constantinople captured by Crusaders who set up a Latin Empire
1205	King Philippe II Auguste of France presents Saint-Denis with relics from Constantinople	
1209	Dome decoration of the church of the Virgin, Studenica, Serbia [234]	
		1210 Venetians occupy Crete (until ceding the island to the Turks in 1669)
1220s–30s	Mosaicists at St Mark's, Venice, use the images in the Cotton Genesis [232]	
1239	Crown of Thorns is brought from Constantinople to Paris	
c.1261	Deesis mosaic set up in the south gallery of St Sophia, Constantinople [238]	1261 Michael VIII recaptures Constantinople
		1262 Mistra recaptured
c.1266	Wall-paintings at Sopocani, Serbia [235]	
1282–1303	Empress Theodora restores Monastery of Lips [246]; illuminated manuscripts for a Palaiologina [240–3]	1282 Skopje captured by Milutin
1290s	Michael Glabas restores the Theotokos Pammakaristos (Fethiye Camii)	
1293	Constantine Palaiologos restores St John Stoudios	
1294–6	Constuction and decoration of the Theotokos Paregoritissa, Arta, by the Despot of Epiros [253–4]	
1295	Decoration of the Theotokos Peribleptos ('St Clement'), Ohrid, Macedonia [255–6]	
		1299 Marriage arranged between King Milutin of Serbia and the daughter of Andronikos II
c.1304–8	Maria, widow of Michael Glabas, builds and decorates a funerary parekklesion at the Fethiye Camii [247–50]	
1306/7	Decoration of the Mother of God Ljeviška, Prizren	
after 1307?	Decoration of St Nikitas, Čučer	
1310–14 or 1329 or later	Construction and decoration of 'Holy Apostles', Thessaloniki, by Patriarch Niphon [251–2]	
1313–47	Documented career of the painter John Pagomenos in Crete	
1314	Church of Sts Joachim and Anna built by Milutin at Studenica	

	Early Christian & Byzantine Art	A Context of Events
c.1315–21	Decoration of the restored church of the Saviour in Chora (Kariye Camii), Constantinople [259–64]	
1317/18	Decoration of St George at Staro Nagoričino	
		1321–8 Civil war between Andronikos II and his grandson Andronikos III
		1331 Ottoman Turks capture Nicaea
1344	Greek painters decorate the church of the Mother of God, Moscow	
1346	Collapse of the eastern arch and semidome of St Sophia	
1348	Isaias the Greek paints a church in Novgorod	1348 Mistra seat of a Despot
by 1355	Mosaics in the repaired dome of St Sophia restored	
1378	Theophanes the Greek paints the church of the Transfiguration, Novgorod	
1384–96	Prince of Samegrelo calls Manuel Eugenikos from Constantinople to Georgia to paint a church at Kalendžiha	
1395	Theophanes the Greek paints the church of the Nativity of the Mother of God, Moscow	
1399	Theophanes the Greek paints the church of St Michael, Kremlin, Moscow	1399–1402 Manuel II travels through western Europe seeking aid against the Turks
1408	Manuel Chrysoloras presents a manuscript of St Dionysius to Saint-Denis [265–6]	
c.1428	Decoration of the Theotokos Pantanassa, Mistra	
		1430 Thessaloniki captured by the Turks
1453	St Sophia converted into a mosque	1453 Constantinople falls to the Turks. Death of Constantine XI
		1460 Mistra falls to the Turks

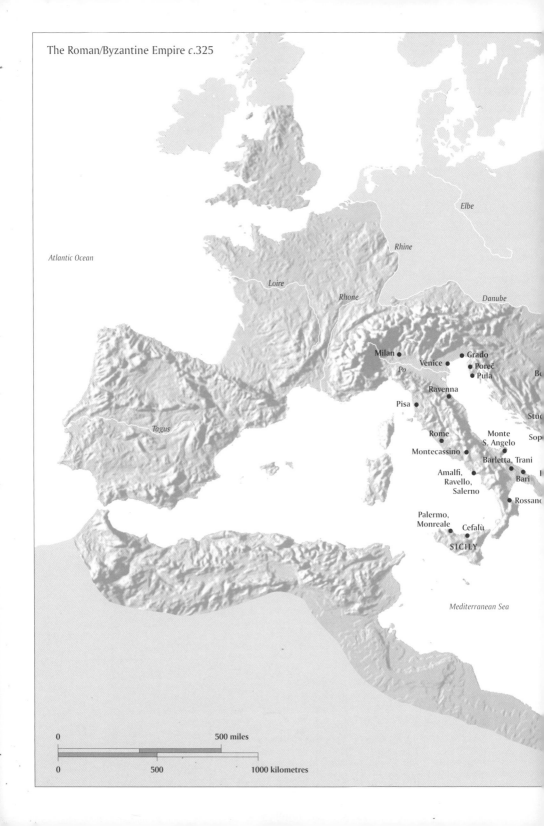

The Roman/Byzantine Empire *c*.325

Elbe

Rhine

Atlantic Ocean

Loire

Rhone

Danube

Milan ●

Venice ●

● Grado

● Poreč

● Pula

Po

Bo

Ravenna ●

Pisa ●

Tagus

Stud

Rome ●

Monte
S. Angelo ●

Sop

Montecassino ●

Barletta, Trani ●

Amalfi,
Ravello,
Salerno ●

● Bari

● Rossan

Palermo,
Monreale ●

Cefalù ●

SICILY

Mediterranean Sea

0 500 miles

0 500 1000 kilometres

Novgorod

Moscow

Don

Volga

Kiev

Dnepr

Dnestr

Caspian Sea

GEORGIA

Danube

Black Sea

Tsalenjikha ● ● Gelat'i

Sinop

ARMENIA

St Nagoričino
kopje, Nerezi
Serres
rid ● Philippi Constantinople
 Pherrai ● Chalcedon
● Thessaloniki ● Nicomedia
oria Mount ● Nicaea
 Athos Prokonnesos

CAPPADOCIA

GÖREME VALLEY

Loukas ● Chios

ens, Daphni ● Ephesus

● Mistra Antalya

CILICIA ● Qalat Seman
 Antioch ●
 ● Riha Tigris

SYRIA ● Dura

Lagoudera Euphrates

CYPRUS

CRETE

PALESTINE
 ● Jerusalem
 ● Bethlehem

SINAI ● Aila

St. Catherine's Monastery

Nile

General

These books attempt a broad perspective although they may also be highly detailed. Some volumes of collected studies and exhibition catalogues are also included here. Publications in English have been preferred on grounds of accessibility.

Peter Brown, *The Rise of Western Christendom* (Oxford, 1996)

Hugo Buchthal, *Art of the Mediterranean World, AD 100 to 1400* (Washington, DC, 1983)

David Buckton (ed.), *Byzantium* (exh. cat., British Museum, London, 1994)

Byzance (exh. cat., Musée du Louvre, Paris, 1992)

Robin Cormack, *Writing in Gold: Byzantine Society and Its Icons* (London, 1985)

—, *Painting the Soul: Icons, Death Masks and Shrouds* (London, 1997)

—, *Byzantine Art* (Oxford, 2000)

F L Cross and E A Livingstone (eds), *Oxford Dictionary of the Christian Church*, 2nd edn (Oxford, 1983)

Elizabeth Dawes and Norman H. Baynes, *Three Byzantine Saints* (Oxford, 1977)

Helen C Evans (ed.), *The Glory of Byzantium* (exh. cat., Metropolitan Museum of Art, New York, 1997)

Paul Hetherington, *Byzantine and Medieval Greece* (London, 1991)

J M Hussey, *The Orthodox Church in the Byzantine Empire* (Oxford, 1986)

Alexander Kazhdan and Giles Constable, *People and Power in Byzantium* (Washington, DC, 1982)

Alexander Kazhdan *et al.* (eds), *Oxford Dictionary of Byzantium*, 3 vols (New York and Oxford, 1991)

Ernst Kitzinger, *The Art of Byzantium and the Medieval West: Selected Studies*, ed. W Eugene Kleinbauer (Bloomington and London, 1976)

Athanasios D Kominis (ed.), *Patmos: Treasures of the Monastery* (Athens, 1988)

Richard Krautheimer, *Early Christian and Byzantine Architecture*, The Pelican History of Art, 4th edn (Harmondsworth, 1986)

Angeliki E Laiou and Henry Maguire (eds), *Byzantium: A World Civilization* (Washington, DC, 1992)

Viktor Lazarev, *Storia della pittura bizantina* (Turin, 1967)

Henry Maguire, *Art and Eloquence in Byzantium* (Princeton, 1981)

Cyril Mango, *The Art of the Byzantine Empire, 312–1453*, Sources and Documents in the History of Art Series (Englewood Cliffs, NJ, 1972, repr. Toronto, 1986)

—, *Byzantine Architecture* (New York, 1976)

—, *Byzantium, The Empire of New Rome* (London, 1980)

Thomas Mathews, *The Art of Byzantium* (London, 1998)

John Julius Norwich, *Byzantium*, 3 vols (London, 1988–95)

George Ostrogorsky, *History of the Byzantine State* (Oxford, 1968)

Robert Ousterhout and Leslie Brubaker (eds), *The Sacred Image East and West* (Urbana, IL, 1995)

S Pelekanidis and others, *The Treasures of Mount Athos, Illuminated Manuscripts*, 4 vols (Athens, 1973–91); vols 3–4 in Greek only

Lyn Rodley, *Byzantine Art and Architecture, An Introduction* (Cambridge, 1993)

Linda Safran (ed.), *Heaven on Earth: Art and the Church in Byzantium* (University Park, PA, 1998

N P Ševčenko and C Moss (eds), *Medieval Cyprus* (Princeton, 1999)

Treasures of Mount Athos (exh. cat., Museum of Byzantine Civilisation, Thessaloniki, 1997)

The Treasury of San Marco, Venice (exh. cat., Metropolitan Museum of Art, New York, 1984)

Maria Vassilaki (ed.), *Mother of God* (exh. cat., Benaki Museum, Athens, 2000)

Christopher Walter, *Art and Ritual of the Byzantine Church* (London, 1982)

Kurt Weitzmann, *Studies in Classical and Byzantine Manuscript Illumination* (Chicago, 1971)

—, *Studies in the Arts at Sinai* (Princeton, 1982)

—, *The Icon* (New York, 1978)

—, *The Monastery of Saint Catherine at Mount Sinai: The Icons* (Princeton, 1976)

Kurt Weitzmann (ed.), *Age of Spirituality* (exh. cat., Metropolitan Museum of Art, New York, 1979)

The Early Period
(Early Christian/Early Byzantine/Late Antique)

The emphasis here is on books that focus on the art, ideas, society and events up to approximately the end of the sixth century – the scope of chapters 1–3. Books in English are again preferred. For the monuments of Ravenna, however, the massive studies in German by F W Deichmann are essential; there is no English substitute.

Peter Brown, *The Cult of the Saints: Its Rise and Function in Latin Christianity* (Chicago, 1981)

—, *Power and Persuasion in Late Antiquity: Towards a Christian Empire* (Madison, WI, 1992)

Averil Cameron, *Continuity and Change in Sixth-Century Byzantium* (London, 1981)

—, *The Mediterranean World in Late Antiquity, AD 395–600* (London, 1993)

Friedrich Wilhelm Deichmann, *Ravenna, Hauptstadt der spätantiken Abendlandes*, 4 vols (Wiesbaden, 1969–89)

—, *Frühchristliche Bauten und Mosaiken von Ravenna* (Baden-Baden, 1958)

Jaš Elsner, *Art and the Roman Viewer* (Cambridge, 1995)

—, *Imperial Rome and Christian Triumph* (Oxford, 1998)

Antonio Ferrua, *The Unknown Catacomb: A Unique Discovery of Early Christian Art* (New Lanark, 1991)

André Grabar, *Christian Iconography, A Study of its Origins* (New York, 1968)

Joseph Gutmann, *Sacred Images: Studies in Jewish Art from Antiquity to the Middle Ages* (Northampton, 1989)

Martin Harrison, *A Temple for Byzantium* (Austin, TX, 1989)

Judith Herrin, *The Formation of Christendom* (Princeton, 1987)

Ernst Kitzinger, *Byzantine Art in the Making* (Cambridge, MA, 1977)

Spiro K Kostof, *The Orthodox Baptistery of Ravenna* (New Haven, 1965)

Richard Krautheimer, *Rome: Profile of a City, 312–1308* (Princeton, 1980)

Rowland J Mainstone, *Hagia Sophia* (London, 1988)

Konstantinos A Manafis, *Sinai: Treasures of the Monastery of Saint Catherine* (Athens, 1990)

Marlia Mundell Mango, *Silver from Early Byzantium* (exh. cat., Walters Art Gallery, Baltimore, 1986)

Robert Mark and Ahmet Akmak (eds), *Hagia Sophia* (Cambridge, 1994)

Thomas F Mathews, *The Early Churches of Constantinople: Architecture and Liturgy* (University Park, PA, 1971)

Thomas F Mathews, *The Clash of Gods, A Reinterpretation of Early Christian Art* (Princeton, 1993)

F van der Meer and Christine Mohrmann, *Atlas of the Early Christian World* (London, 1966)

Robert Milburn, *Early Christian Art and Architecture* (Aldershot, 1988)

Sister Charles Murray, *Rebirth and Afterlife. A Study of the Transmutation of Some Pagan Imagery in Early Christian Funerary Art*, British Archaeological Reports, International Series, 100 (Oxford, 1981)

Kenneth Painter (ed.), *Churches Built in Ancient Times* (London, 1994)

Procopius, trans. by H B Dewing, *The Anecdota or Secret History, Buildings*, vols VI-VII, Loeb Classical Library (London and Cambridge, MA, 1935–40, and later reprintings)

Kurt Weitzmann, *Late Antique and Early Christian Book Illumination* (New York, 1977)

Kurt Weitzmann and Herbert L Kessler, *The Frescoes of the Dura Synagogue and Christian Art*, Dumbarton Oaks Studies, 28 (Washington, DC, 1990)

—, *The Cotton Genesis*, Illustrations in the Manuscripts of the Septuagint, 1 (Princeton, 1986)

The Middle and Late Periods
(including Iconoclasm)

The problems of making a selection are here especially acute. A range of recent studies and some older standard works have been included. But in addition to publications in English, again preferred for reasons of accessibility, the reader should be aware that new books and articles are constantly appearing in the most important languages for the study of Byzantine art and ideas, namely French, German, Greek, Italian and Russian.

The Alexiad of Anna Comnena trans. by E R A Sewter (Harmondsworth, 1969)

Jeffrey Anderson, Paul Canart and Christopher Walter, *Codex Vaticanus Barberinianus Graecus 372: The Barberini Psalter* (Stuttgart, 1992)

Michael Angold, *The Byzantine Empire 1025–1204* (London, 1984)

—, *Church and Society in Byzantium under the Comneni* (London, 1995)

Hans Belting, Cyril Mango and Doula Mouriki, *The Mosaics and Frescoes of St Mary Pammakaristos (Fethiye Camii) at Istanbul*, Dumbarton Oaks Studies, 15 (Washington, DC, 1978)

Eve Borsook, *Messages in Mosaic: The Royal Programmes of Norman Sicily, 1130–1187* (Oxford, 1990)

Charalambos Bouras, *Nea Moni on Chios, History and Architecture* (Athens, 1982)

Robert Browning, *Byzantium and Bulgaria* (London, 1975)

Leslie Brubaker, *Image as Exegesis* (Cambridge, forthcoming)

Anthony Bryer and Judith Herrin (eds), *Iconoclasm* (Birmingham, 1977)

Hugo Buchthal, *Miniature Painting in the Latin Kingdom of Jerusalem* (Oxford, 1957)

Hugo Buchthal and Hans Belting, *Patronage in Thirteenth-Century Constantinople*, Dumbarton Oaks Studies, 16 (Washington, DC, 1978)

Annemarie Weyl Carr, *Byzantine Illumination, 1150–1250* (Chicago, 1987)

Kathleen Corrigan, *Visual Polemics in the Ninth-Century Byzantine Psalters* (Cambridge, MA, 1992)

Anthony Cutler, *The Aristocratic Psalters in Byzantium*, Bibliothèque des Cahiers Archéologiques, 13 (Paris, 1984)

—, *The Hand of the Master: Craftsmanship, Ivory and Society in Byzantium (9th–11th Centuries)* (Princeton, 1994)

Otto Demus, *Byzantine Mosaic Decoration* (London, 1948, repr. New Rochelle, NY, 1976)

—, *The Mosaics of Norman Sicily* (London, 1949)

—, *The Church of San Marco in Venice: History, Architecture, Sculpture*, Dumbarton Oaks Studies, 6 (Washington, DC, 1960)

—, *The Mosaics of San Marco in Venice*, 4 vols (Chicago and Washington, DC, 1984)

—, *The Mosaic Decoration of San Marco, Venice*, ed. Herbert L Kessler (Chicago, 1990)

Mary-Lyon Dolezal, *Ritual Representations: The Middle Byzantine Lectionary Through Text and Image* (in preparation)

Ann Wharton Epstein, *Tokalı Kilise*, Dumbarton Oaks Studies, 22 (Washington, DC, 1986)

Jaroslav Folda, *The Art of the Crusaders in the Holy Land, 1098–1187* (Cambridge, 1995)

J F Haldon, *Byzantium in the Seventh Century* (Cambridge, 1990)

Michael Jacoff, *The Horses of San Marco and the Quadriga of the Lord* (Princeton, 1993)

Jeremy Johns, *Early Medieval Sicily* (London, 1995)

Walter E Kaegi, *Byzantium and the Early Islamic Conquests* (Cambridge, 1992)

Konstantin Kalokyris, *The Byzantine Wall Paintings of Crete* (New York, 1973)

Anna D Kartsonis, *Anastasis, The Making of an Image* (Princeton, 1986)

Ernst Kitzinger, *The Mosaics of St Mary's of the Admiral in Palermo*, Dumbarton Oaks Studies, 27 (Washington, DC, 1990)

—, *I mosaici del periodo normanno in Sicilia, 1–2, La Cappella Palatina di Palermo* (Palermo, 1992–3); 3, *Il duomo di Monreale* (Palermo, 1994), series in progress

Viktor Lazarev, *Old Russian Murals and Mosaics* (London, 1966)

Hrihoriy Logvin, *Kiev's Hagia Sophia* (Kiev, 1971)

John Lowden, *Illuminated Prophet Books* (University Park, PA, 1988)

—, *The Octateuchs* (University Park, PA, 1992)

Paul Magdalino, *The Empire of Manuel I Komnenos* (Cambridge, 1993)

Hans Eberhard Mayer, *The Crusades* (Oxford, 1972)

Rosemary Morris, *Monks and Laymen in Byzantium, 843–1118* (Cambridge, 1995)

Doula Mouriki, *The Mosaics of Nea Moni on Chios*, 2 vols (Athens, 1985)

Robert S Nelson, *The Iconography of Preface and Miniature in the Byzantine Gospel Book*, Monographs on Archaeology and the Fine Arts, 36 (New York, 1980)

Donald M Nicol, *The Last Centuries of Byzantium* (London, 1972)

Dimitri Obolensky, *The Byzantine Commonwealth* (London, 1971)

Robert Ousterhout, *The Architecture of the Kariye Camii in Istanbul*, Dumbarton Oaks Studies, 25 (Washington, DC, 1987)

Michael Psellus, *Fourteen Byzantine Rulers* trans. by E R A Sewter (Harmondsworth, 1966)

Nancy Patterson Ševčenko, *Illustrated Manuscripts of the Metaphrastian Menologion* (Chicago, 1990)

Paul A Underwood, *The Kariye Djami*, vols 1–3 (New York, 1966); vol.4, ed. Paul A Underwood (Princeton, 1975)

Christopher Walter, *Art and Ritual of the Byzantine Church* (London, 1982)

Kurt Weitzmann and George Galavaris, *The Monastery of Saint Catherine at Mount Sinai: The Illuminated Greek Manuscripts* (Princeton, 1990)

Annabel Jane Wharton, *Art of Empire* (University Park, PA, 1988)

Mark Whittow, *The Making of Orthodox Byzantium, 600–1025* (London, 1994)

Index

Numbers in **bold** refer to illustrations

Acknowledgements

The advice and encouragement of the Art &
Ideas commissioning editor, Marc Jordan, and
series editor, Pat Barylski, have been of great
value. Pat, ably assisted by Julia MacKenzie,
has supervised this book's preparation and
production at every stage. She and Julia have
earned my respect and admiration, as well as
my gratitude. Michael Bird edited the entire
text with insight and discernment, improving
it significantly in the process. Susan Rose-
Smith undertook the illustration research with
an inspiring blend of ingenuity, persistence,
and good humour. Phil Baines designed the
layout with sensitivity and flair: the result is a
true blend of art and ideas. The following
friends and colleagues kindly helped in trac-
ing photographs: Charles Barber, Robin
Cormack, Antony Eastmond, Giovanni Freni,
George Galavaris, Herbert Kessler, Ernst
Kitzinger, Cyril Mango, John Mitchell, V
Nersessian, Ann Terry, Hjalmar Torp, and
Annabel Wharton. Efthalia Constantinides was
a source of advice and photographs to whom
I turned on many occasions; she always
provided prompt help. And Helen Evans, by
her enthusiasm and encouragement, played a
significant part in bringing this project to
completion. I thank them all most warmly.
A book without footnotes creates special
problems for an academic author, and
demands an act of trust on the part of any
reader. Many have trodden the various paths I
take in this volume, but only the expert will
recognize to whose work I am most indebted
and at what points. I profoundly regret the
resulting impossibility of giving credit where
it is due. Several of the translations, for exam-
ple, are from Cyril Mango's indispensable *Art
of the Byzantine Empire, 312–1453* (see Further
Reading), whereas others are from different
sources, and some are my own. Some of the
art I consider has been the subject of magiste-
rial publications in recent times (the church of
Nea Moni on Chios, for example), and such
studies provide a sound basis for discussion,
but I have also chosen to consider other
works that remain poorly understood or are
rarely reproduced. I trust that the section of
Further Reading – which is not in any sense a
bibliography of the sources consulted – will
nonetheless prove helpful.

 I hope this book can be of use to people at
many levels. It represents a particular view of
Early Christian and Byzantine art, inevitably a
selective and personal one. I gratefully
acknowledge all those who helped me to
form that view, and in particular Robin
Cormack, first as supervisor and then as
colleague at the Courtauld Institute of Art.
This book is that acknowledgement.

J L

For Richard Armstrong

Photographic Credits

Author: 50, 140, 147, 267; Biblioteca Apostolica Vaticana: 111–113, 117, 159, 160, 161, 173, 174, 177, 221, 223, 224, 240, 241–245; Bibliothèque Nationale, Paris: 46, 109, 110, 114–116, 125, 126, 165, 176; Bodleian Library, Oxford: 168; Osvaldo Böhm, Venice: 205, 209; Dr Beat Brenk, Basel: 178, 184, 185; British Library, London: 49, 162–164, 229, 236; British Museum, London: 124; Mario Carrieri, Milan: 36, 127, 206, 207, 231; Dr E Constantinides, Athens: 152, 256; Conway Library, Courtauld Institute of Art, London: 88, 151; Courtauld Institute of Art, London (E Hawkins): 39, 91, 92, 101, 239, 240, 264; Dumbarton Oaks, Washington, DC: 41, 42; Dumbarton Oaks, Washington, DC, Photographic Archive: 93, 99, 104, 105, 238; Electa, Milan: 2; Werner Forman Archive, London: 128, 129, 230; Fotorudi, Barletta: 233; Ara Güler, Istanbul: 100, 145, 212, 250, 259–263; S Haidemenos, Thessaloniki: 1, 94, 107, 252; Sonia Halliday, Weston Turville: 37, 40, 106, 135, 217; Robert Harding Picture Library: 34; P Huber: 244; Arkeoloji Müzeleri Müdürlügü, Istanbul: 130; A F Kersting, London: 181, 257; Renco Kosinozic, Poreč: 84, 85; Kunsthistorisches Seminar, Basel: 200; M Mepiaschwili, R Schrade, W Zinzadse, *Die Kunst des alten Georgiens*, 1976: 213; Metropolitan Museum of Art, New York: 98; Reproduced through the courtesy of the Michigan-Princeton-Alexandria Expedition to Mount Sinai: 38; G Millet, *Daphni*, 1899: 158; Mountain High Maps, Copyright © 1995 Digital Wisdom, Inc: Map relief, pp.436–7; National Gallery of Art, Washington, DC: 239; Dr V Nersessian: 44; Österreichische National-bibliothek, Vienna: 47, 48, 52–54, 116, 167; Vivi Papi, Varese: 169–171; Monumenti Musei e Gallerie Pontificie, The Vatican: 13, 14, 19, 23, 118–121; Istituto suore di Priscilla, Rome: 11, 12; Publifoto, Palermo: 180, 181–183, 187, 189, 190, 194, 197, 199, 202; RMN, Paris: 122, 123, 228, 265, 266; Het Koninklijk Penningkabinet, Rijksmuseum, Leiden: 60; Fabbrica di San Pietro, The Vatican: 27; Josephine Powell, Rome: 32, 33, 35, 134, 136–137, 139, 210, 214–216, 218, 234, 235, 255; Reproduced by courtesy of the Director and the University Librarian, the John Rylands University Library of Manchester: 237; Scala, Florence: 12, 17, 18, 20, 22, 28, 29, 30, 61–68, 70–74, 76–83, 188, 191, 198, 201, 204, 208, 232; Alberto Scardigli, Florence: 51, 175; Edwin Smith Archive, Saffron Walden: 150; Soprintendenza Archeologica di Roma: 69; Staatliche Museen zu Berlin – Preussischer Kulturbesitz, Museum für Spätantike und Byzantinische Kunst: 43; Staatsbibliothek zu Berlin: 31; State Historical Museum, Moscow: 102, 103; Studio Kontos ©: 89, 131–132, 138, 150, 154–157, 253; Christopher Tadgell, London: 193; Topkapı Saray, Istanbul: 222; Alessandro Vasari, Rome: 16; By courtesy of the Board of Trustees of the Victoria & Albert Museum, London: 96, 97; Warburg Institute, London: 87; Professor Annabel Wharton, Durham, North Carolina: 108; Yale University Art Gallery, Dura-Europos Archive: 7, 8, 10

Phaidon Press Limited
Regent's Wharf
All Saints Street
London N1 9PA

Phaidon Press Inc.
180 Varick Street
New York, NY 10014

www.phaidon.com

First published 1997
Reprinted 1998, 2001, 2003
© 1997 Phaidon Press Limited

ISBN 0 7148 3168 9

A CIP catalogue record for this book is
available from the British Library.

Text typeset in Bitstream Amerigo,
chapter numbers in Sophia

Printed in Singapore

Cover illustration Enamelled reliquary,
early 9th century (see pp.169–72)